# ALBERTINA

*The History of the Collection*

*and*

*Its Masterpieces*

Barbara Dossi

# ALBERTINA

*The History of the Collection*
*and*
*Its Masterpieces*

Prestel

MUNICH · LONDON · NEW YORK

"Order and completeness were the two qualities I desired my little collection to possess. I read the history of art, I put my prints in order according to school, master and date. I made catalogues, and I must say in my own praise that I never heard of any good master or learned about any good artist without seeing if I could acquire one of his works, so that I might not simply praise his merits in words, but have them before my eyes."

Johann Wolfgang von Goethe,
The Collector and His Circle
in Goethe on Art

# Contents

Forewords   7

Preamble   8

Preface and Acknowledgments   9

The History of the
Graphische Sammlung Albertina
11

The Foundation and Growth of the
Drawings and Print Collection
46

COLOR PLATES
65

Duke Albert of Saxe-Teschen
Biographical Dates
153

Directors and Principals of the Collection after 1822   158

Endnotes   159

Selected Bibliography   179

List of Color Plates, Color Illustrations, and Figures   184

Index of Proper Names   190

# Forewords

Ten years ago Barbara Dossi made a momentous discovery in the Albertina archives. What she found was the key to the asterisks assigned to each drawing and marked on each of the old inventory sheets—known as the Cahier sheets—listing the maker, title, and technique. The asterisks constitute a code for the most distinguished collections from which Albert of Saxe-Teschen, the founder of the Albertina, acquired the drawings. This discovery proved of greater significance than the original task which had led to it, namely researching into the history of the collection and tracing the provenance of the Italian drawings for a general inventory under Veronika Birke's direction. A decision was soon taken to base a publication on the results of this discovery. Drawing primarily on Walter Koschatzky's preparatory work, Barbara Dossi researched for a number of years in numerous archives and in so doing, has decisively enlarged our knowledge of the history of the Albertina collection, particularly with regard to the activities of the owners and directors following the era in which the Albertina collection was founded.

Barbara Dossi has now given us the first truly comprehensive survey of what has taken place in the Albertina since the Age of Enlightenment. In the 18th century, at a time when financial backing for such purposes was lavish, the collection was founded as an institute dedicated to art education and the promotion of art history. Present day Austria is much smaller and, in today's terms, the funds are more modest. Nevertheless, the acquisitions policy at the Albertina continues to uphold its international reputation, keeping its founding spirit alive and in tune with the times.

We should like to express our heartfelt appreciation to Prestel for presenting Barbara Dossi's exemplary book to the public in such a sumptuous edition. Now that a new study center is being built at the Albertina and Albert's former palace is undergoing restoration, we hope that Barbara Dossi's insights into the history of our collection and the superb works of art it contains will awaken fresh public awareness as to how important the Albertina has always been.

KONRAD OBERHUBER
Director of the Albertina

Keeping, enlarging, and studying an historical collection as vast and important as that at the Albertina presents each generation with a new challenge. Firstly, the works already in our possession must be protected as far as possible from the wear and tear that almost inevitably accompany the storage and use of museum collections. Secondly, every generation at the Albertina is eager to add to the nucleus of the collections. The acquisitions policy is, of course, also directed at contemporary art which has gradually yet perceptibly been incorporated into historical segments. Thirdly, a study of works already in our collection is always called for. In addition to mounting numerous touring exhibitions, we strive to keep alive the history of the museum, its collections, and the people it concerns for generations to come. Consequently, our aim is not to treat the works in the collection merely from an art historical standpoint. It is just as important to make the public aware of the history of the Albertina as an institution. During the darkest war years, for instance, the Albertina was saved from destruction only through the courageous and selfless efforts of the staff and friends of the museum untiringly committed to its welfare.

More than two hundred years have passed since the Albertina was founded. Since then work has gone on virtually without interruption to enlarge and improve the collections. The economic and social conditions experienced by different generations associated with the Albertina varied considerably, and these in turn exerted an influence on each generation's appreciation of art and artists. However, throughout its history, there has never been any doubt as to the importance of the collection within the broader context of European cultural heritage. In the light of this, it seems only appropriate that Walter Koschatzky should have perpetuated the analogy of the Albertina's history being like a baton, passed on from one generation to the next, when he retired in 1984.

Embedded in a large-scale project which has now led to a general inventory of the Italian drawings in the Albertina, Barbara Dossi's research grew into a survey so comprehensive in scope and so far-reaching in its implications that an independent publication seemed called for. We are indebted to the author in many respects, not least of all for deepening our insights into, and knowledge of, the era of Albert of Saxe-Teschen and Marie Christine of Austria. Equally important is Barbara Dossi's research into the Albertina in the first half of the twentieth century. Thus at the close of the millennium, a wealth of historical background material has been revealed. It only remains to see what future generations will make of it.

VERONIKA BIRKE
Deputy Director of the Albertina

# Preamble

I heartily welcome the publication of this volume and have the greatest respect for its author.

From its very inception the Albertina has preserved the magnifying glass used by Adam von Bartsch. A large rectangular glass in a wooden frame, it symbolizes the task handed down by great scholars before us—a task to which we are committed to the utmost in serving this magnificent collection in the spirit of our predecessors. It has become a tradition for retiring Directors of the Albertina to hand on this magnifying glass to their successors like a baton in the relay of intellectual and spiritual commitment. I handed the glass on in 1986 just as I had received it a quarter of a century earlier from Otto Benesch. It always reminded me that, as researchers and scholars at the Albertina, we were all committed to one special philosophy. Consequently, it seemed to me only appropriate to devote my scholarly endeavours into researching this. However, the events which racked the past century, the wars, upheavals, and associated destruction, together with the consequences of the Habsburg law on the young republic at the close of the Great War in 1918, seemed to have allied themselves against our efforts to an unusual degree. The Albertina archives had disappeared, the inventories were lost, and any publications that appeared were scanty indeed. Of course, in every scholar's life there seem to be more than enough negative moments and disappointments—endless wasted hours during which it is hard to maintain one's belief in the purpose of one's work or in its success. However, all the more frequently come the supreme moments of joy occasioned by a chance find of paramount importance. Only those who have experienced similar good fortune can begin to imagine what this is like. This was the case for me when, after having searched in vain throughout Europe, I came upon Habsburg archive material in the attic of the Hungarian State Archives in Budapest, tied up in bundles which had been singed at the edges. Communism still reigned and much of the material had been destroyed when the building had caught fire after being bombed in 1956. Yet there it was and it was still legible. Try to imagine what I felt when I stumbled upon the *Mémoires* of Duke Albert of Saxe-Teschen and was able to initiate research into the history of the Albertina based on these documents. Admittedly, I was moved to do so because I had always admired, in fact envied, the history of the Kunsthistorische Sammlungen which Alphons Lhotsky had managed to write in the midst of the war, and I had always regretted that there was nothing like it on the Albertina.

Now the baton has passed into other hands. Barbara Dossi's work is of the greatest importance. May it serve to benefit the rich collection that we have inherited with all its related commitments, and enhance its reputation by widening the circle of its admirers. May it also perpetuate the unique spirit that is the Albertina's.

For these reasons my thoughts are with this book and its author.

WALTER KOSCHATZKY
Former Director of the Albertina

# Preface and Acknowledgments

First and foremost my warmest thanks go to Veronika Birke, who encouraged me to write this book, accompanied the entire process with personal attention and great understanding, and supported the project at all stages. When she undertook to draw up a general inventory of the Italian drawings in the Albertina late in the 1980s, she suggested that I write an account of the history of the collection. Konrad Oberhuber, the Director of the Albertina, approved this project, supported the necessary research work from the beginning, and smoothed the way to publication.

Taking earlier publications as my point of departure, and following closely in the footsteps of Walter Koschatzky, Selma Krasa, and Alice Strobl, I began to delve into the history of the collection. There turned out to be little material available. In the early 1960s Otto Benesch scrutinized the archives then available without, however, carrying out further research. Of his predecessors, Alfred Stix just fleetingly touched the subject, and neither Joseph Meder nor Joseph Schönbrunner went into more depth in 1922 and 1887, respectively, than Moriz Thausing, who published the first account of the history of the collection in 1870.

Since priority in this undertaking was given to gathering all facts concerning the inception and further development of the Albertina collection and to distinguishing these from unverifiable or speculative material, a thorough examination of the sources was needed. Looked at as a whole, the amount of authentic material that had been preserved—relating to the earliest phase of the collection—was less than that for later years. This is mainly due to the fact that archive material not included in the entailment had been the personal property of Archduke Frederick's since 1919. This was then taken out of Austria and either scattered or destroyed. The years following the death of Albert of Saxe-Teschen, on the other hand, can be accurately reconstructed over quite long periods, particularly since  inventories of acquisitions had been drawn up from 1822 and continuous inventories from 1895 onwards. Starting in 1919, archive records have been arranged chronologically by year and are for the most part complete.

Recent research on the collection focuses on what is known as the Raccolta Durazzo, the first large collection of prints which Albert of Saxe-Teschen commissioned Durazzo to acquire. In addition, it has brought to light hitherto unknown accounts by contemporaries of the size and growth of the cabinet collection, and has revealed the criteria which guided Albert and his contacts to art agents, artists, and collectors. Definitive evidence as to which acquisitions were actually made by Albert and to their— hitherto untraceable—provenance, has proved invaluable. The discovery of coded references in the historical inventory lists of the drawings collection, together with the key to unravel them, was the luckiest find in this connection. The exhaustive, basic research into the little known and scarcely published development of the Albertina and its collection, rendered necessary by the discovery, and the consequent follow-up, also led to new results with far-reaching implications. It entailed a study of the period between 1822 and 1919 under the Habsburg archdukes Charles, Albrecht, and Frederick, and the years after World War I when the Austrian monarchy had been abolished. At that time the (arch)ducal collection was nationalized and also menaced by a fateful series of interrelated events. Further objects of this research were the amalgamation of the Albertina and the copperplate engravings cabinet of the Imperial Court Library in 1920, the hardships incurred between 1935 and 1945, and, finally, the subsequent development of the collection under each of the post-war directors. Here, the focus has been on their acquisitions policies and activity.

The material compiled from years of research was ultimately so complex and comprehensive that it seemed best to separate the general history of the collection from what had originally been intended—that is, the history of the Italian drawings—and to publish two books. Thus the present volume emerged. The second, being written by Barbara Dossi and Janine Kertész, is in the pipeline. Its working title is *Die italienischen Zeichnungen der Albertina und ihre Provenienzen* (The Italian Drawings in the Albertina and their Provenance) and will appear as volume v of the general inventory of Italian drawings in the Albertina, published by Veronika Birke and Janine Kertész.

The selection of works reproduced in the present volume aims, on the one hand, at providing a survey of the collection's history since its inception and its development. On the other hand, the text is followed by a lavish section of colored plates of masterpieces in the Albertina. The selection follows Albert of Saxe-Teschen's acquisition policy. Consequently, emphasis has been laid on sheets illustrating the important results of research conducted into the history of their provenance, as well as on acquisitions made since 1822 by other directors.

I should like to express my appreciation to Walter Koschatzky for his active involvement in the present volume while work was in progress. He not only gave me his own private research material but also the personal memoirs of his tenure as Director of the Albertina. I also enjoyed the invaluable support of colleagues from the National Archives in Budapest, the Staatsarchiv in Dresden, and especially of Franz Dirnberger and Leopold Kammerhofer of the Haus-, Hof- und Staatsarchiv, as well as Sabina Bohmann and Herbert Hutterer of the Österreichisches Staatsarchiv in Vienna. Of my colleagues from the Österreichische Nationalbibliothek I should particularly like to thank Christine Bader for details from the section on information for scholars in the Österreichische Nationalbibliothek, Herbert Friedlmeier for his help in researching photographic material in the picture archives, and Alfred Martinek for making relevant newspaper articles and microfilms available.

Franz Wawrik, Director of the Map Collection and Globe Museum at the Österreichische Nationalbibliothek, and his colleague Elisabeth Zeilinger, were of great help to me in my research on Albert of Saxe-Teschen's collection of map and plans. Gottfried Mraz, Director of the Viennese Haus-, Hof- und Staatsarchivs, kindly helped me in authenticating various handwritten records. Paul Lorenz, Professor at the Classical Philology Institute of Vienna University, offered to translate a particularly relevant, complex passage in Latin. Brigitte Riegele of the Viennese City and State Archives smoothed the way for me in my search for biographical data. Katharina Papatheodoru of the Biographical Dictionary Division of the Viennese Academy of Sciences placed the material collected there at my disposal.

I should like to express my gratitude to all my colleagues at the Albertina who dedicated so much time and hard work to supporting this project in many different ways. Some of these colleagues deserve special praise. Marie Luise Sternath gave me important pointers with regard to the content. Christine Ekelhart very kindly offered to translate difficult passages in French. She also read the various stages of my manuscript with an accurate and critical eye. Marian Bisanz-Prakken, who has had the office next to mine for many years, has always been there to empathize with the successes and setbacks incurred during research and writing. Antonia Hoerschelmann and Marietta Mautner Markhof actively helped me in my selection of modern works. Drawing on years of experience, Fritz Koreny unstintingly gave me advice and help when it came to putting the finishing touches to the manuscript. Richard Bösel helped me with translations from Italian. Gudrun Luger's commitment to hunting out specialist publications was an invaluable aid to the project. Elisabeth Thobois patiently took care of curatorial matters whenever they cropped up. I am equally indebted to Renata Antoniou and Ingrid Kastel in the Division for Photographic Reproduction for all their help. Peter Ertl invariably took an active interest in what were often unusual demands on him for photographs related to the history of the collection. Christian Benedik and Erwin Pokorny were always there when I needed them for help with computer problems. I am indebted to Karin Schwarz and Marianne Feiler for their rapid and reliable support in typing up the manuscript, and to Franz Pfeiler for his cooperation in administrative matters. Without the active commitment shown throughout the project by my colleagues at the collection and, first and foremost, Johann Oppenauer, I would not have been able to come to grips with many a heavy burden—in both the literal and figurative senses of the word—in the hands-on side of research. With regard to access to material, Johann Wachabauer never hesitated to help as quickly as possible.

Thanks to the competence and experience of my publishers, the last phases leading up to publication were ones of efficient cooperation during which I felt that I was in the best possible hands. And, finally, I come to my family who encouraged me and gave me moral support.

BARBARA DOSSI

# The History of the
# Graphische Sammlung Albertina

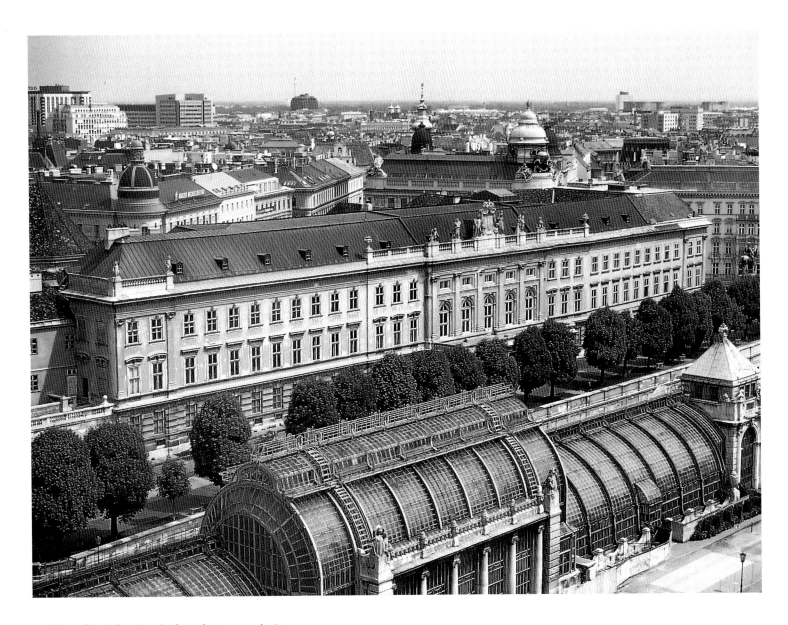

1   View of the Albertina; the front facing onto the Burggarten

THE ALBERTINA IN VIENNA (Fig. 1) represents one of the world's largest and most valuable art collections. Art historically speaking, it is also one of the most complete of its kind. A single, independent institute, it is attached neither to a museum complex nor to a library and in this, too, it is unusual.[1]

Albert, Duke of Saxe-Teschen (7.11.1738—2.10.1822) spent more than fifty years (p. 17) acquiring the drawings and prints[2] that make up the nucleus of the present collection. The palace on the Augustinerbastei (Augustine Bastion) at the heart of Vienna, as well as the collection it houses, owe their name to his commitment to collecting.[3]

By the time Albert died at 84 in 1822, the collection comprised roughly 14,000 European drawings[4] and 200,000 prints[5] dating from the fifteenth to the early nineteenth centuries.[6] From the 1770s, considerable funds[7] had been prudently and judiciously allocated to what the Duke regarded as a legacy to posterity which reflected the enlightened education he had received, his profound knowledge and the fruits of the efforts he had put into creating it. He viewed his collecting activity as bequeathing responsibility to later generations—indeed, the far-sighted provisions of his will have ensured that the collection has been preserved from dissolution.[8]

2   The Archduchess Marie Christine
*Christmas presents given to members of the Imperial family*
Vienna, Kunsthistorisches Museum, Gemäldegalerie

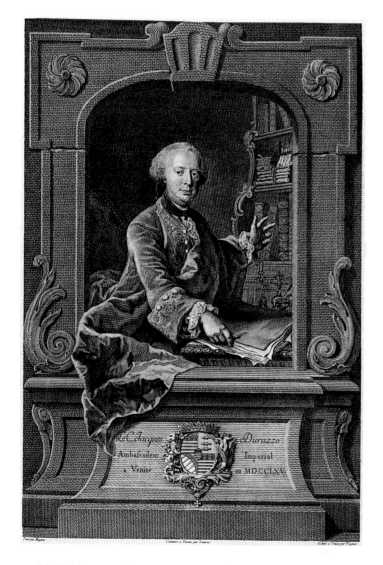

3   Jakob Schmutzer after Martin van Meytens
*Giacomo Conte Durazzo*, 1765, Graphische Sammlung Albertina

Prince Albert[9] (p. 18) grew up at the Saxon court in Dresden during the era of the War of the Austrian Succession and the Seven Years' War. He was the eleventh of the fourteen children of Frederick Augustus II, Prince Elector of Saxony (1696–1763)—Augustus III,[10] later King of Poland—and Maria Josepha (1699–1757), Archduchess of Austria. Upbringing and education prepared Albert for a diplomatic as well as a military career. Presumably because of the hardships of the war years, he was eager to enter on the dual career intended for him.[11] When he was 21, his father finally agreed to allow him "to join the Imperial Austrian army and what he had so passionately longed for ... to participate in the war effort."[12] In autumn 1759 Albert and his brother Clement joined the Austrian army as cavalry officers under the command of Field Marshal Leopold Joseph, Count Daun. In 1760 the brothers were in Vienna, where they presented themselves at court. As Albert was to recall in his *Mémoires de ma Vie*[13], he immediately succumbed to the charms of the seventeen-year-old Archduchess Marie Christine (5.13.1742–6.24.1798; p. 18). The story goes that she was Maria Theresia's favorite daughter. "Gradually we were introduced to the other members of the wonderful and large Imperial family ... In the evening a concert took place in the Empress' apartments. At it the two elder Archduchesses had the opportunity of displaying their skills in this craft. Both were pretty but the younger of the two united a liveliness of mind and spirit with a charming appearance, a perfect figure and an enchanting face, all qualities which filled me with enthusiasm."[14] From the political standpoint, Prince Albert's rank and career prospects did not make him a suitable match for her. He himself conceded that, as the fourth son of the Prince Elector of Saxony, he had only "the bleak prospect of a small appanage without a position and dignity in the eyes of the world".[15] That same year, two years before his marriage, he was still referring to himself as "an impoverished younger son, ... possessing nothing more than a small appanage and what was paid to him as a general in rank."[16] For all that, Maria Theresia took him under her wing from the outset. Moreover, Marie Christine was the only one of her daughters who did not have to make a political match. She was free to marry for love. On April 8, 1766 she was given in marriage to Albert at Schlosshof near Vienna.[17] The prospects which, only a few years before, had seemed so "bleak" to Albert had now brightened considerably. Maria Theresia arranged respectable, influential and lucrative positions for her son-in-law as a governor—first, from 1765 in Hungary and then, from 1780, as Governor of the Austrian Netherlands.[18] In addition, the couple's material well-being was ensured by Marie Christine's large dowry,[19] which, converted into modern currency, would be worth 422 million schillings.[20] This sumptuous dowry was what enabled Albert, Duke of Saxe-Teschen, as he was now styled, to devote himself to serious art collecting and building up a comprehensive art cabinet that was to be of the highest standard. Like his paternal ancestors, who had lavished enormous sums and effort[21] on enlarging the Dresden collections, Albert had already busied himself with art in all its various genres and media.[22] He now began to sharpen his focus, concentrating on drawings and prints[23] which were to become a consuming passion for the rest of his life—understandably so, since he himself loved to draw (p. 19, and Figs 17, 78) and he shared this interest with his wife (p. 20; Fig. 2).[24]

Between the ages of 30 and 40, Albert systematically set about collecting on the grand scale. In the spirit of the Enlightenment, his goal was a collection which would be universal in content, ordered chronologically and intended for use by scholars and historians. His acquisitions policy and system of ordering the collection, especially the print collection, derived from ideas he had developed in Pressburg with the Genoese connoisseur Giacomo Conte Durazzo (Fig. 3)[25] in 1773. "On my last journey in 1773, the opportunity presented itself of observing the Prince's scholarly preoccupations, among them laying the foundation of a collection of fine prints. It was rich in the work of distinguished French and English artists but not proportionately furnished with the work of the Old Masters, among whom the Germans and the Italians—in this field superior to all other nations—vied with one another for supremacy. After we had considered the matter together, the Prince, by virtue of his enlightened intellect, realized how much the old engravings might serve to unite visual pleasure with the enlargement of knowledge. From this observation arose the plan of making a collection which

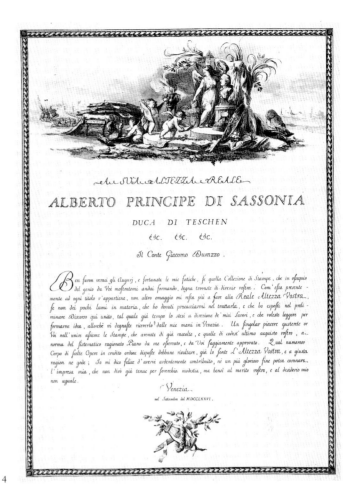

4   Giacomo Conte Durazzo, *Discorso Preliminare*,
page with dedication to Duke Albert, September 1776
Graphische Sammlung Albertina

5–14   Giacomo Conte Durazzo
*Discorso Preliminare*, foreword (Figs. 5–6) and text, 1776
Graphische Sammlung Albertina

## Discorso preliminare.

*[Four facsimile manuscript pages in decorative frames, containing handwritten Italian text, numbered 7, 8, 9, and 10.]*

7

8

9

10

11

12

13

14

*Sublimi feriam sydera vertice.*

would serve a loftier purpose than all others and would, therefore, differ essentially from them."[26] The conception informing this ambitious project was, as a result, to be far more than mere entertainment or educating the public's taste. On the contrary, the aim was—and what makes it particularly forward-looking for its time—primarily to impart knowledge of art and history of art.

Count Durazzo not only played a major role in bringing the print collection into being. He was, more importantly, involved in the project in the hands-on sense. After Duke Albert had charged him in 1774 with taking over the project,[27] he began collecting art from Venice, where he had resided since 1764 as the Austrian emissary. Research conducted for the present book has brought new material to light on the scope of this task and the time spent on it. It also entailed "not inconsiderable expense."[28] In 1776, after only two years of activity, Durazzo was able to hand over to the Duke and Archduchess (p. 21) not 30,000 prints, as tradition has had it hitherto,[29] but "a work which comprises 1,000 objects [i.e. prints]."[30] The collection Durazzo had amassed was presumably put in the Duke's hands in Venice between July 5 and 7, 1776.[31] Having so successfully discharged his obligation, Durazzo continued to collect on his own responsibility. In 1784, eight years later, he presented Albert and Marie Christine with a second, much larger, collection which he had compiled at his own expense. It consisted of a "series of approximately 1,400 Masters and more than 30,000 prints."[32]) In *Descrizione della Raccolta di Stampe di S. E. il Sig. Conte Jacopo Durazzo,*[33] published that same year, 1784 (perhaps on the occasion of this lavishly generous present), Bartolomeo Benincasa gives a good idea of how this came about: "For love of these instructive studies and in the comprehensive knowledge which has accrued to him through the remaining prints, which were initially present in duplicate, Count Durazzo was readily able to resolve on undertaking a new task conceived on the same groundwork. And, at the expense of more time and laboring under more difficulties but [blessed] with no less good fortune than in the first instance, he managed to assemble a second collection for his own use. He gave these volumes a new frontispiece with the following [Latin] inscription: Giacomo, Count Durazzo, Imperial Emissary in Vienna, has, with great pleasure, given over a large number of prints to Albert of Saxony and Marie Christine of Austria and has presented the collection of leaves from early times, enlarged with great connoisseurship, for the sake of the lofty sentiment of the Duke and his friends. 1784."[34]

In the founding charter, which is known as the *Discorso Preliminare* (Figs 4–14),[35] which Durazzo appended to the first collection in 1776, he was expansive indeed on the project he had in mind. The collection was to represent a *Practical History of Painting and the Art of Engraving down to the Present Time* ... (Fig. 10).[36] This meant nothing less than an encyclopedic survey of the visual arts from the early Renaissance. He stressed that its "principal merit ... was to be its chronological arrangement."[37] Durazzo repeatedly emphasized his system of structuring the art collection by region, Schools[38] and artists in chronogical order. Comparing his system with other, larger collections, he described his project as an innovation: "The superiority of such a method in comparison with richer collections quite obviously results from far more comprehensive theoretical studies."[39]

However, we have reservations about describing this arrangement as a "new system"[40] in comparison with other art collections of the time, which were still largely classified by subject areas in the traditional manner.[41] The practice of structuring collections on scholarly lines entailing criteria like School and chronological order by artist in fact predated Durazzo. The French art specialists and collectors Pierre Crozat as well as Jean and Pierre-Jean Mariette were using this academic method by the early eighteenth century. Crozat applied it mainly to his collection of drawings[42] while the Mariettes were ordering the print collection belonging to Prince Eugene, which they arranged and catalogued from 1717, on the same lines.[43] Further, the print collection[44] amassed for Augustus the Strong, Albert's grandfather, in 1720—a first outside France—was gradually structured in this way. Although its first director, Johann Heinrich von Heucher continued to divide the collection into subject areas,[45] his successor from 1746, Carl Heinrich von Heinecken, elected to order it by region (School), albeit not chronologically, but alphabetically by artist.[46] In 1771 von Heucher published *L'Idée Générale d'une Collection complette d'Estampes;* his system presumably reflects the influence of Pierre-Jean Mariette's method of classification in more detail.[47] Another celebrated example of the use of a scholarly classification system is the collection King John v of Portugal had gathered between 1724 and 1728 for his *History of French Painting and Engraving from the Close of the 15th Century to the Present.*[48] Here, too, Jean and Pierre-Jean Mariette contributed substantially to the structuring of the collection as well as the compilation of approximately 150 volumes of engravings on the principle employed for Prince Eugene's collection.[49] Then in 1757 the print catalogue by the "noted Professor of the Leipzig Academy",[50] Johann F. Christ, was published. It, too, was largely ordered on the basis of Schools.[51] Christ's system provided for a further, chronological, subdivision by painters, this last group further subdivided under the heading of engravers.

Durazzo came to Vienna in 1749. There he was able to study "Mariette's system as exemplified in Prince Eugene's collection in the commendably clear and well considered universality of its ordering."[52] He followed this classification system in respect of Schools, subdividing them by painters—and even at that time by engravers—in chronological order and, within the body of works, by subject matter. Just as von Heinicken had started to do by 1771, Durazzo joined Adam von Bartsch (Fig. 15)[53], in embarking on consequential "innovations which already corresponded to a modern, scholarly way of thinking."[54]

At roughly the same time, Adam von Bartsch was working on restructuring and cataloguing the print collection belonging to the Vienna Kaiserliche Hofbibliothek. However, whereas the Mariette system placed, in part, engravers' œuvres on the same level as the painters' work,[55] Durazzo,[56] and Bartsch[57] were already placing engravers on an equal footing with painters in all cases. The new structuring and classification system was not confined to print cabinets.[58] This is clearly shown in the reordering of the Viennese Imperial Picture Gallery begun in the 1770s. In 1776/77 Joseph Rosa seized the opportunity for ordering paintings chronologically by national schools when they were moved to the Obere Belvedere.

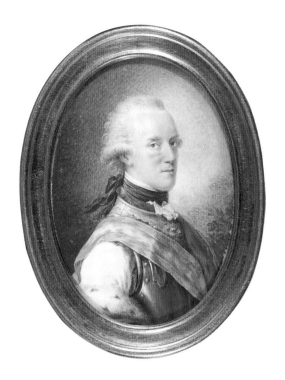

Friedrich Heinrich Füger
*Albert, Duke of Saxe-Teschen*
Graphische Sammlung Albertina

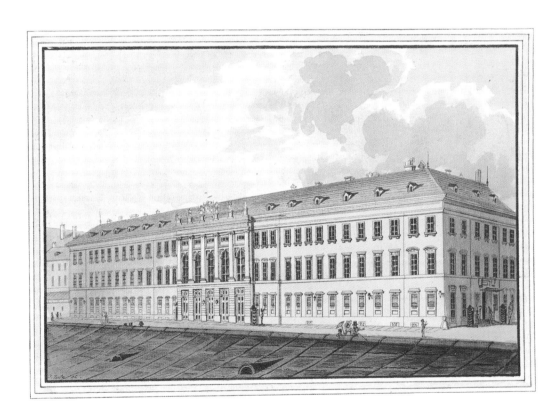

J. Lutz after Eduard Gurk
*Duke Albert's Palace*, after 1804
Graphische Sammlung Albertina

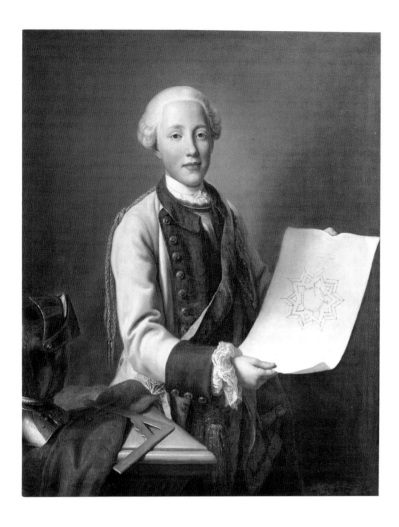

Pietro Rotari
*Albert, Prince of Saxony, in a white coat holding a fortification plan,*
before 1763
Moritzburg Castle near Dresden

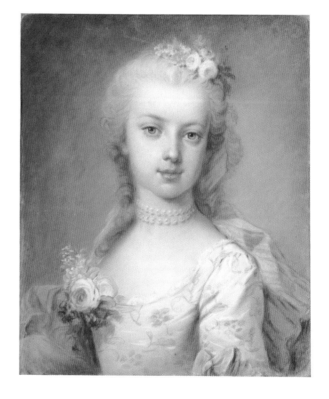

In the manner of Jean Etienne Liotard
*The Archduchess Marie Christine*
Vienna, Kunsthistorisches Museum

*Vue de la Grotte à reservoir. A.*

Albert of Saxe-Teschen
*Design for a grotto in the park of Schoonenberg Castle*, 1782
Graphische Sammlung Albertina

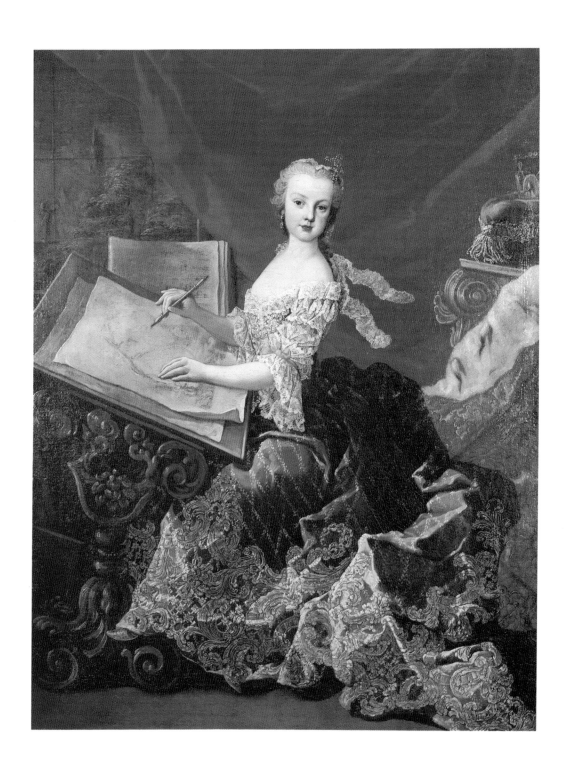

Anonymous
*The Archduchess Marie Christine*
Budapest, National Museum, Historical Picture Gallery

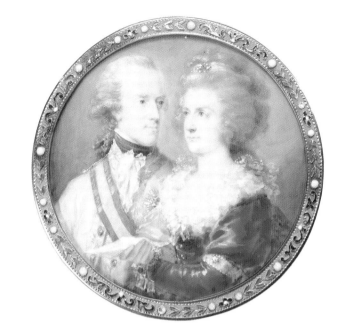

Friedrich Heinrich Füger / Jean Galucha (?)
*Albert, Duke of Saxe-Teschen and*
*the Archduchess Marie Christine*
Vienna, Kunsthistorisches Museum

Jean–Baptiste Isabey
*Archduke Charles of Habsburg–Lorraine*
*(1771–1847)*, 1812
Graphische Sammlung Albertina

Detail of binding (monogram CL)
for inventories of prints drawn up
under Archduke Charles
Graphische Sammlung Albertina

Entail inventory of Duke Albert's drawings collection, 1822
Graphische Sammlung Albertina

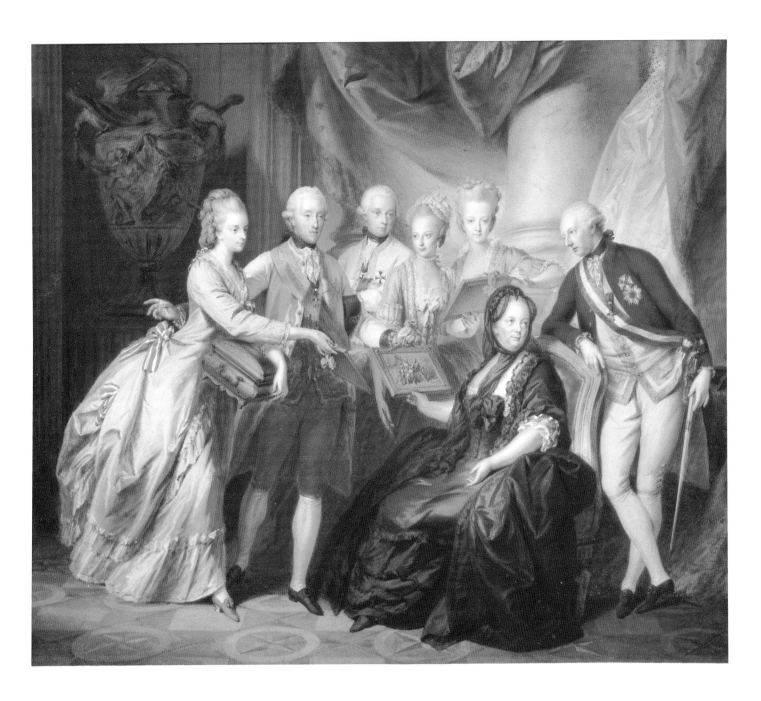

Friedrich Heinrich Füger
*Duke Albert and the Archduchess Marie Christine Showing*
*Works of Art (Drawings ?) Brought from Italy to the Royal Family*, 1776
Vienna, Österreichische Galerie

One of the original cassettes used for
Duke Albert's drawings collection
Graphische Sammlung Albertina

Monogram of Duke Albert (AS) on the index volumes
of the hand-written catalogue of his library
Graphische Sammlung Albertina

Original cassette for the inventories
of Duke Albert's drawings and prints
Graphische Sammlung Albertina

From 1778 Christian von Mechel continued his work.[59] By 1781 the new arrangement of the paintings had been completed.[60] As Günther Heinz pointed out, "the new function of the museum emerged in the Josephine era in the history of the Imperial Gallery: the paintings … no longer belong to subject areas, arranged by thematic content, … now they are representative of the individual phenomena [marking] the history of art. The principle underlying collections had, with the commitment to didacticism and subsequently to scholarly research, completely changed. In this era the principle of showing as complete a series of paintings as possible exemplifying all epochs and nations was established…. Arrangement was not the only evidence of new principles. The first scholarly catalogue, published in 1783 by Mechel, is unequivocal documentary proof of the didactic and ethical spirit."[61] Mechel himself makes a point of stressing this in the foreword: "The purpose of all endeavors was to use this fine … building in such a way that the arrangement of its contents … would be instructive and as far [as] possible would become a visible history of art. A large collection of this kind, destined more for instruction than for ephemeral pleasure, seems like a rich library in which he who thirsts for knowledge rejoices at encountering works of all types and eras, … by observing and comparing them he can become a connoisseur of art."[62] In this connection von Mechel underscored the importance of copperplate engravings: "the old … prints published at various times and by a great variety of masters after paintings in the Gallery have … proved particularly useful in this fashion."[63]

Theoretical writings on the history of art by eighteenth-century scholars also show that the instructional value of prints began to be accorded significance in the latter half of the eighteenth century concomitantly with the realisation that they had an esthetic and taste-molding function as well. In 1728 Gerard de Lairesse published the *Big Book of Painters*. In it he described the didactic purpose of engravings: "The intention which one has in using and contemplating a print is twofold: first, in order to encourage our eye and give pleasure; second, from it to enlarge our [*sic*] thinking if one plans to make something."[64]

By contrast, towards the end of the eighteenth century, emphasis clearly lay on the educational value of prints. That this is so is shown by two passages from theoretical treatises on art. First, in their *Dictionnaire des Arts de Peinture, Sculpture et Gravure*, Watelet and Lévesque (1792) maintain: "One can assert … that of all emulative arts, including painting, there is none that is of such general usefulness as the craft of engraving. From its inception, it has been used in a variety of intellectual fields; we are indebted to this medium of art for the best possibility of conveying visual things."[65] Huber and Rost, in their *Handbook for Art Lovers and Collectors* (1796) seem to have entertained similar ideas: "He who is convinced of the use and pleasure accorded by a taste for prints is astonished at how few connoisseurs of them there still are…. Prints are instructive and useful for youth because through them objects are imprinted on their memories more vividly and permanently than by means of verbal representation."[66]

Huber and Rost go on to add: "Through the art of copperplate engraving the greatest masterpieces of the world's most celebrated painters are made known and, through being reduplicated, the greatest masterpiece will often be torn from the destructive jaws of

time and preserved for centuries to come. They are also the most instructive school for the artist and connoisseur studying them if he does not have the opportunity of schooling himself at first hand from good paintings…. Finally, prints are highly advantageous for forming our taste. They conduct us to correct notions of the beautiful in art and lead us to knowledge of the paintings."[67]

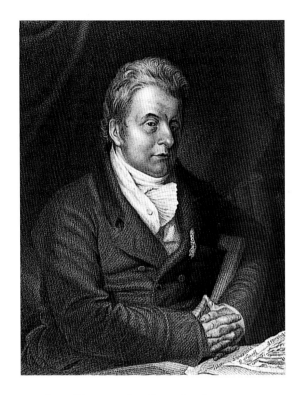

15   James Thomson after George Lewis
*Portrait of Adam von Bartsch*
Graphische Sammlung Albertina

Johann Georg Sulzer did not confine his observations to prints, remarking in 1774 "that man owes the major part of his intellectual and spiritual education to the influence of the fine arts."[68] He pointed out that their formative influence was wide-ranging: "Because they are so exceptionally useful, they deserve to be supported politically by all imaginable means and to be disseminated throughout all classes of the public."[69]

The superstructure of such thoughts mirrored the expectations placed in the fine and decorative arts by the Age of Enlightenment. The intention behind the creation and systematic ordering of Duke Albert's print collection was not an isolated phenomenon in eighteenth-century Europe. On the contrary, it was embedded in a pragmatic and intellectual context. Durazzo's extraordinary achievement was not underestimated by his contemporaries as Bartolomeo Benincasa's appreciation (1784) of Durazzo reveals: "We have not yet managed to find any other collection in which both the intention of collecting a large number of fine engravings and the purpose of illustrating a universal history of painting and painters are thus united. That is the spirit [which informs] the collections assembled by Count Durazzo. To this end he has conceived the plan, designed the system and underpinned both with learnèd writ-

ings and literary research." [70] Durazzo had inspired collecting of European art on the grand encyclopedic scale as well as the systematic arrangement of it in chronological order and by artist. In this respect and with his high esthetic standards, he thus exerted a formative influence on Albert's style of collecting. These criteria were to shape the development of Albert's collection of prints and drawings.

While he was buying prints, Albert probably began to collect drawings for the purpose of making his collection as comprehensive and instructive as possible. In collecting drawings systematically, he was following a trend that had been growing since the late seventeenth century in many European countries—especially in England and France. Apart from their function as an integral part of the creative process, drawings by artists who had achieved acclaim in other media were coming into their own, by now appreciated in their own right. The growing interest in drawings as autonomous works of art and, therefore, collector's items is reflected in eighteenth-century theoretical writings on art. It is fascinating to observe that, in 1681, a Roger de Piles was still defining drawing as "part of painting". [71] However, even then he emphasized that the specific value of drawings was their immediacy. In a similar vein, André Félibien had already declared in 1676: "In painting what one generally calls drawing is the visible expression or visual image of thoughts and of what has first taken shape in the imagination…. This art … is the basis of painting." [72] About thirty years later (in 1708), de Piles modified his opinion to concede that the drawing, "where it represents the idea of the work as a whole … cannot be regarded as part of painting." [73] By now he had come to value drawing independently of painting, calling it the "key to fine art." [74] In the *Histoire des Arts qui ont Rapport au Dessein* (1698), Pierre Monier was already pointing out "that drawing is the foundation of painting, sculpture and architecture." [75] In an attempt to enhance the status of drawing, he even went so far as to derive it from a divine idea: "The divine idea … is what first inspirits drawing, which one should rather regard as the gift of heaven than as a human invention." [76]

In 1715 Jonathan Richardson the Elder explained the importance of drawings: " … and these are exceedingly prized by all who understand, and can see their beauty; for they are the very spirit and quintessence of the art. Here we see the steps the master took, the materials with which he made his finished paintings, which are little other than copies of these, and frequently (at least in part) by some other hand; but these are undoubtedly altogether his own, and true and proper originals." [77] Richardson stressed the autonomy and originality of drawings in a treatise, *Traité de la Peinture et de la Sculpture*, he wrote with his son, published in 1728: " … as he that works by invention, or the life, endeavoring to copy nature, seen or conceived, makes an original. Thus, not only that is an original painting that is done by invention, or the life immediately; but that is so too which is done by a drawing or sketch so done." [78] In 1732 Comte de Caylus gave a talk at the Académie de Peinture et de Sculpture in Paris dedicated to the drawing. Entitled *Discours sur les Dessins*, it dealt with "Considerations … not only on the drawing in particular, which I consider the foundation of art, but on which I, too, would have to be instructed here, but on drawings in general, their charm, their use and connoisseurship of them." [79]

Caylus had this to say on the value of the drawing in the development of an artist's idea: "What in essentials is more pleasant than to retrace the creative process of an artist of the first rank or to pursue his first spontaneous idea, … to reconstruct the various modifications which grow out of divers considerations and to attempt to clarify one's notions of them; finally to see oneself with him in one's own room and to be able to judge for oneself by studying the motives which might have led him to changes." [80] When Mariette wrote the auction catalogue for Pierre Crozat's drawings collection in 1741, [81] he added his "thoughts on the draughtsmanship of the leading painters." [82] Mariette was eager to extol the virtues of being knowledgeable in this field: "I do not even wish to begin to list all the benefits to be had from the study of drawings nor how important being knowledgeable about them is for the education of taste." [83]

A few years later (in 1745), Antoine J. Dezallier d'Argenville's *Abrégé de la vie des plus fameux peintres* was published in Paris with an extensive *Discours sur la connaissance des Desseins*. [84] He agreed with Richardson in claiming that: "Drawings are a painter's first idea, the first spark [to kindle] his imagination. They reveal his style, his intellect, his way of thinking: they are the first originals which often aid a master's pupils to paint pictures which are nothing but copies of them. Further, drawings symbolize the fertility and liveliness of an artist's genius, the dignity and magnanimity of his feelings as well as the ease with which he has expressed them." [85] A few pages later d'Argenville outlines what for him makes drawings invaluable: "Inventiveness, improvement, good taste, lofty judgement, the expression of passions, a sublime thought, a claim to intellect and freedom of hand constitute the true beauty of a drawing." [86] This treatise was published in German in 1767 as *Leben der berühmtesten Maler*. [87] Christian L. von Hagedorn underscored the importance of the drawing and draughtsmanship in *Betrachtungen über die Malerey* (1762), concentrating entirely on the drawing in the third book of Part Two. [88] Like his precursors, Carl H. von Heinecken emphasized in *Idée Générale d'une Collection complette d'Estampes* (1771) that the special value of a drawing lay in its directly reflecting the artist's idea: "A sketch shows what the artist thought about his sujet. Connoisseurs pay attention to the idea only and see in their imagination all lines as if they were already complete." [89]

The above contemporary witnesses to the intellectual currents of their time are important sources for the creation of Albert's collection of drawings. The enormous interest shown in drawings, the growing desire to own them and, consequently, the demand for them had given the art market a strong boost in this sector since the close of the seventeenth century. That this was so is shown in the upturn in dealing in art and in the increased activity of art auction houses. [90] Albert, too, benefited from the general trend, which enabled him to deploy all his personal commitment, acumen and resources in building up his collection. Always *au fait*, with a well-organized and far-flung network of contacts, he knew how to check current market trends and to turn them to his advantage. [91] His contacts with connoisseurs, collectors, artists and art agents throughout Europe not only furthered his acquisitions policy, they also sharpened his critical eye and his feeling for quality. Albert's ledgers dating from 1783 to 1822 (Fig. 16) record the monies he

spent on his prints and drawings. They totalled 1,265,992 guilders—today the equivalent of approximately 126 million Austrian schillings or about one hundred times the original sum paid out for all these works of art.[92]

While he was Governor of Hungary, Duke Albert had begun to build up his print collection between 1766 and 1780.[93] From 1781, after he had become Governor of the Austrian Netherlands in Brussels, his prospects for considerably enlarging his collection were on a far grander scale than hitherto. Hungary had been on the fringes of the European art world but his new seat was close to the great cultural centres of Holland, France, Germany, and England, offering him superb opportunities for collecting. Despite his numerous political and social commitments, Albert even managed to find leisure for drawing during his early years in Brussels, as his sketches for a summer residence at Schoonenberg (Laeken) near Brussels show (p. 19; Fig. 17). However, he had very little time for art during the latter half of the 1780s,[94] when the Emperor Franz Joseph II carried out radical reforms that caused political tension to mount, culminating in Lowland rebellions in 1787 and 1789. Albert and Marie Christine tried in vain to prevent the ruthless implementation of the new administrative regulations and Church policies or, at the very least, to mitigate their consequences. Nevertheless, the situation grew so dangerous that they were forced to leave the country in November 1789.[95] In July 1791 they did return to Brussels but remained there only a year. After French

17 Albert of Saxe-Teschen
*View of old Schoonenberg Castle near Brussels*
Graphische Sammlung Albertina

troops had invaded the Austrian Netherlands and the Imperial army commanded by Albert had been defeated at the decisive battle of Jemappes, he and his wife were again forced to flee. Moreover, they suffered irreparable material losses, particularly to their art collections, when one of the three ships with their personal possessions which had departed from Rotterdam for Hamburg on November 8, 1792 went down in a storm before December 25.[96] As the bill of lading,[97] which has been preserved, shows (Figs 18–19A), the precious cargo that was lost at sea seems to have included two transport chests marked *Gallerie d'Estampes*, a chest with paintings, five *caisses* filled with tapestries, 37 chests filled with *meubles divers*, and 42 listed in the bill of lading under the heading of *Bibliothèque*. A great many *ouvrages formant des Corps et Suites d'Estampes reliées* which had been in the library must have been lost then (Figs 20–22).[98] Although drawings were not explicitly listed as such, they may well have been implied by the terms *Estampes* or *Bibliothèque*. This assumption would seem to be supported by comparison with Albert's estate inventory of 1799, in which drawings were presumably included under the headings of *copperplate engravings* and *library* (Fig. 23). In addition, if Otto Benesch's conjecture was correct that "the drawings ... were originally laid between the leaves of folios [in the library],"[99] a considerable number of drawings may have been lost at sea in the 42 chests listed as *Bibliothèque*. No more precise sources of information have been preserved on the content of the *Caisses ou Ballots*. Albert's Counsellor to the Court and cabinet secretary, Girtler von Kleeborn, made the following despairing comment on the turn of events: "Heaven and earth, hell and the devil have all conspired in our misfortune. The first and most richly laden ship which we had dispatched from Rotterdam to Hamburg has gone down with everything in it.... That ship carried the largest part of our silver, our library, and our valuable furniture from Scoonen-

16 Duke Albert's ledger with monies spent on drawings and prints from 1783–1822
Graphische Sammlung Albertina

berg.... That ship was insured for 380,000 Dutch florins; I believe that its true value was probably closer to a million. And the greatest problem with regard to the insurance is that no one knows for certain what really was contained in the hold compartments. There were only 36 hours to do the packing so that everything happened without invoice and in haste, all the more so because at this critical juncture everyone had nearly lost their heads."[100] Albert, too, remarked "that ultimately only the most valuable things could be saved. Everything else had to be abandoned to the enemy."[101] Sorely tried by these misfortunes and with their health impaired as a consequence, Albert and his wife spent the next two years going from one German city to the other, although they also spent some time in Vienna. The collection was temporarily housed in Dresden in the care of assay-office officials charged with inspecting it.[102] As might be expected, during the hard years between 1790 and 1792 less money was spent on the collection than at any other time between 1783 and 1822, as the ledgers with their lists of acquisitions show (Fig. 16).

In 1794 Albert was once again given an important command in the war against France as an Imperial Field Marshal. As he had predicted, however, the battles on the upper reaches of the Rhine were from the start a hopeless undertaking for his forces. He knew that

18, 19, 19A   Three–page inventory of cargo transported for Duke Albert which went down in a storm late in 1792
Budapest, Hungarian National Archives, Habsburg Family Archives

20–21   Index vols of the catalogue of the library
owned by Albert, Duke of Saxe-Teschen
Vol. 1, 'Note preliminaire', Graphische Sammlung Albertina

22   Index vols of the catalogue of the library
owned by Albert, Duke of Saxe-Teschen
Vol. 1, table of contents of Vol. VI, Graphische Sammlung Albertina

he would be defeated: "One could not be so blind as not to see what a burden such a difficult and thorny post was nor could one be so conceited as to consider oneself capable of mastering with certainty all difficulties that would arise." [103] Resigned to defeat, he finally asked to be discharged of his duties. The Emperor Franz [104] relieved him of his command on April 10, 1795. The decision to retire from the field was not easy for Albert since the prospect of a military career had played a major role in his education from early youth: "Thus I ended, and not without sorrow, as I must admit, the career which I had been pursuing with such eagerness and passion from my youth in order to devote the years that might remain to me in this world to a less turbulent life. Never will my devotion to the soldierly life in which I have grown grey with age diminish, nor my eagerness in furthering the fame of the army in which I have had the honor to serve and for which I shall never cease to have a true and deep affection." [105]

Albert and Marie Christine now returned to Vienna, where the Emperor Franz placed the Silva-Tarouca Palace, which is now the

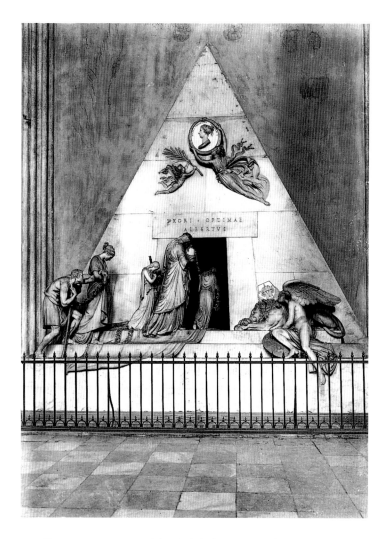

collection by 1800.[113] However, parts of the collection remained in Dresden until at least the latter half of the 1790s.[114] The collection is not likely to have been assembled in its entirety in Vienna until 1805, when all construction work on the Palace (p. 17) had been completed.[115] The estate inventory of April 1, 1799 gives its value as "200,000 Fl" [guilders], matching that of the house in Vienna (Fig. 23).[116] That means it would have been worth the equivalent of about 20 million Austrian schillings in today's currency.[117] Contemporary sources are informative on the growth of the collection of drawings and prints over the following 20 years. At the time of the Congress of Vienna (1814/15), Auguste de La Garde-Chambonas reported that the collection comprised "nearly 12,000 original drawings and 130,000 prints."[118] In 1818 the drawings section is said to have comprised "12,000 items" and the print collection "more than 145,000 items".[119] By 1821 Franz Heinrich Böckh was speaking of "about 14,000" drawings in 237 volumes" (presumably this means coffins) and "157,952 prints ... in 884 portfolios."[120] The number of drawings given by Böckh corresponds exactly with that mentioned by Joachim Heinrich Jaeck in 1822.[121] However, Böckh mentions fewer prints than in the ducal inventories of 1821, brought to light by the present research, which record 163,000 sheets.[122]

23    The estate of Duke Albert on April 1, 1799
Budapest, Hungarian National Archives,
Habsburg Family Archives

Albertina (it was given outright to them in 1794),[106] at their disposal.[107] Now that he was free of all obligations to the military and had returned to Vienna with the intention of staying there permanently, Albert was once again in a position to commit himself to collecting. After Marie Christine's death on June 24, 1798, enlarging and arranging his collection were all that remained to him and he withdrew from society.[108] The following passage from his Mémoires reveals how he suffered at the death of the wife to whom he had been so happily married: "After 32 years of the happiest union I lost the most perfect wife who ever lived, the most precious being to me on earth and the beloved object of all my happiness. Never during this long time together was our happiness clouded, nor was it ever marred by the smallest or even the most insignificant disagreement."[109] Albert commissioned the sculptor Antonio Canova to make Marie Christine's funerary monument. It was erected in the Augustine church in 1805 (Fig. 24).[110]

Albert's collection, which comprised, according to contemporary accounts, approximately 5,000 drawings and 70,000 to 80,000 prints in 1800,[111] was "exhibited in a very long, unobstructed gallery which this art-loving prince had especially made for this purpose a year ago [1800]."[112] The rooms of what was called the Old Albertina giving on to the street once belonged to the Augustine monastery. They must, therefore, have been used to display the

24    Funerary monument of the Archduchess Marie Christine
in the Augustine Church, Vienna

Archduke Charles of Austria (1771–1847; p. 21), famous for having defeated Napoleon at the battle of Aspern (1809), who was the nephew, adopted son and sole heir of the childless couple,[123] had an inventory of the collections drawn up in 1822, immediately following Albert's death. In his will of 1816, Albert had left his art collection entailed (*fideicommissum*)[124] in order to secure its continuance in Austria as a Habsburg family possession and thus prevent its being divided or disbanded (Figs 25–27).

As an official letter sent by the Archduke to the Emperor Franz shows, checking of the collections and the inventories began in April 1822. "The season of the year now allows the counting of the collections which his majesty has entailed on the family in clause §7 of His Royal Highness the Duke's will. I have accordingly charged my chief steward, Count Grünne, with taking the necessary preliminary measures together with Counsellor to the Court Kleyle. The previous inspectors are, therefore, to give over the entire collections item by item and the maps and plans to Captain Rosenberg of my regiment, the drawings and copperplate engravings to the artist Rechberger, in good repute as a connoisseur and lawful man, and two newly appointed officials of recognized probity. Once given over, the items are to be marked in the lawful manner and stamped, the inventories to be drawn up by the intermediaries and then the stamp to be destroyed [*sic*]. If I may hope to have thus thwarted, by virtue of the prudent measures taken, all suspicion of embezzlement and to have corresponded to Your Majesty's wishes as expressed to me, I do hope to humbly give notice before the actual commencement of taking over and should, however, there be further commands to be given, beg to be able to request the disclosure of said."[125] Archduke Charles did not appoint the directors of his collection, Lefèbvre and van Bouckhout,[126] to draw up the inventory. Instead, presumably to avoid "all suspicion of embezzlement," he charged the connoisseur and artist Franz Rechberger[127] with the task and had Gottlieb Straube[128] assist him. The above signed document is of major significance because it implies that the only drawings that bore the impress of Albert's stamp (Fig. 76) were those that he himself had purchased. Further, the document would seem to indicate that the stamp was destroyed after the inventory had been completed.[129]

By May 1822 Rechberger's report on the collection of drawings was available for official inspection: "Your Imperial Majesty! I take the liberty of humbly showing to your Royal Highness that I have looked through the collection of original drawings together with the inventory list previously drawn up and have found them in good condition. The collection exceeds 13,000 items and is kept in 230 portfolios. It contains leaves of the first rank from the hands of the most important Masters of the four principal Schools, which are not easy to find on the market and whose rarity increases with every day. Further, a large number of first intellectual designs, often merely fleeting sketches by great artists, which bear the stamp of authenticity and delight both connoisseur and artist. The genuineness of no lesser number is guaranteed by the cipher or name of

25–26 The will of Albert, Duke of Saxe-Teschen,
written in his own hand, title page and 1st page, 1816
Vienna, Haus- Hof- und Staatsarchiv, Family Documents

a former owner on them, such as Crozat, Mariette, Ploos van Amstel, Bianconi, Reynolds etc., names universally honored among connoisseurs and likely to be so for a long time to come. It is a peculiarity of most collectors that they always strive to enrich their inventories with new names and, therefore, it is inevitable that gradually a not insignificant number of lesser art productions creeps into them, whose greatest merit will always be to have enlarged the list of names. Finally, no collection is entirely free of spurious pieces and copies because the greatest Masters have always found most emulators. Leaves of this sort have nevertheless much that is good and useful for budding disciples of art because a beautiful thought is also valuable when it is expressed by means of a mediocre vehicle; they must not, however, be passed off as originals. There now follows the inspection of the copperplate engravings collection which, because of its significant size, should probably take quite a bit longer to complete (Figs 28–30)." [130] In the course of checking the drawings against the inventories, [131] Rechberger drew up the *Catalogue des Dessins de la Collection de feu Son Altesse Royale le Duc Albert de Saxe passés en Fideicommis à Son Altesse Impériale L'Archiduc Charles en 1822,* which is known as the fidecommissum inventory of the drawings (p. 22; Fig. 31). [132]

Rechberger introduced his undated report on the print collection as follows: "The copperplate engravings collection, with the inspection of which Your Imperial Majesty has had the kindness of charging me, ranks equally with the cabinets in Paris and Dresden and with that of the Royal and Imperial Court Library, the finest part of which once made up the collection of Prince Eugene and cost its noble owner five times one hundred thousand thaler. The connoisseur marvels at the large number of notable, extremely rare

and even one-of-a-kind works and ultimately perceives that this collection is not merely the result of large sums of money spent on it but principally the consequence of a particular and almost miraculous union of fortunate events and represents, so to speak, the union of various celebrated [sic] collections whose dissolution [time and] circumstances have caused. Finally, it is the fruit of a long and happy life and an excellent and immut[ab]le love of art." [133] As they had done for the drawings, Rechberger and Straube [134] drew up in the years that followed a further *fideicommissum* inventory on the basis of the ducal print inventories. [135] This was the seven-volume *Catalogue des Estampes de la Collection du feu S. A. R. le Duc Albert de Saxe-Teschen delaissée en Fidéicommis à S. A. I. L'Archduc Charles* (Figs 32–33). [136] However, on September 7, 1822, [137] just after checking prints against the inventory had begun, [138] Straube recorded, having apparently counted erroneously, only 145,989 (Fig. 34) leaves in 862 portfolios in the print collection. [139] By contrast, recent studies, taking into account historical sources on the size and growth of the collection, [140] suggest that Albert left between 190,000 and 200,000 prints. [141]

Archduke Charles of Austria, who put Franz Rechberger [142] and, after his death in 1841, Carl Sengel [143] in charge of the collections, increased the number of drawings, according to the acquisitions inventory, by approximately 18,000 items and some 1,000 leaves of prints. [144] Albert had opened the collection to connoisseurs on request since the early nineteenth century. [145] "When Archduke Charles inherited it in 1822 ... it was also open to a wider public, and it is by virtue of the magnanimity of the noble owners that since then it has been readily accessible to visitors without interruption." [146] In 1847 Duchesne confirmed that: "The public is admitted to this collection." [147] On Archduke Charles's death in 1847, the collections were entailed on his eldest son and heir, Albrecht (1817–1895). [148] Not long after Albrecht had taken over the collection, it narrowly escaped being destroyed by fire. During the revolution fire broke out under the roof of the Hofbibliothek and spread to the neighboring sections of the building (on October 31, 1848). [149] When the treasures were once again threatened, this time with confiscation by Prussia in 1866, the entire collection was moved to Ofen Fortress in Budapest. [150] Carl Sengel remained head curator of the collection until 1863. His successor was Carl Müller (1864–1868). [151] After Müller's death Moriz Thausing [152] became the first professional art historian to preside over the art cabinet. Thausing, a specialist in Albrecht Dürer's drawings, published the first survey of the history of the collection in 1870. [153] Unlike the authors mentioned above, he insisted in it that the collections had not been opened to the public until Archduke Albrecht had inherited them: "Archduke Albrecht, who has most generously opened his cabinet of drawings and copperplate engravings to art lovers and seekers of knowledge from all countries, has given these private collections the character of a public museum." [154] Thausing's figures, published in 1870, tally with an anonymous publication (1871) on Vienna, [155] which records "15,000 to 16,000" drawings and "some 200,000" prints. [156]

After Thausing's death in 1884, Joseph Schönbrunner [157] succeeded him, first in the capacity of inspector and, from 1896, as head curator of the art institute which had been called the Collectio

27  Clause 7 of the will of Albert, Duke of Saxe-Teschen, 1816, with provisions for the entailing of his art collection
Vienna, Haus- Hof- und Staatsarchiv, Family Documents

28–30 Three–page appraisal of Duke Albert's
drawings collection, 1822
Budapest, Hungarian National Archives,
Habsburg Family Archives

Albertina since the 1873 Vienna Exhibition. [158] In an address given
in 1886, Schönbrunner summarized some important milestones in
the collection's history, including the way the collection was
exhibited in Albert's day: "At that time Duke Albert's prints were
still arranged as they had been by Count Durazzo. He was of
the opinion that the painters, as composers, were of paramount
importance. They were divided into two large sections: Italian and
transalpine. For this reason all titles and section names in the
Albertina Collection were also in Italian, as were the catalogues.
Subsequently everything was translated into French; even artists'
proper names were written in French as far as possible, and
naturally all catalogues and inventories were now also in French.
The Italians were in turn again divided into four Schools: the
Roman-Florentine, the Bolognese, the Venetian and the Lombard
Schools. The transalpine [work] taken together also formed four
schools: the German, Netherlandish, French and English, with a
miscellaneous School for all the other peoples. This division was
abandoned in the print collection after the Duke's death but was
 retained for the drawings collection." [159] Schönbrunner went into
the preservation and mounting of the leaves in detail, aspects

31    Entailment inventory of Duke Albert's drawings collection
Title page, Graphische Sammlung Albertina, Archives

33    Entailment inventory of Duke Albert's print collection
Title page of Vol. 1, Graphische Sammlung Albertina, Archives

which will be cited here extensively because of their importance for the history of collecting and of this collection and especially because they shed light on curatorial practice: "The collections are on the third floor of the Augustinian monastery [Fig. 35], abutting the Archducal Palace in rented rooms since in the latter (i.e. the Palace), there is no space for this comprehensive collection. This third floor can be reached from the Palace and adjoins it structurally. After passing a separate stair and an antechamber, commodious, since it was not built until 1873, one goes through a door to arrive ... at a corridor-like room ... 44 cupboards are mounted in a continuous row against the long wall to the left. They contain what is really the copperplate engravings collection in 749 magnificent russia-leather volumes in Imperial format. Across

32    Entailment inventory of Duke Albert's print collection
7 vols, Graphische Sammlung Albertina, Archives

from this long wall there are … 17 piers between the windows against which cupboards with glass doors are placed. In them the drawings are kept in 234 portfolios. The number of drawings has already reached well over 16,000 … They constitute undisputedly the most interesting part of the art collection and are laid in chest-like portfolios, known as coffins, which in turn are covered in sturdy calf's leather and are in other respects very handsomely decorated…. The … magnificent [russia-leather] bindings mentioned above enclose the copperplate engravings and etchings, which are glued on to very good and beautiful hand-milled paper. The price of each of these russia-leather bindings is 40 fl; further, the price of the paper on to which the prints are glued is approximately 1 fl a sheet, hence amounting in all to a total of 140 fl a volume consisting on average of a hundred leaves. Moreover, there are other volumes which contain the very old treasures and whose folios consist in what is known as Basle cardboard, which at the time it was bought cost 4 fl a sheet. However, some rather inferior bindings are also used. These are the ones in the second section or for the paintings, which only have russia-leather spines and edges and whose doublures are merely a covering of marbled paper. Let me take the opportunity of emphasizing the value of robust leather bindings. Long years of practical experience justify the author of this report in so doing. It would have been extremely wasteful to have saved money here, for all linen and straight-grain bindings and portfolios would have probably been ruined several times over with heavy use by the public, apart from the damage

34   Listing of the ducal print collection,
7 September 1822
Budapest, Hungarian National Archives,
Habsburg Family Archives

35   Carl Müller
*Joseph Meder in the
so-called 'Alte Albertina'*,
1915, Graphische
Sammlung Albertina

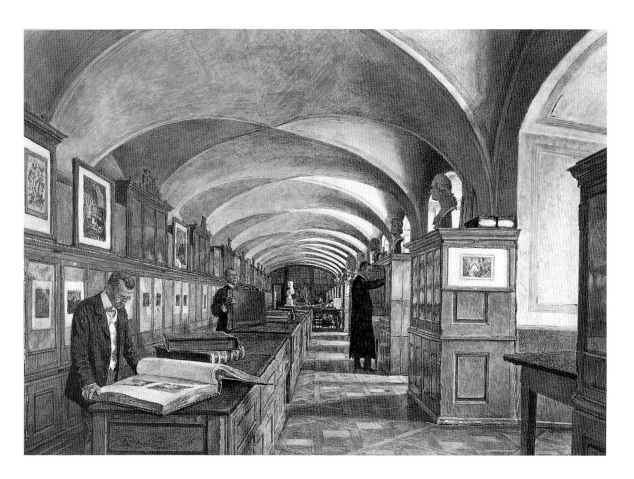

which the content would have suffered through repairs being repeatedly necessary, and the appearance of always looking worn. Further, it must be reported that for 16–18 years [1868/70] work has been going on to protect the drawings in that said drawings are being fitted with the passe-partouts which are today widely known in order to protect them if possible from wear. In earlier times the copperplate engravings were mounted on loose leaves and kept in splendid portfolios—here known as Albertine portfolios (red genuine Safavid leather backs with lovely impressed designs in gold. The doublures of the covers are tough, scarlet paper) [Fig. 81]. Most recently, in several collections which are in the process of being developed, the prints are also in passe-partouts. This practice is probably easier to implement with the earlier engravings in so far as their number is not so exaggeratedly large and amounts to at most a few thousand leaves although they take up a great deal of room. It should be mentioned with regard to space that about 50–60 Albertina drawings used to fit into a portfolio; however, now that they have been mounted in passe-partouts, at most 18–20 do so. Consequently, the drawings will take up just as much space

37    Hans V. F. Schnorr von Carolsfeld
*Mythological Scene* (copy after Adam F. Oeser)
Graphische Sammlung Albertina

when this new practice is adopted. The large and very large sheets, both the drawings and the copperplate engravings, are mounted on supports in several supplementary formats, of which the Albertina requires three…. The supplementary sheets are mounted on very thick support paper and, like the smaller formats, are only glued on the upper and left edges. The purpose of this with the old things is so that one can still lift the sheets on the right-hand lower corner and it makes it practicable to view them from the reverse, partly because of what is known as the watermark and also for the sake of [studying] the texture of the paper or written observations of earlier owners, which is often of the greatest importance in establishing the provenance of items. This manner of glueing sheets of large format has the additional advantage that the sheets can stretch or shrink again without causing creases or what is known as piles at the edges." [160]

According to the above detailed descriptive account, passe-partouts were not used until the latter half of the nineteenth century. [161] Prior to that time prints and drawings were glued to loose pieces of cardboard and laid in cases known as coffins. In 1801 Hans-Rudolph Füssli wrote of "more than 500 folio portfolios, of delicate and tasteful workmanship, in which both copperplate engravings and drawings were kept unbound for the greater ease of those looking at them. The former were kept on a shelf but the latter were glued on to stiff paper." [162] By 1834 Duchesne was complaining that this way of mounting leaves, which came to be known as Albert Mounting (Figs 51, 75), quite frequently caused damage by wear and tear: "These drawings are all glued to pieces of cardboard according to a uniform method by which they have often been damaged." [163]

Albert's prints especially are likely to have been mounted on supports very early on and kept in volumes or coffins. As Benincasa

36    Inventory entry recording that Duke Albert decorated the walls of his private apartments with drawings

reports, Durazzo handed over his second *Raccolta di Stampe* in 1784 in this form: "We shall take the liberty of here giving a short description of the material of the leaves on which the copperplate engravings are mounted [as well as] the volumes or coffins in which they are arranged successively and according to size and of the marvellous overall impression made by the entire mode of presentation … " [164]

How the drawings were kept and presented cannot be traced so far back nor so clearly. It is known, however, that drawings were also kept in portfolios from, at the latest, the 1890s. [165] As quoted above, Schönbrunner had already noted in 1886 with regard to the system by which the ducal library was structured that the original "organization … was abandoned in the engravings collection after the Duke's death … but was re[tained] for the drawings collection." [166] He went on to add: "Rechberger, who was unusually knowledgeable, began to reorganize the copperplate engravings collection … and divided [it] within a national framework … into three sections." [167] Schönbrunner had this to say on the criteria according to which the collections were, albeit only partly, rearranged: "The first section comprises what is called engravers' work; i.e. all that is taken into consideration here are the actual engravings of an artist (1ère Sect./Graveurs). The second section shows more of the painters' compositions without laying emphasis on the way they have been reduplicated (2de Sect./Peintres). The third section, on the other hand, contains only those works which were made by means of the etching needle and acid (actually etchings) (3e Sect./Eaux fortes; [168] Fig. 38). This arrangement in three sections is—although rather complicated—however, highly instructive and has only been possible because of the enormous supply of leaves in the greatest variety of states (*états*) in the collection … A not inconsiderable portion of the prints and woodcuts is still there in the red portfolios mentioned in the beginning as Albertine as the earliest part (old arrangement). [169] Through this new arrangement most of Albert's prints which had originally been "mount[ed] on loose leaves and kep[t] in magnificent portfolios" [170] were detached from their supports and remounted in albums that have remained essentially unchanged to this day. The frontispieces of the albums are decorated at the bottom with Archduke Charles's monogram 'CL' (Carl Ludwig: e.g. Fig. 39). New inventory sheets were also drawn up at that time. They have been preserved in two versions, which, however, are incomplete. Archduke Charles had coffins bearing his monogram made to keep them in (p. 22).

In 1886 Schönbrunner counted approximately 17,000 drawings [171] and found the print collection rather more extensive, comprising "slightly more than 220,000 leaves". [172] By 1891 Wilhelm Weckbecker was talking of "some 18,000" drawings and "approximately 220,000 sheets of engravings" by 1891. [173] Ulysse Robert's account of the archducal collection in 1898 records: "The copperplate engravings number 230,000 and the drawings 18,000." [174] The figures given correspond for the most part with the growth of the collection as recorded in Archduke Albrecht's lists, [175] which record that, between 1847 and 1895, more than 2,000 drawings and 12,000 prints were added to the collection. [176] After Albrecht's death in 1895, Archduke Frederick (1856–1936) [177] took over the collections, the last member of the

38  Inscriptions on spines of bindings for historical print inventories divided according to Franz Rechberger's system into three sections, Graphische Sammlung Albertina

39  One of the frontispieces in the inventory volumes of prints, arranged in sections, Graphische Sammlung Albertina

40 Title page of the drawings inventory book,
begun in 1895, of the Albertina archducal art collection,
Graphische Sammlung Albertina, Inventories

House of Habsburg to do so. Schönbrunner was head curator of
the collection until 1905, succeeded by Joseph Meder, who retain-
ed the post until 1922.[178] Between 1896 and 1908 they collabor-
ated on a twelve-volume series, entitled *Handzeichnungen alter
Meister aus der Albertina und anderen Sammlungen*.[179] It was
made possible by the collotype planographic photo-mechanical
non-screen printing process. In 1895 Schönbrunner began to
inventory the drawings in numerical order (Fig. 40).[180] The prints
were inventoried from 1897.[181] Meder, who launched the idea of
mounting changing exhibitions, published the authoritative work
on drawings, *Die Handzeichnung, ihre Technik und Entwicklung*,
in 1919 and, in 1932, a critical catalogue of Dürer's prints.[182] From
1922 advances in the collotype technique facilitated publication of
a series of *Albertina-Faksimile*, reproductions of famous drawings
in the Albertina,[183] since the technique was by now advanced.
Schönbrunner and Meder each kept a handwritten *Chronik der
Albertina* as well as a *Diarium der Albertina*,[184] which are impor-
tant contemporary sources on the Albertina. In their publications
on the history of Albert's collection,[185] however, they did not go
beyond Thausing although the archducal archive material, as
Schönbrunner confirmed in 1887 and Meder again in 1916,[186]
was then still extant and available for use.[187]

The end of the Austro-Hungarian monarchy[188] after the First
World War saw the entailed Habsburg-Lorraine estates become

public property in compliance with an Austrian law enacted on
April 3, 1919 (Figs 41, 42).[189] Austrian state art collections, among
them the Albertina, were menaced by this state of affairs in several
respects. In this connection it should be remarked that the "young
republic of German Austria" proclaimed on 12 November 1918
was subjected " ... from its inception to severe political and econo-
mic pressure."[190] That meant that its art treasures were among the
possessions most coveted by the victorious powers and by the
several states that had once been part of the Austro-Hungarian
monarchy. "The weeks and months immediately after the dissolu-
tion of the monarchy were particularly dangerous. The young, self-
proclaimed Republic of German Austria had not yet been recogni-
zed by treaty."[191] As Alphons Lotzky explained, from January
1919 "the Hofbibliothek and the art historical collections includ-
ing the Schatzkammern were especially [at risk]; the Graphische
Sammlung Albertina, the Paintings Gallery of the Fine Arts Acad-
emy and the Natural History Museum also had to tread care-
fully.... The three Western allies, that is the United States of
America, the United Kingdom of Great Britain and Ireland, and
the French Republic, registered no claims to Austria's cultural
heritage; the Kingdom of Italy, on the other hand, was moved to ...
assert quite considerable claims [first of all addressed to archive
material, paintings and manuscripts].... It is particularly note-
worthy that these demands were given weight by the use of
force."[192] In February 1919 the Italian cease-fire commission
deployed troops to confiscate valuable objects from the Kunst-
historisches Museum, the Fine Arts Academy and from what had
been the Imperial Hofbibliothek.[193] As Director Meder recorded,
at that time in the Albertina, too, "it was greatly feared that the
Italians [might urge] claims which had already" resulted in "brutal
interventions in the Hofbibliothek, the Hofmuseum and the Fine
Arts Academy."[194] Fortunately, the assaults threatened against
Austrian art treasures were not launched on the Albertina although
unrest and uncertainty on this sore point did not subside until the
summer of 1919. Moreover, "threats were still [being uttered] by
the Soldiers' Councils."[195] In order to prevent further confiscation
of art objects, the peace treaty of St. Germain-en-Laye (Figs
43–45)[196] contained "clauses which provided for the settling of
claims in cultural matters through arbitration. This enabled Aust-
ria to present her view of the legality of the claims that had been
made before an international committee of three legal experts.
Negotiations were conducted at the same time with the states that
were interested parties."[197] This was not the only danger that
threatened the art collections: "At the very time when Austria
could hardly ward off assaults on her cultural heritage, she was
dealt ... a much greater blow from her own ranks. In view of the
famine, the Cabinet in Council resolve[d] in 1919 [on 26 Septem-
ber] to sell works of art owned by the state in order to procure food
staples that were absolutely necessary."[198] As the Cabinet minutes
reveal, the Treasury (Staatsamt für Finanzen) had by this time
"already made contact with reputable foreign art dealers, specifi-
cally a representative of the leading New York art dealers, Sir
Duveen [sic]."[199] The wording of the minutes then runs: "Said [art
dealer] would be able to buy and sell all the available art owned by
the state of Austria and, if need be, to pay an advance of 10 to 15
million dollars on the sale.... As for the type of objects that might

be sold, the Gobelin collections spring to mind. … In addition, there would be historic furniture, other antiques, paintings, manuscripts and codices which would be sure to find connoisseurs abroad.… In order not to infringe existing regulations such as the prohibition on exporting art treasures [Fig. 46], the jurisdiction of the State Historical Monuments Commission etc., it would be necessary to place the operation firmly within the law."[200] Three days later, on September 29, 1919, Bruno Enderes was given the power of attorney to arrange the sale of art owned by the state.[201] On October 16, 1919 the above mentioned law enacted on December 5, 1918 forbidding the export and sale of art and articles of cultural and historical significance was revoked by statute (Fig. 47).[202] On the basis of the new law, the Austrian government tried hard during the winters of 1919, 1920 and 1921 to sell art owned by the state.[203] Works in the Albertina were not, as far as the records show, among those selected for this purpose although "drawings and prints"[204] could now legally be sold. "Apart from the catastrophe which carrying out this intention would have been for Austria's cultural heritage, it also violated the provisions of the peace treaty, which by now had been drafted. Article 196 of the treaty expressly stated that, of all objects from collections which had formerly belonged to the Austro-Hungarian government or the Crown, none might be sent abroad, scattered or be at anyone's disposal to sell. However, this article of the peace treaty had not been intended by its framers to protect Austrian art. On the contrary, it was meant to secure any foreign claims that might still arise."[205]

No sooner had the Entente Powers found out about the idea of "liquidating" Austrian state art collections than the next danger loomed on the horizon. According to Cabinet minutes no. 118 of October 28, 1919, General Mauclère had hinted soon after the law of October 16, 1919 had been enacted that "perhaps the Entente might claim the art treasures itself as security for the loan it was to grant."[206] Not long after that, on November 19, 1919, the Reparations Committee did indeed resolve to form a subcommittee consisting of art specialists from the Entente Powers "charged with the following tasks. 1. to draw up a complete inventory of the art treasures in the Republic of Austria, to which end the catalogues and notes would be used which the Austrian government has pledged to make available.… 2. to make as exact an appraisal of the inventoried objects as possible in order to … give the Reparations Committee a general idea of the value of their security."[207] In January 1920 work began in the various collections, museums and archives.[208] This time the Albertina collections were also affected. On January 19, 1920 Meder noted: "The Allied Appraisal Commission [convened] in the Albertina: Mr. Köchlin, Mr. Guiffrey, Mr. Demont and Mr. Bate, in order to conduct preliminary talks on the subject of further visits."[209] So promptly did the Commission set to work that the following day, January 20, 1920, was the "first appraisal day."[210] Two months later, on March 24, 1920, pre-sale appraisal had been concluded.[211] Meder wrote as follows on the completion of the task and its results: "The overall estimate was

41–42 Statute of the state of German Austria, no. 209; law enacted April 3, 1919

extraordinarily positive with regard to our quality.... That means the preliminary work of the Allied Committee may be regarded as finished." [212] What was going on in the Albertina was "followed ... by Viennese art lovers ... with mounting apprehension ... [particularly since] ... utter confusion" reigned " ... on the purpose ... of the inventory and appraisal." [213] Even though there "had been assurances from within Entente circles that there was no reason for alarm on the part of art lovers" [214] and the Education Office [Unterrichtsamt] had announced that "there is no question ... of any threat whatsoever to the Albertina," [215] the suspicion remained that "the collections of the Albertina or some of its most valuable items" might be used for security. [216] This seems to be the gist of what Meder was suggesting in his final entry in the *Diarium der Albertina* in which he expressed concern yet, oddly, broke off in mid-sentence: "The future will show what with these pawned objects ...." [217] Anticipating events, [218] we should like to remark here that the drawings and prints in the Albertina, valued at 20 million gold Krone (10-Mark gold-pieces; the sum is today the equivalent of roughly 910 million Austrian schillings), [219] were not, after all, used as security.

The situation of the Albertina collection was soon once again critical when, on October 29, 1920, the Prague Agreement came

43–45    Statute of the Republic of Austria, no. 303; the Treaty of Saint-Germain-en-Laye of September 10, 1919

into force. It authorized the Czechoslovak government to claim art from Austria.[220] On July 21, 1921 the Chechoslovak Federal Foreign Ministry made known[221] that this claim amounted to nearly all the Dürer drawings in the Albertina, that is 133 leaves.[222] Meder rejected this claim as unjustifiable on August 10, 1921 in a *Refutation of the legal basis of the Czechoslovak claims on the Albertina*.[223] On December 19, 1922 the Allied Reparations Committee agreed to accept Meder's refutation of the Czechoslovak claims.[224]

Finally, reports of plans being mulled over by Archduke Frederick of Austria also gave rise to concern and alarm in Austria. Under the provisions of the statute of April 3, 1919, he had no right to what had been an entailment on his family.[225] Nevertheless, he seems to have embarked on negotiating the sale of works in the Albertina to America. According to the few sources to have been published in this connection, he may be supposed to have "transferred the disposal of his possessions and all his interests to an American syndicate" by the summer of 1919.[226] One of the aims of the syndicate was to "file an objection to the nationalisation of the Viennese Albertina."[227] In January 1922 things came to a head when it was reported from New York that the Albertina collection was about to be sold for approximately 6 million dollars.[228] This alarming rumor "from an utterly reliable source"[229] was immediately denied "by informed parties" who cited the Austrian statute of April 3, 1919.[230] Evidently it was only a rumor although doubts about the inviolability of the Albertina as a public institution continued to be justified for the time being.[231]

All these vague and confusing yet alarming threats that the Albertina collection would be looted, used as security or sold came to nothing, essentially for two reasons. First, the economic crisis was alleviated, in Austria at least. When the domestic situation had become acute, Chancellor Ignaz Seipel succeeded in "obtaining the help of the League of Nations in finding a way of filling the state coffers again. By October 4, 1922 the Geneva Protocol had been ratified by the legislatures of England, France, Italy and Czechoslovakia on the one side and by Austria on the other … A loan of 650 gold Krone (10-Mark gold-pieces) was pledged."[232] The most far-reaching consequence of this transaction for Austrian art collections was that "in 1923 … most Allied states" waived "their general right to security as set out in the peace treaty."[233] Second, vehement protest was registered from the outset not only in Austria but also from abroad. The first concerted reaction was to the confiscation of objects in the Kunsthistorisches Museum and the Hofbibliothek in February and March 1919 and the demands made by the Italian military commission.[234] From fall 1919 there were mass demonstrations against the Austrian government's plans to sell art[235] and even against the drawing up of inventories and appraisals made in Austrian art collections by specialists appointed by the

46  Statute of the State of German Austria, no. 90; law enacted on December 5, 1918

47  Statute of the state of German Austria, no. 479; law enacted on October 16, 1919

48 Index volumes of the hand–written catalogue of the
library belonging to Albert, Duke of Saxe-Teschen,
undated (drawn up after 1819)
Graphische Sammlung Albertina

also moved at that time to what was provisionally the Staatliche
Graphische Sammlung Albertina. Since August 11, 1921 the insti-
tution has been officially designated the Graphische Sammlung
Albertina.[248] Tietze's comment on the uniting of the collections
was: "Vienna once owned two collections of prints and drawings:
the Archducal Albertina and the Hofbibliothek print collection.
Both were designed to be pretty much the same so that their in-
ventories probably overlapped by as much as three-quarters. They
differed, however in that the Albertina had a more complete collec-
tion of classic *œuvres* in prints and drawings whereas the Hof-
bibliothek, due to its links with the old Palatina, [boasted] a magni-
ficent collection of single-leaf prints (woodcut incunabula). More-
over, the former owned the famous collection of drawings whereas
the latter had a really remarkable collection of architectural draw-
ings. Both sets of collections had been nationalized through the
breakdown of the monarchy … and … the union [was] brought
about in 1920 by which the Albertina became richer through the
[addition of] the old Hofbibliothek copperplate engravings collec-
tion and the latter through the treasures of the Albertina. Together
they have become a new Albertina which may well be the world's
richest and most superb collection of this kind."[249]

The united collections amounted to between 800,000 and
830,000 leaves. However, since in many sections there were dupli-
cates of individual items, from 1920 duplicates in quantities that
are difficult to ascertain were sold to pay for new acquisitions.[250]
The controversial policy of sales to finance acquisitions[251] was
inaugurated by Meder and then carried out mainly by his successor,
Alfred Stix,[252] who was Director of the Albertina from July 1923
until early May 1934. Although only a negligible number of prints
was acquired between 1919 and 1934,[253] about 3,400 leaves were
added to the drawings collection during that time.[254] Stix not only
acquired some superb pieces.[255] He also deserves great credit for
publishing the Albertina inventory catalogues.[256] In his foreword
to a catalogue published in 1927, he merely touches on the history
of acquisitions in the Albertina.[257] On January 1, 1934 Stix moved
to the Kunsthistorisches Museum as its Director. Not long after-
wards, on May 5, 1934, the Albertina was placed under the control
of the Österreichische Nationalbibliothek until 1938. The Director
of the two institutions was Josef Bick.[258] In 1935–36 the Graph-
ische Sammlung Albertina was once again faced with dissolution.
Archduke Frederick's only son and sole heir, Albrecht of Habsburg-
Lorraine,[259] entertained notions of selling out.[260] Anton Rei-
chel,[261] then Deputy Director of the Albertina, collated all infor-
mation that came to him in two memoranda.[262] They reveal that
Archduke Albrecht gave the London art dealer Colnaghi and,
apparently without their knowledge, the New York firm of
Duveen, an offer of first refusal on the Albertina collections, an
offer that would have cost each of them dear.[263] It is virtually
impossible to reconstruct which works and how many of them
were to be at the disposal of the one or the other art dealer since the
sources are contradictory. What is known with a fair degree of cer-
tainty concerns, and understandably so, the most valuable works.
Quantitative estimates run between 16,000 and 250,000 items.
Reichel recorded verbatim that "Gustav Mayer …, a partner in the
London firm of Colnaghi," was granted "first refusal in 1935 by
Archduke Albert on approximately 16,000 to 20,000 leaves from

Entente Powers.[236] Indignation at Archduke Frederick's proposed
sale of art in the Albertina to America was voiced from fall
1920.[237] The art historian Hans Tietze was one of the most
redoubtable defenders of Austrian public art collections. Quick to
realize the implications of their sale and export, he went public
with what he knew and fought unremittingly to keep them in Aus-
tria.[238] However, it should be noted, in connection with the after-
math of the First World War, that Archduke Frederick took over as
his private possessions all the family assets which were not express-
ly entailed and sold most of them.[239] Among them were the historic
appointments of the Palace, including furniture, tapestries, chan-
deliers[240]) and paintings, archive material and books (Figs 48,
49)[241] that went back to Albert's day, the collection of minia-
tures,[242] and some 3,800 drawings and 4,600 prints which had
been acquired between 1895 and 1919 during his tenure.[243]

On December 25, 1920 the Austrian government resolved to
unite the Albertina, which had been under archducal admin-
istration until April 3, 1919, with the print collection of what had
been the Imperial Hofbibliothek.[244] The move entailed bringing
together approximately 18,000 drawings and 220,000 to 230,000
leaves of prints of (arch)ducal provenance[245] and, on the other
hand, more than 5,000 drawings, most of them architectural as
well as 550,000 to 600,000 prints from the Imperial collections.[246]
Some 2,000 architectural drawings from public archives[247] were

the Albertina" as well as "an assurance of permission from the Chancellor ... for ... export." [264] In preparation he drew up "a sort of inventory of the most famous objects in the Albertina ..., [interested] the museum in Boston in the sale ... and presumably also [paid for] the trip to Austria of the leading Boston Museum specialist in prints and drawings, M. Rossiter." [265] Rossiter for his part looked back on what took place then as follows: [266] "In March 1935 a cable from Gustav Mayer ... gave the Museum of Fine Arts the first hint it had that something unusual was afoot .... What he had to say on arrival was not only pressing, it was breath-taking. He reported that the Austrian Government had decided to return to the Habsburgs all the Imperial property it had confiscated ....The Archduke Albrecht's property included the world-famous collection of graphic art in the Albertina Museum .... This collection the Archduke Albrecht had decided to sell, and he had appointed G[ustav] M[ayer] as his agent. Because of years of friendship with me and with the [Boston] Museum, ... G.M. had come to offer the Albertina collection to the Museum .... At the Committee meeting which the Director (Harold Edgell) promptly called, it was voted to accept Mr. Mayer's proposal and acquire the Albertina collection. The asking price was a good round sum, but, considering the quality and distinction of the material, it was relatively modest, ... " [267] Weber's research in the US on these secret agreements has shown that the Collection was to be divided up between the Boston Museum and the Fogg [Art Museum in Cambridge]. The section heads in the two museums agreed to waive all other acquisitions for that year. [268] According to Weber, high-ranking officials under the British Foreign Secretary and the US State Department were cognizant of the secret plan. However, under no circumstances were the curators of the Albertina or anyone else in Vienna supposed to know about it. [269] Mayer went to Vienna and carried out his inventory in the Albertina Studiensaal between late March and Easter 1935. [270] Although Bick, the Director of the Albertina, informed the Chancellor of this, and although it was reported in diplomatic circles in early June 1935 that there was talk in London of the sale of the Albertina, [271] no measures were taken to prevent either talk or action. Consequently, Mayer had no trouble making new inventory lists of selected drawings and prints in the Albertina in early September 1935. This time he was in distinguished company: Paul J. Sachs, the Director of the Fogg Art Museum, and Agnes Mongan, Curator of Drawings. Henry Rossiter, Curator of the Print Collection of the Boston Fine Arts Museum and W.G. Russell Allen, Chairman of the Print Department Visiting Committee, all came with him to Vienna. Their legal representative was W.A. Roseborough of the legal firm of Sullivan and Cromwell. [272] By early December it looked as if the sale would be clinched: "One morning, G.M. announced that a group of some 16,000 prints and drawings were to be released to us. This seemed to be too good to be true, and that is exactly how it turned out, for when G.M. went to the Minister of Finance to complete arrangements, he encountered evasions of all sorts, to be told at last that someone in Boston had talked to newspapers there. The complete story was sent at once to Vienna, where repercussions were immediate, loud and angry. G.M. was informed that because of the delicate situation the authorities feared that at the moment the transfer could not take place." [273] On December 23, 1935 Austrian newspapers reported: "In the foreign press, especially the American press, the news has been bruited for some time now that the nucleus of the Albertina collections is to be sold to the Boston Museum in America for the sum of twenty million dollars." [274] A postscript hastened to deny the veracity of the reports: "We have been told by genuinely informed sources that this news is wholly unfounded." [275] Nonetheless, the issue remained touchy. On December 30 the New York art dealer Duveen registered great interest in buying by cabling Reichel that their bid was higher than that of anyone else in the world. [276] Shortly thereafter, on January 11, 1936, Bick, the Director of the Albertina, implored the Austrian Ministry of Education to deny the rumors: "Since ... an increasing number of newspapers is inquiring at the Albertina whether the widespread news is true, the Ministry of Education [Bundesministerium für Unterricht] should issue an official denial through regular chan-

49   Index volumes of the catalogue of the library belonging to Albert, Duke of Saxe-Teschen, Vol. 1, title page, Graphische Sammlung Albertina

nels, a statement to the effect that all rumors on the sale of the Albertina or part thereof are unfounded."[277] The publicly issued official statement of January 13, 1936 was entitled *False Rumours on the Sale of the Albertina Inventory Abroad* and ran as follows: "Recently reports have been spread by interested parties abroad referring to the sale of the collections of our Albertina to a foreign museum. Although it would seem obvious that the character of such reports is invention pure and simple, let it be officially and explicitly stated that all rumors of the sale of the state Graphische Sammlung Albertina or a part thereof are untrue and fabrications."[278] This statement duly appeared in the press both with and without comment on January 14, 1936.[279] The most penetrating commentary was that of Hans Tietze, the art historian who had voiced most concern whenever the threat to the Austrian cultural heritage seemed imminent.[280] As he saw it, the "rumors of selling the Albertina" had arisen "not only from sensationalism and gloating over the misfortunes of others but also from genuine concern."[281] He asked the public to consider: "whether it is untrue in the raw as it has been reported hitherto, nevertheless, it must rest on some sort of true foundation .... Despite denials, the rumor has not been stopped. It cannot possibly have happened that a world-renowned specialist could inspect the Albertina collections so thoroughly, if only for an appraisal, without someone's approval. It is not reassuring that representatives of the art market are hovering unceasingly over what they expect to be their prey."[282] It seemed plausible to Tietze "that the former owner has, from the first, set

everything in motion to acquire again what, in his view, is his lawful possession, of which he has been robbed .... The owner has sold off the leaves from the Albertina which had not yet been included in the entail and were for that reason returned to him in a fashion which causes reputable collectors and dealers to shake their heads in dismay. Beyond all doubt the battle which is being fought by him—or by those who acquired his rights—with the aim of liquidating the collection's assets ... the only way of preserving the Albertina is to keep it public property .... One should not forget that it is utterly irreplaceable ... once destroyed, an Albertina can never be built up again because there is no longer the material to do so in this world."[283]

Despite public denials of his intentions, Archduke Albrecht was reluctant to abandon the idea[284] of "entirely or partly selling off the Albertina as soon as it may be returned to us."[285] Mayer, too, continued to entertain the notion that he would be able to "secure the Albertina for the [Boston] Museum."[286] He does not seem to have realized until late June 1936, after renewed talks with high-ranking Austrian government officials had undeceived him, how hopeless this undertaking was.[287] Archduke Albrecht, however, made one more attempt on the art treasures in the Albertina in late March 1938 after the National Socialists had usurped power. Bick had been dismissed[288] and Reichel was now Acting Director of the Albertina. Reichel recorded "that the commercially-minded Archduke Albrecht approached me ... in late March 1938 through an intermediary with the intolerable proposal that I should make suit-

able reports on particularly valuable objects in the Albertina, for a fee which he was prepared to pay." [289] Referring to a memorandum dated July 14, 1938, [290] Archduke Albrecht as "[Archduke Frederick's] only son and heir [and,] like his father, a Hungarian national" [291] addressed himself on August 3, 1938 "in a petition to the Hungarian government that the German Reich government should 1) recognize that ownership of the Albertina art collection and those of the two Viennese palaces [292] is his by right and 2) charge an authorized official from their ranks with the following special commission: a) appraisal of the art-market value of the collection by suitable experts; b) negotiations with Archduke Albrecht and his appointed representative on the type, amount, value and use of damages to be paid." [293] On October 27, 1938 the Austrian Finance Ministry, invoking the law of April 3, 1919, [294] informed Duke Albrecht that the Albertina, both as a building and a collection, was the property of the Republic of Austria and "that, under Austrian law, Archduke Albrecht never had nor has any legal claim to the transference of Carl Ludwig's entailed properties to him as a natural or artifical person." [295] The Ministry concluded that "Duke Albrecht's petition ... " should be "rejected out of hand." [296] On November 15 the Austrian Ministry of the Interior and Cultural Affairs declared: "We can ... only agree unreservedly with this statement." [297]

The Albertina Collection survived the Second World War without damage since it had been stored in good time in the vaults of two large Viennese banks as well as the Bad Ischl-Lauffen salt mines. [298] However, bombs struck the Albertina Palace on March 12, 1945, just a few days before the war ended. The northeastern tract with its facade facing the Viennese State Opera House was demolished in the raid (Fig. 50). [299]

After Reichel's death in February 1945, Heinrich Leporini [300] and George Saiko [301] were temporarily in charge of the Albertina's affairs. The latter saved the Dürer drawings from confiscation by the Russians. [302] Bick, who was reappointed Director of the Albertina in May 1945, oversaw the initial phase of the reconstruction of the Palace and the return of the collection. He was succeeded by Karl Garzarolli-Thurnlackh, who held the position from March 1946 until April 1947. [303] Even during the war years and the lean post-war years that followed, a consistent acquisition policy was carrried out so that between May 1934 and late 1947 the collection grew by approximately 400 drawings and 3,000 prints. [304] Otto Benesch, [305] Director of the Albertina from late 1947 until late 1961, added another 3,600 drawings and some 2,400 prints. [306]

His publications and exhibitions show that Benesch was a wide-ranging generalist as an art historian. [307] His magisterial writings include the Albertina Inventory Catalogue of fifteenth and sixteenth-century Netherlandish drawings [308] as well as the corpus of Rembrandt drawings, *The Drawings of Rembrandt*, [309] and *Meisterzeichnungen der Albertina*. [310] Benesch also researched in depth and with profound critical insight into the history of the collection. Since most of the ducal archive inventories had been "destroyed for all time," he was gloomy about the "prospects of writing a history of the collection." [311] Walter Koschatzky, Director of the Albertina from early in 1962 until fall 1986, [312] deserves particular praise for systematic research into source material which has clarified so many aspects of the history of the collection and its founder. [313] His greatest achievements include making known Albert's autobiography, *Mémoires de ma Vie* (1738–98); [314] publishing Conte Durazzo's *Discorso Preliminare* [315] and discovering invaluable archive material in Budapest which had been presumed lost. It comprises correspondence, travel diaries, and expert appraisals of the Albertina collections undertaken after Albert's death. [316] Thanks to Koschatzky's untiring commitment to public relations as well as his numerous authoritative publications and the outstanding exhibitions he mounted, [317] the Albertina is today both popular and famous worldwide. He retired on September 30, 1986. During his tenure the collection was enlarged by about 5,400 drawings and approximately 6,200 prints. [318]

Erwin Mitsch [319] was Interim Director for about a year after Koschatzky retired. Since September 1, 1987 Konrad Oberhuber [320] has been Director of the Albertina. The author of numerous scholarly publications, [321] he is committed to both museum education and research. Oberhuber's exhibition and acquisitions policies focus on the Austrian and international Moderns. [322]

Currently the Albertina collections comprise some 40,000 drawings and watercolors, [323] as well as about 25,000 architectural drawings, [324] which are in a separate section. At present the Albertina print collection is estimated [325] at about 900,000 leaves. [326]

# The Foundation and Growth
## of the Drawings and Print Collection

THE FOUNDATION of Duke Albert of Saxe-Teschen's collection of drawings is closely linked with the growth of his print collection. However, the latter development can be traced further back and reconstructed more precisely. A letter dated January 4, 1766 from the Archduchess Marie Christine to her betrothed is the earliest known mention of prints in connection with Albert. In it she says that she has sent him a volume of engravings, which are not described more precisely, presumably as a present.[327] Johann Georg Wille, a copperplate engraver, art agent, and collector resident in Paris, noted early acquisitions of prints by Albert. His diaries attest to the fact that he quite regularly supplied the Duke with "estampes"[328] in the years between 1768[329] and 1774. A former pupil of Wille's, Jakob Matthias Schmutzer,[330] who founded the Viennese copperplate engraving School in 1766, was the intermediary in these transactions.

As the following passage from Albert's *Mémoires* clearly shows, he had plenty of time for his favorite pastimes while he was Governor of Hungary between 1766 and 1780: "Since my usual civilian and military duties only occupied a small part of my time, I was able to devote myself in addition to studies and reading; I spent most of my time doing just that."[331] During that time Albert must have begun to collect more actively and extensively than was usual in court circles. Count Durazzo's *Discorso Preliminare*[332] proves the existence by 1773 of a collection nucleus comprising mainly contemporary English and French works before Durazzo had encouraged the Duke to build up an encyclopedic and systematically ordered collection. Durazzo describes the fruits of Albert's early collecting activities as a "Collezione di belle Stampe."[333]

In 1774 Albert commissioned Durazzo to acquire works for his *Praktische Geschichte der Malerei und der Stecherkunst*.[334] In December 1775 Albert and his wife went to Italy for six months, presumably for the purpose of studying and acquiring art. The Duke describes their stay in Italy in his *Mémoires*[335] and his travel diary. On Florence, where they stayed with Archduke Leopold (Marie Christine's brother and Viceroy of Tuscany), Albert writes: "I confine myself to saying that I was filled with enthusiasm at the sight of so many admirable treasures which show to what extent man's faculties may be schooled through the furtherance of the fine arts."[336] After sightseeing in Pisa, Lucca and Siena, Albert of Saxe-Teschen greatly enjoyed studying the art treasures of Rome. There his guide was the artist and art historian Johann F. von Reiffenstein: "Since we could only stay four weeks in Rome and it would have been impossible during such a short time to be well grounded in all that was noteworthy—whether the customs of the country, its constitution or the government—and at the same time to study the numerous art treasures of this city, I resolved to give particular weight to this last field of endeavor."[337] Gottfried von Rotenstein's account reveals that Albert "received copperplate engravings as

gifts ... some from Saxony, France, Naples and Rome ... [and] acquired some himself on his Italian journey."[338] A note of Gaetano Moroni's also confirms that Albert and his wife were given prints in Italy. It says explicitly that the couple received "a chest with vedute of Rome engraved by Piranesi in 15 elegant volumes and, in addition, a second chest with a collection of copperplate engravings and prints from the *Calcografia camerale* [copperplate-engravings chamber] in 12 sumptuously made up volumes"[339] as well as other presents from Pope Pius VI. Since there was general awareness in Italy of Albert's interest in art, galleries, art cabinets and academies were made readily accessible to him there. Taking his visit to Naples as an example, the Duke made a note of this, embellished, however, with a critical commentary: "The king, who knew of my interest in these things, immediately gave me the keys to his cabinets so that I might look about in them at my leisure and might remain there as long as I liked. I did not fail to take advantage of this offer and, even though I perceived with joy the great number and beauty of the things exhibited, I was, on the other hand, quite shocked at how little they seemed to be valued in this country, how little care and expense the government [bestowed] on completing this collection and disseminating the knowledge that it could impart."[340] On his way home, at the beginning of July 1776, Duke Albert took possession in Venice of the first of the approximately 1,000 sheets of the extensive print collections put together by Count Durazzo.[341]

Whereas the above mentioned sources, specifically those related to the *Raccolta Durazzo*, represent sound documentation of the founding of Duke Albert's print collection,[342] there are no similar records of how the drawings collection was built up. Where, when and on what occasions particular leaves were bought can rarely be traced and then only for the later phases.[343] This lack of records is primarily due to the circumstance that ducal archives which were not entailed were taken out of Austria in 1919 as the private property of Archduke Frederick and subsequently for the most part scattered or even destroyed:[344] "All the rich and comprehensive archives accompanied the Archduke to Magyaróvár [Hungary] and were sold ... from there in entire groups comprising valuable material. The loss to historical research can never be made good. The rest sustained severe damage in 1945, went to the state archives in Budapest, was systematically ordered there and, more recently, decimated by fire in 1956."[345] What was left of these archives, including the valuable material that Koschatzky discovered in Budapest,[346] makes abundantly clear that the Duke attached great importance to precise records and book-keeping, particularly as far as his collection was concerned.[347] A vast body of primary source material on purchases, correspondence with art agents, lists of acquisitions and expenses[348] must, therefore, once have been extant.

The first indication that Albert of Saxe-Teschen owned drawings is a miniature on parchment which the court commissioned Friedrich Heinrich Füger to paint in 1776. It is a representation of the "Duke and Archduchess … in Maria Theresia's family circle … works of art they had brought with them—apparently drawings"[349] (p. 23).

In his biography of the Archduchess Marie Christine (published in 1863), Adam Wolf gives the earliest known reference to her buying drawings. She is mentioned as having sent drawings by Frans van Mieris and David Teniers to her husband, who was in army camp at Olmütz, in 1778, together with the invoice of Artaria, the agent.[350] The next references with a bearing on the collection go back to the period from 1781, when Duke and his wife were Governors in the Austrian Netherlands.[351] Albert's *Mémoires* show that, in 1781, he and his wife approached the connoisseur and art collector Charles Antoine, Prince de Ligne, soon after Albert had entered on his official duties.[352] After the Prince de Ligne's death in 1792 on the battlefield at the age of 33, the bulk of his outstanding collection of drawings came into Albert's possession in 1794.[353] Albert's notes on a journey he undertook through the provinces of the Netherlands[354] in 1781 reveal that, in addition to his diplomatic duties (he met leading representatives of both the temporal and spiritual powers), he found time to visit numerous churches, castles, art cabinets and academies.[355] His cultural itinerary in Antwerp is set out in the *Liste der bemerkenswertesten Sehenswürdigkeiten der Stadt Antwerpen und der Route, die einzuschlagen ist* (List of the Most Remarkable Sights to See in the City of Antwerp and the Route That is to be Taken).[356] It indicates that the highlights included "Le Cabinet des Tableaux de Mr. Stevens, Les Cabinets des Mrs. Pilaer, et Van Lancker, Le Cabinet de Mr. Peeters, Le Cabinet de Chanoine Knyff" as well as "L'Académie de Peinture, et la Salle des Peintres." In the *Auflistung einiger Maler/Schüler der Akademie von Antwerpen, die zum überwiegenden Teil in dieses Stadt leben* (List of painters/students of the Academy of Antwerp, who live mainly in that town)[357] Albert gives brief descriptions of professors and students at the Antwerp Academy whom he found particularly noteworthy. Moreover, his *Bemerkungen über die 1781 unternommene Reise in verschiedene Provinzen der Niederlande* (Observations on the Journey Undertaken in 1781 through Various Provinces of the Netherlands),[358] mentions that he visited the Académies de Dessein in Ypres and Courtray. An entry in his *Mémoires* for 1781 confirms that Albert deliberately took advantage of the appointment to the Austrian Netherlands to enlarge his collection: "The subsidies … together with the purchases from Hungarian collections gave us the possibility … to spend quite considerable sums … when one also takes into consideration the favorable geographic situation of this country, which is placed between Germany, … France … and Holland and is also adjacent to England …. Hence this country offered us the opportunity … of obtaining all scholarly and literary as well as artistic products of said countries at first hand."[359]

An example of Albert's collecting activity in 1781 is the purchase of a Jean-Baptiste Le Prince drawing at the Paris auction of his work: "This drawing [Fig. 51], … purchased at the auction of work which this artist left, cost 410 livres."[360] The next reference to his collection is in a letter written by Albert to Alexander von Seckendorff on 17 January 1783. In it, Albert notes that he has completed his collection of portrait engravings of distinguished scholars.[361] By the early 1780s Albert's collection was probably so large that he had to hire personnel on 1 March 1783 to organize and care for it. His curators were François Lefèbvre and Joseph van Bouckhout and, from 1 January 1787, they were designated "Inspector[s] of the drawings and the copperplate engravings collections."[362]

The collection grew again in 1784, when Durazzo gave Albert a second lot of prints, this time simply as a lavish present. Over 30,000 leaves with the work of about 1,400 artists were added to Albert's collection at that time.[363] Reports of Albert's interest in collecting, and indications of acquisitions made for his cabinet,

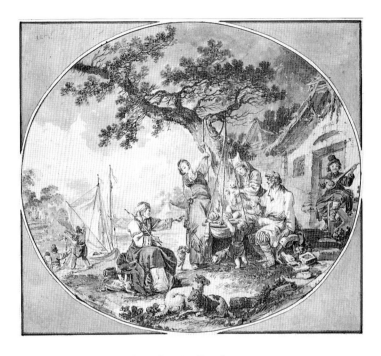

51   Jean–Baptiste Le Prince, *Russian Family*
Graphische Sammlung Albertina

surface again in 1786 when he went to Paris with his wife to visit her sister Marie Antoinette, married to Louis XVI. This trip, too, included a rigorous sightseeing itinerary (*Bemerkungen über verschiedene Besichtigungspunkte in Paris und Umgebung*),[364] which included not only "Eglises / Palais / Etablissements publics / Manufactures" etc. but also "Académies / Collections de Tableaux et autres …" and also private collections under the heading of "Maisons particulières" and "Autres objets divers." Among them were the art cabinets of "Mr. Beaujon, Mr. de la Reynière, Mr. de la Borde, Melle. Guimard, Les Plans et Desseins chez Mr. Peronnet" as well as "Le Magazin de Sykes, Le Magazin de D'Aguerre" and "Le Magazin de Jouillot le fils," which also contained drawings and prints.[365] In his *Mémoires* Albert was particularly enthusiastic about the royal library and engravings collection: "My attention was most attracted by the sight of the royal library, to which Mr. Lenoir conducted us, then in succession the collection of books, the Cabinet des médailles … the large globes owned by Pater Coronelli, the celebrated engravings collection and, last, the gallery with

the King's manuscripts." [366] For his part, Lenoir, the librarian, recorded: "The Archduchess and the Duke of Saxony yesterday visited the four sections of the King's library: printed books, the medallions, the engravings and the manuscripts. The engravings collection probably aroused the greatest interest. The Duke of Saxony is interested; he owns a fine collection of prints. He explained that he has given a commission to have Le Cabinet du Roy in 24 [?] volumes bought." [367] In addition, it is recorded that the Duke and Archduchess received generous presents as they had in Italy, [368] including prints. [369] Drawings, however, are not mentioned in the above sources.

Inventory entries for 1786 and 1788 record that Albert bought two Le Paon drawings and one Meunier drawing at the Paris auction of the Le Paon and Wailly collections. [370] Remarks Albert made in his *Mémoires* on visits to the [Wittelsbach] Düsseldorf Gallery (in 1788), [371] to Johann Friedrich Richter's [372] collection of paintings, drawings and prints in Leipzig (in 1791) and records show that a Joseph Vernet drawing was purchased (in 1790), [373] when the Vernet collection was sold at auction in Paris. Letters written in the 1790s form the next set of significant references to the ducal art cabinet. By then Albert and Marie Christine were already living again in Vienna, although parts of their collection were still in Dresden. [374] A letter written by the Viennese agent Dominik III Artaria to van Bouckhout and dated March 18, 1794 mentions deliveries to Albert, presumably of prints, although they are not specified, from September 1793: "In obedience to Your esteemed request ... I have the honor of enclosing an invoice on all that I have had the pleasure of purveying to Your Royal Highness from the month of September to date; totalling 1362 fl 49 kr in Viennese tender." [375] On July 26, 1794 Albert confirmed that he had received lists of prints from his agents Dominik II Artaria [376] in Mannheim and Joseph Zanna [377] in Brussels. Albert requested that items that were more expensive on Zanna's list should be struck from it: "Schwetzingen, July 26, 1794. / My dear Vanbouckhout, I have received the lists of engravings from Artaria in Mannheim and Zanna in Brussel and I return Zanna's, appended to this letter. On the grounds of differences in price between the lists, cancel all items on Zanna's list marked N B. and I shall retain those of Artaria's which are cheaper than those of Zanna's. / Albert." [378]

A letter dated September 14, 1795 from Albert to Alexander von Seckendorff reveals that, since Albert had retired from public life on April 10 of that year, he had found ample leisure to devote himself to his collection: "Since I see neither the Emperor nor the appointed ministers ... I am perhaps the least informed man in Vienna on matters relating to the war and politics. I therefore spend my time in the morning writing letters or in delighting in plans, drawings, and leaves of prints." [379]

A letter from Albert to van Bouckhout dated October 18, 1795 is quoted here in full as it reveals Albert's scrupulous attention to detail and meticulous correctness in conducting transactions entailing the purchase of art works. In addition, it explicitly mentions specific drawings and the connoisseurs he consulted to appraise his purchases: "Vienna, 18 October 1795. / I have, my dear Bouchautte, received your two letters of the 21st of the month past and the 9th of this month in that order as well as the crates of drawings and engravings, the arrival of which was announced in

them. All that is now missing are the plans for the campaign of 1793, for which you enclosed your invoice in the last [letter]. All leaves have arrived in good condition and in the past few days I have commenced arranging the drawings which you have sent to me with those that I have acquired here since. They already form quite a handsome collection which I shall go through once again with Messrs Bartsch, Rosa, Füger, and other connoisseurs and I shall request the aforenamed to send me his notes in writing so as to be able to make an entirely accurate and complete catalogue of them. I also noticed on the occasion of these shipments that you have not included some drawings and watercolors or gouaches which were supposed to be in separate portfolios between the large, segregated portfolios with various colored engravings. I have, therefore, made a note enclosed here sub A of the drawings I can recall and you will send them to me as well as all other drawings, watercolors or gouaches you may find in our portfolios so that I may have the entire collection here. On this occasion I am also sending you sub B a list of items which are available here so that you may see whether we have them in our collection and so that you may mark those that we do not have. Since you have not sent back to me the small prints in color which were made in Rome, which I received from Artaria in Mannheim, I desire that you should have these sent to me at the earliest opportunity. I did not much admire the representations in the antique manner which his last shipment contained; and even less so the *Galatea*, the *Triumph of Bacchus*, and *Ariadne and Bacchus*. Touching on this last leaf, write to me whether we have it and Guercino's *Aurora* as well as the Guido Reni *Aurora* among the large colored engravings or whether we only have these three large items as watercolors; if we only have them as paintings and not also as colored engravings, I should purchase them here straight off. I notice, moreover, that the price which Artaria is asking in Mannheim for all his engravings and pictures considerably exceeds that for which I might have them here. Therefore I intend in future rather to buy here everything I can find. You will ensure that I receive a list of those series of engravings which said Artaria has delivered to us to date from Mannheim and Zanna from Brussels so that I may have myself be supplied with everything that is still lacking to us. I admit that I did not find the drawing which was sent by Herr Klengel [380] very fine and, moreover, I find it quite expensive. Nonetheless, I still prefer to pay him the 60 ecus he is asking for it to returning it to him. I am annoyed that the engravings which I sent back to Herr Frauenholtz suffered damage on the journey. Since you, however, assure me each time that they were well packed and that the damage must have occurred through the negligence of a Saxon post station, I do not believe that he will be able to demand compensation from me. As far as Herr Derschau's [381] leaves are concerned, I have already arranged all those I have selected among my other engravings and it will now be difficult to remove them again. Nevertheless, I shall see whether this is possible. Moreover, it almost seems to me to be of little use. The list which I sent to you of what I have taken or not taken was so detailed that I think you would have difficulty in finding one more item even if I were to send you the entire baggage. Incidentally, I hope that the dampness which had already damaged this parcel by the time I received it might not encourage Herr Derschau also to demand compensation. All that remains for you

Ecole Allemande

| No. des Feuilles | No. des Desseins | Sujet du Deffein. | Forme du Deffein. | Nom du Maitre. | Date Chrono-logique. | Notes. |
|---|---|---|---|---|---|---|
| | 13. | Le Bourreau mettant sur le Bassin d'Hérodiade, la tête de Saint Jean Baptiste sur un bassin que tient Hérodiade, qui aussi de Double Bram le fond du tableau, on voit d'un côté les ___ d'Hérodiade s'amusant de la danse diade, et de l'autre côté, ___ table ___ qui ___ d'hérodias, au quel elle vient portant la tête du Saint qu'Hérode assis à table. Deffein à la plume, relevé de Blanc au pinceau avec beaucoup de soin et ___ ___ de blanc au pinceau ___ sur papier teint d'une couleur rouge foncée ___ lequel on voit ___ ___ d'un pilastre, le monogramme de l'auteur, et la date de 1513 sont marqués au haut d'un pilastre. | haut 11·5 8·1 | Jean Burgmayer | né en 1474 | ✳✳✳✳ Ce dessin n'est pas assez bon pour pouvoir être attribué à Jean Burgmair qui étoit dessinateur très vigoureux. |

Ecole Allemande

| No. des Feuilles | No. des Desseins | Sujet du Deffein. | Forme du Deffein. | Nom du Maitre. | Date Chrono-logique. | Notes. |
|---|---|---|---|---|---|---|
| 132. | 24. | Le Bourreau mettant, la Tête de Saint Jean Baptiste sur un Bassin que tient Hérodiade. Dans le fond du Tableau on voit d'un côté Hérodiade s'amusant à la danse, et de l'autre Côté, elle est représentée portant la tête du Saint à Hérode assis à table. Deffein à la plume, relevé de blanc au pinceau avec beaucoup de soin sur papier teint d'une couleur rouge foncée. Le monogramme de l'auteur, et la date de 1513 sont marqué au haut du pilastre. | haut 11·5 8·1 | attribué à Burgmayer | né en 1474 | ✳✳✳✳ |

Ecole Flamande.

| No. des Feuilles | No. des Desseins | Sujet du Deffein | Forme du Deffein | Nom du Maitre | Date Chrono-logique | Notes |
|---|---|---|---|---|---|---|
| 666. | 756. | Un Saint Moine à genoux devant la Sainte Vierge, qui ___ l'enfant Jésus ___ ___ ___ qui est assis sur ___ nua, et ___ de plusieurs Glisad Anges, ___ ___ ___ ___ On apperçoit ___ ___ d'une le fond à gauche plusieurs Trophées d'armes. Ce Deffein qui est ___ par le haut, qui est librement ébauché à la plume, et lavé en partie à l'Encre de la Chine. ___ ___ ___ ___ | haut 11·6 11· | Antoine Van Dyck | né en 1600. | Ce dessein est un ouvrage original, mais il paroit être de quelque autre maitre, et non de Van Dyck. |

Ecole Flamande.

| No. des Feuilles | No. des Desseins | Sujet du Deffein | Forme du Deffein | Nom du Maitre | Date Chrono-logique | Notes |
|---|---|---|---|---|---|---|
| 669. | 756. | Un Saint Moine à genoux devant la Sainte Vierge, qui a auprès d'elle l'Enfant Jésus, et qui est assise sur des Nues, entourée de plusieurs Anges. On apperçoit dans le fond à gauche plusieurs Trophées d'armes. Ce Deffein qui est cintré par le haut, est librement ébauché à la plume, et lavé en partie d'Encre de la Chine. | haut 11·6 11· | attribué à Antoine Van Dyck | né en 1600. | |

52–53 Two versions of a design for the ducal historical inventories, corrected by Bartsch; next to them the corrected version recopied Graphische Sammlung Albertina, Archives

54    Adam von Bartsch, *Design for the frontispiece
in the portfolios of the Imperial Print Collection*
Graphische Sammlung Albertina

55    Adam von Bartsch, *Frontispiece for the portfolios
of the Imperial Print Collection collection, 1786*
Graphische Sammlung Albertina

to do is to send me an invoice for the prints which must be paid to him and Frauenholtz. I shall then compare the invoice with the duplicate which I have retained from the shipment of selected leaves sent to you. I shall pay the cost of importing this shipment directly to Nuremberg. I thought I had already returned the Derschau and Frauenholtz engravings to you but I learn from your letter that this is not so; therefore, the engravings will be sent off to Nuremberg today. However, I do not understand why you also require of me the list of the leaves retained here. Should you have misplaced it and not be able to find it, let me know of this so that I may have a copy sent to you. / Albert." [382]

As this letter shows, Albert consulted the opinion of a man who was probably the most distinguished and experienced contemporary connoisseur of prints to have his collection appraised and more particularly to draw up inventories (cahiers): [383] Adam von Bartsch (Fig. 15). [384] This has recently been confirmed through cahier designs bearing von Bartsch's corrections. [385] The version revised by von Bartsch was copied and implemented as the valid version (cf. Figs 52, 53). Since not enough archive material relevant to the issue has come to light, it is not possible to determine how many of Albert's inventory cahiers were drawn up by this method.

Adam von Bartsch (1757–1821), who studied the technical aspects of engraving at the Viennese Kupferstecherakademie, [386] produced a comprehensive body of prints. [387] He came to the Hofbibliothek as a Skriptor (publishing librarian) in 1777. From the outset he was committed to the copperplate engravings collection it housed and became Head Curator of it in 1791. In December 1783 von Bartsch went to Paris and the Netherlands to school his already practiced eye and to buy art. [388] During his travels he stopped at Brussels in 1784, where Albert had resided since 1780 as Governor of the Austrian Netherlands. It is not known whether they were already acquainted or whether this was their first meeting. In 1786 von Bartsch designed and made the plate for the frontispiece for the albums containing the Imperial engravings collection (Figs 54, 55). [389] He not only devoted a great deal of energy to enlarging the collection. He modernized it by implementing and further developing the systematic method of ordering devized by Jean and Pierre-Jean Mariette. [390] He also expanded and reorganized the art cabinet collection (Fig. 56). [391] While working at the Hofbibliothek, he also acted as a consultant to distinguished collectors. [392] Publications, [393] especially the 21 volumes of the scholarly standard work *Le Peintre Graveur* (between 1803 and 1821), ensured his standing as a distinguished specialist in the graphic arts.

Since Albert had returned to Vienna in 1795 to reside there permanently, von Bartsch, who, like Albert's bookbinder, Krauss, lived very near the ducal Palace, [394] had become the Duke's closest adviser and confidant in all that concerned acquisition and cataloguing. [395] Bartsch was presumably involved in a transaction agreed to by the Hofbibliothek in 1796, [396] when Albert desired to exchange some prints from his collection for particular drawings in the Imperial collections. Albert also admired von Bartsch as an artist. The connoisseur and engraver made numerous drawings and prints after works in Albert's art cabinet. [397] From 1804 von Bartsch's decorative covers (Figs 57, 58) adorned the coffins that contained the ducal drawings and prints (cf. Fig. 59). [398]

As meticulous and detailed as the letter quoted in full above, another from Albert to van Bouckhout dated October 31, 1795 deals with the careful checking of prints on offer from Dominik Artaria in Mannheim as well as Friedrich Frauenholtz and Baron Hans A. von Derschau in Nuremberg. In this second letter Albert focuses on a selection of prints and drawings by Francesco Bartolozzi, which the Viennese agent Joseph Friedrich van der Null[399] wanted to sell to him: "In the meantime I have seen the entire collection of works by Bartolozzi which a prosperous agent from here named Van der Niel [i.e. Null] has acquired, as he says, in London for 2,000 pounds sterling. It is astonishing and contains at least two-thirds again as many engravings as ours and, in addition, 60 or 70 original drawings ... and, since he now, with the excellent and complete collection which he already had of this Master's work, possesses two collections, he has offered to let me select from the latter the leaves which are missing in mine."[400] Albert's letter of February 12, 1796 to van Bouckhout again refers to the purchase of prints from the Frauenholtz and Artaria collections. It reconfirms that Albert always subjected the condition and price of work on offer to careful scrutiny before buying. In addition, it reveals that Albert was after complete and perfectly printed series. He kept prints of inferior quality in a portfolio of duplicates. Albert personally checked the mounting and labeling of his collection: "As for ... those we already have which are, however, mediocre or poor prints, send me those for the purpose of comparison ... I hope the mounted prints from the Italian School have arrived [in Brussels] in good condition. I shall gradually send back to you all the other leaves as soon as they have been mounted and labeled. Incidentally, you will find some small parcels in my chests of prints with prints— for the most part in small formats—which have not yet been mounted. I desire you to send these here, for, if I have similar ones here, I may see whether they can be arranged with those here and mounted on paper. I also desire you to send all the colored views of Vienna, Austrian and the Rhine you have ... from the series sold by Artaria, for, after I have completely bought up these sequences, I shall compare them with those there and set aside the poorer prints with the duplicates. Moreover, should there happen to be duplicates in the last shipment of portfolios with prints of the Italian School dispatched to Dresden, send me the poorer prints so that I may add them to the volume of duplicates which I have here. / Albert."[401]

A letter dated February 28, 1796 sent by Albert to van Bouckhout shows particularly well how thoroughly Albert had checked over what was on offer in auction catalogues. Whatever he bought had to satisfy several requirements. First, such works had to be exemplars not yet included in his collection if he was to pay higher prices for them. Second, the prints had to be of high quality and in perfect condition or, third, if they were not, they had to be cheap: "With reference to those [prints] which are marked in the catalogue, ... you should not bid much higher at auction except for those works which we do not yet have and which, in addition, are rare and fine or present in very good prints; and you should only take the others at a low price or let them go by, even if they are not yet contained in our collection."[402]

The same letter shows how much importance Albert attached to having his prints expertly mounted so that they were protected as

56   Adam von Bartsch, *Conclave of the Court Library Officials*
Graphische Sammlung Albertina

57   Adam von Bartsch, *Cover sheet for Duke Albert's drawings coffin*,
1804, Graphische Sammlung Albertina

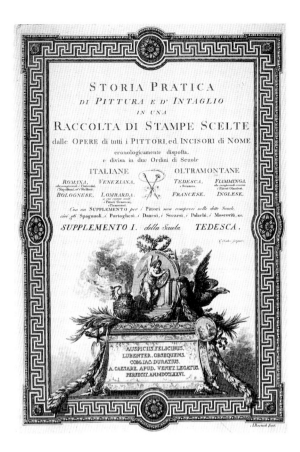

58 Adam von Bartsch
*Cover sheet for Duke Albert's prints coffin*, 1804
Graphische Sammlung Albertina

doubt whether you will find, with the exception of a few valuable items, much in it which will satisfy you. For this reason I only want you to purchase excellent works in good prints there; and do not want you to let yourself in for buying merely to complete our collection if the prints are not fine; or to take mediocre engravings from artists whose work we do not have; particularly not unless artists of considerable repute are concerned. Moreover, you will find the mark N B. next to some numbers in the catalogue indicating prints which I may already have here—good prints but rather expensive. You should, therefore, only buy if the prints are good [and if] you can purchase them at a very reasonable price … I am disinclined to buy as much of Wierix' work because we already have enough of it and, on the other hand, there is so much in these works which does not greatly enhance a collection. I am surprized that Herr Rost wants to send the entire collection of prints to us in Dresden. I do not agree with the purpose which may be behind this; however, it will in any case be of great benefit to you in making your selection. For my part, I am sending you, enclosed, a first list

far as possible: "If the engravings which I have sent back to you should have in part already become detached from the paper, such negligence, I believe, has affected chiefly those which were glued hastily here and not at the bookbinder's. Moreover, it should be noticed that the leaves with prints on the reverse were intentionally only glued at the corners of one side so that it might be easier to turn them and read [i.e. look at] them. Further, the engravings were in general only glued at the edges and without the paper being cut so that—should one want to do so—they may be exchanged more easily without being damaged; and the bookbinder here does not ask a higher price whether he glues them entirely or only at the edges."[403]

Shorter letters from Albert to van Bouckhout dated 12 March, 18 July and 29 July 1796 reconfirm how eagerly Albert set about acquiring missing drawings and prints to complete his collection.[404] These letters touch on contacts to agents mentioned above as well as to prints supplied by Karl Christian Heinrich Rost[405] of Leipzig. One should remember that Albert always had the last word on acquisitions and he instructed van Bouckhout to check potential acquisitions thoroughly in advance to ensure that quality was good and prices were reasonable. In a letter dated November 26, 1796 (Figs 60, 61), Albert reiterates these instructions: "I confirm to you, my dear Bouckhout, the reception of your letter of the 17th of this month and return to you at the same time the enclosed catalogue of the auction in Leipzig. To return once more to this, I

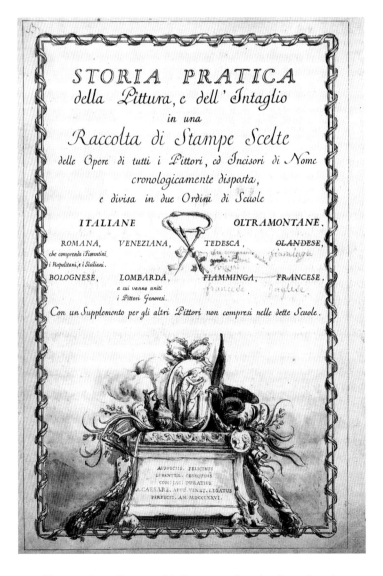

59 Giacomo Conte Durazzo (?), *First cover sheet for the 2nd version of the 'Discorso Preliminare'*, Graphische Sammlung Albertina

of leaves—nearly all of them fine prints—which I had already sel-
ected a year ago from a collection which was about to be sold; and,
since some of these works might already be in my collection in
Dresden, you will send to me those you consider as the same so that
they can be compared and, in any case, be exchanged. However,
you may keep this plan and make a clear copy of it so that, if the
opportunity of purchasing engravings arizes there, you can see
whether there are duplicates here and let me know the price; all the
more so since I have not yet made up my mind on the rather high
price which is asked of me here for said engravings …. The catalo-
gue of the Canova auction which is to take place in Dresden has
just been sent to me. From it I judge that you will hardly find any-
thing in it which would deserve to be added to our collection, with
the exception perhaps of a few handsome works by Marc Anton. In
the same vein, among the drawings I only find no. 1 of Ciro Ferry's
and no. 24 of Canova's which I would like to have, if they are not
too expensive." [406]

For the year 1796 letters from Albert to his agents are not the
only source to reveal how doggedly Albert went about enlarging
his collection. That is the only year for which the archives docu-
ment an increase in the number of drawings and do so with letters
from the highest authority recording some of the most valuable
additions ever to be made to the Albertina collection. The letters
exchanged in the matter are quoted below. At that time a wish
Albert had apparently cherished for quite some time came true (cf.
Fig. 62).[407] He was finally permitted to add drawings from the
Imperial Hofbibliothek to his collection. On 4 July 1796 the Pro-
vost (Präfekt) of the Hofbibliothek, Gottfried, Freiherr van Swie-
ten, wrote to the Chief Steward (Obersthofmeister), the Duke of
Starhemberg: "1796 / Your Grace, His Royal Highness, Duke
Albert of Saxe-Teschen has expressed the wish to me of receiving
some of the drawings which are in the Imperial Hofbibliothek in
exchange for copperplate engravings. Since, on the one hand, the
drawings present in the Library neither represent the necessary
sequence of celebrated Masters nor are particularly valuable in any
respect and, therefore, cannot be useful to exhibit nor use; since,
however, on the other hand each acquisition which adds greatly to
the grand and magnificent supply of prints is useful for the library
and to the public, for this reason, in my opinion, the request of His
Royal Highness might be granted without hesitation. In this matter
I petition Your Grace for permission. Vienna, July 4, 1796. Gott-
fried Frh Swieten." [408]

Starhemberg's petition addressed to the Emperor Franz two days
later on July 6, 1796 is also contained in the archives. It was granted
by the Emperor, who marked it with "Placet Franz" to show that
he approved it: "My very dear Sir! The Court Librarian Freyherr
von Swieten indicates in the enclosure His Royal Highness, the
Duke of Saxe-Teschen, has expressed the desire to exchange some
of the drawings kept in the Hofbibliothek for prints. Since he him-
self assures us at the same time that the drawings there are of no
particular value, however, that every addition to such a magnificent
collection of prints must be welcome to the Library and the public,

60–61    Letter from Duke Albert to Joseph van Bouckhout,
November 26, 1796, Graphische Sammlung Albertina, Archives

62  Page from an (unnumbered) purchase
inventory 'Artaria Compagnie 1784–1828'
Graphische Sammlung Albertina

therefore, in my opinion, the wish of His Royal Highness might be granted without hesitation, approval for which I petition Your Grace. Starhemberg Placet Franz Mpia [i.e. manu propria] / Vienna, July 6, 1796 [on the reverse]." [409] Again, two days later, on July 8, 1796 Starhemberg officially informed the Hofbibliothek that the exchange had been approved: "To … Court Librarian G. v. Swieten July 8, 1796. His Majesty has graciously approved the petition of His Royal Highness, Duke Albert of Saxe-Teschen, to exchange prints for drawings kept in the Hofbibliothek. In compliance with the report of 4th of this month, the Duke will be informed so that that he may accordingly accomplish the exchange in the proper manner." [410]

It certainly seems odd that the value of the drawings was thus downplayed so that copperplate engravings might be exchanged for them, especially since the celebrated Imperial collection of Dürer drawings was meant in the exchange of letters quoted above. Even at that time it was appreciated and valued for what it was. Both Benesch and Koschatzky suspected, and their line of reasoning is compelling, "that the Emperor Franz wanted to lavishly compensate the Duke for the disappointments he had suffered in his political and military career and for the loss of his collection … and this was then done in the grand official manner." [411] Albert really does seem to have expected an official gesture of reparation as his letter to Alexander von Seckendorff [412] of October 25, 1793 indicates: "Moreover, may I assure you that to date there has been no word of the merest thought of any preferential treatment or any other benefit which anyone has wanted to offer us to compensate in some way for the injustice we have suffered." [413]

It has been almost impossible to trace which drawings and how many of them were turned over to Albert in 1796 because records such as inventories of the drawings that changed hands [414] have not been available. Second, the sources are contradictory. [415] Drawings were not so systematically and comprehensively collected by the

Hofbibliothek as printed books, manuscripts and, later, copperplate engravings were. The early history of the Hofbibliothek is closely linked with Duke Albrecht III (1365–1395), the Emperor Frederick III (1440–1493) and the Emperor Maximilian I (1459–1519). Records show that Maximilian's collection of books included colored drawings and pen-and-watercolor drawings. [416] One-off prints made at that time from wooden blocks were glued into some manuscripts and printed works as frontispieces. Series of woodcuts, like the historical and allegorical *Triumphal Procession* and *Triumphal Arch* Dürer made for Maximilian or the illustrations for *Weißkunig* and *Theuerdank* were added to the library at that time. [417] From then until well into the eighteenth century, books and manuscripts continued to be acquired with a lavish hand although there are no records of drawings or prints being bought. Not until 1738, when the celebrated collection of books and prints owned by Prince Eugene of Savoy (1663–1736) was taken over by the Hofbibliothek as one of the largest and most valuable acquisitions in its history, [418] are there again records showing an increase in the number of drawings.

In his library, Prince Eugene had kept a collection of prints classified as *Imagines*. [419] It was arranged and catalogued according to the method developed by the Mariette family of Paris, who were booksellers, art agents and publishers. [420] Jean Mariette and his son, Pierre-Jean, contributed substantially to Prince Eugene's collection as collectors and connoisseurs of the graphic arts. In 1717 Prince Eugene bought a large number of prints from the Mariettes [421] and took Pierre-Jean, who arrived in Vienna with the first delivery, into his employ to arrange and catalogue them. They were arranged and inventoried on lines that were to prove groundbreaking: according to art regions, Schools, and, within these broader categories, chronologically by painters. Within this last group, the engravers are, in part, accorded the same status. Within the *œuvre* of each painter works were subdivided thematically into biblical, mythological and profane groupings. The traditional

63  Volume of engravings from the former collection of Prince Eugene of Savoy, Graphische Sammlung Albertina

system of arranging in subject areas[422] such as animals, plants, historic personages or events was also used. In addition, the collection was classified by techniques used. Nielli and chiaroscuro woodcuts were kept in separate volumes. The notes at the end of Prince Eugene's index volumes, which have proved invaluable for art historians, were jotted down during the collaboration of Pierre-Jean and his father. After Pierre-Jean had traveled in Italy between December 1718 and June 1719, buying for his patron on commission, he returned to Paris. From there he continued to act as an intermediary when Prince Eugene bought items for his collections. When Prince Eugene's copperplate engravings collection was taken over by the Imperial Library in 1738, it comprized, "according to the catalogue [drawn up by Etienne Boyet] 335 volumes".[423] Leaves with prints glued into showy red morocco leather bindings bearing the arms of the House of Savoy (Fig. 63) made up the bulk of the collection. By contrast, the drawings only filled 26 portfolios.[424]

The development and even composition of Prince Eugene's collection of drawings cannot be traced with any accuracy since no stamp was used to mark items in it.[425] The *Catalogus Librorum Bibliothecae*[426] does contain references to the *Imaginum Delineatar. Collectio*,[427] (Figs 64, 65) that is, to Prince Eugene's drawings collection. The references are, however, very sketchy.[428] It is worthy of note that the Italian drawings, which are listed first, are the only group to have been further subdivided.[429] However, neither the individual Italian and French leaves nor landscape drawings and "various items by different Masters" are more precisely defined. Parts of the collection as inventoried, such as representations of plants and birds, are today grouped in the Manuscript Section of the Österreichische Nationalbibliothek under *Codices Miniati*.[430] The actual size of Prince Eugene's collection can only be conjectured. Nevertheless, when one considers that only 26 *portefeuilles* of drawings are listed in the catalogue at the time it changed hands, it cannot have been very large. It undoubtedly "never attained the importance of the engravings collection."[431]

The Library and, from 1738, the Hofbibliothek prints collection continued to be enlarged from 1738.[432] The collection of drawings, on the other hand, is not again mentioned as growing until 1783. That year saw the incorporation of a number of manuscripts and books of drawings comprising the valuable collection once owned by the Emperor Rudolf II (1576–1612). It included a legendary nucleus of Dürer drawings from the Imperial Schatzkammer.[433] Later acquisition of drawings is only recorded in connection with the disbanding of the monasteries between 1765 and 1787, although the records are vague. The only specific reference for this period records that, during the time the monasteries were being disbanded, a total of 9,000 prints and drawings were incorporated in the Hofbibliothek.[434] The size and composition of the Hofbibliothek drawings collection at the time of the exchange requested by Albert of Saxe-Teschen can only be conjectured.

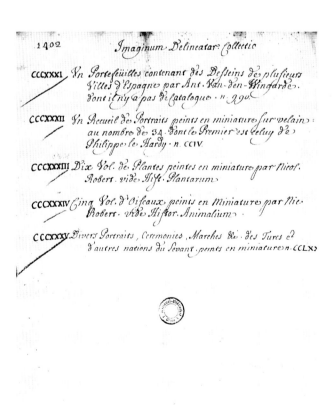

64–65  List of portfolios which belonged to Prince Eugene's drawings collection as *Imaginum Delineatar. Collectio*
Vienna, Manuscript Collection of the Österreichische Nationalbibliothek

66–67 Slip cases in which Duke Albert's historical drawings inventories (called cahiers) were kept (and are still to be found today) Graphische Sammlung Albertina, Historical Inventories

Further, it is not recorded how many of the leaves extant in the Library in 1796, nor of what type, were handed over to Albert or retained in the library. Nevertheless, the value and importance of this collection, regardless of the obviously manipulated evaluation recorded in the exchange documents, were undoubtedly immense. From the beginning[435] the Dürer drawings have always been treated in publications on the history of the Albertina Collection as the most important single acquisition and have been valued accordingly. Otto Benesch, however, was the first to find concrete evidence of their provenance.[436] The old inventory of Albert's drawings collection, which consists of handwritten inventory lists in volumes, called cahiers (Figs 66–68),[437] lists 144 drawings under the heading *Werke Albrect Dürers—This truly unique sequence like all other drawings of Albrecht Dürer's which are extant, comes, with the exception of a very few leaves, from the Imperial Hofbibliothek* (Fig. 69).[438] Among the best-known exemplars are world-renowned drawings like *Hare, Large Piece of Turf* and *Wing*

of a Blue Roller (Plates 4, 5, 6). In addition, Benesch called attention to 26 Rembrandt drawings which came from the Imperial Hofbibliothek[439] and, briefly, to German and Italian drawings[440] from there.

The following, hitherto overlooked, note in what are known as the Old Cahiers, makes it possible with absolute certainty to more than double the number of drawings which was recorded as having come into the Albertina collection from the Hofbibliothek: "This drawing is here marked with three asterisks, as in the following all those are thus marked which came from the Imperial Hofbibliothek, whence they were given; in the same manner other drawings from this collection for which His Royal Highness [Albert] gave engravings not present in the Imperial Library in exchange (Fig. 70)."[441]

The three asterisks (***) are the encoded general key to identifying the drawings which were taken over in the agreed from the Hofbibliothek in 1796. They appear altogether 468 times marking works from all schools in the Old Cahiers.[442] Not only the Dürer drawings are marked in this way. Important works by Rubens,

68   Title page of first volume (Sc. Rom. Vol. I) of Duke Albert's historical drawings inventories (called cahiers) Graphische Sammlung Albertina, Historical Inventories

Rembrandt and Van Dyck (Plates 2–9, 26, 31, 32, 34) also bear the three asterisks, exemplifying the range of important masterpieces of this provenance.

Close study of the Old Cahiers has turned out to reveal not only straightforward, uncoded provenance data for the drawings that entered the collection in 1796.[443] Other combinations of asterisks identify three further sources from which Albert obtained large numbers of works. The system works as follows. One asterisk (*) stands for the sheets from the collection of Charles Antoine de Ligne (1759–1792),[444] which, according to a Cahier note dated November 4, 1794 came into Albert's possession at the Viennese auction of the de Ligne collection: "This drawing was, successively, in the Crozat and Julien de Parme collections. It was last sold at the auction of the estate of Prince Charles de Ligne, like the other drawings from that collection which are marked in this catalogue in the following with one * (Fig. 71).[445] The system of using a specified number of asterisks has made it possible to identify approximately 800 drawings in Albert's collection acquired from the estate of the Prince de Ligne. The bulk of these, comprising more than 400 entries, are Italian: drawings by Leonardo, Michelangelo, Raphael (Plates 12, 14–17) and—from other regional Schools—by Poussin and Lorrain (Plates 25, 37) are among the most famous. More drawings acquired by Albert for the Italian and Netherlandish sections (Schools) have been identified as from the de Ligne collection by means of thorough study of the auction catalogue.[446] The previously known total for these last has been more than doubled by the addition of over 1,700 sheets.

Two asterisks (**) are the symbol for the drawings which Albert acquired from the art collection owned by the Dutch merchant and artist Cornelis Ploos van Amstel (1726–1798)[447] when it was sold in Amsterdam on March 3, 1800. Their provenance is explained and assured by the following note: "This drawing, like all those which in the following are marked with two **, was bought at the auction of Herr Ploos van Amstel's collection (Fig. 72)."[448] The sequence of two asterisks has been counted over 160 times in the Old Cahiers; some 140 of these entries refer to Netherlandish works. Drawings by Hendrick Goltzius and Cornelis Hendricksz Vroom (Plates 20, 33) attest to the quality and importance of the drawings from the Ploos van Amstel cabinet.

Four asterisks have, oddly enough, only been accounted for twice[449] and without an explanation decoding them. Finally, five asterisks attest to the provenance of drawings from the collection owned by the Leipzig banker and councilman Gottfried Winckler (1731–1795).[450] In the latter case the provenance is decoded as follows: "This drawing and the others marked with five * come from the collection of Herr Winckler of Leipzig (Fig. 73)."[451] In the Old Cahiers the provenance of 738 drawings has been accounted for by means of this asterisk sequence. The ducal inventory does not reveal when and on which occasion(s) Albert acquired this collection, which boasts a nucleus of over 300 Netherlandish drawings. However, a letter dated June 14, 1819 from the Leipzig writer on music, Johann Friedrich Rochlitz (1769–1842), attests that Winckler relinquished drawings to Albert at a "sale".[452] As Winckler died in 1795, the drawings must have changed hands before that date.[453] Since the catalogue entries are very brief, it is not clear whether Albert also bought anything, and if so, how many items, at

69   Title page of the historical inventories (called cahiers) of the Dürer drawings (Sc. Tedes. Vol. II)
Graphische Sammlung Albertina, Historical Inventories

the 1815 auction of Winckler's drawings collection in Leipzig.[454] Among the finest works from the Winckler cabinet are drawings by Rubens, Rembrandt, Allart van Everdingen, and Jan van Huysum (Plates 27, 30, 35, 40).

The discovery of the system of using asterisks as symbols and the decoding of what they mean has greatly advanced knowledge of the provenance of the ducal drawings. In addition, the time and manner of acquisition have been assured in three cases.

The additions to Albert's collection marked in this manner are among the few later made whose provenance and date of acquisition is assured. In Albert's later life there are only sparse records of dated offers of sale or acquisitions of drawings or prints. In a letter dated 26 January 1798 to van Bouckhout in Dresden, Albert repeatedly points out emphatically with reference to prints listed for sale at auction by Friedrich Frauenholtz that he is only interested in "items of good quality and reasonably priced."[455] A letter from Albert dated October 6, 1806, addressee unknown, reveals

## École Romaine. (70)

| No. des Deffeins | Sujet du Deffein. | Forme du Deffein. | Nom du Maitre. | Date Chronologique. | Notes. |
|---|---|---|---|---|---|
| | Étude pour un grand Tableau. Le Deffein est composé de neuf figures d'hommes nuds en différentes attitudes qui semblent être en querelle. On voit en effet à droite un homme animé et criant, ayant en main un Stilet ou autre arme, il est retenu avec force par deux autres, son pied gauche est posé sur une pierre quarré qui se trouve derrière lui, à ses pieds est couché un homme mort renversé sur le côté, et derrière celui là est un autre à genoux qui semble tomber en avant, et qu'un troisième soutient avec peine, à gauche il y a trois hommes debout qui par leurs attitudes semblent être plutôt spectateurs attentifs de la Rixe, que d'y prendre une | haut 10-3 15-6 | Antoine dit del Pollajuolo | né en 1426. | ✳✳✳ Ce Deffein est marqué ici de trois ✳✳✳ ainsi que le seront à la Suite tous ceux qui ont été reçus de la Bibliothèque Impériale et Royale, d'où ils ont été donnés ainsi que d'autres Deffeins venant de cette Collection, pour lesquels Son A. R. a fourni en revanche à la Bibliothèque de Sa Majesté des Estampes qui manquaient dans celle là. |

## École Romaine. (71)

| No. des Feuilles | No. des Deffeins | Sujet du Deffein. | Forme du Deffein. | Nom du Maitre. | Date Chronologique. | Notes. |
|---|---|---|---|---|---|---|
| 34 | 39 | La Sainte Vierge assise tenant sur ses genoux l'Enfant Jésus qui tient une de ses mains, et qu'elle contemple avec complaisance. Deffein rare, hardiment fait à la plume et rehaussé de blanc au pinceau sur papier passé d'une teinte grise. | haut 6-6 4-9 | Philippe Lippi | né en 1400. | Ce Deffein a été successivement dans la Collection de Mr. Crozat et de Julien de Parme. Il a été acheté en dernier lieu à la vente de celle du feu le Prince Charles de Ligne, ainsi que les autres Deffeins de cette collection que l'on trouvera marqués d'un ✳ dans la Suite de ce catalogue. |

## École Flamande. (72)

| No. des Feuilles | No. des Deffeins | Sujet du Deffein. | Forme du Deffein. | Nom du Maitre. | Date Chronologique. | Notes. |
|---|---|---|---|---|---|---|
| | | Notre Seigneur monté sur une ânesse suivi de ses Disciples, faisant son Entrée en Jérusalem, en donnant la Bénédiction au Peuple. On remarque un homme étendant un Drap sur son passage. Deffein fort ancien fait avec soin à la plume sur papier jaunâtre. | haut 6-8 2 | Ancien Maître Flamand inconnu. | | ✳✳ Ce Deffein, ainsi que tous ceux qui ci après sont marqués du deux ✳✳ ont été achetés à la Vente de la Collection de Mr. Ploos van Amstel. |

## École Flamande. (73)

| No. des Feuilles | No. des Deffeins | Sujet du Deffein. | Forme du Deffein. | Nom du Maitre. | Date Chronologique. | Notes. |
|---|---|---|---|---|---|---|
| | | Le Portrait d'une jeune Dame, représentée à mi corps, elle a un chapeau orné de plumes en tête, tient une petite fleur dans la main droite, et autour du Col un fil auquel sont attaché les Lettres NIT ANV. Deffein remarquable par sa Vétusté, il est contourné à la plume soigneusement lavé à l'encre de la Chine, et relevé de blanc au pinceau sur du papier grisâtre. On l'a attribué à Luc de Leyde, dont cependant il ne paroit pas être l'ouvrage. | haut 16-4 12-3 | Ancien Maître Flamand. | | ✳✳✳✳ Ce Deffein et les autres marqués de 5 ✳ viennent de la Collection de Mr. Winkler de Leipzig. |

that he returned an unspecified batch of drawings but wanted to keep some sheets in Vienna for closer inspection.[456] On November 3, 1810 Albert's Mannheim art agent, Dominik 11 Artaria,[457] is voluble on the quality of "a manuscript missal of the Virgin with approximately 8,000 miniatures of as consummate beauty and workmanship … as any extant anywhere in the world."[458] However, there is no record of Albert's having bought the work thus praised. In a letter dated December 15, 1810 Albert refused the offer of prints made by a M de Taubé.[459] Carl, Count Rechberg wrote on March 30, 1818 that he, as the intermediary of the publishers St. Auber, rue St. Lazare, Paris, had 25 Carl Wernett drawings that might be of interest to Albert.[460] Moreover, although it is recorded that Albert provided artists with both moral and financial support,[461] only two instances of his having bought contemporary works are assured. Jakob Gauermann noted in his sketchbook and diary, begun in 1798, that he had received "for a landscape (Amor and Psiche [sic] with Pan) 30 f. from Duke Albert in Vienna" on August 28, 1799 (Figs 74–75).[462] Johann Evangelist Scheffer von Leonhartshoff noted in his diary on March 15, 1819: "During that time I made several drawings of my invention, one of which Duke Albert of S:T: bought for ten ducats."[463]

The sources mentioned above are for the most part precisely dated. Consequently, it has been possible to discuss them in chronological order. From these assured sources it has been possible to reconstruct the development of Duke Albert's collection within a specific time framework. More authenticated data on acquisitions, albeit chronologically not fixed, are available, primarily for the drawings, again from notes in the Cahiers and, further, from the impress of the collection stamp.[464] Study of old auction catalogues has also led in several cases to the identification of individual works which found their way into Albert's collection. In addition, there are even mentions or clues on the reverse of drawings or on the cardboard on which they are mounted. The conclusions to be drawn from all these data gleaned in various ways point either to owners just before Albert and/or they trace a longer chain of provenance.[465]

74    Jakob Gauermann, *Diary, 1789*, page 42 verso
Penultimate entry: d[en] 28 August 99 für eine Landschaft (Amor und Psiche bey Pan) v[on] Herzog Albert in Wien empfang[en] 30. f. – (Cf. Fig. 75), Graphische Sammlung Albertina

70    Page from the historical inventories referring to the meaning of three asterisks in identifying provenance (i.e.: Vienna, Kaiserliche Hofbibliothek, 1796), Graphische Sammlung Albertina, Historical Inventories

71    Page from the historical inventories referring to the meaning of one asterisk in identifying provenance (i.e. : Prince de Ligne, 1794), Graphische Sammlung Albertina, Historical Inventories

72    Page from the historical inventories referring to the meaning of two asterisks in identifying provenance (i.e. : Ploos van Amstel), Graphische Sammlung Albertina, Historical Inventories

73    Page from the historical inventories referring to the meaning of five asterisks in identifying provenance (i.e. : Gottfried Winckler), Graphische Sammlung Albertina, Historical Inventories

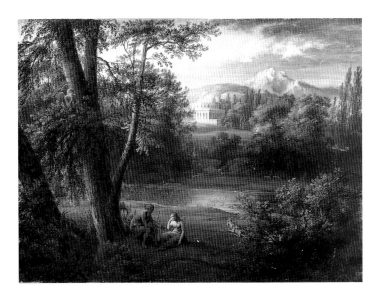

75    Jakob Gauermann, *Landscape with Psyche, Cupid, and Pan*
Graphische Sammlung Albertina

When tracing provenance from contemporary collections, one should keep mind that, during the eighteenth century, the middle classes rose to a new eminence in many European countries. Consequently, a new class of collector gradually grew up to join the aristocracy in the pursuit of art.[466] During the closing years of the eighteenth century and the early nineteenth century this development was brought to a head by the violent political and social upheavals accompanying the French Revolution: "At the turn of the century … looting of castles [and] disbanding of monasteries brought a great deal of movement to old collections. The dissolution of valuable [cabinets] led to active collecting in bourgeois circles. Since the number of auctions increased from year to year, numerous collections [were created] in all [European] capitals."[467] Albert of Saxe-Teschen, for one, benefited from the volatility of the art market as a consequence of the political and social unrest "which forced many people to flee … [and to] liquidate countless estates."[468] As Franz Rechberger was to point out not long after Albert's death: "Connoisseurs … realize … that this collection was not merely the result of vast sums lavished on it but was … so to speak, the distillation of various famous collections, the dissolution of which was brought about by the condition [of the times]."[469]

With only a very few, notable exceptions, it is virtually impossible to determine where Albert bought his prints.[470] However, the provenance of the drawings can be traced in about 20 to 30 percent of all cases. Since most verifiable references to provenance are to French collections, one may assume that Albert bought most of his drawings in France. Between 1770/80 and 1822, when he was building up his collection, numerous reputable collectors and agents were active in Paris.[471] Moreover, Paris, like London, led the market in sales of drawings at auction during the period in question.[472] Works in Albert's collection which can be verifiably traced come from the Charles Antoine de Ligne collection discussed above as well as the cabinets of Julien de Parme, the Marquis de Lagoy and Jean-Denis Lempereur.[473]

Many renowned cabinets of drawings were established in England, too, during the eighteenth century. Scions of noble or rich bourgeois families were not the only Englishmen to go on the "Grand Tour" to Europe and Italy, in particular to imbibe culture and complete their education. English artists did the same.[474] As contemporary accounts of such travels record,[475] trade in valuable antiques as well as paintings, drawings and prints flourished in Rome, Florence, Venice and Bologna. Visitors to Italy, first and foremost traveling Englishmen, bought art for their own collections and at home acted as intermediaries in sales on a grand scale.[476] Although Albert did not acquire as much from English collectors as he did from French sources, contemporary English collections are known to have contributed to his. The most important of these include those of the painters Nathaniel Hone, Thomas Hudson, Sir Joshua Reynolds and Charles Rogers.[477] He may also have acquired works through the numerous auctions of drawings held in London.[478]

By contrast, the provenance of only a few works acquired by Albert can be traced to contemporary collections in the Netherlands, apart from drawings owned by Cornelis Ploos van Amstel.[479] From the lists of art cabinets Albert intended to visit on his travels in 1781,[480] one can assume that Albert was well in-formed on art-market trends and collections throughout the Netherlands, especially during his tenure as Governor in the Austrian Netherlands. The art auctions held in Amsterdam should also be mentioned in this connection. Between 1780 and 1822, numerous particularly large collections of drawings were sold at auction there.[481] On the other hand, relatively few works in Albert's collection can be traced to Italian, German and Austrian collections. This leaves French collections as his most important source, followed by England and the Netherlands. Verifiable sources for several works acquired by Albert are the collections of the Commendatore Genevosio of Turin and the above-mentioned Winckler of Leipzig.[482] Albert is recorded as having bought drawings in bulk from the widow of the artist Christian Wilhelm E. Dietrich.[483] There are also a few scattered references to the cabinets of Wilhelm G. Becker in Dresden, Johann F. Richter in Leipzig and Johann F. Frauenholtz of Nuremberg.[484] Although there is no record of provenance for specific works, links were established with the artist and collector Johann C. Klengel of Dresden. Albert was also in contact with Karl C. H. Rost, a Dresden art agent.[485] In Vienna, the Chancellor of the Exchequer, Wenzel, Duke Kaunitz (1711–1794), was publicly committed to promoting enlightened cultural policies, especially in the fields of scholarship and the arts.[486] His circle included "Joseph Freiherr v. Sperges, Joh. Melchior Edler v. Birkenstock, … Paul Anton v. Gundel, … the Duke of Saxe-Teschen, … Prince Carl Joseph von Ligne and other noble and cultured connoisseurs."[487] Many of these men were also Freemasons.[488] As Meder has pointed out, "Vienna … was the right place to promote Albert's passionate commitment to art on a grand scale. Trade and a fluid market furthered stimulating contacts with like-minded connoisseurs and competitors who encouraged fair and friendly rivalry in the same good cause. Above all, there were collections on similar lines which were instructive and promoted comparison and exchange."[489] Among these were the collections owned by Duke Esterházy, a patron of the arts, the Duke of Liechtenstein and Moriz, Count Fries. Nikolaus II, Duke Esterházy (1765–1833), whose art collections were assembled from his castles and transferred to the Viennese Stadtpalais,[490] owned "a picture gallery comprizing more than a thousand paintings … 3,500 drawings and 50,000 prints."[491] There are no records showing that Albert of Saxe-Teschen, who had been in contact with the House of Esterházy since his Pressburg days,[492] ever exchanged works with them or received any as presents. The Dukes of Liechtenstein were also important patrons of the arts and collectors.[493] The valuable art collections owned by the House of Liechtenstein included a print collection which was kept in Vienna. It included not only copperplate engravings but also an important collection of drawings. Although the size and arrangement of this collection can only be conjectured,[494] Albert did own some works from it.[495] Valuable works Albert owned, including some 200 Italian drawings alone (e.g. Plate 36) can, on the other hand, be traced back to the cabinet of Moriz, Count Fries (1777–1826).[496] His palace in Josephsplatz figured prominently in the Viennese art world in the late eighteenth and early nineteenth centuries. Finally, drawings owned by the Viennese diplomat and man of letters Johann Melchior Birckenstock[497] and the Artaria family of art dealers[498] also found their way into Albert's collection.

The provenance of works in the collection can, therefore, be traced to contemporary collections and through notes in the Cahiers, the impress of stamps on items in the collection and auction catalogues (this holds again mainly for the drawings).[499] In addition, earlier owners, primarily in France but also in England, Italy, the Netherlands and a few isolated instances from the German states are verifiable.[500] It is particularly interesting to trace the provenance of works that entered Albert's collection via several owners, sometimes in immediate succession. Chains of provenance of this type include the Crozat—Mariette—d'Argenville—Gouvernet—Julien de Parme—Prince de Ligne[501] set of records as well as Crozat—Calvière—Lempereur—St. Morys—Julien de Parme and Mariette—Destouches—St. Morys. In England, Jonathan Richardson the Elder—Thomas Hudson—Sir Joshua Reynolds is the chain most commonly established.[502] Incidentally, chains of successive ownership are rare in this collection although the provenance of certain drawings, especially those by the most celebrated artists, can be traced without gaps all the way back to their progenitors. Notably the Dürer drawings went from the artist's heirs to the collection of the Emperor Rudolf ii, then to the Imperial Schatzkammer and, in 1783 to the Viennese Hofbibliothek before being exchanged for prints in Albert's collection in 1796 (e.g. Plates 4, 6).[503] Raphael drawings went via his contemporary Timoteo Viti to the Antaldi family in Urbino and then, in the early eighteenth century, to the Crozat collection before following the pattern outlined above: Mariette (or Gouvernet)—Julien de Parme—Prince de Ligne and, finally, Albert of Saxe-Teschen (e.g. Plate 14). One of the earliest and most splendid chains of provenance can be traced without interruption back to the collection built up in England by the Duke of Arundel. Others can be traced back to the French collection of drawings amassed by Everard Jabach, the cabinet owned by Paulus ii Praun of Nuremberg and the Italian collections of Giorgio Vasari (Plate 13) and Sebastiano Resta.[504]

The drawings Albert of Saxe-Teschen personally acquired bear, with rare exceptions,[505] the impress of the stamp he used for his collection (Figs 76, 77). The prints in it, however, were not stamped with Albert's seal, perhaps because there were so many of them. Albert may well have designed the seal himself. A drawing from his own hand (inv. no. 25,791) shows that he was using this monogram in 1819. (Figs 78, 79) It has not been ascertained whether the stamp was already in use during his lifetime or whether the drawings were not thus marked until the inventory which was drawn up after his death in 1822. What is recorded, however, is that the stamp was to be destroyed after that inventory had been completed.[506] This impressive and highly decorative signet of ownership (p. 24, Fig. 80) also adorns in gold tooling the spines of the red morocco leather bindings in which Albert's prints were bound (Fig. 81) and the bindings containing the inventory lists of both the print and drawings collections (p. 24)[507] as well as various other volumes in his library (Fig. 82). Albert kept the drawings in other coffins (p. 24). When he began doing so cannot be determined but the practice presumably dates from some time in the 1790s.[508] In the course of research for the present book, it became possible to identify the coffins in which the drawings were kept as the work of the Viennese bookbinder Georg Friedrich Krauss (Fig. 83).[509]

76  Impress of Duke Albert's seal (enlarged)

77  Seal used by the Graphische Sammlung Albertina

The drawings and prints in Albert's estate can be divided into the major European art regions as follows. Five groups of drawings and six main groups (termed Schools in this system) of prints were subdivided into an Italian (comprizing Roman, Venetian, Bolognese and Lombard) section. There were also German, Netherlandish and French sections as well as a miscellaneous section for all those that did not fit into the others.[510] The prints also had an English grouping. Chronologically the collection spanned the period from the closing years of the fourteenth century[511] to 1822, the year Albert died. Within the Schools, works were ordered chronologically by artist.[512] Two systems were used concomitantly when the inventory was drawn up. First, the sheets of cardboard on

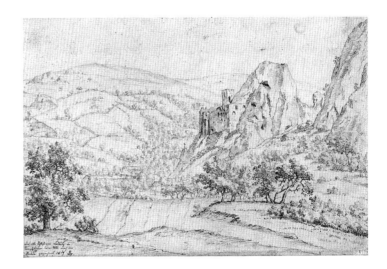

78  Albert of Saxe-Teschen, *The old castle at Lednitz*, 1819
Graphische Sammlung Albertina

79  Detail of Fig. 78 showing Duke Albert's monogram AS (enlarged)

80   Duke Albert's monogram, detail of Fig. 81

81   Original coffin for Duke Albert's print collection
Graphische Sammlung Albertina

which one (or more) original(s) were mounted were systematically numbered by No. de' Foglii or No. des Feuilles. Second, the individual drawings or prints received, respectively, a No. des Desseins or a No. delle Stampe (cf. Figs 71–73). The inventory numbers began with no. 1. However, continuous inventory numbers were not given at that time.[513]

The entailment (*fideicommissum*) inventories drawn up from 1822 (p. 22, Figs 31–33)[514] give an overview of which art regions were represented in Albert's cabinet and the ratio of the number of drawings in each School to the whole. His drawings collection comprised some 13,600 sheets. Here the German School was most strongly represented with about 3,700 sheets, followed closely by the Netherlandish School with some 3,300 inventory entries. The French School comprised roughly 1,900 works and the Miscellaneous Section about 1,300. Quite a few ascriptions have changed as scholarship has advanced. However, this has usually happened within the framework of a particular School. Therefore the weighting of individual Schools within the collection has remained basically the same as it was in Albert's day.

The ducal prints collection presumably comprised some 200,000 leaves,[515] at least as far as the sources allow conclusions to be drawn.[516] Here the Italian School was better represented than the others, followed by the German and, almost level with it, the French and Netherlandish Schools. The rest of the prints were assigned to the Miscellaneous Section and there was also a smaller English grouping of prints.

The number of drawings and prints from the various countries and periods also roughly reflects proportionately the overall art production in those regions at each period represented in the ducal collection. Moreover, the number of sheets ascribed to each of the artists active at any time represented corresponds as a rule to the place taken by their work in the overarching art historical context.[517]

The developmental survey of the arts which Albert undertook to create with his collection is so impressive because it is both comprehensive and dense. Viewed as a whole, the number of late medieval and Early Renaissance drawings in the collection is proportionate to the number of extant sheets from these periods. This means that they represent a relatively small part of the ducal collection.[518] The bulk of Albert's collection consists of drawings and prints dating from the sixteenth to the eighteenth centuries and the early nineteenth century. The currents in art of these periods are admirably covered. The High Renaissance and Mannerism are particularly well represented in the Italian and Netherlandish Schools. The collection of seventeenth and eighteenth-century works is astonishingly wide-ranging and complete in its coverage of all the important art regions, that is, the German, Netherlandish, Italian, and French Schools.[519] Less complete and focused is the representation of both trends and regions between 1800 and 1822, the year Albert died. On the one hand, work by many distinguished German and Austrian art of this period is missing from the collection. So are quite a number of famous names in French art of the time.[520] On the other hand, the inference must surely be that Albert's selection for this period as a whole tends to reflect his personal preferences, which are shown in a wide range of work by lesser-known *Maîtres Modernes* (Fig. 84).[521] The English School, however,

which comprizes only about 70 sheets, was not at all well represented in Albert's collection.[522] The fragmentary coverage of this important field and in particular the at best sparse representation of its groundbreaking exponents of modern landscape painting, a genre which Albert otherwise obviously appreciated,[523] may well reflect the contemporary Continental response to English art in general.[524]

Albert's collection includes all genres, usually in a direct ratio to their spread in any particular period in the wider European context. More particularly, there is a strong concentration, well in excess of the contemporary values as a whole, in the sector of landscape or topography. Here seventeenth-century Dutch drawings and prints and nineteenth-century German and Austrian works are noticeably well represented. Perhaps here too, as well as in a marked preference for closed, meticulously rendered compositions, we can once again recognize Albert's personal taste.

82   Duke Albert's monogram on the spine of Adam von Bartsch's, *Le peintre graveur*, vol. IV, Vienna 1805
Graphische Sammlung Albertina

83   Bookbinder inscription 'Krauss' as it appears on some spines for drawings in the archducal collections, Graphische Sammlung Albertina

84   Title page of Duke Albert's inventory sheets for drawings by contemporary artists (*Maîtres Modernes*)
Graphische Sammlung Albertina, Historical Inventories

As has been pointed out, the collection reflects the ideals of universality and educational value originally laid down by Count Durazzo.[525] Albert's idealism and commitment to high standards ensured that they were admirably put into practice. His aim was not merely to represent particular periods of art history. Nor was he after work by an élite of celebrated artists or even rare collector's items. His selection criteria and acquisitions policy had as their objective the amassing of a complex whole, which was also to feature the work of the great Masters when and if the rank of work on the art market and the asking price for it met his exacting standards. The collection assembled by Duke Albert of Saxe-Teschen is one of the most important, both in respect of quality and encyclopedic completeness, not only of its creator's time but of any period from which collections are known.[526] In essentials the collection

has retained its original structure and content. It has, of course, been added to and some sections have been expanded:[527] from 1822 to 1857 by Archduke Charles of Austria, from 1847 to 1895 by Archduke Albrecht and, from 3 April 1919 by a succession of directors of the Albertina. The later acquisitions consist primarily in drawings and prints representative of prevailing currents in art at the time they were added to the collection. The Archdukes Charles and Albrecht bought mainly drawings by their German and especially Austrian contemporaries and Old Master prints (Plates 10, 29, 48, 51).[528] However, since none of Albert's successors insisted on systematic collecting with completeness in mind as he had, noticeable gaps arose in the nineteenth century[529] which were not closed until later and then not entirely.[530]

When Archduke Frederick entered on the entailment in 1895,[531] he inaugurated the open-ended system of cataloguing the drawings with consecutive inventory numbers which have continued on down to the present (Fig. 40).[532] Meder strongly influenced Frederick's acquisition policy, gearing it towards Austrian and German as well as some nineteenth and twentieth-century French and English work.[533] Moreover, Frederick and Meder bought more drawings and fewer prints from earlier periods than had the Archdukes Charles and Albrecht.[534] Unfortunately, nearly all these latest acquisitions "were lost to the collection ... since, when it was taken over by the state of Austria ... they [were] not incorporated in the entailment [and, therefore,] were not given back to their owner."[535] As a result, only the roughly 1,400 drawings and 1,000 prints added to the Albertina collection after April 3, 1919 during Meder's tenure, which lasted until late in 1922 (Plates 18, 38, 60, 66, 67), are all that remain of what was acquired by Frederick.[536]

The sale of duplicates[537] financed the numerous and varied acquisitions made between 1923 and 1934, when Stix was Director of the Albertina (Plates 1, 21, 23, 42, 45–47, 54, 58, 59, 62–65, 68, 69, 74).[538] Stix astutely concentrated on adding what was deemed necessary to completing the collection of Italian drawings

of the fifteenth to the eighteenth centuries.[539] Moreover, he acquired nineteenth-century French drawings, which, prior to his tenure, had represented a gap in the collection,[540] as well as nineteenth and twentieth-century Austrian, German and French prints and drawings.[541] Stix also succeeded in rounding out the sixteenth-century German and Baroque Austrian drawings collection.[542] With the acquisition of the Viennese Artaria Collection in 1936, a great many more of the latter as well as South German works came into the collection.[543] A large number of Italian works executed after 1914 were also added.[544] In the years between 1934 and the end of the Second World War, the acquisitions policy pursued by the Albertina continued to focus primarily on German and Austrian nineteenth and twentieth-century drawings (Plates 44, 52, 56, 57, 61, 71)[545] and prints from Austria and neighboring countries. Inventory work on Old Master prints continued throughout the second quarter of the twentieth century but virtually no new acquisitions in this area were made during that period.

Even after 1945 acquisitions policy continued under successive Albertina directors to focus on Austrian art. The magnificent collections of Rudolf von Alt, Gustav Klimt, and the Expressionists Egon Schiele and Oskar Kokoschka in the Albertina were acquired by Otto Benesch. He also added Old Master drawings and an important body of work by the classic Moderns which is international in scope (Plates 11, 49, 55, 70, 76, 77).[546] Walter Koschatzky's acquisitions policy concentrated on the nineteenth and twentieth centuries, with a special focus on nineteenth-century drawings and watercolors (Plates 50, 53, 75, 78, 81, 82, 85).[547] In addition, both Benesch and Koschatzky were committed to a policy of making the Albertina collection broadly representative of the diverse movements that emerged on the international art scene after 1945. Their commitment to this sector has been actively furthered by the current director, Konrad Oberhuber, who has stepped up the acquisition of work by an international array of contemporary artists (Plates 72, 73, 79, 80, 83, 84, 86).[548]

# COLOR PLATES

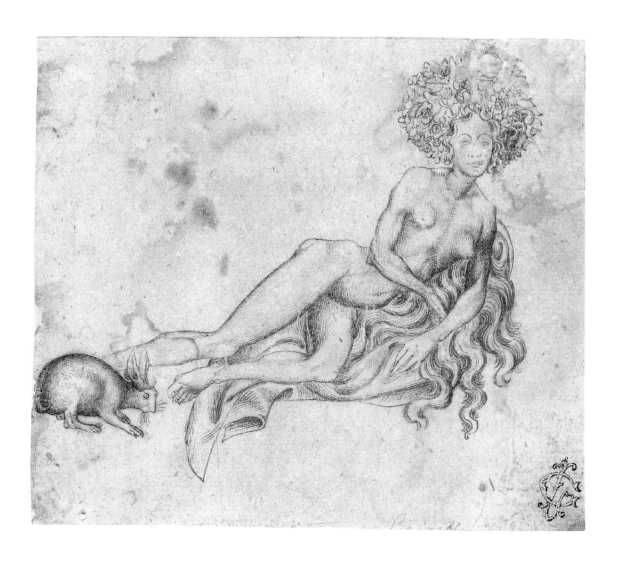

1   PISANELLO (ANTONIO PISANO)   1395–1455
*Allegory of Luxury.* Acquired under Alfred Stix

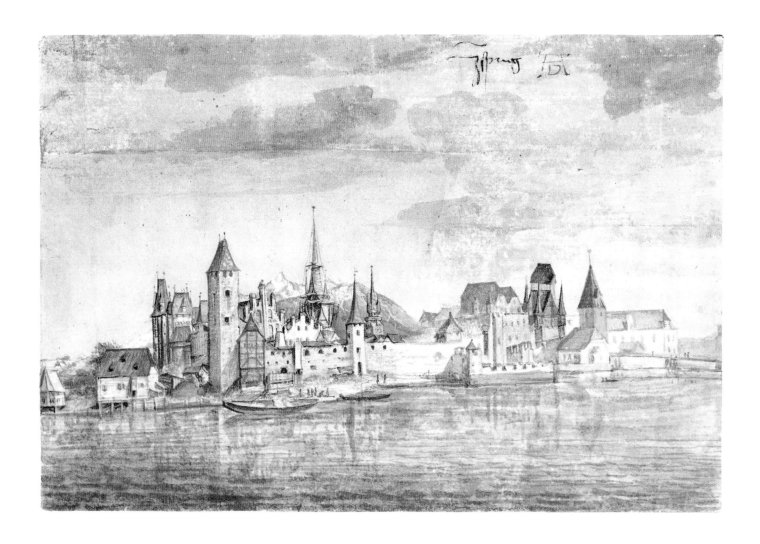

2  ALBRECHT DÜRER  1471–1528
*Innsbruck*. Acquired by Duke Albert

3  ALBRECHT DÜRER  1471–1528
*Mary with a Multitude of Animals*. Acquired by Duke Albert

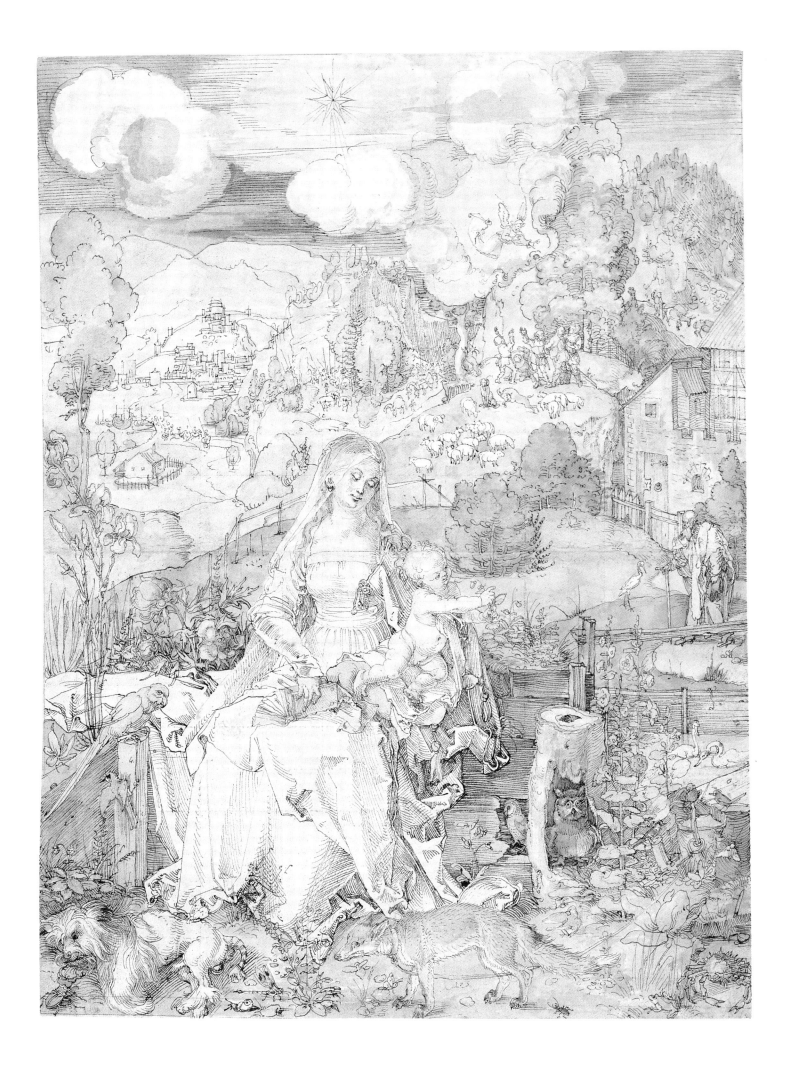

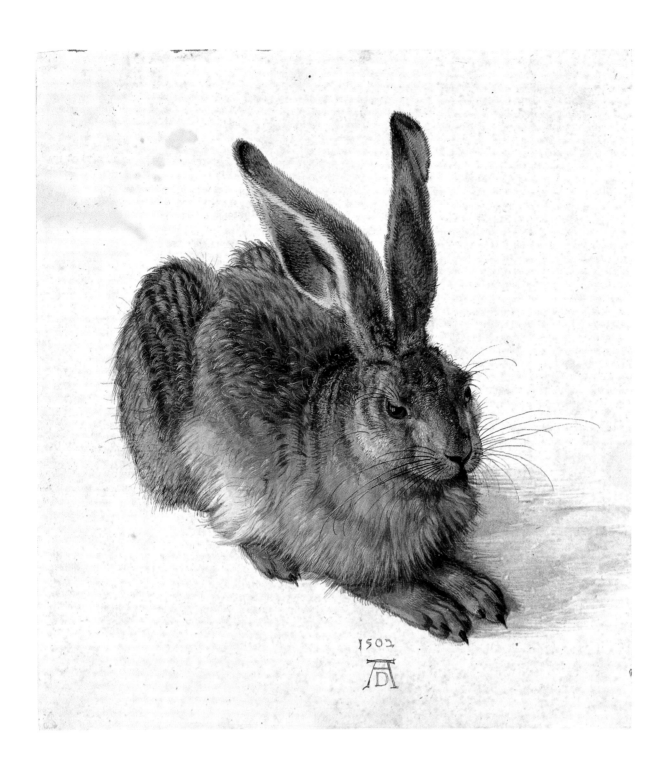

4   ALBRECHT DÜRER   1471–1528
*Hare*, 1502. Acquired by Duke Albert

5   ALBRECHT DÜRER   1471–1528
*Large Piece of Turf*, 1503. Acquired by Duke Albert

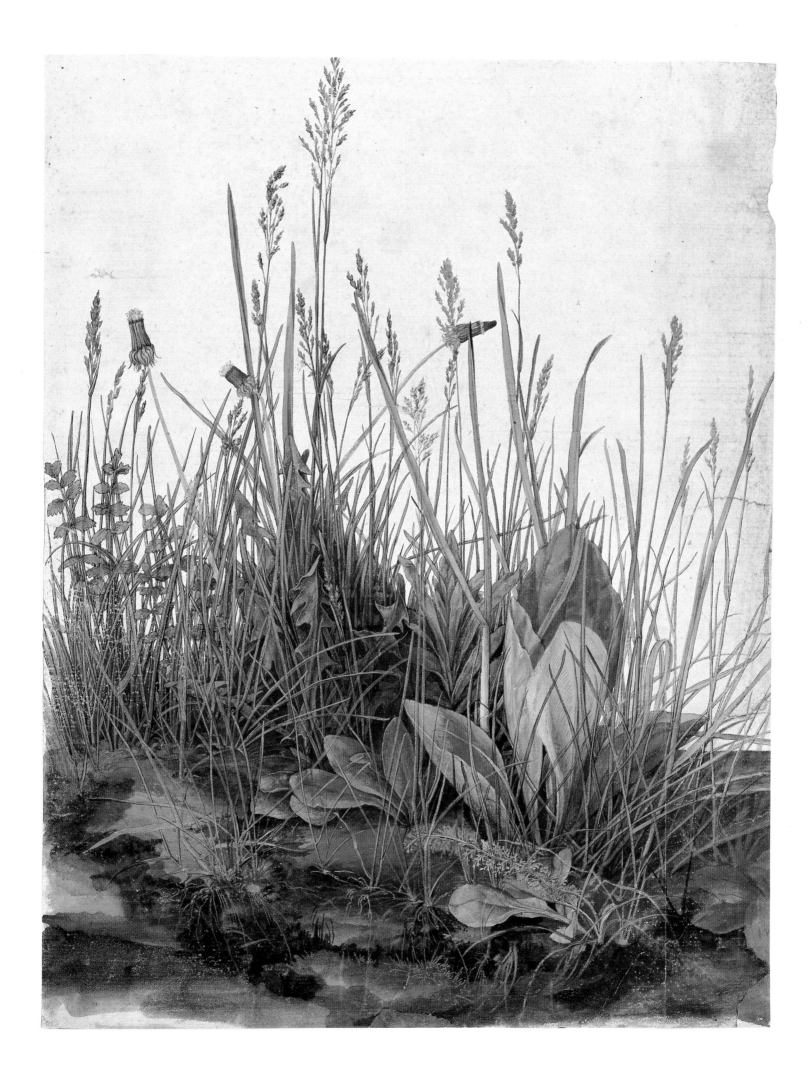

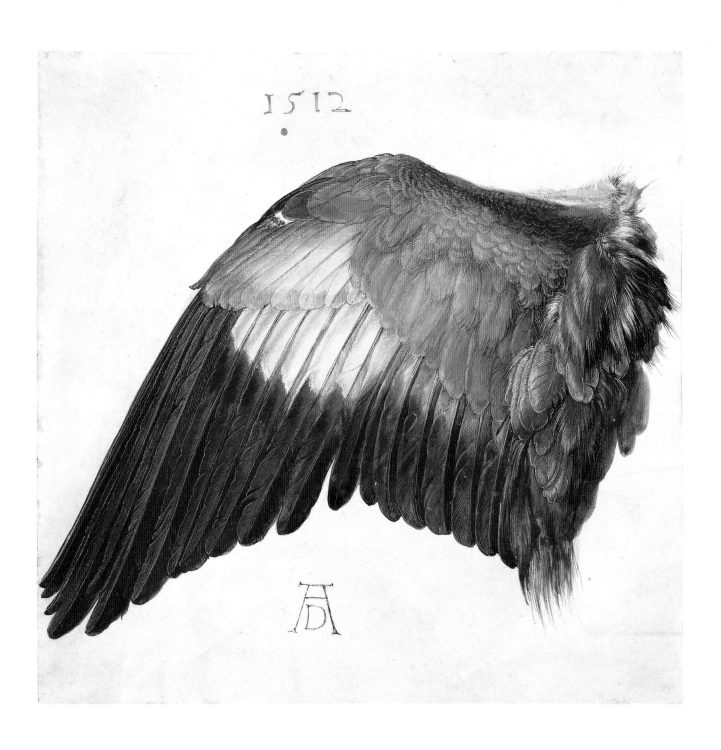

6   ALBRECHT DÜRER  1471–1528
*Wing of a Blue Roller*, 1512. Acquired by Duke Albert

7   ALBRECHT DÜRER  1471–1528
*The Virgin and Four Saints*, 1511. Acquired by Duke Albert

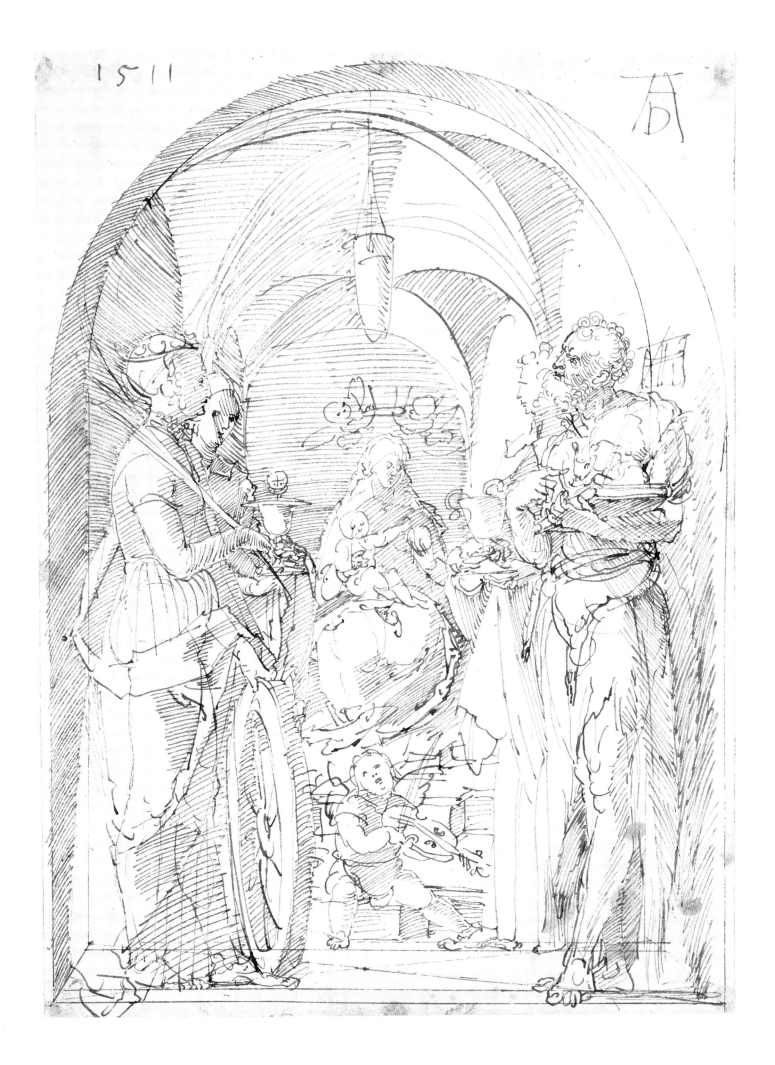

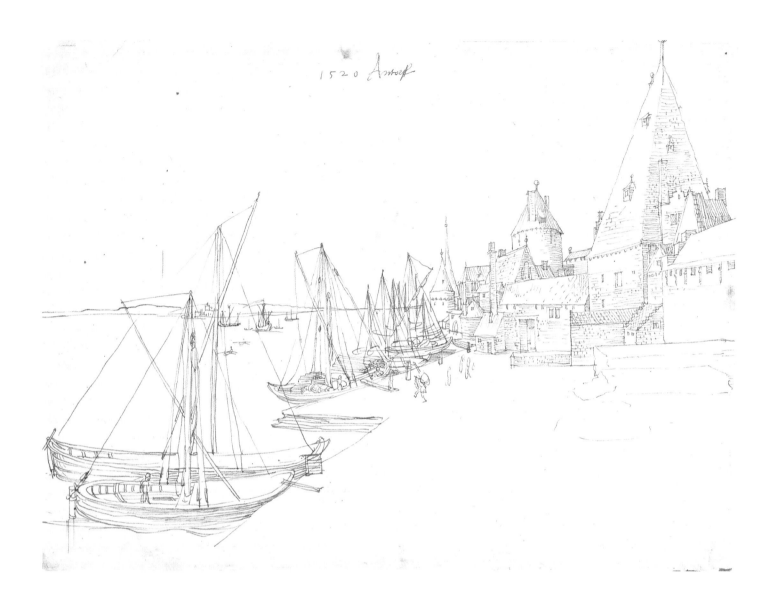

8  ALBRECHT DÜRER  1471–1528
*Antwerp Harbor*, 1520. Acquired by Duke Albert

9  ALBRECHT DÜRER  1471–1528
*Study of an old man's head*, 1521. Acquired by Duke Albert

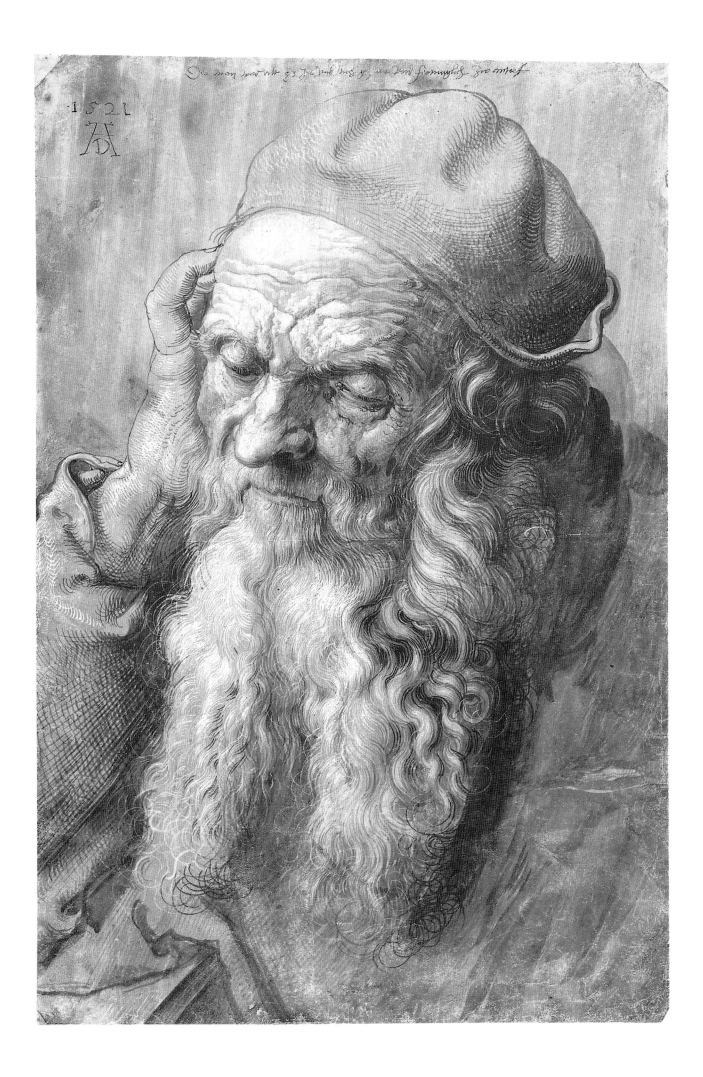

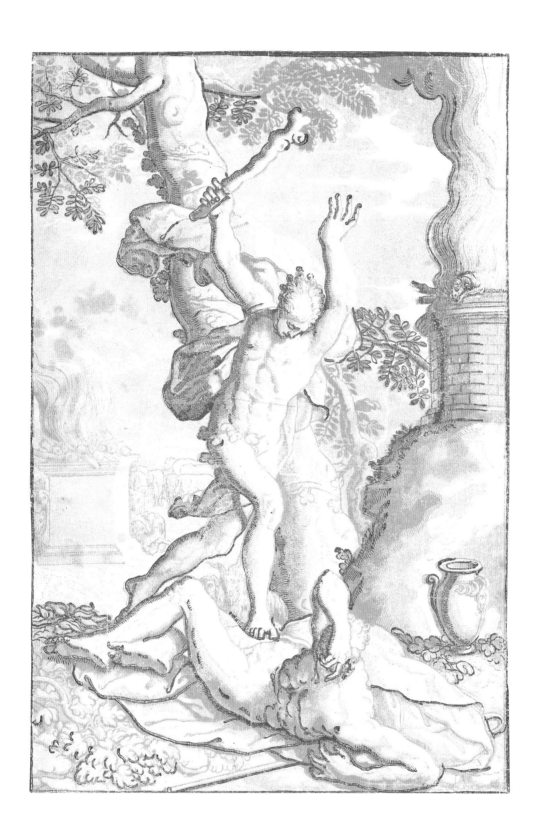

10   GIOVANNI GALLO AFTER MARCO PINO DA SIENA

*Cain Slaying Abel.* Acquired under Archduke Charles

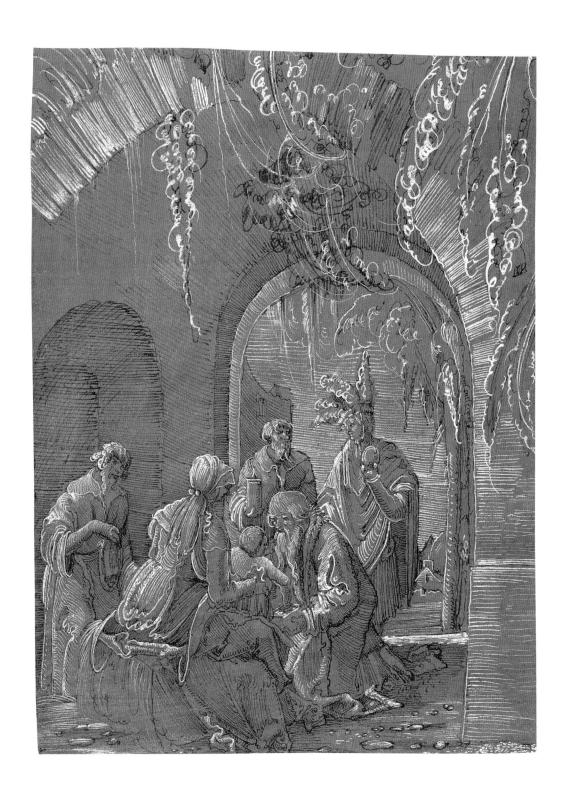

11 ALBRECHT ALTDORFER 1480–1538
*Adoration of the Magi.* Acquired under Otto Benesch

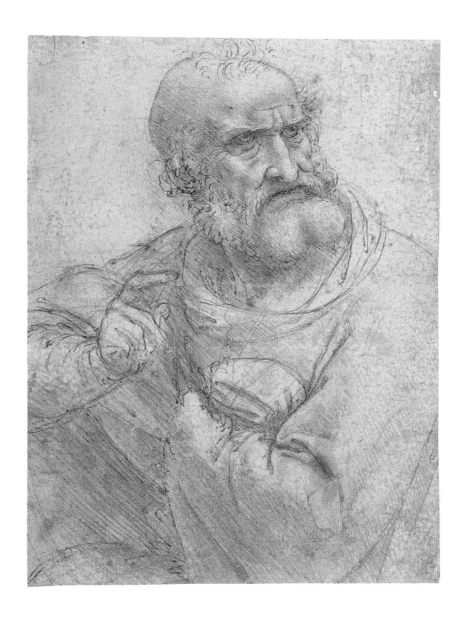

12    LEONARDO DA VINCI   1452–1519
*Half-length of an Apostle (Peter?).*
Acquired by Duke Albert

13   GIORGIO VASARI   1511–1574
*Sheet framed with eight drawings.* Acquired by Duke Albe▶

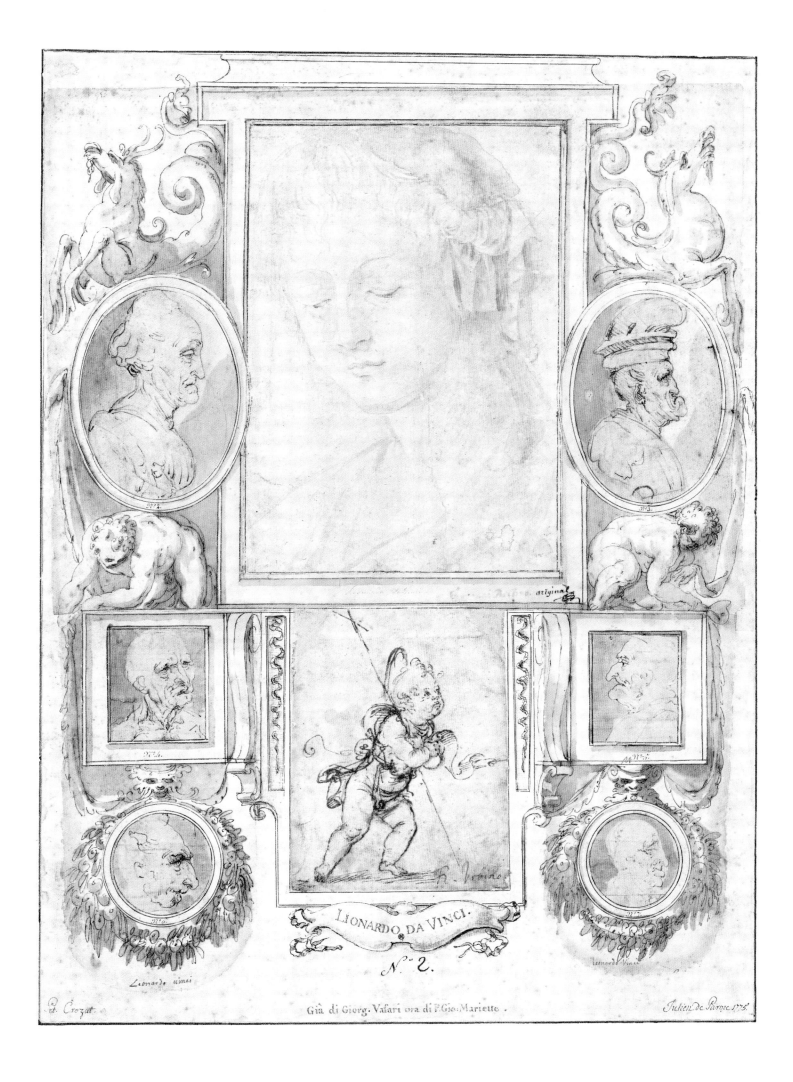

et. Crozat.

Già di Giorg. Vafari ora di P.Gio.Mariette.

Julien de Parme 1775

LIONARDO DA VINCI.

N.º 2.

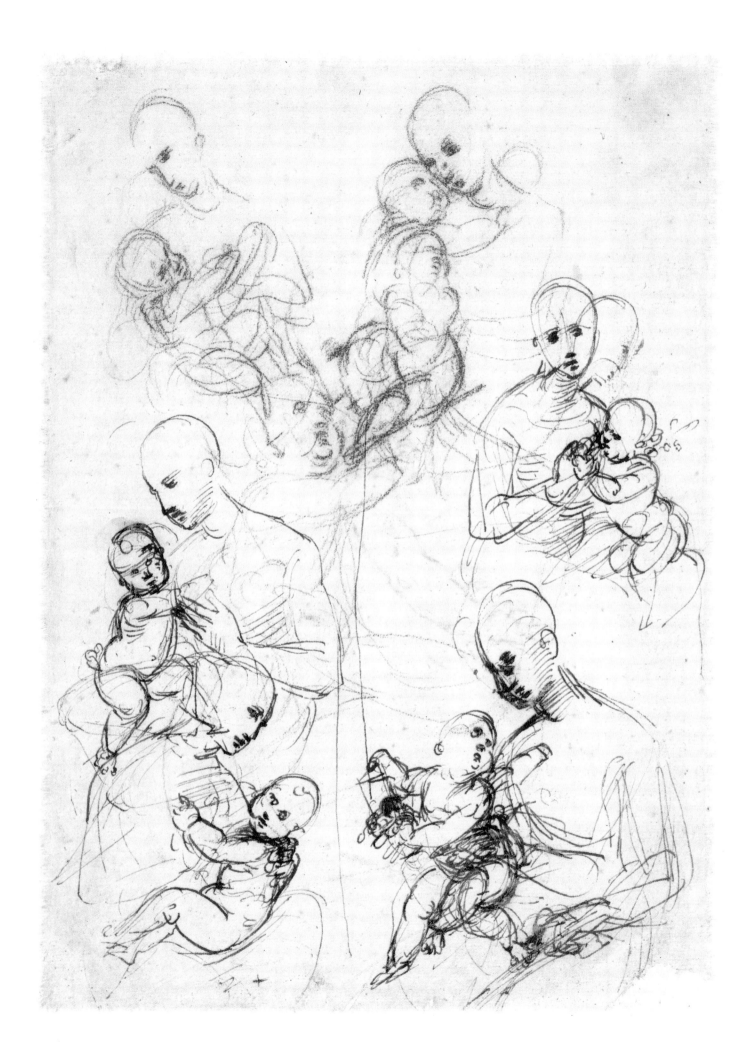

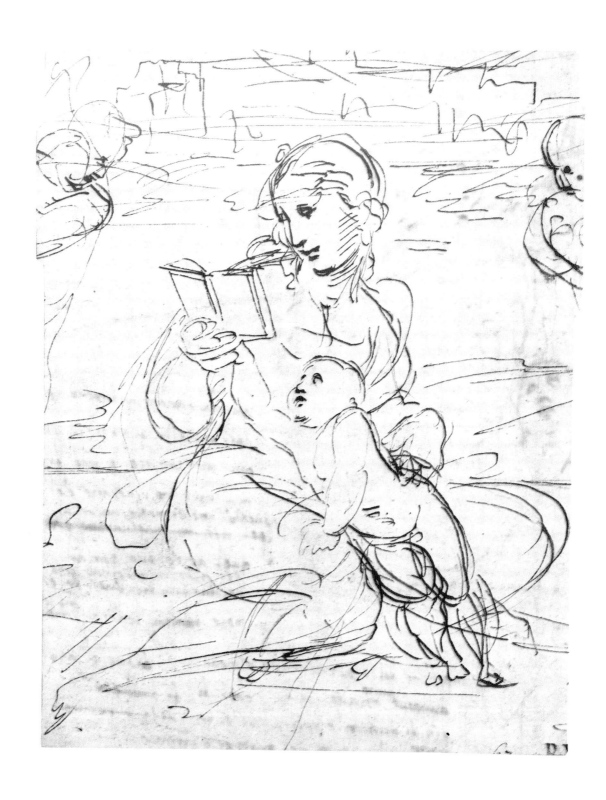

15   RAPHAEL   1483–1520
*Virgin, Reading, and Child*. Acquired by Duke Albert

14   RAPHAEL   1483–1520

*Studies for a Madonna and Child*. Acquired by Duke Albert

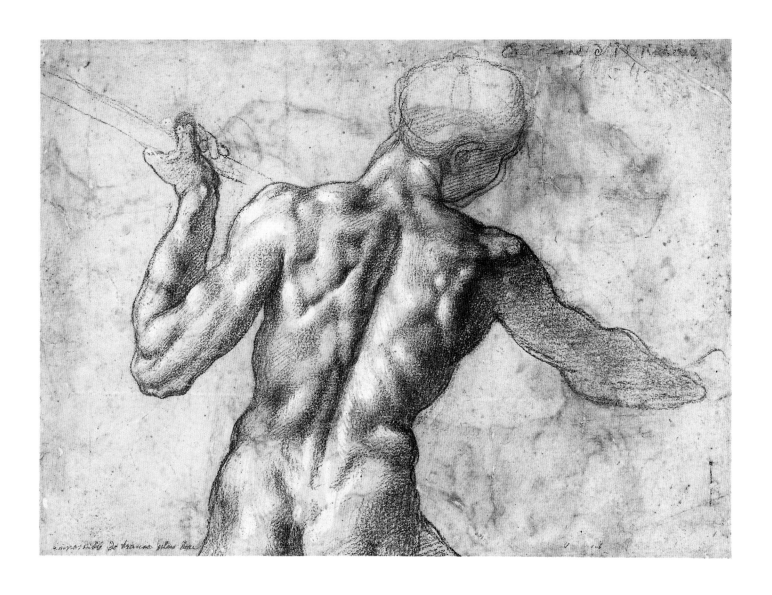

16  MICHELANGELO BUONARROTI  1475–1564
*Male nude, seen from the back*. Acquired by Duke Albert

17  MICHELANGELO BUONARROTI  1475–1564
*Seated male nude (ignudo) and two arm studies*. Acquired by Duke Albert

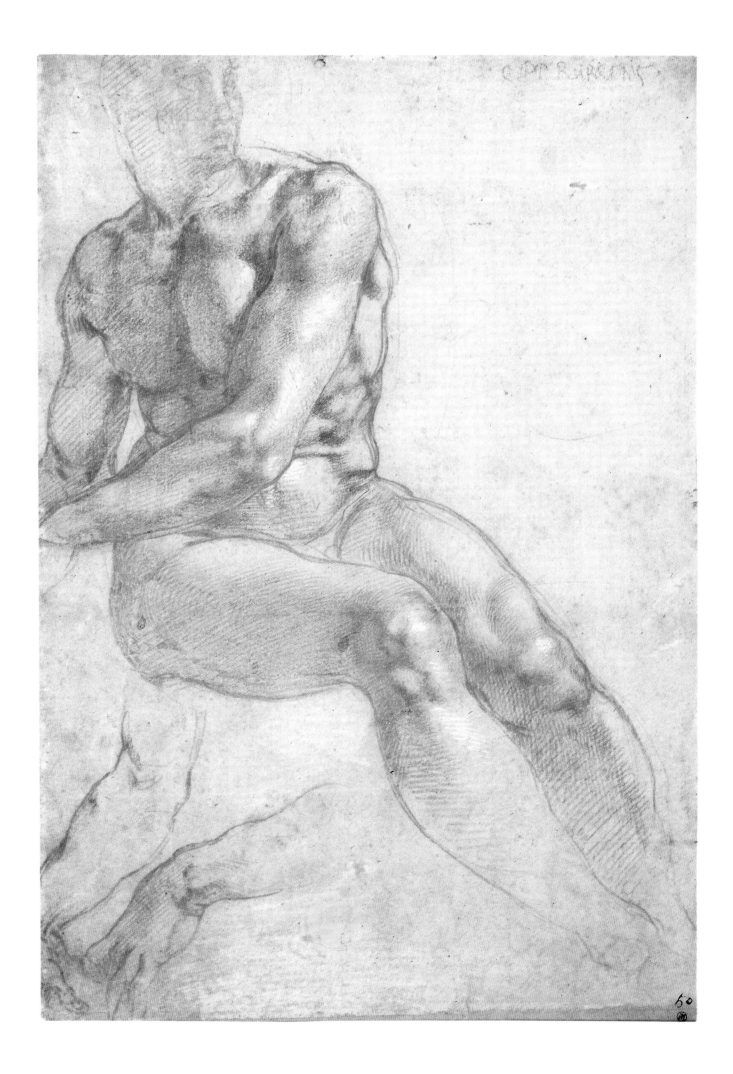

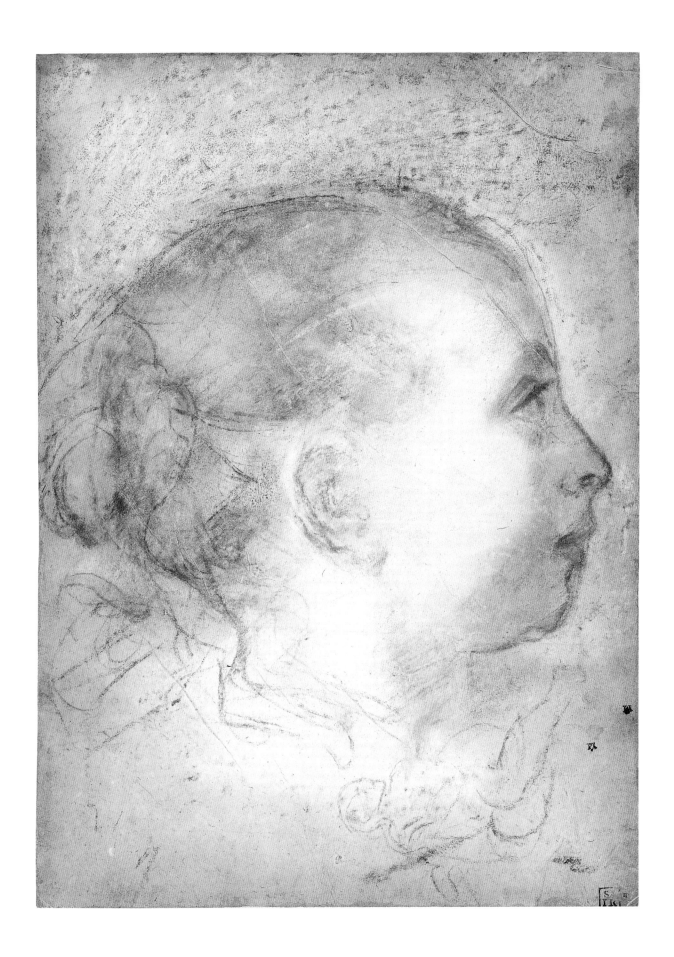

18  FEDERICO BAROCCI  1535–1612
*Woman's head in profile*. Acquired under Joseph Meder

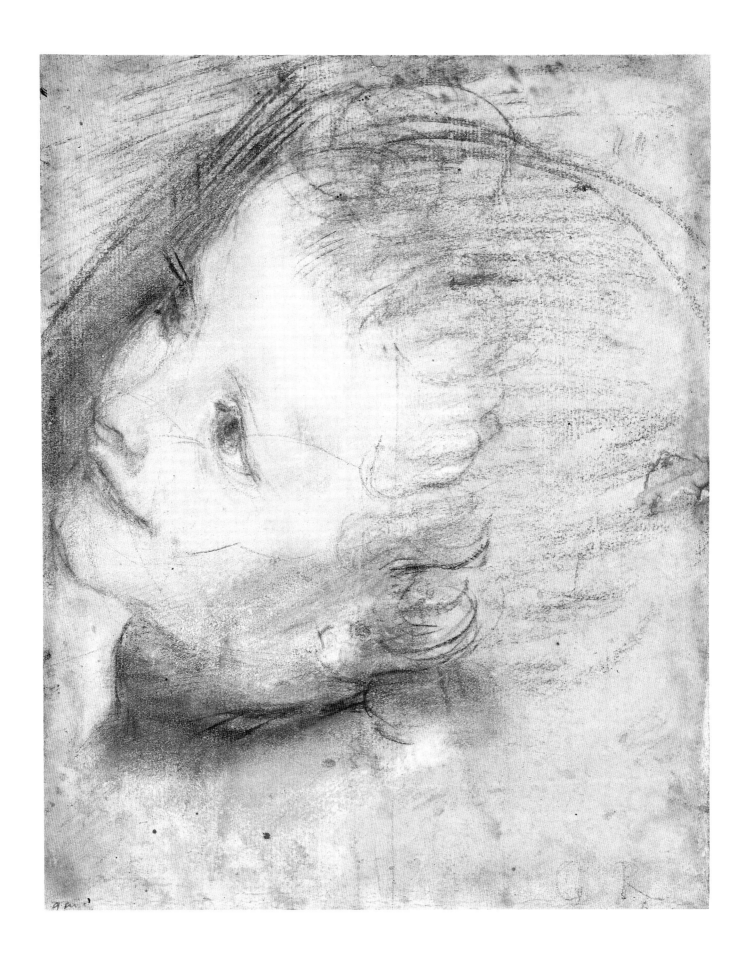

19  FEDERICO BAROCCI  1535–1612
*Study for a head of the Christ Child*. Acquired by Duke Albert

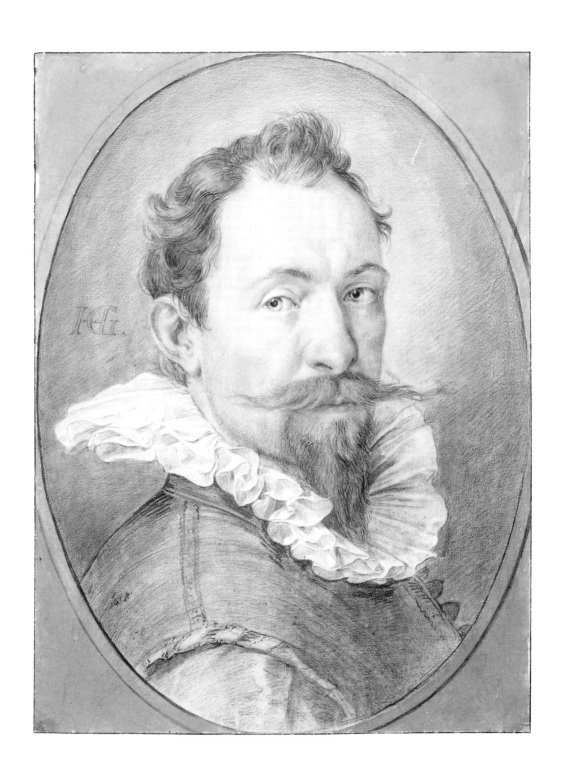

20 HENDRICK GOLTZIUS 1558–1617
*Self-Portrait*. Acquired by Duke Albert

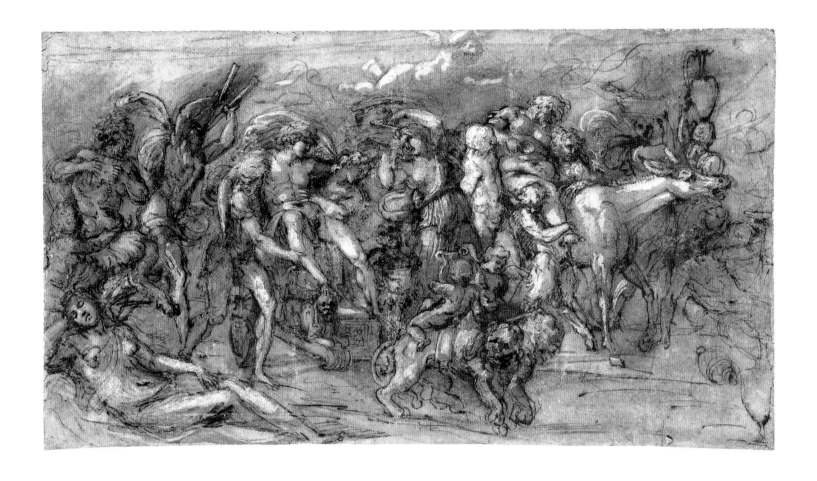

21   ANNIBALE CARRACCI   1560–1609

*The Triumph of Bacchus and Ariadne.* Acquired under Alfred Stix

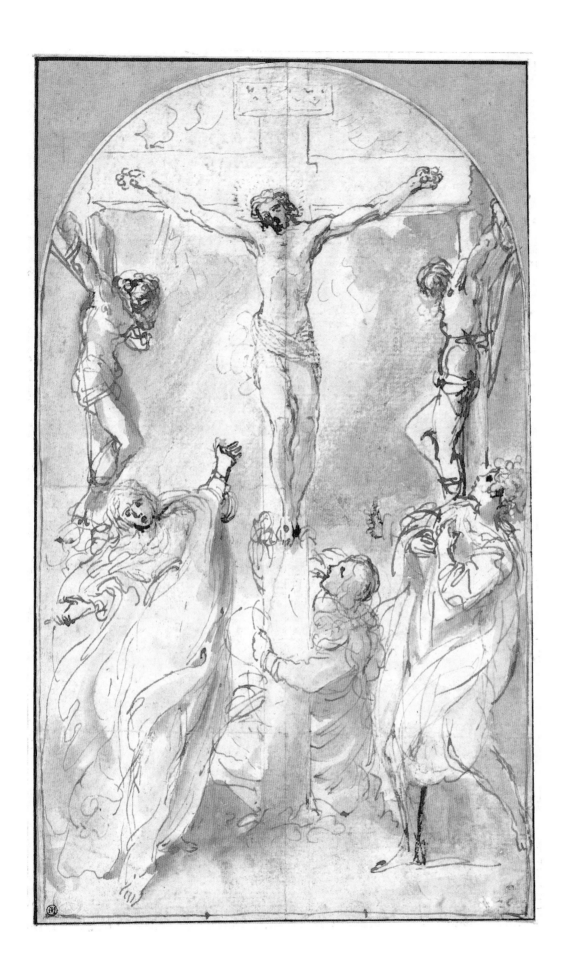

22  LUDOVICO CARRACCI  1555–1619
*Crucifixion*. Acquired by Duke Albert

23   GUIDO RENI   1575–1642
*Apollo in the Chariot of the Sun.* Acquired under Alfred Stix

24   GUERCINO (GIOVANNI FRANCESCO BARBIERI)
*The Virgin with the Infants Christ and St John*. Acquired by Duke Albert

25 NICOLAS POUSSIN 1594–1665

*View of Rome from Monte Mario*. Acquired by Duke Albert

26   ANTONY VAN DYCK   1599–1641
*The Betrayal of Christ*. Acquired by Duke Albert

27   PETER PAUL RUBENS   1577–1640
*Two Young Women, one holding a Lapdog*.
Acquired by Duke Albert

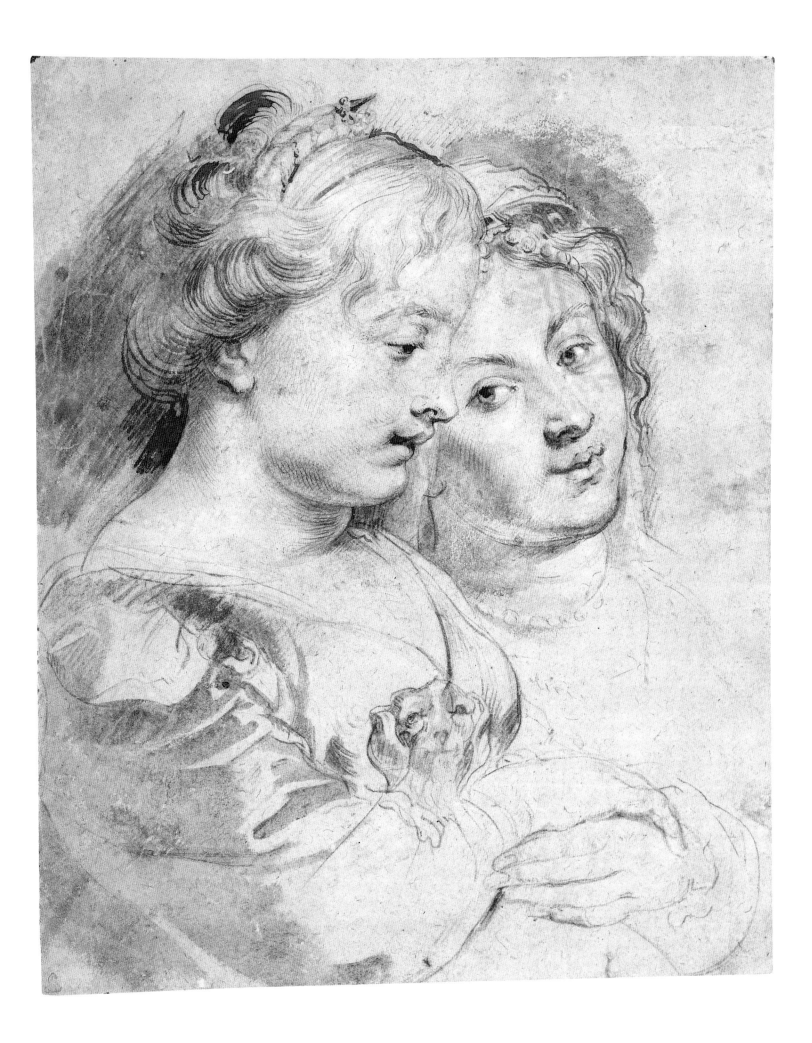

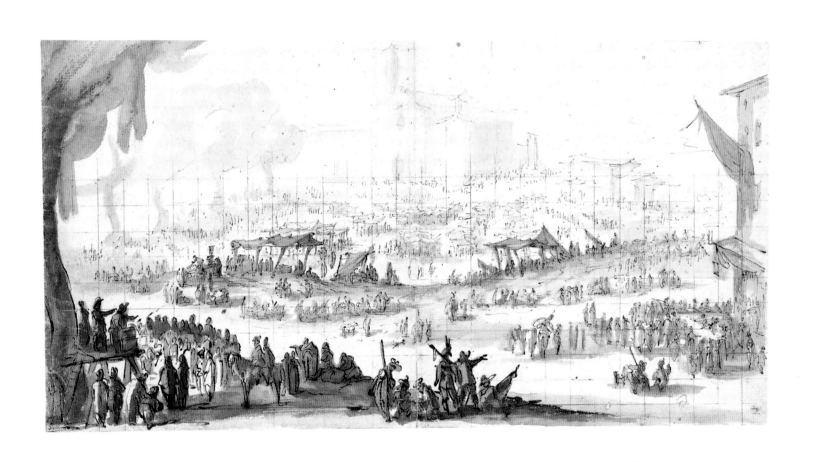

28   JACQUES CALLOT   1592/93–1635

*The Santa Maria della Impruneta Fair near Florence.* Acquired by Duke Albert

29A  STEFANO DELLA BELLA  1610–1664

*Death Seizes the Countess and Beats the Drum for the Nobleman*. Acquired under Archduke Albrecht

29B  STEFANO DELLA BELLA  1610–1664

*A Nobleman and a Warrior in Combat with Death*. Acquired under Archduke Albrecht

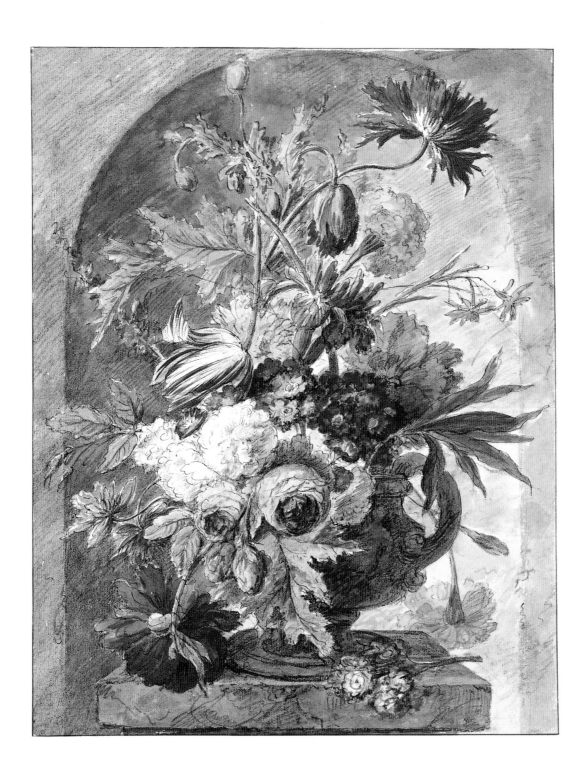

30 JAN VAN HUYSUM 1682–1749
*Still–Life with Flowers*. Acquired by Duke Albert

31 PETER PAUL RUBENS 1577–1640
*Study of a dress*. Acquired by Duke Albert

32   REMBRANDT HARMENSZ VAN RIJN   1606–1669
*Three studies of an elephant with an attendant.* Acquired by Duke Albert

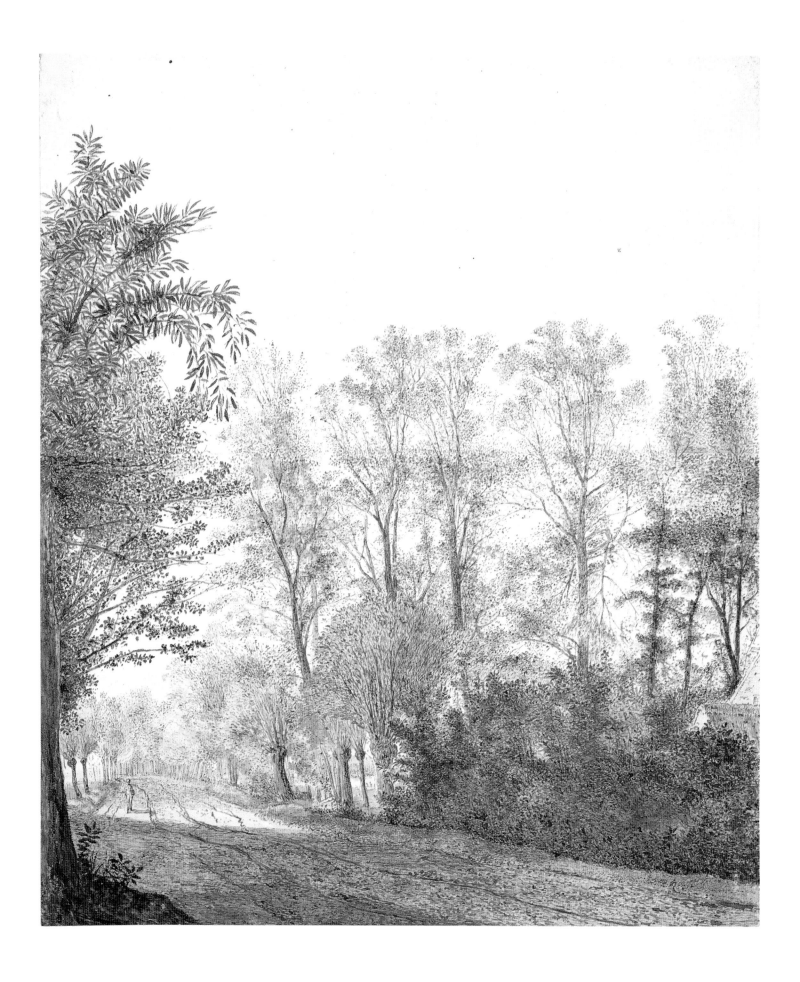

33   CORNELIS HENDRICKSZ VROOM   1591–1661
*A Tree-Lined Country Lane*. Acquired by Duke Albert

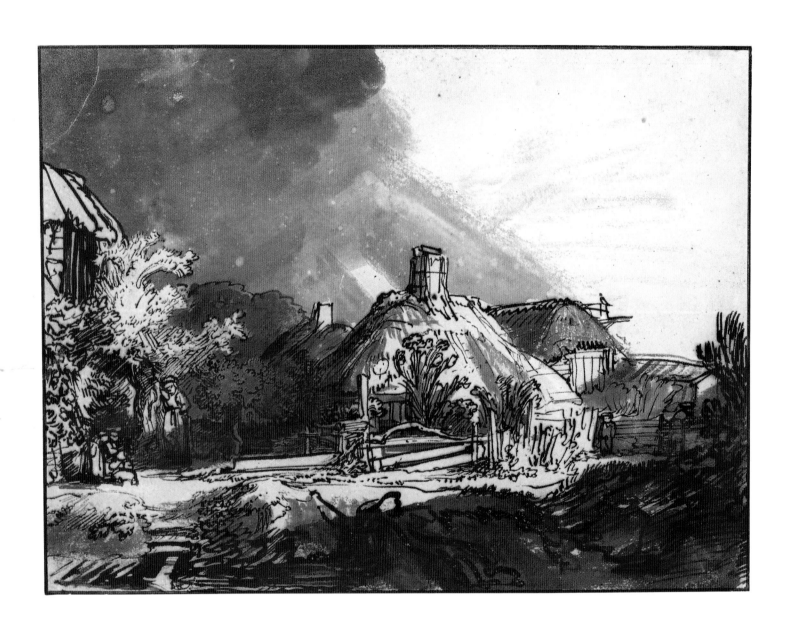

34   REMBRANDT HARMENSZ VAN RIJN   1606–1669
*Cottages before a Stormy Sky (in Sunlight)*. Acquired by Duke Albert

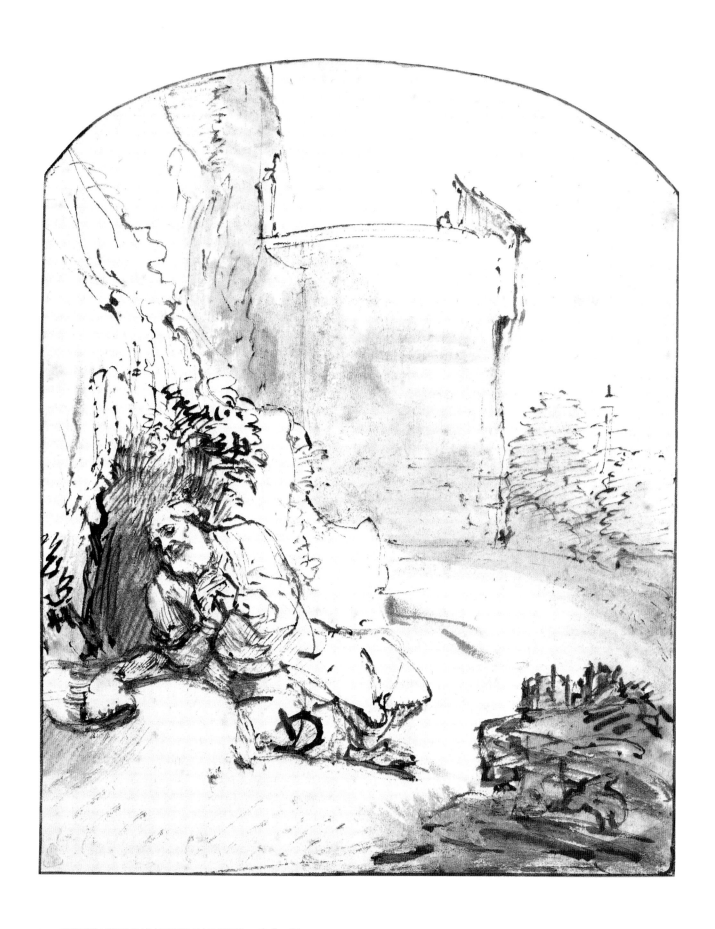

35   REMBRANDT HARMENSZ VAN RIJN   1606–1669
*Jonah at the Walls of Nineveh*. Acquired by Duke Albert

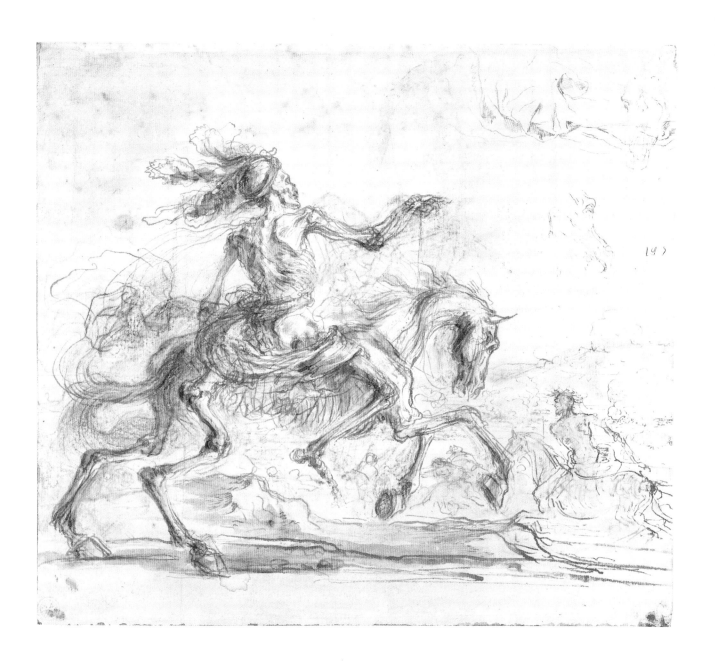

36  STEFANO DELLA BELLA  1610–1664
*Death Riding across a Battlefield*. Acquired by Duke Albert

37  CLAUDE LORRAIN  1600–1682
*Copse and a Shepherd, Resting*. Acquired by Duke Albert

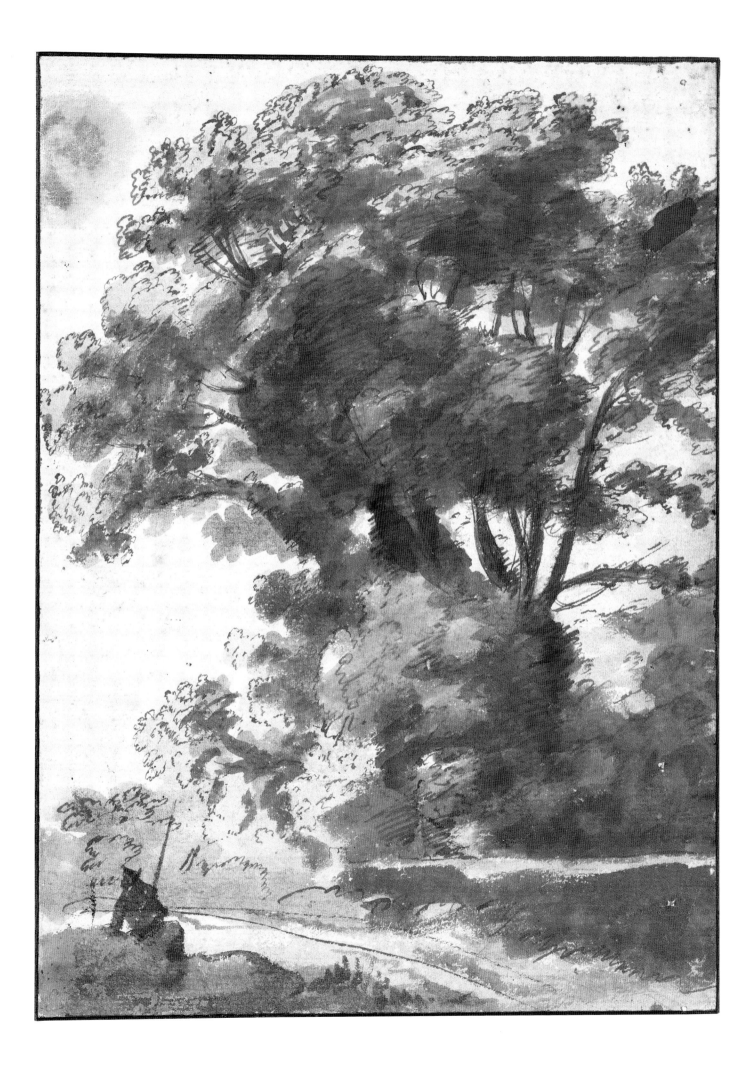

38   FRANCESCO SOLIMENA   1657–1747

*The Apotheosis of Louis XIV*. Acquired under Joseph Meder

39   CARLO MARATTA   1625–1713
*Adoration of the Shepherds*. Acquired by Duke Albert

40   ALLART VAN EVERDINGEN   1621–1675
*Storm at Sea*. Acquired by Duke Albert

41   PIETER JANSZ. SAENREDAM   1597–1665
*Interior of St Laurence's Church (Grote Kerk) in Alkmaar*, 1661. Acquired by Duke Albert

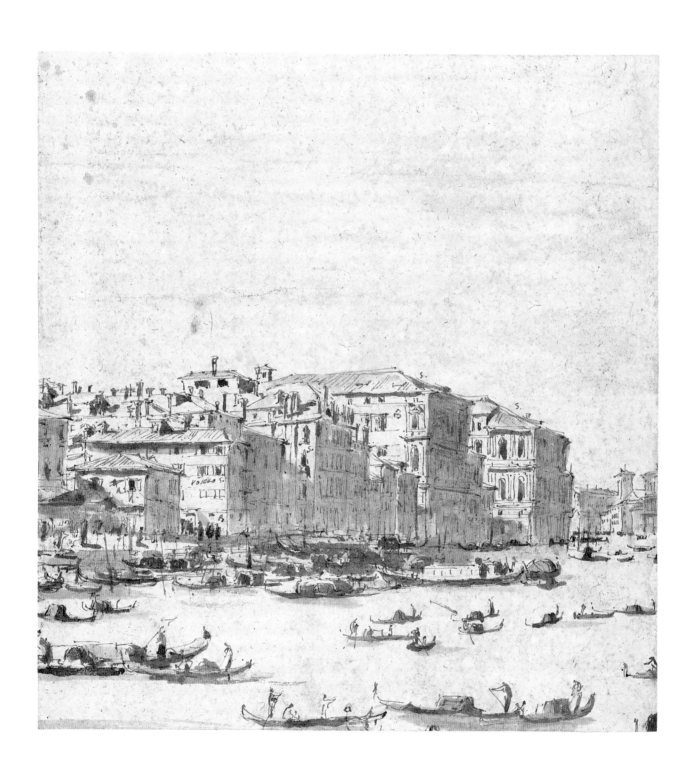

42   FRANCESCO GUARDI   1712–1793
*The Grand Canal near the Fish Market*. Acquired under Alfred Stix

43   GIOVANNI BATTISTA TIEPOLO   1696–1770
*Saints Fidelis of Sigmaringen and Joseph of Leonessa Banish Heresy*.
Acquired by Duke Albert

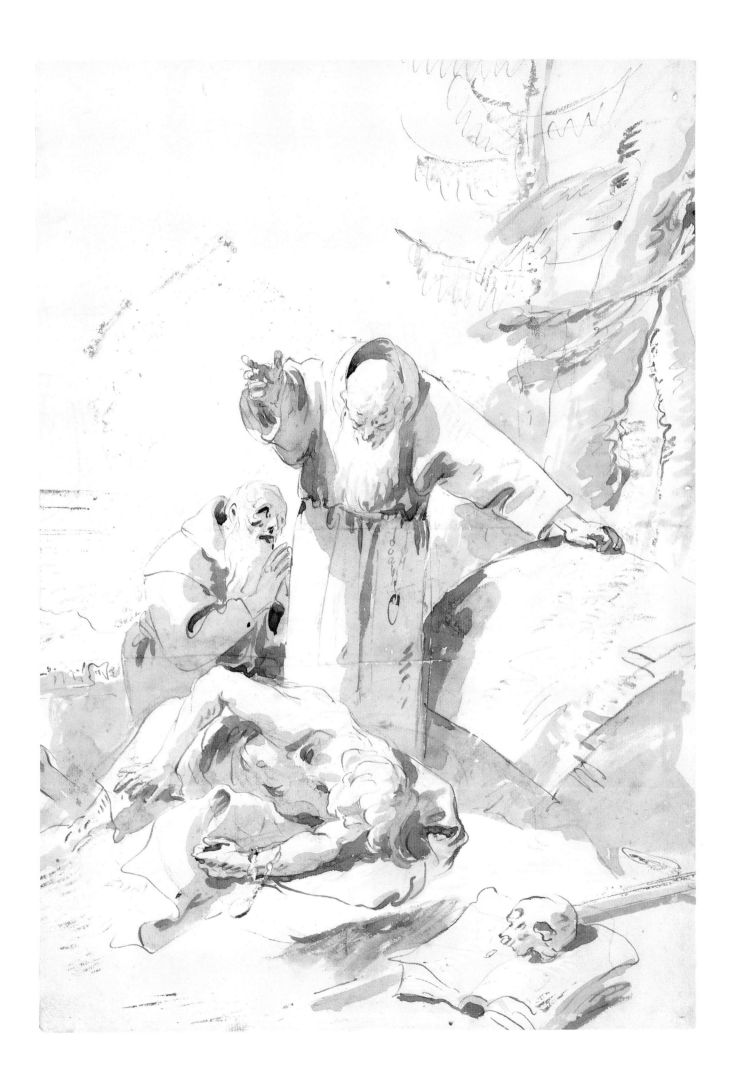

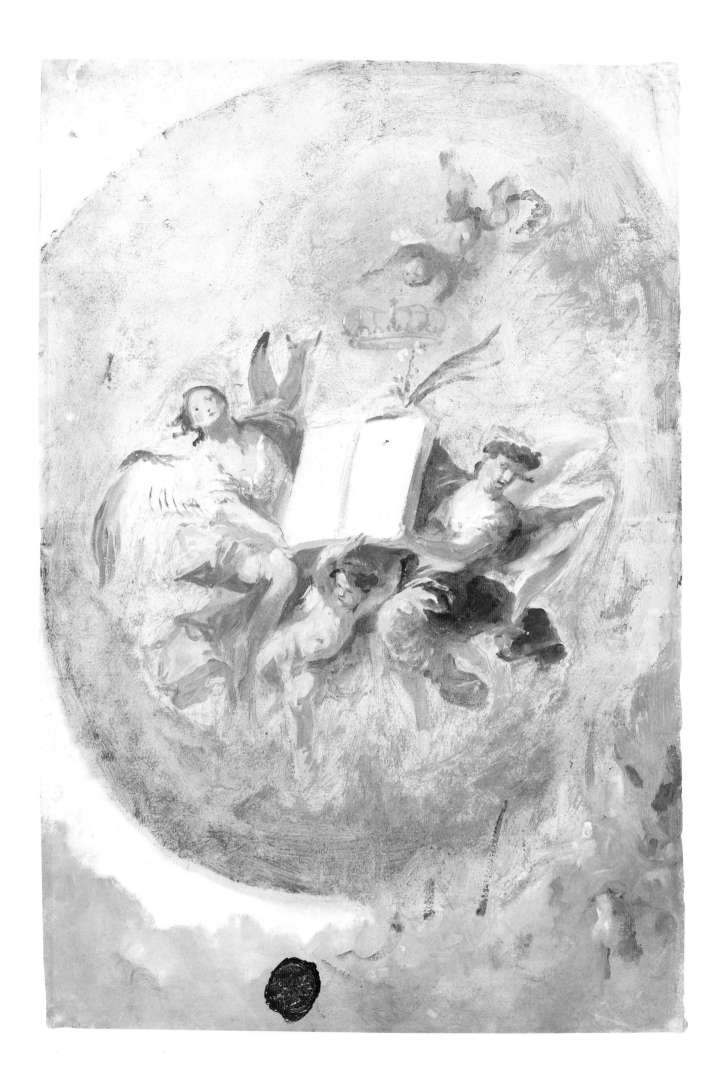

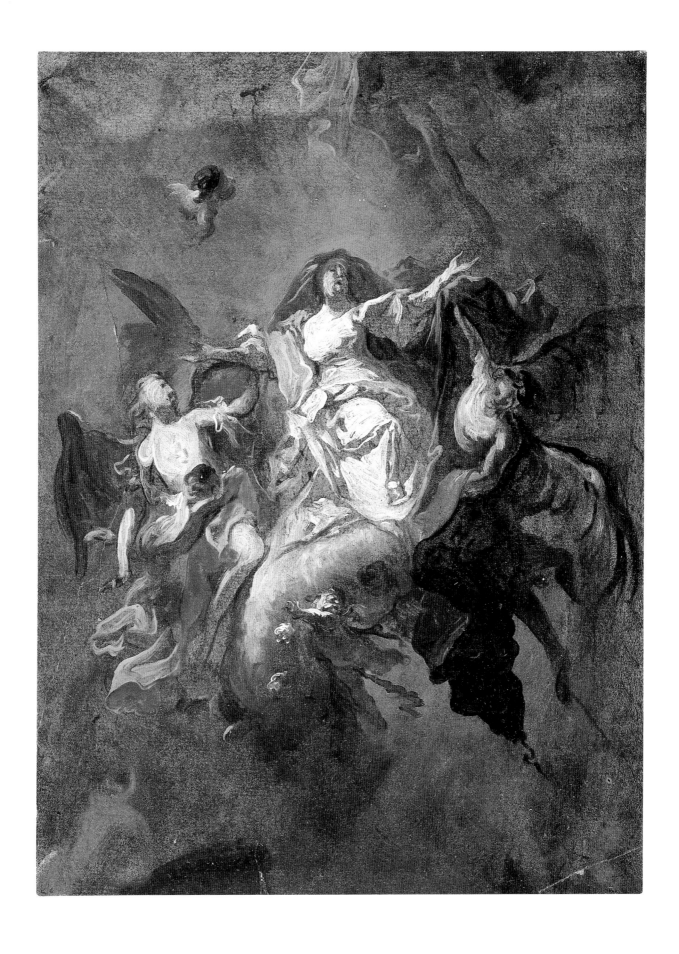

44  FRANZ ANTON MAULBERTSCH  1724–1796
*Angels with the Book and the Crown of St Stephen*. Acquired between 1934 and 1947

45  FRANZ ANTON MAULBERTSCH  1724–1796
*The Assumption*. Acquired under Alfred Stix

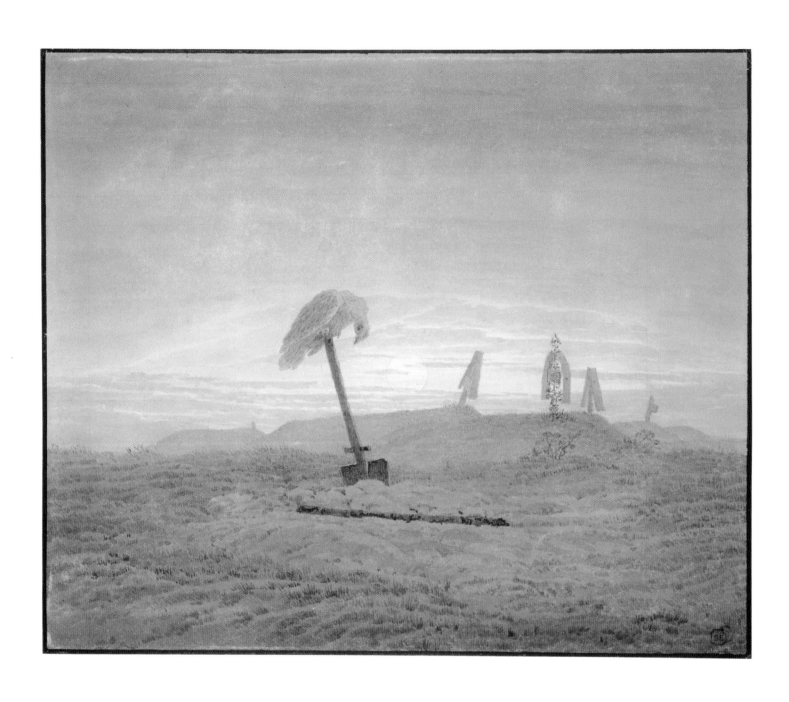

46 CASPAR DAVID FRIEDRICH 1774–1840
*Landscape with Graves*. Acquired under Alfred Stix

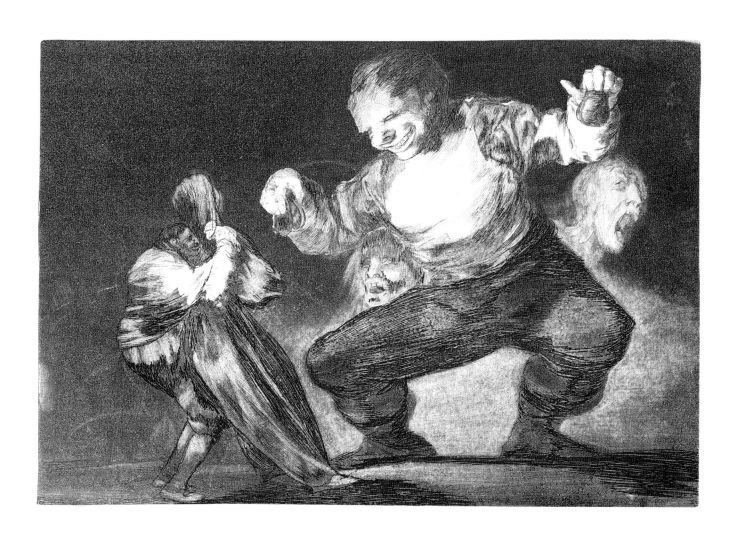

47   FRANCISCO DE GOYA   1746–1828
*Bobalicón (Folly).* Acquired under Alfred Stix

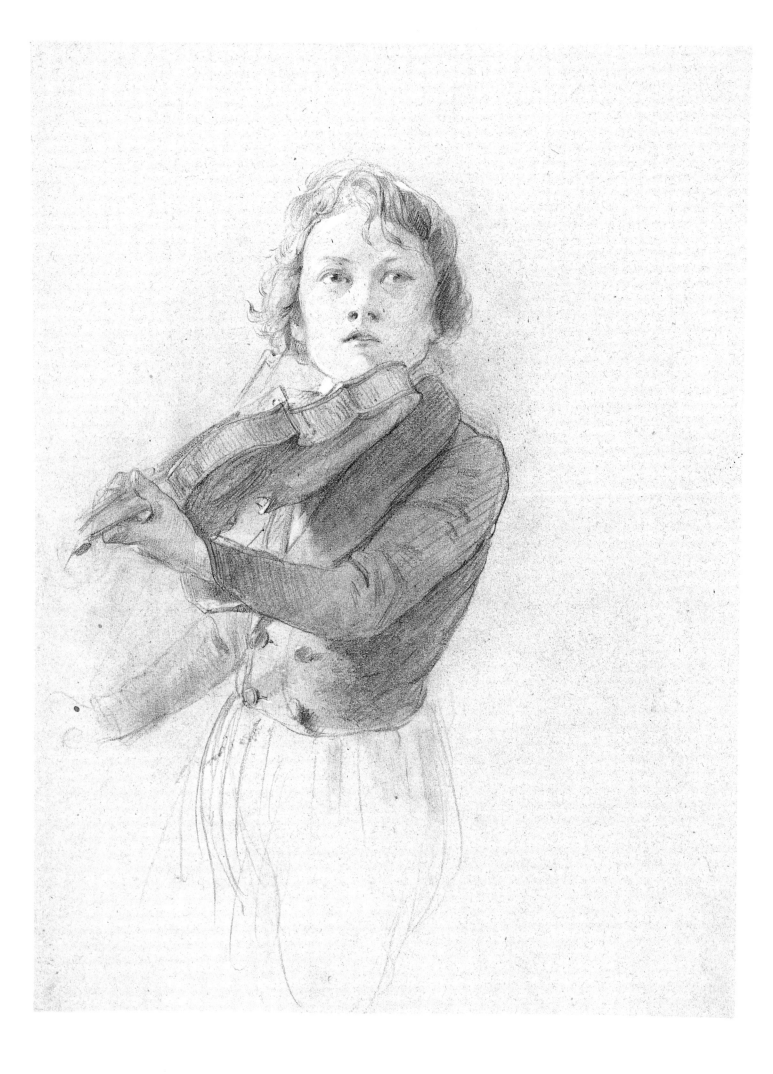

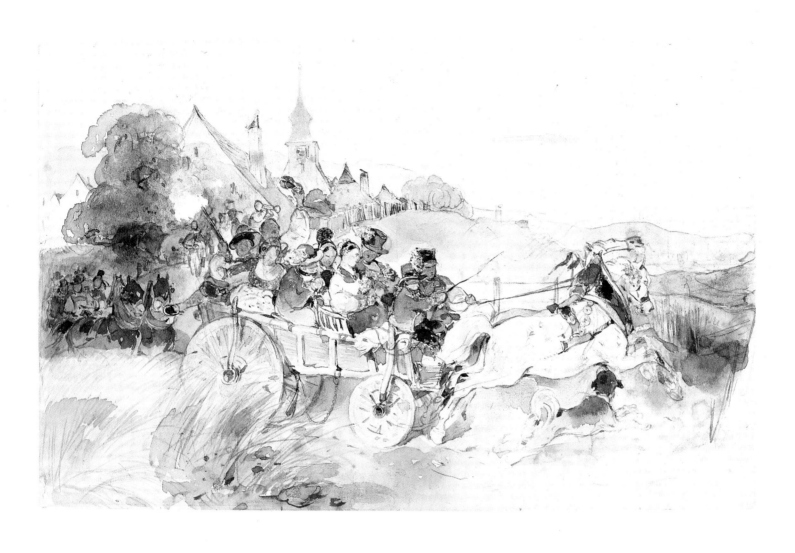

49   CARL SCHINDLER   1821–1842
*Wedding Trip*. Acquired under Otto Benesch

48   JOSEPH DANHAUSER   1805–1845
*Boy Playing the Violin*. Acquired under Archduke Charles

50   ANTON ROMAKO   1832–1889
*Carnival in Venice*. Acquired under Walter Koschatzky

51 SEBASTIAN WEGMAYR 1776–1857
*Roses*. Acquired under Archduke Albrecht

52 THOMAS ENDER 1793–1875
*Arva Castle*. Acquired between 1934 and 1947

53   THOMAS ENDER   1793–1875

*The Matterhorn Viewed from the Gornergrat.* Acquired under Walter Koschatzky

54   EDOUARD MANET  1832–1883
*Laburnum, Iris, and Geranium*. Acquired under Alfred Stix

55   RUDOLF VON ALT  1812–1905
*The Spa Promenade at Teplitz*. Acquired under Otto Benesch

Teplitz Aug 876

56   VINCENT VAN GOGH   1853–1890
*Graveyard in the Rain.* Acquired between 1934 and 1947

57   JAMES ENSOR   1860–1949
*Two Girls.* Acquired between 1934 and 1947

30069.

58   CAMILLE COROT  1796–1875
*Southern Landscape with a Large Tree*, 1871. Acquired under Alfred Stix

59   ADOLPH MENZEL  1815–1905
*Sawmill*, 1892. Acquired under Alfred Stix

60   PAUL GAUGUIN   1848–1903
*AUTI TE PAPE (Women at the River)*, 1894. Acquired under Joseph Meder

61   KÄTHE KOLLWITZ   1867–1945
*Sketch for the etching 'Outbreak'*, 1901. Acquired between 1934 and 1947

62   AUGUSTE RODIN   1840–1917
*Figure studies*. Acquired under Alfred Stix

63    PAUL CÉZANNE    1839–1906
*Château Noir and Monte Sainte-Victoire*. Acquired under Alfred Stix

64　ALFRED SISLEY　1839–1899
*Forest Track*. Acquired under Alfred Stix

65　GUSTAV KLIMT　1862–1918
*Floating, study for an allegorical mural for Vienna University: Medicine*.
Acquired under Alfred Stix

66   MAX LIEBERMANN   1847–1935

*On the Beach at Nordwijk*. Acquired under Joseph Meder

67    FRANZ MARC   1880–1916

*Horses Resting*, 1911/12. Acquired under Joseph Meder

68   MARC CHAGALL  1887–1985
*Lute Player*, 1911. Acquired under Alfred Stix

69   WASSILY KANDINSKY   1866–1944
*Composition*, 1915. Acquired under Alfred Stix

70   ALFRED KUBIN   1877–1959
*Mammoth*. Acquired under Otto Benesch

71   EGON SCHIELE   1890–1918
*Seated Couple (Egon and Edith Schiele)*, 1915. Acquired between 1934 and 1947

1920.84. Villen am See.

72   PAUL KLEE   1879–1940
*Villas on a Lake*, 1920. Acquired under Konrad Oberhuber

73    NADESHDA OUDALTSOVA    1885–1961
*Composition*. Acquired under Konrad Oberhuber

74　LOVIS CORINTH　1858–1925
*Still–Life with Flowers*, 1922. Acquired under Alfred Stix

75   HERBERT BOECKL   1894–1966
*The Erzberg*. Acquired under Walter Koschatzky

76   FERNAND LÉGER   1881–1955
*Still-Life with Blue Vase*. Acquied under Otto Benesch

77   HANS HARTUNG   1904–1989
*Composition*. Acquired under Otto Benesch

79   BARNETT NEWMAN   1905–1970
*Untitled*, 1960. Acquired under Konrad Oberhuber

78   PABLO PICASSO   1881–1973
*Jacqueline lisant*, 1958. Acquired under Walter Koschatzky

80 JACKSON POLLOCK 1912–1956
*Untitled*. Acquired under Konrad Oberhuber

81   MARIA LASSNIG   b. 1919
*Head*, 1963. Acquired under Walter Koschatzky

PACKED KUNSTHALLE /PROJECT FOR KUNSTHALLE BERN - SWITZERLAND - July 1961/

82　CHRISTO　b. 1935
*Project for Packed Kunsthalle Bern*, 1961.
Acquired under Walter Koschatzky

83　FRITZ WOTRUBA　1907–1975
*Tectonic Figure Composition*, 1964.
Acquired under Konrad Oberhuber

84   FRANZ WEST   b. 1947
*Made by (Untitled)*, 1976/77. Acquired under Konrad Oberhuber

85   ARNULF RAINER   b. 1929
*Above Gromaire.* Acquired under Walter Koschatzky

86
MAX WEILER
b. 1910
*Natural*
*Phenomenon*
*(Avalanche)*,
1988.
Acquired under
Konrad
Oberhuber

# Duke Albert of Saxe-Teschen
## Biographical Dates

July 11, 1738
BORN IN DRESDEN

Prince Albert (Albrecht) Casimir was born on July 11, 1738 in Moritzburg Castle near Dresden. He was the sixth son and eleventh child of Frederick Augustus II, Elector of Saxony (1696–1763) and his wife, Maria Josepha, Archduchess of Austria (1699–1757).[549] The Saxon prince grew up at the Dresden Court and, like his brothers, was educated for a diplomatic and military career.[550]

1756 – 1763
THE SEVEN YEARS WAR

During the Seven Years War, Saxony was allied with Austria. Albert and his younger brother Clement joined the Austrian army. In autumn 1759 they were assigned as cavalry officers to the staff of Field Marshal Leopold Joseph, Count Daun (1705–1766). After the recapture of Dresden in January 1760, the two princes went to Vienna to be introduced at the Imperial Court.

1760
MEETS THE ARCHDUCHESS
MARIE CHRISTINE;
ALBERT COMMISSIONED GENERAL
FIELD MARSHAL-LIEUTENANT
IN THE IMPERIAL ARMY,
AND IS GIVEN COMMAND OF
A CUIRASSIER REGIMENT

It was love at first sight when Prince Albert met the seventeen-year-old Archduchess Marie Christine of Austria (May 13, 1742– June 24,1798) early in January 1760.[551] From the outset Maria Theresia supported the union although Albert was poor and certainly not what the House of Habsburgs were accustomed to finding acceptable as husbands for their daughters.[552] The 'Declaration by Prince Albert of Poland and the Electorate of Saxony as

Imperial General Field Marshal-Lieutenant'[553] dates from May 4, 1760. On 13 May Albert was given command of a cuirassier regiment.[554]

February 15, 1763
THE PEACE OF HUBERTUSBURG;
THE END OF THE SEVEN YEARS WAR

February 26, 1763
ALBERT BECOMES GENERAL
OF A CAVALRY REGIMENT

On February 26, 1763 Maria Theresia made Prince Albert of Saxony General of a cavalry regiment.[555]

March 17, 1764
RECEIVED INTO THE DRESDEN FREE
MASON LODGE OF THE THREE SWORDS

Like so many aristocrats of the Enlightenment, Prince Albert, too, became a Free Mason.[556] On March 17, 1764 he was received into the Lodge 'Of the Three Swords' in Dresden, a stronghold of Freemasonry. This lodge was a strictly observant one with a tendency to mysticism. Organized on purely hierarchical lines, it viewed itself as the spiritual heir to the old Order of Knights Templars. Albert became Protector of the Bohemian Lodges and was active in promoting Strict Observance. Its Viennese Lodge was established in 1755 as the 'St Pölten Grand Command' with Duke Albert of Saxe-Teschen as Protector.[557]

In this connection it is noteworthy that the Viennese Scottish Grand Lodge was named after Albert 'Albert of the Golden Helmet'.

With the virtual disbandment of Strict Observance in Austria in 1779/80, Albert's active commitment to his Lodge seems to have ended. By 1780, when the heyday of the Viennese lodges began, Albert's name no longer appears on the membership rolls.

August 18, 1765
DEATH OF THE EMPEROR
FRANZ I STEPHAN OF LORRAINE

Emperor Franz I Stephan of Lorraine died unexpectedly in Innsbruck on August 18, 1765.

December 26, 1765
ALBERT MADE FIELD MARSHAL
AND GOVERNOR OF HUNGARY

When Albert was appointed 'Imperial and Royal Field Marshal and Captain-General of the Imperial and Royal Armies in Hungary [and] locum tenens Regius [Viceroy] in said Kingdom',[558] Maria Theresia entrusted her future son-in-law with important tasks and a political agenda entailing heavy responsibilities. He was granted the necessary financial means for discharging his responsibilities.

January 7, 1766
ALBERT GOES TO PRESSBURG
AS GOVERNOR OF HUNGARY

April 8, 1766
MARRIAGE OF ALBERT AND
ARCHDUCHESS MARIE CHRISTINE

The bethrothal and nuptial festivities lasted for days (April 2–9, 1766). The marriage contract ws signed on April 5, 1766,[559] the marriage ceremony took place in church three days later and was celebrated on April 8, at Schlosshof near Vienna.[560]

Most of Marie Christine's sumptuous dowry came from her father, Emperor Franz I Stephan of Lorraine.[561] It consisted of landed property and money, today worth the equivalent of 422 million Austrian shillings.

1766 – 1780
GOVERNOR OF HUNGARY

From 1766 to 1780 Albert and his wife lived in Hungary at the newly renovated Viceroy's seat, Pressburg Castle.[562] Albert was particularly anxious to carry out the reforms proposed by Maria Theresia. They included improvements in the social status and welfare of her subjects, the abolition of serfdom (achieved in 1781 under Joseph II) and, ultimately, complete freedom of religion. While he was Governor of Hungary, Albert must have started collecting art on a large scale. The influence and hands-on support he received in this undertaking from Giacomo Conte Durazzo (1717–1794; Fig. 3) were decisive.[563] Between 1774 and 1784 Durazzo collected more than 30,000 leaves of prints for Albert. They were to form the nucleus of his art cabinet, which was universal in scope.

December 28, 1775 – July 13, 1776
ITALIAN JOURNEY

Late in December 1775 Albert and his wife left for an extensive tour of Italy. Their itinerary took them from Marburg, Laibach and Görz to Venice, Ferrara and Bologna, and finally to Florence, Rome and Naples. The highlights were Turin, Milan, Verona, Padua and again Venice.[564] Albert wrote about the journey and described the varied impressions it made on him, notably what he saw and learned about art, in a travel diary and *Mémoires de ma Vie*.[565]

Early in July 1776 he received the first collection of prints from Count Durazzo: 'un' Opera di mille Oggetti composto.'[566]

1778/79
THE WAR OF BAVARIAN SUCCESSSION

In 1778/79 the War of Bavarian Succession saw Albert stationed with troops in Moravia and Silesia. Prussia and Saxony opposed Austria's claims to the Bavarian crown. The war ended on May 13, 1779 with the Peace of Teschen. All that was ceded to Austria at that time was the Bavarian Inn District, which is now the Inn section.

July 4, 1780
DEATH OF GRAND DUKE CHARLES
OF LORRAINE: ALBERT AND HIS WIFE
SUCCEED TO THE GOVERNORSHIP
OF THE AUSTRIAN NETHERLANDS

November 29, 1780
DEATH OF MARIA THERESIA

Their succession to the General Governorship of the Austrian Netherlands in Brussels marked a turning-point in the lives of Albert and Marie Christine. Maria Theresła had decreed on the occasion of their marriage that they were to hold this high office on the death of Grand Duke Charles of Lorraine. However, the death of Maria Theresia on November 29, 1780 prevented their taking office immediately.

July 10, 1781
ARRIVAL IN BRUSSELS AS GOVERNORS
OF THE AUSTRIAN NETHERLANDS

On June 3, 1781 Albert and Marie Christine left for Brussels, where they were received with due ceremony. The Brussels City Palace and Mariemont Castle were placed at their disposal as residences. However, Albert and his wife prefered Schoonenberg Castle (Laeken) near Brussels, which was built by Charles de Wailly with the help of Louis de Montoyer and Antoine-Marie Payen between 1781 and 1785.[567]

August 31 – September 13, 1781
JOURNEY THROUGH THE PROVINCES
OF NETHERLANDS

Albert made important notes on his journey through the provinces of the Netherlands in *Notes sur le Voyage que nous avons faites dans quelques provinces des Pays-Bas en 1781*. He also kept a travel diary: *Journal du premier Voyage fait en 1781 dans les Provinces des Pays*.[568] Highlights of this trip were Mechelen, Antwerp, Ghent, Bruges, Ypres, Courtrai, Mons, Namur. Back in Brussels, Albert and Marie Christine made a point of enjoying cultural events as a welcome diversion from their diplomatic duties.

During their early years as Governors, Albert and Marie Christine concentrated on building, decorating and furnishing Schoonenberg Castle and, more importantly, adding to their art collection.

Links with collectors must have become increasingly important to Albert during this period of his life. A fellow connoisseur was

Charles Antoine, Prince de Ligne (1759–1792), who lived close by at Beloeil Castle and owned a superb cabinet collection of drawings and prints.[569] Sources show that Albert cleverly took advantage of the favourable location of his new post to enlarge his collection. By this time his collection was so large that he evidently found it necessary on March 1, 1783 to hire two curators (inspectors) to look after and organize it.[570]

### from mid–1780
POLITICAL UNREST GROWS
IN THE AUSTRIAN NETHERLANDS

Since the early 1780s political unrest had been growing as a reaction to far-reaching and drastic reforms implemented by the Emperor Joseph II, which effected radical economic and institutional changes. Political opposition by traditionalists was strong and the Church offered stubborn resistance to structural reform.

### July 26 – August 28, 1786
TRIP TO PARIS

In 1786 Albert and Marie Christine went on two trips. After a visit to Vienna early in the year, they went to Paris in July to stay with Marie Christine's sister, Marie Antoinette. While in Paris, Albert and Marie Christine did a great deal of cultural sightseeing. Among the numerous lavish presents given to them on their departure were some prints for their collection.[571]

### January 1, 1787
EDICTS ISSUED BY THE EMPEROR
JOSEPH II PROVIDE FOR CONFORMITY
OF THE NETHERLANDISH
ADMINISTRATION AND LEGAL SYSTEM
WITH THE PATRIMONIAL DOMAINS;
REVOLT IN BRABANT

### May 30, 1787
THE IMPERIAL EDICTS ARE REVOKED
BY ALBERT AND MARIE CHRISTINE

The Josephine reforms already carried out, especially the measures to reform and reorganize the Church (disbandment of monasteries, attacks on Church privileges and the cutting of religious ceremonies and holidays), created a powerful backlash of Catholic resistance. Attempts at centralizing the goverment of the Austrian Netherlands from January 1, 1787 led to organized revolt by conservative Catholic as well as radical revolutionary groups. On April 17, 1787 the Estates of Brabant convened in Brussels and declared the Emperor's reforms unconstitutional. Albert and Marie Christine were so disgusted by the Imperial measures that they revoked all Imperial edicts which infringed the constitution which had been in force in the Duchy of Brabant since 1356 ('Joyeuse Entrée'). The people of Brabant were enthusiastically supportive of the Governors but Albert and Marie Christine had overstepped the jurisdiction of their office. Relations with Joseph II were strained from then on.

The 'Brabant Uprising' was quelled by force in late October 1787 and Imperial authority reasserted itself for the time being.

### June 18, 1789
SUSPENSION OF THE BRABANT
CONSTITUTION ('JOYEUSE ENTRÉE')
LEADS TO THE BRABANT UPRISING

### October 24, 1789
OUTBREAK OF ARMED RESISTANCE
AGAINST AUSTRIA

### November 18, 1789
ALBERT AND MARIE CHRISTINE FLEE

The Emperor Joseph II reacted to the refusal of the Brabant Estates to levy taxes, by suspending the constitution ('Joyeuse Entrée') of the Duchy of Brabant, rebellion broke out again in late July and this time the situation was more critical. Fierce armed resistance, probably modelled on the storming of the Paris Bastille on July 14, 1789, began on October 24, with an attack on Austrian forces at Turnhout.

The unrest grew so dangerous that Albert and Marie Christine were forced to leave the Netherlands in November of that year. They then spent most of their time in the Rhineland as guests of Marie Christine's brother, Maximilian, Prince-Bishop of Cologne.

A few weeks later the Austrian forces were defeated and the rebellious Austrian Netherlands proclaimed their independence. The Austrian administration had to flee Brussels early in December 1789.

### January 11, 1790
PROCLAMATION OF THE
'ÉTATS BELGIQUES UNIS'

On January 7, 1790 the representatives of the Estates General of the Austrian Netherlands convened in Brussels. They proclaimed the independence of the 'United States of Belgium' on January 11. However, the former provinces were torn by internecine strife and the 'États Unis' only lasted until December of that year.

### February 20, 1790
DEATH OF THE EMPEROR JOSEPH II

On February 20, 1790 the Emperor Joseph II died. His brother Leopold (1747–1792), who had been Grand Duke of Tuscany since 1765, succeeded him and was crowned Emperor on October 9, 1790. Although Leopold II sought a peaceful resolution of the continuing conflicts with the Belgians and although he revoked many of his brother's edicts, his Imperial authority was not recognized by his rebellious subjects in the Austrian Netherlands. Accords between Austria on the one hand and Prussia, England and Holland on the other provided for the restoration of Habsburg rule. It was restored, by force, in December 1790. The reconquest of Belgium began on December 2, when Austrian troops marched into Brussels.

### December 10, 1790
THE HAUGE CONVENTION

The rights of Austria to Belgium were confirmed by the European powers at the Hague Convention on December 10, 1790. The original constitution had, however, to be restored in essentials. The sovereignty of the United Provinces of the Netherlands was guaranteed and the controversial Josephine reforms were abandoned.

January 11, 1791
MARIE CHRISTINE'S WILL PROVIDES FOR
THE ADOPTION OF ARCHDUKE CHARLES
OF AUSTRIA AS HER HEIR

March 3, 1791
THE EMPEROR LEOPOLD II APPROVES
THE WILL

The Archduchess Marie Christine had long
thought of adopting Archduke Charles
(p. 21). The earliest mention of this is in the
will she made in 1776.[572] Leopold is
thought to have expressed his approbation
verbally to his sister Marie Christine early
in October 1790 in Frankfurt, where they
had met for his coronation as Emperor.[573]
Presumably knowing that her brother
approved of the adoption, Marie Christine
drew up a will on January 11, 1791.[574]
In it she named Charles—not for the first
time—[575] as her sole heir after the decease
of her husband. The Emperor Leopold II
approved this will on March 3, 1791.[576]

The adoption of Archduke Charles of
Austria by Marie Christine is not confirmed
by special decree. It is only recorded in her
will and there he succeeds to his inheritance
only after the decease of her husband. The
time frame for establishment of the adop-
tion is between October 1790 and March 3,
1791.

June 15, 1791
RETURN OF ALBERT AND
MARIE CHRISTINE TO BRUSSELS

By the time the Governors returned to Brus-
sels on July 15, 1791 to the cheers of the
populace, the Josephine reforms had been
rescinded and the old Estates system had
been restored.

October 1, 1791
ARCHDUKE CHARLES MOVES IN
WITH HIS ADOPTIVE PARENTS

On October 1, 1791 Archduke Charles
arrived in Brussels[577] to be instructed in
diplomatic and political affairs by Albert
and Marie Christine in preparation for his
future tenure as Governor.

March 1, 1792
DEATH OF LEOPOLD II

April 20, 1792
FRANCE DECLARES WAR ON AUSTRIA

After the sudden untimely death of the
Emperor Leopold II on March 1, 1792,
France declared war on Austria on
April 20. French forces invaded the
Austrian Netherlands. In this time of
political crisis, Leopold's eldest son
succeeded to the throne of the Holy
Roman Empire as the Emperor Franz.

November 6, 1792
DEFEAT OF AUSTRIA AT JEMAPPES

Although the Austrian army under the com-
mand of Albert of Saxe-Teschen was initi-
ally successful against France, the first deci-
sive defeat it suffered was at the Battle of
Jemappes on November 6, 1792. French
forces occupied the entire Belgian territory
until late in November 1792. After the
defeat at Jemappes, Albert, who had fallen
seriously ill, again had to flee the Nether-
lands with Marie Christine. In November
their possessions were packed up in haste to
be shipped to Hamburg. One of the three
ships went down in a storm in the English
Channel. It carried valuable works of art,
an important part of the ducal collection.[578]

Albert and Marie Christine then divided
their time between Aachen, Bonn, Cologne,
Münster, Dresden and Vienna.

March 16, 1793
RELIEVED OF THE AUSTRIAN
GOVERNORSHIP IN BELGIUM

In spring 1793 the war against France
seemed to be going well for Austria. After
the Austrian victory at Neerwinden on
March 18, 1793, Austrian troops advanced
once more into Belgium. The Emperor
Franz had, however, relieved Albert and
Marie Christine of the Governorship
shortly before the victory in a handwritten
edict of March 16, 1793,[579] which transfer-
red it to his brother, Archduke Charles of
Austria.

April 4, 1794
ALBERT DESIGNATED REICH FIELD
MARSHAL

November 4, 1794
ALBERT ACQUIRES DRAWINGS
AT THE AUCTION OF THE CHARLES
ANTOINE DE LIGNE COLLECTION

On April 4, 1794 Albert was designated
Reich Field Marshal, commander-in-chief
of the allied forces fighting against France.
He was, however, aware that his troops
were weakened and inferior in numbers to
the French forces. It came as no surprise
to him that his armies could not withstand
the onslaught of the French on the upper
reaches of the Rhine. In despair at the hope-
less prospects for Austria in the field after
such hardships, he wrote to the Emperor on
February 25, 1795 requesting to be relieved
of his command.

On November 4, 1794 the drawings
collection owned by Charles Antoine de
Ligne (1759–1792), who had fallen in
battle, was sold at auction in Vienna.
Albert acquired more than 1700 sheets of
drawings at the auction.[580]

February 25, 1795
ALBERT REQUESTS TO BE RELIEVED
OF HIS COMMAND

April 10, 1795
ALBERT RELIEVED OF MILITARY DUTIES;
MOVES TO VIENNA

The Emperor Franz granted Albert's request
on April 10, 1795. Albert's political and mil-
itary career was now at an end. That same
year Albert and Marie Christine returned
to Vienna. The Silva-Tarouca Palace on
the Bastion, now known as the Albertina,
was placed at their disposal as a residence.
The Emperor had already made over the
property to them in 1794. Albert commis-
sioned Louis de Montoyer, who had already
worked for him in the Austrian Nether-
lands, to renovate and refurbish the palace.
Now Albert had ample time to devote him-
self to enlarging and organizing his collec-
tion.

July 8, 1796

THE EMPEROR FRANZ II APPROVES
THE EXCHANGE OF DRAWINGS FROM
THE HOFBIBLIOTHEK FOR PRINTS
FROM ALBERT'S COLLECTION

On July 8, 1796 a wish Albert had apparently long cherished came true. He was granted permission by the Emperor to exchange prints from his own collection for valuable drawings in the Imperial Hofbibliothek, among them celebrated drawings from Albrecht Dürer's hand. Entries in the ducal inventory lists (called Cahiers) show that about 470 drawings found their way into Albert's collection at the time of the swap. [581]

October 17, 1797

THE PEACE OF CAMPO FORMIO;
AUSTRIA WAIVES RIGHT TO BELGIUM

After the fortunes of war had gone this way and that for both sides in the struggle for the Austrian Netherlands, the French finally defeated Austria. On October 17, 1797 Austria signed the Peace of Campo Formio, giving up Belgium, Lombardy and the left bank of the Rhine. In exchange large parts of the Veneto as well as Istria and Dalmatia were ceded to Austria.

June 24, 1798

DEATH OF MARIE CHRISTINE

The Archduchess Marie Christine, who had fallen gravely ill in spring 1798, died on June 24, at Kaunitz Palace in Vienna. That year Albert commissioned the sculptor Antonio Canova to make a marble funerary monument to his wife (Fig. 24). It was set up in the Augustine Church in autumn 1895. [582]

Albert faithfully executed all the provisions of his wife's will. Under its terms, Archduke Charles was made sole heir to their joint estate. [583]

March 3, 1800

ALBERT BUYS DRAWINGS
AT THE AUCTION OF THE CORNELIS
PLOOS VAN AMSTEL DRAWINGS
COLLECTION IN AMSTERDAM

Albert bought 160 drawings, most of them by Netherlandish artists, at the Amsterdam auction of the collection owned by the Dutch merchant and artist Cornelis Ploos van Amstel. [584]

from 1800

ALBERT'S PALACE RENOVATED
BY LOUIS DE MONTOYER:
WITHDRAWAL FROM PUBLIC LIFE

Renovation and refurbishment of the Silva-Tarouca Palace went on from 1800 to 1804 (p. 17). [585] During the Napoleonic wars (1805 and 1809) Albert had withdrawn to his Hungarian estates. [586] His retirement from public life became more pronounced. However, in 1803 he went to Baden to the spa and again in 1821 he took the waters at Karlsbad and Pystian. [587] His life now centred round enlarging and arranging his collection.

June 16, 1816

ALBERT'S WILL

In the will he had drawn up on June 16, 1816, which contains codicils added in 1819, Albert prudently entailed his art collection. *Fidecommissum* status ensured that it could not be disbanded and that it would stay in Austria. [588]

February 10, 1822

ALBERT OF SAXE-TESCHEN DIES

On February 10, 1822, after months of illness, Albert died at the age of 84. He was buried beside his wife in the Capuchin crypt in Vienna.

# Directors and Principals of the Collection
## after 1822

### Archducal Collection

ARCHDUKE CHARLES
OF AUSTRIA
1771–1847

*Franz Rechberger*, 1771–1841
1822–1827: Principal
of the Collection
1827–1841: Director
of the Collection

*Carl Sengel*, 1797–1872
1841–1847: Director
of the Collection

ARCHDUKE ALBRECHT
1817–1895

*Carl Sengel*, 1797–1872
1847–1863: Director
of the Collection

*Carl Müller*, 1814–1868
1864–1868: Director
of the Collection

*Moriz Thausing*, 1838–1884
1868–1876: Principal
of the Collection
1876–1884: Director
of the Collection

*Joseph Schönbrunner*, 1831–1905
1884–1895: Inspector
of the Collection

ARCHDUKE FRIEDRICH
1856–1936

*Joseph Schönbrunner*, 1831–1905
1895–1896: Inspector
of the Collection
1896–1905: Director
of the Collection

*Joseph Meder*, 1857–1934
1905–1909: Inspector
of the Collection
1909–April 3, 1919: Director
of the Collection
April 3, 1919–December 25, 1920:
Director of the nationalised
Graphische Sammlung

### (State) Graphische Sammlung Albertina from 1920

| | | |
|---|---|---|
| *Joseph Meder*, 1857–1934 | December 25, 1920 – end 1922 | Director of the Albertina |
| *Alfred Stix*, 1882–1957 | January – June 1923 | Acting Principal of the Albertina |
| | July 1923 – May 1934 | Director of the Albertina |
| *Josef Bick*, 1880–1952 | May 1934 – March 1938 and July 1945 – March 1946 | Director of the Albertina |
| *Anton Reichel*, 1877–1945 | March 1938 – August 1942 | Acting Principal of the Albertina |
| | August 1942 – February 1945 | Director of the Albertina |
| *Heinrich Leporini*, 1875–1964 | February – May 1945 | Acting Principal of the Albertina |
| *George Saiko*, 1892–1962 | May – July 1945 | Acting Principal of the Albertina |
| *Josef Bick*, 1880–1952 | July 1945 – March 1946 | Director of the Albertina |
| *Karl Garzarolli-Thurnlackh*, 1894–1964 | March – August 1946 | Principal of the Albertina |
| | August 1946 – April 1947 | Director of the Albertina |
| *Otto Benesch*, 1896–1964 | May 1947 – end 1947 | Principal of the Albertina |
| | end 1947 – end 1961 | Director of the Albertina |
| *Walter Koschatzky*, b. 1921 | January 1962 – September 1986 | Director of the Albertina |
| *Erwin Mitsch*, 1931–1995 | October 1986 – August 1987 | Interim Principal of the Albertina |
| *Konrad Oberhuber*, b. 1935 | Since September 1987 | Director of the Albertina |

# Endnotes

## Abbreviations

| | |
|---|---|
| exh. cat | exhibition catalogue |
| Ak. d. Wiss., Wien | Akademie der Wissenschaften, Vienna |
| All. Verw. Archiv | Allgemeines Verwaltungsarchiv (general administrative archive) |
| auct. cat. | auction catalogue |
| BDA | Bundesdenkmalamt (Federal Office for the preservation of historical monuments, Vienna) |
| lf. | leaf size |
| BM | Bundesministerium (federal ministry) |
| repr. | size of representation |
| dat. | dated |
| Doc. Abt. Biogr. | Document from Abteilung Biographisches Lexikon, Akademie der Wissenschaften, Vienna |
| bord. | border |
| Habs. Fam. A. | Habsburg Family Archives |
| HHSTA | Haus-, Hof- und Staatsarchiv, Wien (property and state archive, Vienna) |
| inv. no. | inventory number |
| Jg. | Jahrgang (year) |
| l. | left |
| c. | center |
| N. F. | Neue Folge (new sequence) |
| t. | top |
| O-Me-A | Obersthofmeisterakten |
| ÖNB | Österreichische Nationalbibliothek |
| ÖSTA | Österreichisches Staatsarchiv |
| Öst. Biogr. Lex. | Österreichisches Biographisches Lexikon |
| Pl. | Plate size |
| r. | right |
| sign. | signed |
| b. | bottom |
| UNA | Hungarian National Archives, Budapest |

Since the Albertina archives and the records archives are in different parts of the building, two different names have been given here. When dimensions are stated, height comes before width.

1 For publications on the history of the Albertina collection cf. pp. 33–45 with note, esp. note 313.

2 For the current inventory figures cf. p. 45. For the history of the growth of the collection cf. p. 30–45.

3 Joseph Meder wrote on the naming of the collection: " ... the systematic growth of what united a collection of the most valuable drawings and copperplate engravings was, by [Albert's] death in 1822, known as 'Sammlung des Herzogs Albert' (The collection of Duke Albert [of Saxe-Teschen]); later this collection of art was known as 'Sammlungen des Erzherzogs Karl auf der Augustinerbastei' (Collections of Archduke Charles on the Augustine Bastion) and later as 'Galerie und Bibliothek des Erzherzogs Albrecht' (Archduke Albert's Gallery and Library). The collection was named after each successive owner. The year of the 1873 Exhibition ... Albertina Director ... Thausing suggested it should be named 'Albertina', i.e. 'Collectio Albertina', in honour of the founder. The name soon caught on and was retained even under the next heir to the collection, Archduke Frederick, ...." (Meder 1922, p. 73). After the collection was amalgamated with the Imperial Copperplate Engravings Collection (Kaiserliche Kupferstichsammlung) in 1920 the name 'Staatliche Graphische Sammlung Albertina' came into official use but was changed in 1921 into 'Graphische Sammlung Albertina' (cf. p. 42).

4 This figure is based on the sources quoted on p. 31 and p. 32 and is confirmed in essentials on the basis of what is known today: added to the entry figures for the following years (cf. from p. 32), it gives the current total inventory figure.

5 Cf. p. 32.

6 With the exception of some single leaves which date from before the 15th century.

7 Cf. p. 27.

8 In 1816 Albert entailed (*fideicommissum*) his art collection in his will in order to assure that it would be kept together and remain in Austria as a Habsburg possession (cf. notes 124 and Figs. 25–27).

9 For an outline history of Albert's life see pp. 153–157. Cf. Koschatzky and Krasa 1982 (with further references).

10 In 1733 Frederick Augustus II was elected King of Poland (cf. exh. cat. Essen 1986, p. 40 and passim).

11 Cf. Koschatzky and Krasa 1982, pp. 26–30.

12 Albert of Saxe-Teschen, *Mémoires*, Vol. 1, p. 101 (cf. Koschatzky and Krasa 1982, p. 27).

13 The complete edition of the *Mémoires* is in Dresden (Staatsarchiv, Nachlass (estate) of Albert of Saxe-Teschen). A second copy, damaged by fire is in the UNA (Habsb. Fam. A., P 298-1d, Nr. 2; photocopies of it, which are quoted in the present work, are contained in 17 volumes in the Albertina). The undated *Mémoires* are for the years 1738–1798, in the supplement volumes the subsequent years until 1812. Albert planned and outlined them after he fled (at the close of 1792) from the Austrian Netherlands (cf. Vol. I, preface, p. 3) and had them recorded in French by several secretaries.

14 Albert of Saxe-Teschen, *Mémoires*, Vol. 2, p. 202f. (see Koschatzky and Krasa 1982, p. 33).

15 Albert of Saxe-Teschen, *Mémoires*, Vol. 1, p. 103 (see Koschatzky and Krasa 1982, p. 27).

16 Albert of Saxe-Teschen, *Mémoires*, Vol. 5, p. 688 (see Koschatzky and Krasa 1982, p. 61).

17 See p. 154; (letters) written by Albert and Marie Christine indicate that the marriage was a particularly happy one (see Koschatzky and Krasa 1982, passim, esp. pp. 62–64 and p. 210f.).

18 See Koschatzky and Krasa 1982, esp. p. 12 and p. 16; exh. cat. Vienna, Albertina, 1969, p. 51.

19 Much of the dowry came from the estate of her father, Emperor Franz I Stephan of Lorraine (1708–1765), who died in 1765. The marriage portion in cash amounted to 100,000 guilders, which would be about 10 million Austrian shillings in today's currency (I am indebted to Mr Schwab-Trau, of the Vienna University Institute of Numismatics for converting the sums). Cf. the nuptial contract of April 5, 1766 (UNA, Habsb. Fam. A., p 1490–1d, Nr. 6, p. 103 verso) and the ratification of the nuptial contract by Saxony on 19.4.1766 (HHSTA, Familienurkunden (family records) No. 2026; cf. exh. cat. Vienna, Albertina, 1969, p. 51).

20 In February 1766 Marie Christine was given "Hungary-Altenburg [Magyaróvár, today: Moson-Magyaróvár] and Mannersdorf (each worth 2,700,000 fl.), the Duchy of Teschen (worth 73,4512 fl. 40 kr), bank bonds worth 598,166 fl. 40 kr. ... and ... also in bank bonds 188,696 fl. 31 1/2 kr. ... worth a total of 4,221,375 fl. 51 1/2 kr." (Mikoletzky 1963, p. 389; cf. Koschatzky and Krasa 1982, p. 77). I am indebted to Mr Schwab-Trau, of the Vienna University Institute of Numismatics for converting the sums. According to G. Biermann, *Geschichte des Herzogthums Teschen*, Teschen 1894, p. 236, Maria Theresia made over the Duchy of Teschen to Albert and Marie Christine on 31.5.1766 (I am indebted to Gregor Semrad, Vienna, for pointing this out to me).

21 Frederick Augustus I the Strong (1670–1733), Elector of Saxony (from 1694), began as King Augustus II of Poland (from 1697) to reorganise the Dresden collections which had grown by leaps and bounds, and to exhibit them in discrete sections. His son, Frederick Augustus II, as King Augustus III of Poland, actively continued to organise the collections systematically. The lively interest taken in art at the Dresden court may well have exerted a formative influence on his young son Albert (see exh. cat. Munich 1992, p. 22f.; Heres 1991, pp. 98–133; Cremer 1989, from p. 107; exh. cat. Essen 1986, pp. 195–201, pp. 277–279; Meder 1922, p. 78).

22 Cf. Albert of Saxe-Teschen, *Mémoires*, Vol. 1, passim.

23 As a collector, Albert increasingly concentrated on drawings and prints (see p. 46f.). A focus of interest in his prints collection included military plans, maps and atlases. From 1787 he had François Lefèbvre in his employ as Inspector (Curator) of the drawings and maps collection (see note 126). There are no definitive sources on the beginnings and scope of the plans and maps collection. The four-volume hand-written *Catalogue des Cartes et Plans appartenant à Son Altesse Royale Monseigneur le Duc Albert de Saxe* (ÖNB, map collection, without inv. no.; the

volumes catalogue plans owned by Albert and the Archdukes who succeeded to the collections) contains neither acquisition dates nor totals of works in the collection. On the title page of Vol. 11 is the date 1802 (added later?). In Vol. 11 there is also a note in the original writing of the secretary on p. 498 which records that leaves were kept "sur les tables dans le Cabinet des Cartes." That leaves 1802 as the *terminus ante quem* for the existence of a map cabinet. There is no evidence for a date on which collecting began in this field. In 1887 Schönbrunner estimated this collection at 23,000 to 24,000 leaves (Schönbrunner 1887, Berichte (Reports), p. 204). Presumably based on the above mentioned 4-volume catalogue, a later handwritten catalogue of the archducal maps and plans collection organised on geographical lines in 17 volumes (ÖNB, map collection) contains, in Vol. 1 (on the 1st cover flap) as well as in Vol. XVII (on the last page) a mention of "25,540 leaves counted in June 1924 Bauer." Elisabeth Zeilinger, ÖNB, map collection, informs me that that currently the maps and plans owned by Albert and his heirs (up to the time they were given to the map collection in 1921) is only about 7,000 leaves as inventoried. However, it should be noted that atlases and maps consisting of more than one sheet were inventoried as 1 item. On the map collection see Trenkler 1949; Stummvoll 1968 and 1971; Wawrik 1991/92, pp. 141–161. Albert and Marie Christine also owned paintings, porcelain, jewelry, silver, and carpets. Cf. the estate inventory of 1799 (Fig. 23) and Albert's will (HHSTA, Familienurkunden, fa 2264).

24 See the drawings in the Albertina under the heading Div. Schools, Vol. 12, 12a, 13.

25 Giacomo Conte Durazzo (1717–1794) came from a rich aristocratic Genoese family which had been culturally and politically active in Genoese affairs for generations. He went to Vienna as an ambassador in 1749. There, soon after his marriage in 1750 to Aloisia E. Ungnad von Weissenwolf, he abandoned diplomacy for posts in theater and opera administration. In 1754 he became General-Spectakeldirektor and Hofkammermusikdirektor (Director-General of Spectacles and Court Chamber Music). Conflicts and intrigues caused Durazzo to leave Vienna in 1764 for Venice, where he became Imperial Austrian emissary. After returning to Venice in 1773, he visited Albert in Pressburg. See Dizion. Biogr. 1960–1995, Vol. 42 (1993), pp. 150–153; exh. cat. Vienna, Albertina, 1976; Koschatzky 1964, pp. 3–16; Koschatzky 1963 (Durazzo I), pp. 47–61.

26 Durazzo 1776, 1st version, inv. no. 30858ᶜ, recto (Fig. 7). My thanks to Richard Bösel for translating this (and other) Italian texts.

27 Cf. Benincasa 1784, pp. 4–5: "His Highness, Duke Albert of Saxe-Teschen, … who had commisioned him [Durazzo] in 1774 to collect engravings."

28 Giacomo Conte Durazzo, Legation report to the Duke of Kaunitz, 15.6.1776 (HHSTA, Staatenabteilung Venedig 43 (alt [old] 52), fol. 106 verso, 107).

29 Cf. Koschatzky 1963, p. 5; Koschatzky 1963 (Durazzo I) p. 56; Koschatzky and Krasa 1982, p. 12, p. 130.

30 Durazzo 1776, version I, inv. no. 30858ᵇ, recto (Fig. 5). There is no precise evidence indicating which sheets were handed over because there are no records of the transaction.

31 Early in July 1776 Albert and his wife were on their way back from the Italian journey they had been on since December 1775. They stayed in Venice, where they were given the collection (see Durazzo 1776, 1st version, preface), from July 5 to 7,1776, and visited Durazzo each day (cf. Albert of Saxe-

Teschen, *Mémoires*, Vol. 10, pp. 623–637; Albert of Saxe-Teschen 1776, pp. 105–108).

32 Benincasa 1784, p. 47. Because records of provenance are lacking for these sheets in the inventory lists of the ducal print collection, they cannot be distinguished from the rest of Albert's prints. Durazzo started an engravings collection of his own but when he began to do so is unknown, which was sold at auction in 1872 (cf. auct. cat. Durazzo 1872 [Lugt 1938, no. 33450]; 386 drawings were also sold at auction then) and 1873 (cf. Lugt 1938, no. 34052).

33 See Benincasa 1784; the title translates as: *Description of the Engravings Collection of Jacopo, Count Durazzo*.

34 Benincasa 1784, p. 6. I am indebted to Paul Lorenz, Professor at the Vienna University Institute of Classical Philology, for translating it from Latin. When and where this second collection was placed in Albert's hands is not mentioned. The frontispieces mentioned in it can no longer be ascertained in the Albertina In his *Descrizione* always refers to "due Raccolte", "Raccolte unite dal Conte Durazzo" or "due accennate Raccolte" (Benincasa 1784, pp. 7f., 41), that is, to what the collection contained by 1784. For the addition of a Scuola Inglese in the 2nd Durazzo collection cf. note 38.

35 The sheet with the dedication to Albert (Fig. 4), on which Durazzo records that the collection given to Albert in Venice was already his is dated September 1776. There are two versions of the *Discorso Preliminare* in the Albertina: inv. no. 30858ᵃ⁻ᶠ (version I) and inv. no. 30858¹⁻⁵ (Version II). Cf. Koschatzky 1991/92, pp. 37–39; Koschatzky 1964, pp. 3–16 (with a translation of the *Discorso*).

36 Durazzo 1776, Version I, inv. no. 30858ᵈ, verso. The decorative brush drawing which serves as the cover of this text (Fig. 59) might be from Durazzo's hand. Adam von Bartsch made a copy of it and then translated it into an etching in 1804 (Fig. 58; cf. Bartsch 1818, p. 26, no. 60; Koschatzky 1964, p. 5). The engraving is still used as the cover for the coffins in which the ducal prints are kept.

37 Durazzo 1776, Version I, inv. no. 30858ᵈ, recto (Fig. 9).

38 He divided the print collection into "due Classi di Scuole Italiane ed Oltramontane," and subdivided the Italiane, which contained the largest number of leaves, into La Romana, La Veneziana, La Bolognese, La Lombarda. The Oltramontane was subdivided into La Tedesca, L'Olandese, La Fiamminga, La Francese (Durazzo 1776, Version I, inv. no. 30858ᵈ, verso). The first collection, the 1776 one, did not have a separate section for English prints. Durazzo added a Scuola Inglese to his second collection, completed in 1784: "Thus the numerous copperplate engravings of work by important English artists were given their own classification, entitled—as the same Conte Durazzo did for the collection he later gathered together—The English School" (Durazzo 1776, Version II, inv. no. 30858¹, p. 8f., note.).

39 Durazzo 1776, Version I, inv. no. 30858ᵈ, verso (Fig. 10).

40 Durazzo 1776, Version i, inv. no. 30858ᵈ, verso and inv. no. 30858ᶜ, recto (Figs. 10–11).

41 See Koschatzky 1963, pp. 8–11. Abbé Michel de Marolles (1600–1681) is regarded as the initiator of the development which led from ducal Kunstkammern which were universal in scope to systematically ordered and catalogued specialist collections. His collection was "the first to also have a scholarly catalogue. It was divided into artists and objects—that is, imagines" (Krasa 1986, p. 293). In the 1666 catalogue Marolles grouped the artists neither by national school nor chronologically but according

to their fame (Marolles 1666, p. 19; cf. Schnapper 1994, pp. 247f., 251–253; Koschatzky 1963, p. 10). Marolles divided his second collection, with a catalogue which appeared in 1672 thematically, and by "Maîstres … sans ordre." He did not, however, carry out his plan of later ordering it by nation or alphabetically (Marolles 1672, p. 10f.).

42 On Crozat see Dossi and Kertész (work in progress). Crozat, who probably began to collect art in about 1683, arranged the drawings (he also had prints) in his collection by regions (called schools) and subdivided these chronologically by artists (cf. Hattori 1993, pp. 20–22).

43 On Jean and Pierre-Jean Mariette see p. 55; Dossi and Kertész (in progress). The copperplate engravings collection owned by Eugene of Savoy was chiefly ordered by regions (Schools) and also chronologically by artists as well as partly by subject matter (see Krasa 1986, pp. 293–331).

44 See exh. cat. Essen 1986, p. 277f.; Dittrich 1981, pp. 43–54.

45 See exh. cat. Essen 1986, p. 278; Dittrich 1981, p. 43.

46 Heinecken divided the prints into 12 classes. He subdivided most of the collection into national Schools and then subdivided the Schools alphabetically: first by painters and then, even this early, by engravers. Cf. Heinecken 1771, p. 3f., p. 111–115, p. 138f., pp. 174–179, pp. 196–206, p. 213–216 and pp. 492–499.

47 Heinecken was a friend of P.-J. Mariette's and acquisitions made for the Dresden cabinet by Heinecken are recorded from 1743 with Mariette acting as an intermediary (cf. exh. cat. Essen 1986, p. 277; Dittrich 1981, pp. 43–54).

48 Mandroux-França 1986, p. 52.

49 See Mandroux-França 1986.

50 Christ 1757, title page (see Koschatzky 1963, p. 12).

51 In addition to Ecoles, they were subdivided into Portraits, Histoires & Portraits en Maniere noire, Differents Estampes en Livres ou en Paquets. Têtes, Bustes & autres œuvres des anciens Estampes d' Architecture (cf. Christ 1757, p. a2).

52 Koschatzky 1964, p. 14.

53 See p. 50f.

54 Krasa 1986, p. 296.

55 Prints were ordered chronologically by painters, in some cases also by engravers: however, for instance, Marcantonio Raimond's prints after works by Raphael can only be found under the heading Raphael.

56 Cf. Durazzo 1776, Version II, inv. no. 30858¹, p. 9: here Raimondi is classified under his own name.

57 Cf. "Copperplate engravings which derive from a painter and engraver, each of whom has his own Œuvre, must be classified under that of the copperplate engraver and not the painter. For instance, it would be preferable for a sheet engraved by G. Edelinck after Raphael to be missing under the former than the latter and the work of the copperplate engraver would have pride of place." (Bartsch 1820, p. 7). Cf. Adam von Bartsch *Le Peintre Graveur*, vol. 21, Vienna, 1821, Index p. XI

58 See Meijers 1990, p. 146f. and Summary, p. 3.

59 Mechel may have been directly inspired by the Düsseldorf Paintings Gallery. Shortly before he came to Vienna, he had made copperplate engravings of the works in it (cf. Mechel 1778, preface, p. X). Christian Ludwig von Hagedorn, to cite another early example, had already arranged his paintings 20 years before in national groupings (cf. Hagedorn 1755, p. 6f.; Koschatzky 1963, p. 12).

60 Cf. Mechel 1783; see also Meijers 1990, p. 34.

61 Heinz 1967, p. 15.

62 Mechel 1783, p. xif.

63 Mechel 1783, p. xviii.

64 Lairesse 1728, 1st Part, 4th chapter, p. 57.

65 Watelet and Lévesque 1792, Vol. 2, p. 605f.

66 Huber and Rost 1796, p. 46f.

67 Huber and Rost 1796, p. 50f.

68 Sulzer 1771–1774, p. 613.

69 Sulzer 1771–1774, p. 614.

70 Benincasa 1784, p. 7f.

71 Piles 1681, p. 46f.

72 Félibien 1676, p. 396.

73 Piles 1708, p. 126f.

74 Piles 1708, p. 127.

75 Monier 1698, preface.

76 Monier 1698, 1st Book, 1st chapter, p. 3.

77 Richardson 1715 in the new edition of 1792, p. 63.

78 Richardson 1728, Vol. 1, p. 121.

79 Caylus 1732 in the new 1845–46 edition, p. 400.

80 Caylus 1732 in the new 1845–46 edition, p. 401.

81 Cf. Mariette 1741.

82 Mariette 1741, title page.

83 See Mariette 1741.

84 D'Argenville 1745–1752, Vol. 1 (1745), pp. xv–xx.

85 D'Argenville 1745–1752, Vol. 1 (1745), p. xvi.

86 D'Argenville 1745–1752, Vol. 1 (1745), p. xxii.

87 D'Argenville 1767–1768.

88 Hagedorn 1762, 2nd Part, pp. 499–513.

89 Heinecken 1771, p. 518.

90 See Pomian 1987, passim (esp. pp. 53–56 and p. 222); see also p. 60f.

91 See pp. 48–53.

92 Mr. Schwab-Trau, Vienna University Institute of Numismatics kindly converted the sum for me.

93 See the chapter on the Foundation and Growth of the Drawings and Print Collection, from p. 46.

94 Cf. ledger entries on sums spent, Fig. 4.

95 See p. 155.

96 The shipwreck can be dated between 8.11. and 25.12.1792: Albert noted the date of departure of the vessels as "Le 8 Novembre, jour fixé pour le Départ des effets" (Albert of Saxe-Teschen, *Mémoires*, Vol. 16, p. 122). On 25.12.1792 Albert's secretary, Girtler v. Kleeborn, described the disaster as very recent (cf. p. 28f.).

97 "Record of the chests which contained the property of Your Royal Highnesses and [accompanying] persons, which were lost when the ship La Femme Lemonge under Captain Muester went down" UNA, Habsb. Fam. A., p 298–84, no. 67.

98 Cf. Albert's library catalogue (Albertina), Vol. 1, Index, 3rd Section, u, b (Fig. 22) and Vol. 1, *Note preliminaire*, last sentence of the note (Fig. 21). In 1795 Johann Georg Meusel mentioned the "excellent [copperplate engravings] collection ... of Duke Albert of Saxe-Teschen," whose "comprehensive critical description [was] lost being transported from the Netherlands, together with other valuable items" (Meusel 1795, p. 519). What Meusel meant by "description" was probably in essentials the inventory lists drawn up by Durazzo, which are also mentioned in the *Discorso Preliminare*, in a *Nota* added after 1792, as lost with the ship that went down (Fig. 6): "it should be ... noted that it has not hitherto been possible to draw up new ... catalogues [to replace] those which, for the most part, were lost in a shipwreck with everything Conte Durazzo recorded in the matter" (Durazzo 1776, Version 1, inv. no. 30858ᵇ, verso, *Nota*).

99 Benesch 1964, p. 17; it is not known what Benesch's source was.

100 Letter written by Albert's Cabinet Secretary, Girtler von Kleeborn, to Hofrat Faulhaber on 25.12.1792; UNA, Habsb. Fam. A., p 298–40a (see Koschatzky and Krasa 1982, p. 190).

101 Albert of Saxe-Teschen, *Mémoires*, Vol. 16, p. 122.

102 See note 126.

103 Albert of Saxe-Teschen, *Mémoires*, Vol. 16, p. 134 (see Koschatzky and Krasa 1982, p. 197).

104 On July 5, 1792 Archduke Franz (Francis) was elected Emperor of the Holy Roman Empire as Franz ii; on August 11, 1804 he had himself crowned Franz i, Emperor of Austria.

105 Albert of Saxe-Teschen, *Mémoires*, Vol. 17, p. 255 (see Koschatzky and Krasa 1982, p. 201).

106 HHSTA, O-Me-A no. 130 from 1794, fol. 312–315 from 26.3.1794: Note to Albert and Marie Christine, referring to the making over of the Tarouca Palace with all projected additions. The contract of this transaction is dated 22.3.1794 and is in HHSTA, O-Me-A no. 130 from 1794, fol. 286–292. See Koschatzky and Krasa 1982, p. 202f.

107 "The entire property was handed over in December 1794 .... In 1795 Marie Christine and Albert were finally able to move into the Tarouca Palace. Extensive construction work had been planned from the outset ...." (Herzmansky 1965, p. 56; see Pellar 1988, exh. cat. Vienna, Albertina, 1969, p. 9f.). They were to live together in the Palace for only a few years. When Marie Christine became terminally ill early in 1798, they moved into a house in the Augarten and in May 1798 into a garden house belonging to Prince Kaunitz in Mariahilf, where Marie Christine died on June 24, 1798 (see Koschatzky and Krasa 1982, p. 209f.). On the history of the Albertina building see Herzmansky 1965 and Herzmansky 1966.

108 In 1870 Thausing wrote: "There are eyewitness accounts of how the elderly man spent his days in these sacrosanct rooms from early in the morning until late at night. The only leisure he allowed himself was the time needed for meals and walks. Scholars and artists passing through Vienna always found him at home, invariably hard at work arranging and enlarging his collection of art treasures." Thausing 1870–1871, p. 76; cf. Meder 1922, p. 84. Albert's appearance has been recorded for posterity. In his later years he was "a slender old man wearing a white Empire wig and dressed in a blue frock coat and high boots, ... [who] as a lonely man, followed by a little white dog ... visited his treasured art and book collections" (Meder 1922, p. 74).

109 Albert of Saxe-Teschen, *Mémoires*, Vol. 17, p. 268 (see Koschatzky and Krasa 1982, p. 211).

110 See Krasa 1967–1968, pp. 67–134.

111 Cf. De Freddy 1800, p. 413; Fueßli 1801–1802, p. 203; [anonymous], *Guide du voyageur à Vienne, description et précis historique de cette capitale*, Vienna 1803, p. 121f.

112 Fueßli 1801–1802, p. 203; cf. Schönbrunner 1887 (Berichte: Reports), p. 191.

113 See Herzmansky 1965, p. 61f.

114 Cf. letters written by Albert in 1796, p. 52f.; Koschatzky and Krasa 1982, p. 207f. There are no records showing which and how many parts of the collection were still in Dresden at that time.

115 Renovation and enlargement work on the building lasted from 1800 to 1804 (see Herzmansky 1965, pp. 61–77).

116 UNA, Habsb. Fam. A., p 298–57, p. 18.

117 The considerable discrepancy between the sum given in 1799 (20 million shilling) and the (in today's money) 126 millionen shillings which Albert spent from 1783 to 1822 on acquiring items for his collection (see p. 27, note 92) is due to an enormous increase in annual expenses for drawings and prints from 1800 compared with the years before that (see Fig. 16). Albert spent far more on art in 1811 than in any other single year: the equivalent of roughly 11.6 million Austrian shillings today. There are no records showing which works he bought in 1811. However, there was a huge turnover in prints sold at auction in 1811 (see Lugt 1938 under '1811'). Mr. Schwab-Trau of the Vienna University Institute of Numismatics has very kindly converted the sums for me.

118 La Garde-Chambonas 1820 in the new edition of 1901, p. 399.

119 See [anon.] *Wien und dessen Merkwürdigkeiten ...*, Vienna 1818, p. 112f.

120 Böckh 1821, p. 288.

121 Jaeck mentions "14,000 leaves in 237 volumes" (Jaeck 1822, p. 190).

122 Albert's inventory lists of 1.6.1821 indicate a total number of approx 163,000 leaves catalogued by region (school) and subdivided by artists in alphabetical order.

123 Charles Louis (Ludwig) of Habsburg-Lorraine, Archduke of Austria (Florence 1771 – Vienna 1847), was the third son of the Grand Duke of Tuscany, who was to become the Emperor Leopold ii, and Marie Louise de Bourbon. Appointed Stadholder General of the Netherlands by his brother, the Emperor Franz ii, he visited his adoptive parents in Belgium in 1791 to be instructed in his duties. He took office in 1793. During the Napoleonic Wars he won numerous victories, the most famous of which was the Battle of Aspern in 1809. His military career ended that year. In 1815 he married Henriette von Nassau-Weilburg. They had four sons and two daughters (see Hamann 1988, pp. 219–222; Öst. Biogr. Lex. 1957–1994, Vol. 3 (1965), p. 239f.).

124 The will Albert had drawn up on 16.6.1816 (with codicils dated 1819) is both in the HHSTA: Familienurkunden 2264, 1816 VI. 16, fol. 1–14, and in the UNA: Habsb. Fam. A., p 1490, no. 19, 3d, pp. 22–32. In clause 7 (Fig. 27) Albert stipulates that the eldest Archduke of each generation to follow is to administer the drawings, copperplate engravings and plans collections as long as he should live in Austria. The whole collection which Albert bequeathed and all that each heir to the entailed collection might add to it during his lifetime remained entailed (*fideicommissum*): "In that I bequeath to my sole heir to remain at his disposal—under the title of the worldly possessions not included in the legacy in the meantime however, I make over to my country maps, plans, drawings and copperplate engravings collections in *fideicommissum* which, after his death, shall be entailed on his heirs and from then on always on an Archduke who shall be of the present Austrian Family who shall live in the domains of the Austrian Monarchy" (see Koschatzky 1991/92, p. 92; Koschatzky 1971, p. 59f.).

125 Letter of 12. April 1822 (UNA, Habsb. Fam. A., p 1490, no. 19, 3d, p. 33; photokopies: Albertina archives; see Koschatzky and Krasa 1982, p. 240f.).

126 François-Joseph Lefèbvre (Brussels, ca 1762 – Deutsch Wagram 1835) was, from 1.1.1787 Inspector (Curator) of Albert's collection of drawings and plans (cf. codicil 'c' of Albert's will; HHSTA, Familienurkunden, fa 2264). Like Joseph van Bouckhout, he entered Albert's employ on March 1, 1783 as a Journalier on a daily basis. In 1792 Lefèbvre and van Bouckhout fled the Austrian Netherlands with Albert and Marie Christine and afterwards took care of the ducal art collection which had been transported to Dresden. Presumably the two curators moved to Vienna in about 1805, after the Palace had been renovated. Lefèbvre, who was now Director of the drawings collection, seems to have lined his pockets during the Napoleonic Wars by helping himself to items

from the ducal cabinet, particularly from the Dürer collection. This must be the reason why Archduke Charles replaced him with Franz Rechberger after Albert's death. Lefèbvre was officially discharged in 1826. The Albertina collection contains numerous drawings and watercolours from Lefèbvre's hand, most of them series of views of the Austrian Netherlands (see Koschatzky 1971, pp. 60–73; Englebert 1965, pp. 83–90; Benesch 1964, p. 21; Meder 1919, p. 646, note 3). All that is known about Joseph (van) Bouckhout (Boeckhaut) is his name and the circumstance that he worked on a daily basis (Journalier) from March 1, 1783 and from January 1, 1787 as Curator (Inspector) of Albert's copperplate engravings collection. Research on the present book has brought the dates of his death and birth (1756) to light: Joseph Boeckhaut, retired Curator of the Albrechtisch Picture Gallers (herzogl. Albrechtischer Bilder-Gallerie Inspektor), died on April 28, 1825 at the age of 69 in Vienna (Vienna, Stadtarchiv, Alte Civiljustiz Verlassenschafts-Abhandlung Fasc. 2-3317/1825).

127 Franz Rechberger (Vienna 1771–Gutenstein 1841) studied between 1785–1795 at the Vienna Fine Arts Academy, where he trained as a landscape painter and engraver. A friend and colleague of Adam von Bartsch, Rechberger acquired quite a reputation as a connoisseur. From 1797 he was Curator of the drawings and copperplate engravings cabinet owned by the banker Moriz von Fries. When the banking house went bankrupt in 1820, many of the drawings and prints in the von Fries collection found their way into Albert's cabinet. After Albert's death, Archduke Charles appointed Rechberger to check the collection against the inventory lists. He remained Curator of the collection—from 1827 Director—until his death by his own hand (1841). The new arrangement of the prints collection in three sections was his work (see p. 37).

128 The scanty sources indicate that Straube was the Curator of Archduke Charles's Curator (Gallerie-Inspector) from 1822/23–1831.

129 It is impossible to determine whether and, if so, to what extent the drawings were marked with Albert's stamp (see p. 61f.). What is known, however, is that when the drawings were checked against the inventories, not all the leaves which were in the collection at the time of Albert's death were thus marked. There are drawings which are listed in the old inventories (Cahiers), that is, belonged to Albert's estate yet do not bear the impress of any stamp. The drawings acquired by Archdukes Charles, Albrecht and Frederick after Albert's death do not bear a mark showing whose they were. Even after that, acquisitions were not marked with the impress of a stamp to show they belonged to the collection. Not until the 1940s, and then not consistently, was the front of passepartouts thus marked (in black) (Fig. 77). From about 1988 this seal appears in gold colour (see Lugt 1956, p. 2, p. 23).

130 Undated report made by Rechberger before May 13, 1822 to Archduke Charles (UNA, Habsb. Fam. A., p 1490, no. 19, 3d, p. 46f.; photocopies in the Albertina archives). The report must have been written before May 13, 1822 because Archduke Charles had already sent it on to the Emperor Francis by then: "To his Majesty the Emperor and King. Vienna 13th May 1822. Herewith I lay before Your Majesty the preliminary report by the artist F. Rechberger charged with the taking over the ducal art collections. From it may it please Your Imperial Majesty to ascertain in general the value of the drawings as art … I have inventoried

what is there in compliance with regulations and have given it over to the charge of the officals responsible" (UNA, Habsb. Fam. A., p 1490, no. 19, 3d, p. 45; photocopies in the Albertina archives).

131 For the ducal drawings inventories (Cahiers) see p. 56f. and note 437.

132 Franz Rechberger registered, in the entailment inventory, which is not dated but must have been drawn up between 1822 and 1825 (= when the 1st volume of the entailment inventory of the prints appeared), about 13,600 drawings. The figure tallies with the historical sources for the size of the collection size (see pp. 30–32) and is verifable if the acquisitions made from 1822 are subtracted.

133 UNA, Habsb. Fam. A., p 1490, no. 19, 3d, p. 49f. (photocopies in the Albertina archives). My thanks to Leopold Kammerhofer, HHSTA, for transcribing Rechberger's report.

134 Franz Rechberger, Director of the Gallery, and Gottlieb Straube, Curator of the Gallery are the undersigned who are responsible for the inventory and cataloguing.

135 The inventories follow Durazzo's system. Albert's print collection was arranged and catalogued according to it (see p. 13f.).

136 Volumes I and II are dated 1825; volumes III and IV 1826; Vol. V 1827. Volumes VI and VII are not dated. The works they contain are ordered by region, that is by School, and the Schools are subdivided chronologically by artists. These volumes contain no figures pertinent to the size of the print collection.

137 Gottlieb Straube, Inventory of the ducal prints of 7 September 1822 (UNA, Habsb. Fam. A., p 1490, no. 19, 3d, p. 38; photocopies in the Albertina archives).

138 Between May 1822, after the drawings collection had been completely inventoried (see p. 32), and September 1822 the size of the print collection was estimated. An exact check of the works against the inventory lists against the works took several years (see note 136).

139 The leaves kept in portfolios were obviously not counted correctly. By 1821 there were some 163,000 leaves according to the inventory lists for the catalogues listing artists in alphabetical order (see note 122); however, they must have been overlooked. Works such as gallery and landscapes were not in portfolios although they were also bound but were apparently not counted.

140 In 1870 Thausing speaks of, apparently underestimating the figure, some 200,000 works (see p. 33, note 156); Schönbrunner in 1886 of "somewhat more than 220,000 leave[s]" (see p. 38, note 172); Weckbecker in 1891 of "circa 220,000" items (Weckbecker 1891, p. 57) and Robert wrote in 1898 "Les estampes sont au nombre de 230,000" (Robert, 1898, p. 137). If we subtract the number of acquisitions made by the Archdukes Charles (18,000 leaves by 1847) and Albrecht (12,000 items by 1895) from the above figure, we arrive at an overall figure of 190,000 to 200,000 works in Albert's collection. Even if one goes backwards from the present size of the collection (see p. 45, note 326) subtracting acquisitions made down to 1822, the figure one arrives at for the ducal print collection is approx 200,000 leaves.

141 The difference between the 190,000 to 200,000 leaves in Albert's collection and the 163,000 which can be verified as having been in the portfolios in 1821 (see note 122), must be due to the remaining, that is bound prints (such as gallery and bound landscapes or vedute). Schönbrunner, Weckbecker and Robert obviously added these to the total (note 140).

142 For Rechberger's new ordering and arrangement of the prints in sections see p. 37.

143 Carl Sengel (1797–21.6.1872) was Albert's clerk from 1811. From 1823 he was Librarian, and, after Rechberger's death (in 1841) until his retirement (in 1863), Director of Archduke Charles's collection.

144 What was counted were the drawings and prints in the *Verzeichniss der Original-Zeichnungen und Kupferstiche, welche von Weiland Seiner kaiserlichen Hoheit dem durchlauchtigsten Herrn Erzherzoge Carl vom 10. Februar 1822 bis zum 30. April 1847 angekauft, und der von Weiland Seiner Königlichen Hoheit dem durchlauchtigsten Herzoge Albrecht von Sachsen Teschen hinterlassenen fideikommissarischen Kunstsammlung einverleibt wurden* (Albertina archives). See also the *Verzeichnisz der Kunst-Gegenstände und Bücher, welche Seine Kaiserliche Hoheit der Erzherzog Carl in den Jahren 1822 bis Ende Junius 1829 für die Gallerie anzuschaffen geruhet haben* (Albertina archives) and *Pränumerationen 1826–45* (Albertina archives). For Archduke Charles's acquisitions see note 528.

145 Cf. Böckh 1821, p. 290; Jaeck 1822, p. 191; Schönbrunner 1887 (Berichte), p. 190.

146 Schönbrunner 1887 (Berichte), p. 190. On the enlargement of the entailment, see Herzmansky 1966, p. 11.

147 Duchesne 1834, p. 108.

148 Albrecht Frederick Rudolf of Habsburg-Lorraine, Archduke of Austria (Vienna 1817 – Arco Castle 1895) was Archduke Charles's (1771–1847) eldest son. Both a landed proprietor and an industrialist, Albrecht was primarily interested in pursuing a military career. In 1844 he married Princess Hildegard of Bavaria. His only son died in infancy. For this reason he adopted his brother's sons, among them Archduke Frederick (see Hamann 1988, pp. 45–47; Öst. Biogr. Lex. 1957–1994, Vol. 1(1957), p. 12f.).

149 See Koschatzky 1971, p. 85; Stummvoll 1968 and 1973, Vol. 1 (1968), p. 430f.; Buchowiecki 1957, p.169f.

150 See Koschatzky 1971, p. 87; Schönbrunner 1887 (Berichte), p. 204; J. Meder, *Chronik der Albertina 1824–1900*, under 1866.

151 Carl Müller (22.7.1814–18.11.1868), son of the Viennese art and music dealer Heinrich Müller, came to Archduke Charles after studying philosophy (Vienna) as Official (a civil service posting) in 1841. From 1847 he was librarian and, from 1864 to 1868 Gallery Director to Archduke Albrecht (cf. Doc. d. Abt. Biogr.).

152 Moriz Thausing (Tschischkovitz near Leitmeritz, Bohemia, June 3, 1838 – Leitmeritz, August 11, 1884) studied history and German literature from 1856 in Prague and Vienna. In 1862 he went to the Vienna Academy of Fine Arts as a librarian. From 1864 he was Official (in a civil service capacity) to Archduke Albrecht. From the end of 1868, after Müller's death, he was head of the collection, first as Librarian and then as Gallery Inspector (Curator). From 1869 he recorded commissions and acquisitions made at art auctions for the Albertina (Albertina Archives). Joseph Schönbrunner continued his work until 1892. In 1873 Thausing became Reader (außerordentlicher Professor) in Art History at Vienna University. From 1876 until his death (in 1884) he was Gallery Director. In 1879 he had the chair of Art History at Vienna University. From 1880 he was a member of the Imperial Academy of Arts and Sciences (Wissenschaften: see Höflechner and Pochat 1992, pp. 25–28; Koschatzky 1971, p. 87f.; Wurzbach 1856–1891, Vol. 10 (1882), pp. 182–185 (with a

153 See Thausing 1870–1871, pp. 72–82 and Thausing 1870 (Mittheilungen), p. 85 f.

154 Thausing 1870–1871, p. 72.

155 [Anonymous], *Vienne, ses monuments, musées, curiosités, environs suivis d' une histoire abrégée de cette capitale*, Vienna 1871, p. 121.

156 Thausing 1870 (Mittheilungen), p. 85 f.

157 Joseph Schönbrunner (14.2.1831–2.12.1905) studied (1845–50) at the Viennese Fine Arts Academy. In 1864 he came to Archduke Albrecht's collection as Official (cf. Zl 215/1922, Aktenarchiv der Albertina). From 1871 to 1884 Schönbrunner, who was also active as a restorer and illustrator, was Custodian, from 2.9.1884 Inspector and, from 1896 until his death, Director of Archduke Frederick's collection (see Krasa, in: Öst. Biogr. Lex., Lieferung 51, 1995; Koschatzky 1971, p. 90 f.).

158 See note 3.

159 Schönbrunner 1887 (Reports), p. 202 f. The address dates from 1886 but was printed in 1887.

160 Schönbrunner 1887 (Reports), pp. 191–193.

161 Cf. Chronik der Albertina 1824–1900 (Albertina archives), entry for the year 1867: at that time the Dürer and Raphael drawings were the first to be put into passe-partouts.

162 Fueßli 1801–1802, p. 203. According to him, Benesch was wrong in writing: "The drawings … [were not] … glued on to cardboard until 1822 after the Duke's death" (Benesch 1964, p. 17). Some drawings were framed and decorated the walls of the ducal Palace (e. g. Figs. 36, 37).

163 Duchesne 1834, p. 108. The drawings were not just attached at the corners but rather the whole surface was glued to the support.

164 Benincasa 1784, p. 46 f.

165 In the beginning Albert probably kept his drawings between the leaves of folio volumes (see p. 28 and note 99). By the 1790s at the latest they were in portfolios (cf. Albert's letter to van Bouckhout dated 18.10.1795, quoted on pp. 48, 50).

166 Schönbrunner 1887 (Reports), p. 203.

167 Schönbrunner 1887 (Reports), p. 203.

168 The inventory lists for the 3rd section are often entitled *Peintres ou Dessinateurs qui ont gravé à l' eau forte sur des dessins de leur invention*.

169 Schönbrunner 1887 (Reports), p. 194; the parts of the print collection which were then left the way they were originally kept are still in what is called the Alte Aufstellung (Old Arrangement).

170 Schönbrunner 1887 (Reports), p. 192.

171 Schönbrunner 1887 (Reports), p. 197.

172 Schönbrunner 1887 (Reports), p. 202.

173 Weckbecker 1891, p. 57 f.

174 Robert 1898, p. 137.

175 The grounds for assuming that the figure is accurate for the prints rest on the premise that in 1822 the ducal collection contained about 200,000 leaves in all (see p. 32).

176 Cf. *Verzeichniss der Original-Zeichnungen, Kupferstiche, Radierungen, Holzschnitte, Lithographien sowie moderner Reproductionen, welche von Weiland Seiner kaiserlichen und königlichen Hoheit dem durchlauchtigsten Herrn Erzherzog Albrecht vom 1. Mai 1847 bis zum 18. Februar 1895 angekauft und der von Weiland Seiner königlichen Hoheit dem durchlauchtigsten Herzoge Albrecht von Sachsen-Teschen hinterlassenen fideicommissarischen Kunstsammlung einverleibt wurden* (Albertina archives). For Archduke Albrecht's acquisitions see note 528.

177 Frederick Maria Albrecht of Habsburg-Lothringen, Archduke of Austria (Gross-Seelowitz 1856 – Ungarisch-Altenburg [Mosonmagyaróvár] 1936), Archduke Charles's grandson, was adopted by his uncle, Archduke Albrecht, on the death of his father (in 1847). Like his forefathers, he pursued a military career. In 1878 he married Isabella von Croy-Dülmen. They had eight daughters and a son, Albrecht. When his adoptive father died in 1895, he succeeded to a rich inheritance. In 1905 he moved from Pressburg to Vienna, where he planned to house the collection in a new building (Herzmansky 1966, pp. 12–15). In 1917 he retired from the army. After the end of the Austro-Hungarian Monarchy, he lived in Hungary (see Hamann 1988, pp. 153–155; Öst. Biogr. Lex. 1957–1994, Vol. 1 (1957), p. 366).

178 Joseph Meder (Lobeditz, Bohemia, June 10, 1857 – Vienna, January 14, 1934) studied German literatur (Vienna University). From 1884 until 1889 he was employed at the Vienna University Library. From 1889 he was Official to Archduke Albrecht (cf. Chronik der Albertina 1824–1900, under 1889). After Schönbrunner's death (December 2, 1905), he was head of the collection in the capacity of Gallery Inspector (Curator). From May 15, 1909 until he retired in December 1922 Meder was Director, until April 3, 1919 Gallery Director to Archduke Frederick. From December 25, 1920 he was Director of the Graphische Sammlung Albertina. On June 1, 1921 (cf. Zl. 212/1922, Akten-Archiv der Albertina) he introduced a reading room. His research focused on the work of Albrecht Dürer. See Benesch (E.) 1970–1973, Vol. IV (1973), pp. 314–316; Koschatzky 1971, p. 94 f; Benesch 1936 (with a bibliography of his writings).

179 See Schönbrunner and Meder 1896–1908. Volumes 1 and 2 were published in 1896 and 1897; volumes 3 to 11 have no year of publication. Volume 12 was published in 1908 (ed. Meder; Schönbrunner had died in 1905). Jospeh Meder was responsible for the annotated inventory from volume 7. In 1922 Meder published a sequel: *Handzeichnungen alter Meister aus der Albertina und aus Privatbesitz*, N. F., Vienna 1922. In addition to this hardback volume, facsimiles of the drawings were also published from 1895 in separate monthly instalments (no date of publication).

180 See p. 64.

181 See the three-volume inventory of the prints in the Albertina: Vol. 1, begun on January 15, 1897 (inv. nos. 1–32 399), Vol. 2 (inv. nos. 32,400–64,399), Vol. 3 (inv. nos. 64,400–93,087). They refer mainly to the prints, which are divided into sections, and some of the leaves which were left as they were in the Old Arrangement (Alte Aufstellung) of the (arch)ducal collection. There is no indication in the volumes of a date to which they were kept up. Meder's log or notes (*Diarium der Albertina*) do show that the inventory had advanced to inv. no. 72,000 by about 1915. Presumably the collection was inventoried by number until the collection was amalgamated with the print collection of the former Hofbibliothek (in 1920). After that the system used in the Hofbibliothek from 1905 was taken over (and has been retained until the present), by which each year begins with inv. no. '1'.

182 Joseph Meder, Dürer Catalogue, Vienna 1932.

183 Joseph Meder (ed.), *Albertina-Facsimile*, 5 portfolios, Vienna 1922–1923:
1) *Handzeichnungen deutscher Meister des XV. und XVI. Jahrhunderts*, Vienna 1922; in 1927 a supplement portfolio was published: *Albrecht Dürer. Handzeichnungen*;
2) *Handzeichnungen französischer Meister des XVI.–XVIII. Jahrhunderts*, Vienna 1922;
3) *Handzeichnungen italienischer Meister des XV.–XVIII. Jahrhunderts*, Vienna 1923;
4) *Handzeichnungen vlämischer und holländischer Meister des XV.–XVIII. Jahrhunderts*, Vienna 1923. "The earlier editions produced when Meder personally worked on them epitomize meticulous reproduction. The sheets, which were also sold singly, fluttered about the world, making the treasures in the Albertina better known than those in most other collections." (Benesch 1964, p. 26 f.). On reproductions of drawings in the Albertina see Maren Gröning, *Albertina-Reproduktionen. Ihre Geschichte von 1780–1930, mit besonderer Berücksichtigung der Reproduktionen nach den Handzeichnungen der Albertina* (working title); Koschatzky 1971, p. 103 f.; Reichel 1924, p. 27; Schönbrunner 1887 (Reports), p. 194.

184 In his *Chronik der Albertina (1871–1900) aufgezeichnet von Jos. Schönbrunner*, Schönbrunner registered official matters, including acquisitions made between 1871–1900 in keywords (Albertina archives). In Meder's *Chronik der Albertina 1824–1900* there are entries by Rechberger, Sengel and Meder (until 1898; Albertina archives). The *Diarium der Albertina 1899–19..* begun by Schönbrunner and continued by Meder contains notes on official matters and also entries on acquisitions from 1899–1921 (Albertina archives).

185 See Meder 1922, pp. 73–85; Schönbrunner 1887 (Reports), pp. 190–204.

186 See Schönbrunner 1887 (Berichte), p. 195. Meder noted that "the collation of all archives with material on the history and administration of the Albertina, library and Plans Cabinet began" in spring 1916. (Joseph Meder, under 1919 in the *Diarium der Albertina*; Albertina archives).

187 Archduke Frederick took over the archives in 1919 as his private property. After that most of the material they contained was scattered or destroyed (see p. 46).

188 A few days after the Armistice (3.11.1918) the Emperor Charles I signed the manifesto on 11.11.1918, in which he waived all rights to political office. On 12.11.1918 the provisional National Assembly proclaimed Austria a republic.

189 Cf. Staatsgesetzblatt für den Staat Deutsch-österreich no. 209: *Gesetz vom 3. April 1919, betreffend die Landesverweisung und die Übernahme des Vermögens des Hauses Habsburg-Lothringen* (see Figs. 41, 42). See Joseph Meder, under 1919 in the *Diarium der Albertina*: "3 [April] the resolution was passed on abolishing the entailment, that is, the Albertina was dispossessed. 4 [April] Meeting of all civil servants a[nd] employees…, at which the disbandment of the institution was announced. General consternation. On 10. [4.] Förster-Streffleur, Section HEad in the Edu[cation] M[inistry] petitioned for protection from intervention … 14 [4.] Received report that their Royal Highness are leaving tomorrow. A Customs commission is checking all luggage in the house. 15 [4.] At 3/4 12 [o'clock] Farewells to their Royal Highnesses from the civil servants a[nd] employees. All deeply moved. Early evening at 6 o'clock departure for West Station in two cars. The End." On the nationalisation of the Habsburg-Lorraine art collections see Turba 1925; Schager-Eckartsau 1922; Frey 1919, pp. 1–22.

190 Zöllner 1979, p. 492.

191 Haupt 1991, p. 65. The "most important treasures in the Albertina" were removed for security reasons to the vaults of the Wiener Bankverein in October 1918. See Joseph Meder, under 1918 in the *Diarium der Albertina* (Albertina archives).

192 Lhotsky 1955, p. 617.

193 As the *Übersicht über die auf Grund der Reparationsverpflichtungen Österreichs bereits abgegebe-*

*nen Kunst- und Sammlungsgegenstände sowie Handschriften und Pläne* (ÖSTA, Allg. Verw. Archiv, Staatsamt für Unterricht, Sign. 15, Fasc. 3088, Zl. 28951 from 1929), "to Italy … Feb 1919 [: from the] Gobelin collection 9 tapestries worth 18,000,000 Shillings, from the Gemäldegalerie of the Kunsthistorisches Museum 66 works worth 3,960,000 Swiss Franks, further from the Painting Gallery of the Fine Arts Academy 90 pictures and a marble relief worth 7,585,000 Shillings and from the Nationalbibliothek manuscripts, incunabula and first editions of music worth 5,325,800 Shillings" (see Haupt 1991, p. 66f.). The touchy issue was finally peacefully resolved in the separate pact made on May 4, 1920 with Italy (see Haupt 1991, p. 68). Lhotsky wrote as follows on the confiscation of manuscripts from what had been—from Augsut 6, 1920 known as the Nationalbibliothek (see Stummvoll 1968 and 1973, Vol. 1 (1968), p. 580)—the Hofbibliothek: "… between February 12 and 20, 1919 the Italians removed first 116 and later more manuscripts from the Hofbibliothek … On February 28, 1919 Coggiola appeared … in the Hofbibliothek with ten armed carabinieri and declared that they would, if necessary by force, take … three treasures belonging to the Palatina: the world-famous *Vienna Genesis*, the *Dioscurides Manuscript* and the *Hortus animae* … the Codices which were confiscated as *security* were not returned to the Palatina until very much later" (Lhotsky 1955, p. 623f.). If the demands made for works of art even after the Peace Treaty of St.-Germain are also taken into account, the Kingdom of Hungary "of all nations to succeed [the Austro-Hungarian Monarchy registered] by far the biggest claims … The total of 147 objects from museums given up by Austria came from the Gemäldegalerie, the Sammlung für Plastik und Kunstgewerbe, the Münzkabinett, and especially from the Arms and Armour Collection (Waffensammlung)" (Haupt 1991, p. 70). Belgium laid claim mainly to the "Ildefonso Altar—a major work of Peter Paul Rubens'—as well as the treasure of the Order of the Golden Fleece" (Haupt 1991, p. 68). "The representatives of Czechoslovakia claimed everything that had ever been in the Bohemian Crown domains … The commission of three legal experts found on August 23, 1922 that the claims made by the Republic of Czechoslovakia were unproven and therefore could not be upheld" (Haupt 1991, p. 68). For records of claims to works of art and the handing over of art objects see ÖSTA (Allg. Verw. Archiv, Staatsamt für Unterricht, Sign. 15, Fasc. 308, *Veräußerung [bzw. Verwertung] staatlichen Kunstbesitzes; Archiv der Republik, Bundeskanzleramt, Auswärtige Angelegenheiten: Deutschösterreichische Friedensdelegation St. Germain* 13, Fasc. III /6 and Neues Politisches Archiv, Österreich 33, Karton 381; Archiv der Republik, Deutsch-Österreichisches Staatsamt für öffentliche Arbeiten, Kanzlei-Abteilung XXI c, ref: *Kunstgegenstände aus Italien, Ausfolgung an die italienische Militärkommission*, g Zl 2845 from 1919, Karton 1851).

194 Joseph Meder, under '15.4.1919' in the *Diarium der Albertina* (Albertina archives). Meder noted on June 20, 1919: "Protection from burglary is difficult and expensive."

195 Joseph Meder, under 29.7.1919 in the *Diarium der Albertina* (Albertina archives). Meder wrote on September 25, 1919: "Provisional takeover of the Albertina. Civil servants under contract. Future of the institution in its present state not assured. Evacuation of Czech cultural property predicted." Shortly thereafter comes a note: "On December 5,

1919 official transferral of the Albertina to provis[ional] state administration … Request protection from all hostile assaults on the property of the Albertina."

196 Cf. Staatsgesetzblatt für die Republik Österreich, Jg. 1920, Nr. 303, esp. Artikel 195f. (Abb. 43–45). Under the terms of the Peace Treaty the country's name was changed from Republik Deutschösterreich to Republic of Austria (see Zöllner 1979, p. 500). On the Austrian delegation to the Treaty conference see Neck 1974, pp. 36–47.

197 Haupt 1991, p. 68.

198 Frodl-Kraft 1980, p. 58. The Cabinet minutes read: "Art treasures and valuable art, antiques, manuscripts and codices, furniture etc are to be sold in the shortest time possible abroad in so far as the sale is not forbidden under the terms of the Peace Treaty" (ÖSTA, Archiv der Republik, Kabinettsprotokoll no. 109 of September 26, 1919, fol. 7).

199 ÖSTA, Archiv der Republik, Kabinettsprotokoll no. 109 of September 26, 1919, fol. 2.

200 ÖSTA, Archiv der Republik, Kabinettsprotokoll no. 109 of September 26, 1919, fol. 2–3. The ban on the export and sale of art objects and objects of cultural significance which stood in the way of these plans had been in force since December 5, 1918. The law reads in abstract: "§ 1. The export of objects of historical, artistic or cultural importance (antiques, paintings, miniatures, drawings and prints … is prohibited" (Staatsgesetzblatt für den Staat Deutschösterreich, Jg. 1918, no. 90; see Fig. 46).

201 Enderes, who held this office from September 29, 1919 to February 17, 1922 (cf. ÖSTA, Archiv der Republik, Staatskanzlei, Zl 35 from 1922), announced on October 10, 1919 that he was to "sell or give as security or liquidate in some other manner part of art possessed [by Austria] art in order to procure foreign currency … a bill [was] drafted at once which amended the regulations which stood in the way of carrying out of such an operation … [Objects seemed suitable] for immediate sale which are, for instance, in the Silber- und Tafelkammer (Silver and Plate Vault) or in the ecclesiastical treasure chamber" ('Der Verkauf der Kunstobjekte aus staatlichem Besitz. Mitteilungen des Sektionschefs Enderes' in *Neue Freie Presse*, October 11, 1919, p. 7).

202 Staatsgesetzblatt für den Staat Deutschösterreich Nr. 479: Gesetz vom (law enacted) 16. Oktober 1919, enabling the government to give as security, liquidate and export individual items owned by the state (see Fig. 47).

203 See Tietze 1923, p. 18: "Through the law of October 16, 1919 … the government was enabled to liquidate parts of the publicly owned art collections for the purpose of procuring food; three times—during the winters of 1919, 1920 and 1921 —serious efforts were made to take advantage of the law and sell art objects, in particular the famous Gobelin collection" (cf. ÖSTA, Archiv der Republik, Beilage zum Ministerratsprotokoll no. 8, of November 30, 1920, fol. 103–104).

204 Cf. Staatsgesetzblatt für den Staat Deutschösterreich, no. 479 of October 16, 1919, § 1 "The state government is enabled … to give as security, to liquidate and to export publicly owned objects of historical, artistic or cultural value (antiques, paintings, miniatures, drawings and prints" (cf. Fig. 47).

205 Frodl-Kraft 1980, p. 58.

206 ÖSTA, Archiv der Republik, Kabinettsprotokoll no. 118 of October 28, 1919, fol. 4.

207 ÖSTA, Archiv der Republik, Bundeskanzleramt/ Auswärtige Angelegenheiten, Neues Politisches

Archiv, Österreich 33, Carton 381, Zl 455/2 from 1920, fol. 163–170.

208 Cf. Enderes' report of February 27, 1920: "I have the honour of … reporting on the activity to date of the … Allied Commission: the French delegate, M Raymond Koechlin, and the experts assigned to him, Gaston Migeon, Jean Guiffrey, Carle Dreyfus and Louis Demonts arrived in Vienna on January 10, 1920 … The work cut out for these gentlemen included visiting, drawing up an inventory of and appraising the following collections, buildings and art treasures: the Bildergalerie and the kunstgewerbliche Sammlung of the Hofmuseum, the Bildergalerie of the Akademie der bildenden Künste, the österreichische Museum für Kunst und Industrie, the Schatzkammer, the geistliche Schatzkammer … the drawings in the Albertina, including those which are currently kept in the Safe at the Wiener Bankverein … after completion of an inventory at the Albertina drawings, Jean Guiffrey left Vienna on February 13, whereas Messrs Koechlin and Demonts remained in Vienna in order to complete written work until February 20, … Finally, I have the honour of reporting the … presentation today of the English emissaries, Monr. Campbell Dodgson (British Museum) and Maclagan (South Kensington Museum), that the work to be undertaken by these experts will chiefly be on prints and … medieval objects of the decorative arts" (ÖSTA, Archiv der Republik, Bundeskanzleramt/Auswärtige Angelegenheiten, Neues Politisches Archiv, Österreich 33, Carton 381, Zl 790 from 1920, fol. 184f.). For the appraisal lists from the museums and archives see ÖSTA, Allg. Verw. Archiv, Staatsamt für Unterricht, Sign. 15 Kunstwesen in genere (see note 219).

209 Joseph Meder, under 1920 in the *Diarium der Albertina* (Albertina archives). Cf. a letter written on January 21, 1920 by Enderes to the Foreign Ministry (Staatsamt für Äußeres): "Raymond Koechlin arrived in Vienna on January 10, 1920 with the experts assigned to him … Gaston Migeon, Carl Dreyfus, Jean Guiffrey and Louis Demonts (all three curators at the Louvre) [..] and began at once to carry out the work with which he was charged" (ÖSTA, Archiv der Republik, Bundeskanzleramt/ Auswärtige Angelegenheiten, Neues Politisches Archiv, Österreich 33, Carton 381, Zl 205 from 1920, fol. 139f.).

210 Joseph Meder, under 1920 in the *Diarium der Albertina* (Albertina archives).

211 Cf. Joseph Meder, under 1920 in the *Diarium der Albertina* (Albertina archives): "On 27 II. Campbell Dodgson and Mr Maclagan began on the appraisal of the copperplate engravings in the Albertina, which, when all had been gone through … was extended on 18. III. to those in the Wiener Bankverein and was finished on 24. III."

212 Joseph Meder, under 1920 in the *Diarium der Albertina* (Albertina archives). On March 27, 1920 Enderes reported: "The task with which the British emissaries have been charged has primarily comprehended drawing up an inventory and appraisal of the Albertina (with the exception of the drawings) and the copperplate engravings collection of the Hofbibliothek" (ÖSTA, Archiv der Republik, Bundeskanzleramt/Auswärtige Angelegenheiten, Neues Politisches Archiv, Österreich 33, Zl 1252 from 1920, Carton 381, fol. 198). On April 24, 1920 the works deposited in the Wiener Bankverein were brought back to the Albertina: "After protracted negotiations between the private parties, the Ministry of Education (Unterrichtsamt), the Revenue Office (Finanzamt: Safesperramt) a[nd] the directors of the Bank, the transport back from the 1st vault of the Wiener Bankverein

to the old rooms of the Albertina could finally be undertaken on 24/IV/1920 … after 19 months of being safeguarded" (Joseph Meder, under 24/IV/1920 in the *Diarium der Albertina*; Albertina archives).

213 'A threat to the Albertina. Mysterious inventory drawn up by Entente specialists' in *Neue Freie Presse*, February 14, 1920 morning edition (Morgenblatt), p. 8.

214 'Inventory of Austrian art objects drawin up by Entente specialists' in *Neue Freie Presse*, February 15, 1920, p. 11.

215 An inquiry directed to the Secretary of State for Education on February 13, 1920: "Rumours of a renewed threat to the Viennese art collections refuse to die down … more than three weeks ago two high-ranking officials … of the Paris Louvre suddenly appeared in the Albertina and demanded to go through the entire inventory of the art collection … When the Director inquired at the State Ministry of Education (Staatsamt für Unterricht) whether he should comply with this demand, he was given the mysterious answer: "We are the conquered." And by now the specialists from the Paris Louvre have been working for weeks, … but no one knows with what right and to what end such thorough inventorying and appraisal item by item of art works of inestimable value … are taking place … therefore … the questions: "What is going on in the Albertina?" (Shorthand minutes of the 60th session of the Constituent National Assembly of the Republic of Austria on February 13, 1920; ÖSTA, Bibliothek). An abstrat of the reply, dated February 16, 1920, runs as follows: "This activity by the Allied Commission … has nothing whatsoever to do with a possible intent to sell or liquidate; it embraces all the public art collections and has proceeded smoothly everywhere. If it has caused... more of a public outcry in the Albertina, this has happened because part of this valuable collection is still in the safe of the former owner [Archduke Frederick] and overcoming the legal and financial difficulties which, due to the restraint on alienation placed on this deposit, have made a number of complicated measures necessary. There is no question whatsoever of a threat to the Albertina." (Appended to the shorthand minutes of the Constituent National Assembly of the Republic of Austria annexe 1919 and 1920, Replies to inquiries (Anfragebeantwortungen) 1–182, No. 112; ÖSTA, Bibliothek).

216 'Inventorying by Entente specialists in the Albertina. Statements by the Director' in *Neue Freie Presse*, February 14, 1920 evening edition (Abendblatt), p. 2.

217 Joseph Meder, under 1920 in the *Diarium der Albertina* (Albertina archives).

218 See p. 42.

219 This sum is mentioned by Hans Sadila-Mantau in his report 'Die Reparationskommission im Kriegsministerium' in *Salzburger Nachrichten*, September 4/5, 1971, p. 21: "Among [the institutions in which] appraisals were carried out were the kaiserliche Schatzkammer, the museums and the Albertina … All appraisals of value were carried out in gold Crowns; thus the entire Albertina was valued at 20 million gold Crowns." Whether this figure represents the correct sum could not be verified since the appraisal lists of the Albertina inventory could not be found, despite a thorough search, in the Albertina archives nor among the records pertinent to these matters in the ÖSTA, HHSTA and the BDA. I also received negative replies from the Archives diplomatiques et de la documentation, Paris, as well as the Archives de France, Paris. I wish to express my gratitude to the colleagues who helped me in the arduous task of looking for corroboration of the data, especially Franz Dirnberger and Leopold Kammerhofer, HHSTA, Sabine Bohmann and Herbert Hutterer, ÖSTA, as well as Theodor Brückler, BDA. In addition, I should like to thank Roman Sandgruber, Professor in the Institute of Social and Economic History at Johannes-Kepler-University in Linz for converting the sum mentioned into today's currency: "A gold Crown [issued in 1920] had a weight of 0.3049 g in fine gold. The 10 K[ronen] piece … reminted today [= 26.2. 1996] with the same fine gold content is worth 455 Austrian Shillings. 20 million gold Crowns amounted, therefore, to the equivalent of 910 million Shillings." A large body of records pertinent to the inventorying and appraisal of Austrian public art collections is available in
a) ÖSTA, Archiv der Republik, Bundeskanzleramt/ Auswärtige Angelegenheiten, Neues Politisches Archiv, Österreich 33, Carton 381; Archiv der Republik, Staatskanzlei, Grundzahl 35 from 1922; Archiv der Republik, Deutschösterreichisches Staatsamt für Finanzen: Zl 18380 from 1920 and Departement 17 Frieden; Archiv der Republik, Ministerratsprotokolle no. 8 dated 30.11.1920 and no. 161 dated February 17, 1922; Archiv der Republik, Kabinettsprotokolle no. 109 dated September 26, 1919, no. 116 dated October 21, 1919 und no. 118 dated October 28, 1919; Allg. Verw. Archiv, Staatsamt für Unterricht, Sign. 15 *Kunstwesen in genere*;
b) in HHSTA, Protokolle des obersten Verwalters des Hofärars for 1920 and 1921;
c) in BDA, Protokollbuch und Akten 1920.

220 Cf. Akten-Archiv der Albertina, Zl 32a/ October 13, 1920.

221 Cf. ÖSTA, Archiv der Republik, Bundeskanzleramt-Auswärtige Angelegenheiten, Abt. 14, Handelspolitik, Liasse *Liquidierung Kunst* 17/1, Zl 47687/3B LI for 1921. This document is (under the same number) appended to the *Mémoire présenté par le Gouvernement de la République Tchécoslovaque pour obtenir, conformément à l'article 195 et annexe IV du traité de paix de Saint-Germain, la restitution d'ojets artistiques et historiques faisant actuellement partie des collections ci-devant impériales de Vienne. Prague 1921*.

222 The list of the inventory numbers wanted can be found in the *Mémoire* (cited in note 221), p. 83.

223 Cf. ÖSTA, Allg. Verw. Archiv, Unterricht, Sign. 15 *Kunstwesen in genere*, Fasc. 3087, *Czecho-Slovakische Kunstforderungen*, Zl 18181 from 1921 und Akten-Archiv der Albertina, Zl 330/1921.

224 Cf. ÖSTA, Archiv der Republik, Bundeskanzleramt, Auswärtige Angelegenheiten, Abt. 14, Handelspolitik, Liasse *Liquidierung Kunst* 17/1, Zl 18743/3B LI from 1922.

225 Cf. Österreichisches Staatsgesetzblatt 1919, no. 209, § 5 (see Figs. 41, 42).

226 'Former Archduke Frederick's property' in *Neue Freie Presse*, September 13, 1921, p. 8 (cf. 'Die Albertina in Gefahr' in *Neues 8 Uhr Blatt*, October 18, 1920, p. 3).

227 'Former Archduke Frederick's property' in *Neue Freie Presse*, September 16, 1921, p. 7. The report also mentions the names of the members of the American syndicate.

228 In *Der Cicerone, Halbmonatsschrift für Künstler, Kunstfreunde und Sammler*, Leipzig, XIV. Jg. 1922, no. 1, January 1922, it says under 'Sale of the Albertina to America', p. 47f.: "It is written from New York: from an absolutely reliable source comes the almost incredible news that the entire collection of the Viennese Albertina is to be sold—the correct expression would be sold off or disposed of—for about 6 million dollars to an American syndicate and that all arrangements for this have been made."

229 *Der Cicerone, Halbmonatsschrift für Künstler, Kunstfreunde und Sammler*, Leipzig, XIV. Jg. 1922, no. 1, January 1922, p. 47f.

230 'A fantastic report on the fate of the Viennese Albertina. Allegedly sold for 6 million dollars?' in *Neue Freie Presse*, January 24, 1922, p. 6 (cf. 'What is going on in the Albertina?' in *Arbeiter-Zeitung*, January 28, 1922, p. 5).

231 In 1935 and 1938 Archduke Frederick's son, Albrecht of Habsburg-Lorraine, also tried to sell works from the Albertina (see pp. 43–45).

232 Zöllner 1979, p. 504.

233 Zöllner 1979, p. 504.

234 The "vociferous protest made by the Austrian Foreign Ministry (österreichisches Staatsamt für Äußeres) " made in February 1919 (Haupt 1991, p. 66) at the confiscation of works in the Kunsthistorisches Museum did not achieve its aim. However, when new demands were made in March 1919, "the Republic resolved on resistance. The Foreign Ministry registered … a vehement protest … The public was mobilised. There were demonstrations in the Academy of Arts and Sciences (Akademie der Wissenschaften); the university and artists declared their solidarity with their colleagues in the Kunsthistorisches Museum. The newspapers reported copiously on what was happening [because] it was viewed as [establishing] a threatening precedent … Due to the unexpectedly vehement backlash both at home and abroad … the immediate danger [could be] averted" (Haupt 1991, p. 67). The following articles were scathing in their criticism: Tietze 1919; Hans Tietze, 'Der Schutz des öffentlichen Kunstbesitzes' in *Die Bildenden Künste, Wiener Monatshefte*, II. Jg. 1919, p. 97; Hans Tietze, 'Der Abtransport von Kunstwerken aus Italien' in *Kunstchronik und Kunstmarkt*, 54. Jg., N. F. XXX, no. 20, February 28, 1919, p. 408–415; Hans Tietze, 'Die Italiener in der Wiener Hofbibliothek' in *Kunstchronik und Kunstmarkt*, 54. Jg., N. F. XXX, no. 23, March 21, 1919, pp. 467–470; Lhotsky 1955.

235 Cf. ÖSTA, Archiv der Republik, Staatskanzlei, Zl 3056/17–23 from 1919 (protests registered by the Austrian Engineering and Architectural Association, The Secession and Hagenbund, the national states, the Rector of Vienna University, the academic senate of Innsbruck University); Max Dvorak, 'Die Versteigerung der Wiener Kunstsammlungen (Viennese art collections to be sold at auction)' in *Neues Wiener Tagblatt*, September 30, 1919, p. 1f.; Robert Orley, 'Der Gesetzesentwurf über die Veräußerung von Kunstobjekten (The bill on the liquidation of art objects)' in *Neue Freie Presse*, October 16, 1919, p. 2; *Neue Freie Presse*, October 21, 1919, p. 9; *Neue Freie Presse*, October 26, 1919, p. 12; *Neue Freie Presse*, November 22, 1919, p. 7f.; *Neue Freie Presse*, January 4, 1922, p. 8; *Neue Freie Presse*, January 6, 1922, p. 8; cf. further: Hans Tietze, 'Verkauf von Kunstgegenständen aus österreichischem Staatsbesitz (Sale of art objects owned by the State of Austria)' in *Kunstchronik und Kunstmarkt*, 55. Jg., N. F. XXXI, no. 3, October 17, 1919, p. 41f.; Hans Tietze, 'Eine Museumskommission für Österreich (A museum commission for Austria)' in *Kunstchronik und Kunstmarkt*, 55. Jg., N. F. XXXI, no. 9, November 28, 1919, pp. 175–177; Hans Tietze, 'Die Gefahren für die Wiener Museen (The threats to Viennese Museums)' in *Die Zukunft der Wiener Museen*, Vienna 1923, pp. 15–23, where he writes on p. 20: "The sale of the Austrian museum collec-

tions or major parts of them could only mean squandering them and would never result in financial benefit, which would be commensurate with the intrinsic value of the objects thus given away nor, on the other hand, might it be seriously considered as a measure to restore Austria. One could not even hope for momentary relief of the most oppressive want—which is what the original liquidation had been intended to do; moreover, from the financial standpoint it would have represented a foolish move which could never be made good."

236 Cf. 'Threat to the Albertina. Mysterious inventory drawn up by Entente specialists' in *Neue Freie Presse*, February 14, 1920, morning edition (Morgenblatt), p. 8; 'Inventorying by Entente specialists in the Albertina. Statements by the Director' in *Neue Freie Presse*, February 14, 1920, evening edition (Abendblatt), p. 1f.; 'Entente appraisal experts in the Albertina. Possibly for the purpose of using them as security' in *Neues Wiener Tagblatt*, February 14, 1920, S. 6; 'Inventory of Austrian art objects drawn up by Entente experts in *Neue Freie Presse*, February 15, 1920, p. 11; 'Viennese art treasures inventoried' in *Arbeiter-Zeitung*, 15.2.1920, p. 6f.; Marcel Dunan, 'Un Inventaire des Trésors d'Art Viennois' in *L' Illustration, Journal Universel*, Paris, no. 4018–4019, 78th year, 6.–13.3.1920, p. 174 and p. 166 (illus.), where it says: "Could the Entente simply stand by indifferent to the dispersing of the Viennese art treasures? Morally speaking, no .... In every regard it would be insane to disperse the collections just to make some money on them which would vanish quickly in the abyss of the present crisis'; 'The last of Austria's riches. The Viennese art treasures in the French spotlight (Der letzte österreichische Reichtum. Die Wiener Kunstschätze in französischer Beleuchtung)' in *Neues Wiener Tagblatt*, April 8, 1920, p. 6.

237 See 'The Albertina in danger (Die Albertina in Gefahr)' in *Neues 8 Uhr Blatt*, October 18, 1920, p. 3; 'The property of Former Archduke Frederick (Das Vermögen des ehemaligen Erzherzogs Friedrich)' in *Neue Freie Presse*, September 16, 1921, p. 7. The article entitled 'Sale of the Albertina to America (Verkauf der Albertina nach Amerika)' in *Der Cicerone, Halbmonatsschrift für Künstler, Kunstfreunde und Sammler*, Leipzig, XIV. Jg. 1922, no. 1, January 1922, p. 48, clamoured for public protest: "Perhaps, however, vociferous protest on the part of the entire public in Austria and Germany and the equally vociferous demand that light should be shed on the tortuous paths of this transaction may still avert such an irreparable loss, not only to Vienna and Europe but, sondern, if the collection (which is likely to happen) should be transferred to several parties, to the entire world. Not a day may be lost if we still want to so something! ... It will, therefore, mean ... organising the most clamorous protest at this disgraceful transaction, let us hope, successfully"; Koschatzky 1971, p. 101f.; Koschatzky 1991/92, pp. 95–98.

238 For an appreciation of the art historian Hans Tietze (March 1, 1880 – April 11, 1954): Frodl-Kraft 1980, pp. 53–63 and Krapf-Weiler 1986, pp. 77–103 (both with further references). "In numerous articles and essays [Tietze has] not only informed the public [on the threat looming], but has also tried to motivate a general awareness [of the necessity] to defend the art collections ... [It is] due to his persistence and clever negotiation tactics ... that loss to the collections by their being delivered up to foreign countries have remained relatively minor ... Moreover [Tietze] not only countered [the] spectre of sale by the government

with idealistic but, what is more, with irrefutable economic arguments: a body of art works of the first rank, cast onto a market which can only absorb a limited number [of such works] would of necessity ... depress prices and amount to dumping" (Frodl-Kraft 1980, p. 57f.). Tietze was a prime instigator of amalgamating the Albertina with the copperplate engravings cabinet of what had been the Imperial court library (Hofbibliothek; see p. 42): "The side-effect of amalgamation, which had been declared from the outset ... [was] to gain an enormous number of duplicates of prints; the intention of regularly liquidating [these assets] ... ma[d]e it possible, despite the catastrophic state of Austria's finances, to carry out a deliberate acquisitions policy from 1920" (Frodl-Kraft 1980, p. 59). For Tietze's writings see Gombrich, Held and Kurz 1958, pp. 439–452.

239 There are records and list of drawings, prints and books taken over by Archduke Frederick as his personal property in the Albertina archives. He took over the various parts of his property at various times, many of which cannot be reliably determined. According to an entry in the *Diarium der Albertina* 1899–19 ... he had cleaned out the archives by August 1919. He had the rest of the items considered his personal property kept in the Albertina "for temporary safe keeping" until 1924 (cf. Zl R 30/1920, Akten-Archiv der Albertina; *Arbeiterzeitung*, January 28, 1922, p. 5). The transfer of this property to him began on September 7, 1924 and had been "in the main completed by the end of 1925" (Zl 220/ 1926; Albertina archives, under the protocols about the takeover by Archduke Frederick). Cf. Reichel's report (Bericht) of May 10, 1927: "Of the entire collection of art works which are the property of Herr Frederick Habsburg-Lorraine, everything, with the exception of a small remainder, has been handed over" (ÖSTA, Archiv der Republik, BM für Unterricht, Sign. 15A–B1, Zl 13936 from 1927). It is not clear whether Archduke Frederick removed leaves for sale before the official date of transfer—in any case books had already been given to him from the library (cf. Zl 40/1921, Akten-Archiv der Albertina). The transfer of property dragged on until 1929 hin (cf. Zl 117/1929, Aktenarchiv der Albertina: on the concluding negotiations). For the sale of works of art owned by Archduke Frederick see auct. cat. Gilhofer and Ranschburg, Lucerne, October 22, 1929: *Lager-Katalog XIX Einzel-Miniaturen des XIII. bis XV. Jahrhunderts von ausgesuchter Qualität Original-Handzeichnungen und Aquarelle des XV. bis XIX. Jahrhunderts, darunter sehr wertvolle und bedeutende Zeichnungen der Albertina, Wien*; auct. cat. Albert Kende/Gilhofer and Ranschburg, Vienna, February 8–10, 1933: *Kunstmobiliar, Luster, Uhren, Bronzen, kunstgewerbliche Gegenstände usw. ... aus dem Wiener Palais und den österreichischen Schlössern des Herrn Erzherzogs Friedrich*; Auct. cat. Gilhofer and Ranschburg, Lucerne, June 28, 1934: *Handzeichnungen alter Meister aus zwei Privatsammlungen*. In retrospect Tietze had this to say on the sales by Archduke Frederick: "Their owner flogged each of the leaves in the Albertina not included in the entailment which were for that reason returned to him in a manner which caused reputable collectors and dealers to shake their heads in consternation" (Tietze 1936, p. 1). The 467th Wiener Dorotheum art auction (July 10, 1941; pp. 34–40) shows that even Archduke Frederick's heirs also made money out of the art he had taken over. Individual drawings were later bought back; the first mention of this dates from 1926 (Zl 72/1926; Akten-Archiv

der Albertina). On Archduke Frederick of Habsburg-Lorraine see Koschatzky 1991/92, p. 92f.; Dossi and Kertész (work in progress).

240 The chandeliers which had originally been installed in the Albertina Fest- and Studiensaal (Ceremonial Hall and Reading Room) were especially missed. After a long search and struggle for adequate finances, Koschatzky managed to find the large central chandelier in Persenbeug Castle and to buy it back with monies given by the Association of Friends of the Albertina (Verein der Freunde der Albertina). Four smaller side chandeliers were copied. On April 15, 1975 all the chandeliers in the Festsaal der Albertina were unveiled (see Koschatzky 1991/92, pp. 147–155). Of the original furnishings owned by Albert of Saxe-Teschen a set of 10 chairs, a bench and a table were bought back through an art dealer in 1994.

241 On the archives see p. 46. On the library: the handwritten, undated, 23-volume *Catalogue des Livres contenus cidevant dans la Bibliotheque Son Altesse Royale le Duc Albert de Saxe Teschen à Bruxelles et dans le quelle on a inscrit successivement les ouvrages achetés, ou recûs de depuis* has been preserved from Albert's time (ÖNB, Handschriftensammlung (complete catalogue); five additional index volumes are in the Albertina, Figs. 48, 49, 20, 21). The exact number of volumes in the library, which also contained the Corps et Suites d'Estampes reliées (the bound series of prints) that had belonged to Albert of Saxe-Teschen (see p. 27 and note 98; Fig. 22), is unknown. As the expert appraisal and inventory of the library after Albert's death reveals, it contained in 1822 "incidentally 20,000 volumes" (UNA, Habsb. Fam. A., p 1490, no. 19, 3d, p. 79). This number is confirmed by A. Schmidt 1837 (see Schmidt 1837, p. 155). By 1841 Archduke Charles had enlarge the library to 25,000 volumes (cf. anonymous, *Vier Wochen in Wien. Ein treuer Führer zu den Merkwürdigkeiten der Kaiserstadt*, Vienna 1841, p. 77). In 1858 "Archduke Albrecht's library [is said to have contained] 40,000 volumes" (see anonymous, *Die österreichische Kaiserstadt. Illustrierter Führer durch Wien und seine Umgebungen*, Leipzig 1858, p. 165). By 1891 the library had grown to "circa 52,000" volumes (Schönbrunner 1887 (Berichte), p. 204; Weckbecker 1891, p. 59). How large the library was in 1919, after the first world war and the end of the Austro-Hungarian Monarchy and how many volumes from it Archduke Frederick too with him cannot be determined because there are insufficient reliable records. In a document referring to the return of the private library of the former Archduke Frederick to the trustees of the estate of Frederick of Habsburg-Lorraine, the number of books is given as "approx 50,000 volumes" (ÖSTA, Allg. Verw. Archiv, BM für Unterricht, Sign. 15A–B1, Zl 9831–III/12 from 1924). The transfer of the library to Archduke Frederick is referred to on 24.5.1927 AS "the imminent carrying out of the transfer" (ÖSTA, Allg. Verw. Archiv, BM für Unterricht, Sign. 15A–B1, Zl 12880 aus 1927). The library is not expressly mentioned in Albert of Saxe-Teschen's will (see note 124) as part of the entailment. For what is actually known about how it was disbanded: an auction at Ulrich Hoepli, Zürich, on April 3, 1930, where "une centaine de très beaux livres provenant de cette célèbre bibliothèque" (foreword, p. VII) were sold at auction; an auction at Gilhofer and Ranschburg, Lucerne, on June 14–15, 1932, where among other items, the 32 volumes of the *Œuvres complètes* of Giovanni B. Piranesi were put up for sale at auction (under cat. no. 359). Today the

Albertina library comprises some 35,000 volumes according to the most recent count. With the approx 55,000 volumes from the ÖNB which are on the shelves in the library rooms of the Albertina, it comprises upwards of 90,000 volumes (see Lunzer-Talos 1995, p. 83).

242 How many miniatures Albert of Saxe-Teschen owned is not clear. A document dated March 23, 1926—referring to the handing over of items to Frederick of Habsburg-Lorraine—reveals that "the most comprehensive collection of miniatures which has hitherto belonged to the property under restraint of alienation, [before March 23, 1926 was] brought to Budapest" (ÖSTA, Allg. Verw. Archiv, Staatsamt für Unterricht, Sign. 15 A–B1, Zl 3697 from 1926). 70 miniatures owned by Albert of Saxe-Teschen and the Archdukes who succeeded to the entail were sold at auction in 1949 at Galerie Fischer, Lucerne. See auct. cat. Galerie Fischer, Lucerne, May 17–21, 1949, pp. 53–64; Keil 1977, p. 9.

242 Archduke Frederick succeeded to the inheritance on the death of Archduke Albrecht (February 18, 1895) and administered the legacy until April 3, 1919. The acquisitions made during his day are recorded in the *Zuwachsverzeichnis Handzeichnungen 1890–1923* and in the *Zuwachsverzeichnis Graphische Blätter 1895–1919* (Albertina archives) (see notes 533–534).

244 The Founding Charter (Gründungsakt der Albertina) of December 25, 1920, Z. 21513–10B.IV des Staatsamtes für Inneres und Unterricht, Wien (Albertina archives). Preliminary documents from January–March 1920: cf. Z 194 –Abt. 10B (Albertina architecture archives). See Joseph Meder, under 1920 in the *Diarium der Albertina* (Albertina archives): "On Dec[ember] 25, 1920[:] The decision on the amalgamation of the Albertina w[ith] t[he] copperplate engravings cabinet of Nationalbibliothek [has been] taken. On January 11, 1921 the document was placed in the hands of the Director, on January 14, 1921 the transaction was confirmed verbally … On January 22, the transport of the volumes of copperplate engravings began, every day from 8–11."

245 For 1921 the inventory book of drawings shows about 22,400 leaves. If the 3,800 drawings returned to Archduke Frederick are subtracted from this number—according to the inventory book, the 3,800 drawings returned to Archduke Frederick must always be subtracted from 1921— there were between 18,000 and 19,000 drawings in 1921. The number of prints added to the collection by Archdukes Charles and Albrecht amounted to some 30,000 leaves according to the Zugangs-Verzeichnissen (lists of acquisitions). Since the works acquired by Archduke Frederick did not find their way into the Albertina and the acquisitions made during Meder's tenure were so to speak matched by the sale of duplicates, there must have been between 220,000 and 230,000 prints in 1921. This is confirmed by F. Lugt, who estimated the number of prints in 1921 as approx 230,000 leaves (Lugt 1921, p. 30).

246 The architectural drawings came from the old Hofbibliothek (e.g. *Atlas Stosch* and the *Vues* Collection ), from the entailment, the Burgarchiv der Burghauptmannschaft, the Krieggeschädigten-Fonds and from the Schloßhauptmannschaft (see auct. cat. Vienna, Albertina, 1996, p. 30; Benedik (work in progress); Stummvoll 1968 and 1973, passim, esp. Vol. 1 (1968), pp. 622–24; Reichel 1922, pp. 119–121). From the k.k. Familien-Fideikommißbibliothek, which was taken over on June 18, 1920 by the State administration (see Stummvoll 1968 and 1971, Vol. 1 (1968), p. 58f.),

some 2,000 leaves of prints came into the Albertina early in 1922 (among them 18th-century English and French tinted engravings) and more than 300 drawings (except for Dürer's *Fechtbuch* most of these were 19th-century Austrian drawings; see W. Koschatzky, *Des Kaisers Guckkasten*, Salzburg 1991) were acquired (cf. Zl 69/1922 and Zl 738/ 1934, Akten-Archiv der Albertina; Reichel 1922, p. 121). There are only a very few definitive historical data on the size of the Imperial copperplate engravings collection. In 1787 Gottfried Freiherr van Swieten spoke of a total of more than 250,000 prints in 717 portfolios; the portraits were kept in 217 and what are known as the historical copperplate engravings in more than 500 portfolios (see Stummvoll 1968 and 1973, Vol. 1 (1968), p. 284f.). There is a further indication in 1840: "At the end of this year the copperplate engravings collection comprised "556 large folios, of which copperplate engravings in 14 portfolios of quite large format, 277 folio cartons of portraits, 634 volumes of copperplate works, galleries and sim., 122 volumes of miniatures and 25 portfolios with prospectuses, festive processions, etc." … Moreover, during the following years … the number of copperplate engravings grew by several thousand leaves and several copperplate works" (Stummvoll 1968 and 1973, Vol. 1 (1968), p. 397f.). Friedrich von Bartsch wrote in 1852: "The classes subsumed under a [*Die eigentliche Kupferstichsammlung nach Malern und Stechern in chronologischer Reihenfolge* (the actual copperplate engravings collection classified according to painters and engravers in chronological order)] and b [*Die Sammlungen nach Gegenständen* (the collections according to subject)] are in 595 large folios (Schools), 290 cartons (portraits) and 69 portfolios, comprising according to an average estimate (not an exact count) 300,000 items" (F. Bartsch 1854, p. x). The inventory of the copperplate engravings collection (that is an inventory for 1885, Albertina) gives a lower figure than in the above sources: according to it, there were only about 230,000 leaves in 1885. In 1918 A. Stix estimated the collection at "about 500,000" leaves (Stix 1922, preface). The approximate count made in 1920 of the prints taken over from the Hofbibliothek in 1920 amounted to more than 560,000 works. I am indebted to Johann Oppenauer for his invaluable help in counting. For the copperplate engravings and drawings collection in the Imperial Hofbibliothek see pp. 54–56.

247 E.g. from the Ministry of Trade and the Lower Austrian archives (Niederösterreich-Archiv); see exh. cat. Vienna, Albertina, 1996, p. 30 and Benedik (work in progress).

248 Ordinance (Erlaß) of the Ministry of the Interior and Education (BM für Inneres und Unterricht) of 11.8.1921, z. 1790/U (dokumentiert im Akt: Zl 212/1922, Akten-Archiv der Albertina).

249 Tietze 1923, p. 28f. Early in 1921 he had even more to say on 'the new Albertina in Vienna': "At last success has come to an undertaking which all those who are in the know have been clamouring for as utterly essential and a matter or courses: uniting the former archducal Albertina art collection and the copperplate engravings collection of the old Hofbibliothek (now the Nationalbibliothek). Thus Vienna has gained an extraordinary collection of prints which perhaps really, as Josef Schönbrunner … had written as early as 1887 with a view to such an amalgamation, at that time only theoretically conceivable, would overshadow everything of the kind in the world … Both now united collections consist in drawings as well as prints but they differed from each other in what

they contained. In the Albertina the two halves were equal; on the one hand, there was a widely known treasure of drawings by the great Masters; on the other a classic Œuvre of rare completeness and extraordinary beauty. By contrast, in the old copperplate engravings collection, the drawings section is rpresented in the first instance by the rich collection of architectural drawings … the classic prints [collection] is, incidentally, also rich and even in the case of individual Masters (e.g. the Little Masters or Rembrandt) even outstanding, albeit undoubtedly inferior to that of the Albertina; however, the collection of Primitives is one of the best in the world … from this superficial description, it is evident how marvellously the two collections complement each other; united, the prints up to the late 18th century quantitatively approach completeness and qualitatively—as a selection of the best from two good collections— probably actually surpass in many sections all modern cabinet collections. The drawings collection is also felicitously rounded off; to the Albertina Dürer drawings are added the Maximiliana [Dürer works commissioned by the Emperor Maximilian I] in the copperplate engravings collection (and, moreover the … Dürer *Fechtbuch* from what was formerly the library entailed on the family) and, with the architectural drawings a special collection will be added … the Albertina … will perhaps feel good cause to combat its weak points … the 19th century is the weak point … the new Albertina [can] … devote its energy … to enlarging the body of material dating from 1800" (Hans Tietze, 'Die neue Albertina in Wien' in *Kunstchronik und Kunstmarkt*, 56. Jg., N. F. XXXII, no. 19, February 4, 1921, PP.367–369; cf. Reichel 1922, p. 122). Frits Lugt characterized the new institution as "une des plus riches de l'Europe" (Lugt , p. 29) and ranked it with the collections of Everard Jabach, Pierre Crozat, Pierre-Jean Mariette and Thomas Lawrence (see Lugt 1921, p. 551).

250 According to the list of additions to the prints collection (Zugangsverzeichnis der Druckgraphik], prints came into the Albertina from 1920 as part of the Boerner swap. Meder records that the Albertina received "on 4 Octob[er 1921] … the offic[ial] notification by telephone concerning the first delivery of duplicates to C. Boerner in Leipzig" (Joseph Meder, under 1921 in the *Diarium der Albertina*; Albertina archives; cf. notification (Mitteilung) from BM für Inneres und Unterricht, November 6, 1921, Z 22454-IV- Abt. 10B; Akten-Archiv der Albertina, Zl 505/November 18, 1921; *Neue Freie Presse*, October 4, 1921, p. 6; Stix 1922, preface). In so far as the number of duplicates exchanged, sold directly or at auction can be estimated at all from doucments and auction catalogues, it was several thousand. Cf. Akten-Archiv der Albertina from 1921, among other things archive material on the duplicates sold in 1923 to the British Museum, London, and in 1924 to the Metropolitan Museum, New York; on the transactions that took place well into the 1930s with the firms of Boerner in Leipzig, Gilhofer and Ranschburg, in Vienna and on the duplicates that went to Frits Lugt in 1923 and 1924. (See Lugt 1956, p. 23f. as well as the articles 'Boerner' and 'Gilhofer & Ranschburg' in: Dossi and Kertész (in progress); Koschatzky et al., *Albertina Wien. Zeichnungen 1450–1950*, exh. cat. Munich 1986, p. 16; Benesch (E.) 1970–1973, Vol. IV (1973), p. 317f.; Benesch 1964, p. 23f.

251 See Krapf-Weiler 1986, p. 83: "On the occasion of the carrying out of this operation a nasty scandal broke out, by the way … Through erroneous

reporting, some of it surely hostile in intent, the impression was created that the most valuable items were to be sold ... Tietze ... defended his policy ... publicly in numerous lectures and newspaper articles (see the comparison of the batch assembled by Hans Ankwicz-Kleehoven in the library of the Fine Arts Akademy in Vienna)." See Hans Tietze, 'Der Streit um die Dubletten der Wiener Albertina' in *Kunstchronik und Kunstmarkt*, 59. Jg, N. F. XXXV, no. 23, September 5, 1925, pp. 373–377, in which he discusses "the fundamental question of whether it was legal in the first place to give up duplicates of prints. As far as I can see, no one has actually contested the legality of this transaction; the history and the standard practice of all prints cabinets in the world would also make this position untenable. The question can, therefore, only concern the scope, speed, method, supervision and liquidation of such transfers. The scope [of the transaction] has become extraordinarily important in Vienna because, through the amalgamation of the old archducal Albertina and the copperplate engravings collection of what was formerly the Hofbibliothek, two very comprehensive and rich prints cabinets have been united, which, of necessity, must have resulted in thousands, if not hundreds of thousands, of duplicates. It was an unprecedented situation, one which may only have occurred once before when Adam Bartsch sold off the rich collection of duplicates which resulted from amalgamating the collection [which had belonged] to Prince Eugene of Savoy with the Hofbibliothek collections in order to enlarge systematically the Primitives and Moderns section within the collection after a shift in emphasis during the Napoleonic Wars. The number of works given up need not, therefore, depend on the overall number of those in the collection and it was really considerable in the Albertina and still is today, despite the sale of works that has taken place. The speed at which duplicates are given up must be guided by two considerations, on the one hand, the liquidation intended, on the other [*sic*] the technicalities of carrying out the task conscientiously and without the danger of mistakes .... The leaves selected for sale have been checked by a commission of experts selected by the officials of the collection after it was ascertained that they were duplicates; in minutes of their proceedings these experts have written down their conviction in each case that these leaves really were duplicates and that giving them up would [do no] harm to the Albertina, in fact would be beneficial ... the last justification of giving up duplicates is the acquisitions ... not only has the decided imbalance of the collection of old drawings been redressed but also the body of old prints has been added to and a 19th century collection as good as been created. It is to the Director's credit and dubiously so, that, in addition, the contemporary currents in art have been allotted a modest place [in the collection]; for these very acquisitions of the Moderns have—although they only make up perhaps 2 to 3 thousandths of all acquisitions in respect of monies—aroused the greatest wrath against the Director. The desecration of the venerable Albertina through exemplars of the work of Munch, Nolde, Kirchner and Kokoschka is what one cannot pardon in him. This difference in the basic attitude to art is what has tainted the discussion." See further: Loehr 1954, p. 122; J. Hupka, 'Die "Albertina" Frage' in *Neue Freie Presse*, 9. to June 10, 1925, under 'Feuillton'; E. H. Buschbeck, 'Um die Albertina' in *Neues Wiener Tagblatt*, April 29, 1925, p. 2f.; Tietze 1923, pp. 39–42.

252 Alfred Stix (Vienna, March 20, 1882 – Vienna, April 29, 1957) studied art history and trained at the Institute of Austrian History Research (Institut für Österreichische Geschichtsforschung: Vienna). From July 1, 1908 he worked in the Hofbibliothek copperplate engravings collection and, from 1911 in the paintings gallery of the Kunsthistorisches Museum. From 1920 Stix was Curator at the Albertina. After Meder retired, he was at first (from January 2, 1923) acting Director and then, from July 1, 1923 to May 5, 1934 Director of the Albertina. On December 22, 1933 Stix was appointed First Director of the Kunsthistorisches Museum. On January 1, 1934 he took up this post—he also continued to manage affairs in the Albertina until May 5, 1934—until he was discharged from it by the National Socialists on May 31, 1938 (see Haupt 1991, p. 258). When he returned from exile in 1945, he was General Director of the Federal art historical collections (Generaldirektor der kunsthistorischen Sammlungen des Bundes) until he retired (on December 31, 1949: see Haupt 1991, passim, esp. pp. 117, 123, 183, 191).

253 Acquisitions made under Meder and Stix amounted to, between April 3, 1919 and early May 1934, in addition to large numbers of works from the old collection (alter Bestand), about 5,900 prints catalogued as new acquisitions. In order to arrive at the actual number, one must subtract the number of duplicates sold, presumably several thousand (see note 250), with the result that, in reality, the size of the collection must scarcely have changed since 1919. See notes 536 and 541 for the emphasis laid on prints under Meder and, from 1923, under Stix.

254 After the Albertina had been nationalised, Meder's tenure saw the acquisition of some 1400 drawings between April 3, 1919 and late 1922 (see note 536). By the time Stix acting Director early in 1923, 23,130 drawings had been catalogued—early in May 1934, at the end of his tenure as Director, 26,495. The collection probably actually comprised close to 23,000 works in May 1934 since the 3,800 drawings which were handed over to Archduke Frederick must be subtracted from the above total of 26,495 drawings. Of the roughly 3,400 drawings catalogued under Stix about 150 came from the original collection (Altem Bestand), 650 (Kutschera Collection) had come into the collection as early as 1922 during Meder's tenure. In fact, that would leave us with approx 2,600 leaves added to the collection during Stix's tenure, many of them handed over from the Wiener Staatsgalerie (later the Österreichische Galerie).

255 See notes 539–542.

256 *Beschreibender Katalog der Handzeichnungen in der Graphischen Sammlung Albertina* (ed. A. Stix), Vols I–V, Vienna 1926–1933 [Vol. VI, ed. A. Reichel], 1941]. Stix collaborated with L. Fröhlich-Bum: Vol. I (*Venezianische Schule*) and Vol. III (*Toskanische, Umbrische, Römische Schulen*); with A. Spitzmüller: Vol. VI (*Die Schulen von Ferrara, Bologna, Parma etc.*). Vol. II was revised by O. Benesch (*Die Zeichnungen der Niederländischen Schulen des XV. und XVI. Jahrhunderts*), Vols IV/V were revised by H. Tietze, E. Tietze-Conrat, O. Benesch and K. Garzarolli-Thurnlackh (*Die Zeichnungen der Deutschen Schulen bis zum Beginn des Klassizismus*). During Stix's tenure as Director, the process of classifying the drawings into works of the first and second rank began in 1923. The first step entailed "rearranging the Italian drawings and creating a top-ranking category which included only original drawings, that means

designs, sketches and drawings based on artists' original invention. The second category will be ... retained as a study collection" (Stix/Fröhlich-Bum 1926, pp. VII–VIII). Some of the Austrian and German drawings were put into the second category.

257 Stix 1927 (foreword to a catalogue for the art dealer Gustav Nebehay), pp. 1–8.

258 Josef Bick (Heilbronn/Neckar, May 22, 1880 – Piesting, Lower Austria, April 5, 1952) took a degree in classical philology, German literature and philosophy (1905). From 1907 he worked on a voluntary basis and then from 1911, as an assistant Curator, from 1917 as Curator at the Vienna Hofbibliothek. In 1923 he became Director and from 1926 General Director of the Nationalbibliothek, and then, on May 5, 1934 Director of the Albertina. On March 16, 1938 Bick was dismissed from his post by the National Socialists (see note 288). From Juli 1945 until March 1946 he was again Director of the Albertina (see Stummvoll 1968 and 1973, Vol. 2, 1973, pp. 3–10).

259 Albrecht of Habsburg-Lorraine, Archduke of Austria (Weilburg/ Baden, July 24, 1897 – Buenos Aires, July 23, 1955), was the only son of Archduke Frederick of Habsburg-Lorraine and Isabella von Croy-Dülmen. He embarked on a military career and, after the end of the Austro-Hungarian Monarchy, was a claimant to the Hungarian throne. Albrecht, who had vast domains in Hungary, married three times and had two daughters (see Hamann 1988, p. 47).

260 For what went on concerning the Albertina, the Boston Museum of Fine Arts, and das Fogg Art Museum in Cambridge, Massachusetts, between 1935/36 see Whitehill 1970, pp. 451–456; Koschatzky 1971, p. 102; Rossiter 1972, pp. 135–137; Koschatzky 1979, p. 15 and p. 19; Pellar 1988, p. 102f.; Koschatzky 1991/92, pp. 88–92, pp. 98–102; Weber 1992, pp. 277–283.

261 The art historian and composer Anton Reichel (Graz, November 20, 1877 – Vienna, February 21, 1945) trained from 1.9.1908, then became an assistant Curator and was Curator of the Albertina from 1918. From 1934 he was Deputy Director, from 1938 acting Director. From August 13, 1942 (cf. Zl 611/1942; Akten-Archiv der Albertina) until his death (February 21, 1945) Director of the Albertina.

262 Memorandum (Gedächtnisprotokoll) by A. Reichel of May 15, 1936 (Akten-Archiv der Albertina); Gedächtnisprotokoll A. Reichels, 1938 (Albertina archives).

263 Gustav Mayer, a partner in the firm of Colnaghi, paid "this considerable sum in pounds sterling ... [and] the big New York art dealers, Duveen ... allegedly the sum of 42,000 pounds sterling". (Anton Reichel, memorandum of May 15, 1936 (Akten-Archiv der Albertina); cf. ÖSTA, Allg. Verw. Archiv, Unterricht, Sig. 15B1(Albertina), Zl 16.884 from 1938).

264 Cf. Anton Reichel, Gedächtnisprotokoll of May 15, 1936 (Akten-Archiv der Albertina); ÖSTA, Allg. Verw. Archiv, Unterricht, Sign. 15B1 (Albertina), Zl 16884 from 1938). 250,000 items for "the Museum of Fine Arts in Boston from the Albertina in Vienna" are mentioned in *Basler Nachrichten*, March 26, 1936 (1. Beilage zu Nr. 85; see notes 274 and 276).

265 A. Reichel, Gedächtnisprotokoll 1938, p. 1 (Albertina archives).

266 See Rossiter 1972.

267 Rossiter 1972, p. 135.

268 Weber 1992, p. 280.

269 Weber 1992, p. 277f.

270 Cf. 'Aufklärung der Albertina-Gerüchte' in

*Der Morgen*, March 23, 1936, p. 3.

271 Cf. a letter sent by the envoy E. Ludwig to the Secretary of State for Education (Staatssekretär für Unterricht), H. Pertner, dated June 1, 1935 (ÖSTA, Allg. Verw. Archiv, Unterricht, Sign. 15B1 (Albertina), Präs. -Zl 1515 from 1935) and the reply from the BM für Unterricht (ÖSTA, Allg. Verw. Archiv, Unterricht, Sign. 15B1 (Albertina), Zl 1515/1935).

272 See Weber 1992, p. 277 and p. 280: "... on September 6 [1935], Mongan took the seat on the train .... There she found Paul and Meta Sachs, along with Henry Rossiter, curator of prints at the Boston museum; W. G. Russel Allen, a collector and chairman of the museum's print Department Visiting Commitee; and Gus[tav] Mayer. She learned that they would all get off in Vienna .... Agnes Mongan began her work in the study room at the Albertina .... There were few people in Vienna, however, who knew precisely what she was up to .... The Austrian vice chancellor Starhemberg, and the minister for financial affairs, both close friends of Archduke Albrecht, were doing everything they could to help the sale along .... Starhemberg knew that legally Albrecht had no right to the Albertina, that the collection belonged to the republic, but he favoured reinstatement of the Habsburgs." See Rossiter 1972, p. 135f.: "I was asked to go to Vienna with Mr. Mayer, remain closely in touch with him, inform the Director of events as they developed and keep Mr. Mayer informed on how the money-raising in Boston was progressing ... One pleasant break in the monotony of waiting was provided by the hours spent in the Albertina's study-room, making lists of prints and drawings." Agnes Mongan also had something to say on this, as Koschatzky noted, in March 1985 in Boston: "Boston had done everything it could formerly, at a time of the most serious economic and political crises in Europe and especially a greatly reduced Austria, to buy the treasures of the Albertina and she, Agnes Mongan, had done everything in her power to contribute to this sale. She felt guilty about this and came today to make peace with the Director of the Albertina." (Koschatzky 1991/92, p. 88f.).

273 Rossiter 1972, p. 137; see Whitehill 1970, p. 454: "Late in the autumn of 1935 it appeared that everything was signed and sealed; Colnaghi's chief mounter was standing by in London to fly to Vienna at a moment's notice to remove all prints and drawings from their mounts and pack them for shipment to England. At this point Mayer and his allies celebrated the ... end of their task with a luncheon at the Hotel Bristol."

274 'Falsche Gerüchte um die Albertina (Rumours about the Albertina false)' in *Wiener Sonn- und Montagszeitung*, December 23, 1935, p. 4; see 'Gerüchte um die Albertina' in *Österreichische Zeitung am Abend*, December 23, 1935, p. 2: "Last Saturday American newspapers brought out spreads full of sensationalism on the news that the collections of valuable drawings in the Vienna Albertina were sold to the Boston Museum for 20 millionen dollars. This news item was sufficient to cause an uproar in Europe too, however, it proved to be nothing other ... than a canard launched by the American press. None of the authorities under whose jurisdiction this matter would fall knows anything at all about the sale of the inestimably valuable masterpieces owned by the Albertina and the American reports were denied out of hand." Concerning the American reports: *The Art News*, a New York weekly, reported on December 21, 1935: "Boston Reported as Purchaser of Albertina Treasures / From a reliable source of information

comes the report that the Museum of Fine Arts, Boston, has purchased a group of drawings from the world-famous Albertina Collection in Vienna at a price believed to be between $ 800,000 and $ 1,000,000 .... It has been known for some weeks past that a portion of the richest collection of prints and drawings the world has ever seen was likely to come on the market and naturally the news of Boston's acquisitions from this source arouses the greatest interest .... What selection Boston may have made from this store of riches ... is not yet known, although rumor repeatedly refers to the purchase of Dürer works." (*The Art News*, New York, XXXIV, no. 12, Dezember 21, 1935, p. 1).

275 'Gerüchte um die Albertina' in *Österreichische Zeitung am Abend*, December 23, 1935, p. 2.

276 Cable from the firm of Duveen, New York, to Anton Reichel, December 30, 1935 (Akten-Archiv der Albertina, records of 1935). Reichel noted on the back of his "reply: All rumours concerning the sale of the Albertina are purely fictitious." Reichel also noted in a memorandum, "that, shortly after rumours of a sale had become widespread, that is, on December 30, 1935, Duveen actually sent a cable to the Albertina, saying that he was prepared to make a better offer than any other firm." (Anton Reichel, Gedächtnisprotokoll of May 15, 1936, p. 2 (Akten-Archiv der Albertina); cf. ÖSTA, Allg. Verw. Archiv, Unterricht, Sign. 15B1 (Albertina), Zl 16884 from 1938).

277 A letter sent by Josef Bick to the BM für Unterricht, January 11, 1936 (ÖSTA, Allg. Verw. Archiv, Unterricht, Sign. 15B1 (Albertina), Zl 1221/6A from 1936).

278 ÖSTA, Allg. Verw. Archiv, Unterricht, Sign. 15B1 (Albertina), Zl 1221/6A from 1936.

279 Cf. 'Keine Abverkäufe aus der Albertina' in *Neue Freie Presse*, January 14, 1936, p. 5 (no commentary); Hans Tietze, 'Gerüchte um die Wiener Albertina' in *Frankfurter Zeitung*, February 14, 1936, p. 1 (cf. quotations on p. 44f.); 'Aufklärung der Albertina-Gerüchte' in *Der Morgen*, March 23, 1936, p. 3.

280 See note 238.

281 Tietze 1936, p. 1.

282 Tietze 1936, p. 1.

283 Tietze 1936, p. 1.

284 He made a second attempt in March 1938 (see p. 45).

285 A letter sent by Archduke Albrecht to Gustav Mayer dated April 8, 1936, Cambridge, Massachusetts, Harvard University Art Museum Archives, Paul J. Sachs file, Albertina Collection (see Rossiter 1972, p. 137). Further abstracts of this letter run as follows: "Dear Mr. Mayer .... We have, as you know, for quite some time negotiated with the Austrian Government the restoration of our in 1919 confiscated properties and the Albertina. The result was that the Austrian Government passed in July 1935 a law according to which they agreed to the return of the properties not only to us—as private individuals—but to the Imperial Habsburg family as well. The only exception in the law was the temporary exclusion of objects of art leaving same subject to separate negotiations .... Several proposals ... were accepted as basis for negotiations and while same were going on and ... quite satisfactorily advanced the American press published wide articles on the subject which resulted a press-campaign in Austria and Germany, thus became so disagreable ... we were compelled to put off the negotiations for a later date. I fear that the news published in America was due to the indiscretion of the prospective buyers in the United States who ... have prema-

turely made known their intention of the Albertina purchase ... those publications brought to me a number of important proposals from international art dealers which ... I am ... compelled to consider most seriously before binding myself this time in regard to the disposal of the Albertina whole or in part when restored to us. I have ... taken the necessary steps to speed matters and I am forming a Company in England which will act of[f]icially on my behalf and with my and my friends assistance negotiate with the Austrian Government. The Company will be registered in London, in about two weeks. As informed you personally I have amongst other offers, one which is particularly interesting made to me by an art dealer of international reputation. I am proposed a loan of at least £ 40,000 against our tapestries for a period of three years free of interest while I am to grant an option for a limited period on the Albertina respectively on the drawings to be restored to us. The loan of £ 40,000 can even be increased against certain concessions to be granted by myself which I will personally discuss with you. The offer of the mentioned art dealer includes full cooperation of his internationally influential political friends, in connection with the restoration of the Albertina and furtherance of our claim .... Hoping to hear from you at your earliest convenience."

286 Rossiter 1972, p. 137; Rossiter gave up all hope of success earlier and returned to Boston in May 1936 (see Rossiter 1972, p. 137).

287 Rossiter wrote: "I decided to return to Boston in May, although G. M. still felt confident. Actually until the very last G. M. believed he would secure the Albertina for the Museum ... on 24 June, 1936, G. M. sent the following cable" (Rossiter 1972, p. 137): "To make position quite clear have with help of British Ambassador had interviews with highest Austrian officials and must come to definite conclusion that under present conditions neither we nor anyone else can succeed in Holmes [=Albertina] matter Returning London tonight." (Cable from Gustav Mayer to Paul J. Sachs of Juni 25, 1936, Cambridge, Massachusetts, Harvard University Art Museums Archives, Paul J. Sachs file, Albertina Collection).

288 On March 13, 1938 Austria was annexed by the Third Reich. Three days later, on March 16, 1938, Josef Bick was arrested by the National Socialists and interned in Dachau. In April 1938 he was transferred to Sachsenhausen (see Stummvoll 1968 and 1973, Vol. 2 (1973), p. 11f.).

289 Anton Reichel, Gedächtnisprotokoll 1938, p. 3 (Albertina archives). He goes on to say (p. 3f.): "Since I fell seriously ill of heart disease on 10 March and ... Leporini was made acting Director of the Albertina, Archduke Albrecht and his legal advisers probably assumed I had compromised myself under the former government (Systemregierung) and would now be useful as putty in their hands for their silly as well as filthy plans. Although confined to my bed, I was able to ... have the Archduke's intermediary taken into custody by the police (Staatspolizei)."

290 In a petition entitled *Zusammenfassendes Memorandum über das konfiszierte ehemalige österreichische Vermögen Erzherzog Albrechts* Archduke Albrecht tried on July 14, 1938 to justify his claim to the Palace and collections of the Albertina (ÖSTA, Archiv der Republik, Ministerium für Finanzen, Zl 56630–17 from 1938, 3rd par.).

291 An unsigned, confidential diplomatic note sent by the Royal Hungarian Legation to the Foreign Ministry (Auswärtiges Amt) of the Third Reich in Berlin on August 3, 1938 (ÖSTA, Archiv der Republik, Ministerium für Finanzen, Zl 56630–17

from 1938).

292 What was meant by the two Viennese palaces was "the so-called Upper and Lower Palace, once an Augustine Monastery and the grounds belonging to same" (a memorandum of Archduke Albrecht's dated July 14, 1938, p. 1, ÖSTA, Archiv der Republik, Ministerium für Finanzen, Zl 56630–17 from 1938).

293 An unsigned, confidential diplomatic note sent by the Royal Hungarian Legation to the Foreign Ministry (Auswärtiges Amt) of the Third Reich in Berlin on August 3, 1938 (ÖSTA, Archiv der Republik, Ministerium für Finanzen, Zl 56630–17 from 1938). On September 12, 1938 the Finance Ministry was required by the Foreign Ministry to obtain, "in the matter of the Albertina … the approval of the Ministry for Domestic and Cultural Affairs (Ministerium für innere und kulturelle Angelegenheiten)"(ÖSTA, Archiv der Republik, Ministerium für Finanzen, Zl 56630–17 from 1938).

294 Cf. § 5 of the law of April 3, 1919, Staatsgesetz-blatt Nr. 209 (see p. 38 and Figs. 41, 42).

295 Letter from the Ministry of Finance to the Foreign Ministry in Berlin dated October 27, 1938, 2. Absatz (ÖSTA, Archiv der Republik, Ministerium für Finanzen, Zl 56630–17 from 1938).

296 Letter from the Ministry of Finance to the Foreign Ministry in Berlin dated October 27, 1938, 3. Absatz (ÖSTA, Archiv der Republik, Ministerium für Finanzen, Zl 56630–17 from 1938).

297 Letter from the Ministry of Domestic and Cultural Affairs (Ministeriums für innere und kulturelle Angelegenheiten) dated November 15, 1938 (ÖSTA, Allg. Verw. Archiv, Unterricht, Sign. 15B1 (Albertina), Zl IV-4-40821-B from 1938).

298 Cf. Transport- und Bergungsprotokolle (records of transport and safe keeping): Unter Bergung 1939–1945, Akten-Archiv der Albertina; Anton Reichel, Gedächtnisprotokoll über den Vollzug der Bergung am August 31, 1942, Archiv der Albertina; BDA, Archiv, Restitutionsmaterialien, carton 4/1, Wiener Museen: exh. cat. According to these documents parts of the Albertina arti collection was moved in the summer of 1929 to Gaming, Lower Austria and in late autumn 1939 to the vault of the Wiener Reichsbank (later National-bank). Further transports were carried out between 1940 and 1942 to the Reichsbank or the main vault in what was formerly the Grossbank Am Hof. In 1944 parts of the collection went to Ernegg Castle in Lower Austria and, from March 7 to 8, 1945 were stored in the Bad Ischl-Lauffen salt mines (the alternative would have been the salt mines in Alt-Aussee; see Nicholas 1994, p. 317; Posthofen 1993, pp. 240–242; Hammer 1986, p. 108 and p. 244). From 1946 the works of art were returned to the Albertina in Vienna. On the safe keeping of Austrian art collections at the end of the second world war see Haupt 1995, Hammer 1986. For the war years see Koschatzky 1971, p. 106f.

299 See Herzmansky 1966, p. 61.

300 Heinrich Leporini (Florenz, July 9, 1875 – Neu Matzen Castle near Brixlegg, June 22, 1964) went to the Albertina as a Curator on May 14, 1914 after studying art history (in Munich and Vienna). Leporini became acting Director of the Albertina when Anton Reichel was unable to be there and again briefly after Reichel's death. He retired on January 31, 1946. Leporini's most important works are *Die Stilentwicklung der Handzeichnung XIV. bis XVIII. Jahrhundert*, Vienna-Leipzig 1925 and *Die Künstlerzeichnung, ein Handbuch für Liebhaber und Sammler*, Berlin 1928. Records on Leporini: Albertina archives; Doc. d. Abt. Biogr.,

Ak. d. Wiss., Vienna.

301 The poet, essayist and art historian George (Emanuel) Saiko (Seestadtl, North Bohemia, February 5, 1892 – Rekawinkel, Lower Austria, December 23, 1962) studied art history, archaeology, psychology and philosophy in Vienna. Until 1939 he was primarily a writer. In 1939 he was forbidden to write by the National Socialists and assigned to the Albertina, where his main task was organising and carrying out the transport and safe keeping of the works of art. From May to July 1945 he was acting Director of the Albertina. From 1950 he was again a writer and man of letters. Shortly before his death in 1962 he received the Grand Austrian State Prize for Literature (Großer Österreichischer Staatspreis für Literatur: see Posthofen 1993; Mayr 1978, pp. 238–240; Doc. d. Abt. Biogr., Ak. d. Wiss., Vienna).

302 When Russian confiscation commandos demanded the most famous Dürer drawings to decorate the walls of the Soviet headquarters, Saiko was able to prevent this operation by a courageous decep-tion—he gave the Russian officers framed facsim-iles of the originals. As it turned out, the facsimiles were not returned to the Albertina despite a writ-ten agreement to the contrary. They were taken to Russia. Early in the 1960s the 'Dürer treasures' were to be sold to the West. The Belgrade museum director addressed himself to the then Director of the Albertina, Walter Koschatzky, who explained the situation to him (see Koschatzky 1991/92, pp. 32–36).

303 Karl Garzarolli-Thurnlackh (Prague, September 25, 1894 – Vienna, September 11, 1964) studied art history and history (in Vienna and Prague) before going to the Landesmuseum Joanneum in Graz as a temporary assistant in 1919. There he was Director of the copperplate engravings cabinet and the painting gallery from 1923 until 1946. On March 15, 1946 Garzarolli became Head Curator and then on August 19, 1946 Director of the Albertina. One of his most important contribu-tions to the Albertina was overseeing the restora-tion of the bombed-out building and ensuring the safe return of the works of art from the places where they were in safe keeping. Garzarolli was Director of the Albertina until April 17, 1947. Then, until he retired (in 1959), he was Director of the Österreichische Galerie in Vienna. His most important works include: *Das graphische Werk Martin Johann Schmidt's 1718–1801*, Vienna–Zurich–Leipzig 1925 and *Die barocke Handzeich-nung in Österreich*, Vienna 1928. Garzarolli also collaborated on the Albertina inventory catalogue, *Die Zeichnungen der deutschen Schulen bis zum Beginn des Klassizismus* (ed. A. Stix), Vienna 1933 (see Erwin Mitsch, in: Albertina-Studien 1964, Heft 3, p. 65f.; Doc. d. Abt. Biogr., Ak. d. Wiss., Vienna).

304 The inventory book for the drawings estimates the number of drawings in the middle of 1947 at about 30,500. The approx 3,800 leaves returned to Archduke Frederick must be subtracted from the above number so that the actual number of drawings must really have been close to 27,000. Of the approx 4,000 drawings listed in the inven-tory, about 500 entries record Alter Bestand (orig-inal collection). Numerous works came from the Wiener Staatsgalerie (later the Österreichische Galerie). Between 1934 and 1947 about 3,000 prints were listed as new acquisitions in the inven-tory in addition to the Alter Bestand. For where the emphasis lay in these new acquisitions see notes 543–545. Leaves confiscated or prints acquired for state collections by the National Socialist regime between 1938 und 1945 were

returned to the lawful owners or their heirs when-ever they could prove ownership of them during the post-war years. In July 1995 the Austrian government passed a law authorizing the sale at auction of art works which could not be restored to any lawful owners (Auction Christie's, Mauer-bach, *Versteigerung der von den Nationalsozialis-ten konfiszierten Kunstwerke zugunsten der Opfer des Holocaust*, October 29 and 30, 1996). Recently Elisabeth Gehrer, a member of the Aus-trian government, required to see unequivocal proof in cases of unclear provenance of art works which found their way into Austrian state mu-seums (after) the second world war (in a directive dated by Weisung January 13, 1998).

305 Otto Benesch (Ebenfurth, Lower Austria, June 29, 1896 – Vienna, November 16, 1964) studied art history (in Vienna) before working from Novem-ber 1, 1920 to January 31, 1923 in a voluntary capacity in the painting gallery at the Kunsthis-torisches Museum. After a period as a volunteer at the Albertina (February 1, 1923 to April 30, 1926), Benesch became a Curator of this collection (May 1, 1926 to October 31, 1938). On January 24, 1934 he inaugurated concerts at the Albertina (see Benesch (E.) 1970–1973, Vol. IV (1973), p. 354). Dismissed by the National Socialist regime on November 1, 1938, Benesch emigrated to France and England. From 1940 he lived in the US (he taught at both Harvard University in Cam-bridge, Massachusetts and the University Institute of Fine Arts in New York). After the war Benesch was invited back to the Albertina. He arrived on March 20, 1947. From May 1, 1947 he was Head Custodian and from December 24, 1947 to December 31, 1961 Director of the Albertina. From 1948 he was a reader in art history at Vienna University (see Koschatzky, Mitsch and Knab 1964, pp. 63–65; Aktenarchiv der Albertina; Doc. d. Abt. Biogr.).

306 In late 1961 the inventory book of drawings gives a total number of 3407. If one subtracts the 3800 drawings returned to Archduke Frederick, that would mean approx 30,300 drawings. Of the approx 3,600 drawings added to the inventory during Benesch' tenure, about 70 are Alter Bestand, many also came to the Albertina from the Wiener Staatsgalerie (later the Österreichische Galerie). Under Benesch about 2,400 leaves of prints were registered as new acquisitions in addi-tion to the Alter Bestand. For where the emphasis lay on acquisitions see note 546.

307 See Benesch (E.) 1979; Benesch (E.) 1970–1973; Benesch (E.) 1961.

308 Benesch 1928.

309 Otto Benesch, *The Drawings of Rembrandt*, 6 volumes, London 1954–1957.

310 Benesch 1964.

311 Benesch 1964, p. 14.

312 Walter Koschatzky (b. Graz, August 17, 1921) studed art history, philosophy, history and archae-ology in Graz between 1945 and 1952. He began working as a civil servant in the state art collec-tions in 1953 in Graz, when he entered the Lan-desdienst (Landesbildstelle). He was transferred to the Neue Galerie am Landesmuseum Joanneum in 1955 and became Director of it in 1956. From January 2, 1962 to September 30, 1986 Koschatzky, who had also been a lecturer at Vienna University since 1972, became Director of the Albertina.

313 Koschatzky's most important works on collecting and the history of the Albertina collections include: *Die Albertina in Wien*, Vienna 1969 (in collaboration with A. Strobl), *Herzog Albert von Sachsen-Teschen 1738–1822 Reichsfeldmarschall*

*und Kunstmäzen*, Vienna 1982 (in collaboration with Selma Krasa), the exhibition catalogues *200 Jahre Albertina* (1969), *Giacomo Conte Durazzo* (1976) and *Herzog Albert von Sachsen-Teschen* (1988, in collaboration with Renata Antoniou) as well as several articles in *Albertina-Studien* (1963–66; ed. Koschatzky).

314 See note 13; Koschatzky 1991/92, pp. 45–48.

315 See note 35; Koschatzky 1964, pp. 3–16; Koschatzky 1963 (Durazzo I), pp. 47–61 and Koschatzky 1963 (Durazzo II) pp. 95–100.

316 See p. 46 and note 346; Koschatzky and Krasa 1982, passim; exh. cat. Vienna, Albertina, 1969.

317 He has also focused on the graphic arts and photography as well as Austrian 19th century art in his books. A bibliography of Koschatzky's is always available in the Albertina.

318 Late in September 1986 approx 39,500 drawings were listed in the inventory. If one subtracts the 3800 drawings returned to Archduke Frederick, this amounts to a total of some 35,700 drawings. Of 5,400 drawings 120 are recorded as Alter Bestand and some came from the Wiener Staatsgalerie (later the Österreichische Galerie). In the area of prints about 6,200 works were registered as new acquisitions in addition to the Alter Bestand. For where the emphasis lay in the acquisitions policy see note 547.

319 Erwin Mitsch (Linz, April 25, 1931 – Vienna, March 17, 1995), from January 2, 1959 to March 17, 1995 Curator at the Albertina and interim Director from October 1, 1986 to August 31, 1987. In addition to the curators who, under Koschatzky and Strobl—up to the year of publication of their *Die Albertina in Wien*, 1969, p. 53f.—are listed, all academic assistants and colleagues who have worked since then at the Albertina and then the head of the restoration division are also listed, each with the date they joined (and left) the staff: Norberta Keil (July 1, 1942 – December 1, 1974); Eckhart Knab (June 1, 1949 – February 9, 1984); Alice Strobl (September 1, 1958 – December 31, 1984); Erwin Mitsch (January 2, 1959 – March 17, 1995); Hans Suesserott (March 1, 1965 – July 31, 1976); Fritz Koreny (since February 1, 1971); Veronika Kreuzberg-Birke (since June 2, 1972); Marie Luise Sternath (since May 5, 1975); Marian Bisanz-Prakken (since December 1, 1976); Christine Ekelhart (since December 1, 1982); Richard Bösel (since April 24, 1984); Barbara Dossi (since May 2, 1988); Antonia Hoerschelmann (since September 1, 1992); Marietta Mautner-Markhof (since May 3, 1993); Markus Kristan (since 1.7.1993); Christian Benedik (since October 16, 1995); Alfred Weidinger (since October 16, 1995); Head of the Restoration Division: Johann Gold (January 1, 1947 – December 31, 1985); Elisabeth Thobois (since early 1986). I am indebted to Franz Pfeiler for helping me compile these data.

320 Konrad Oberhuber (b. Linz, March 31, 1935) studied art history, archaeology, psychology and philosophy before becaming an assistant at the Art Historical Institute (Vienna University) from 1959. From April 1, 1961 to January 31, 1971 he was Curator of the Albertina. Then he researched in the US, primarily at the National Gallery, Washington D.D., and the Institute for Advanced Studies in Princeton, New Jersey. From 1975 to 1987 Oberhuber was a Curator and Professor at Harvard University, the Fogg Art Museum in Cambridge, Mass. Since September 1, 1987 he has been Director of the Albertina. Since June 1990 he has taught at the Vienna University Art Historical Institute.

321 His research has covered a broad range of periods from 16th century art to the present. A bibliography of his writings is available at the Albertina.

322 To date (December 1997) about 3,000 drawings and 6,500 prints have been added to the collection. For the focus of the acquisitions policy see note 548.

323 The inventory book lists up to the present writing (December 1997) just a few more than 42,700. The approx 3,800 leaves Archduke Frederick removed should be subtracted from that figure.

324 See Richard Bösel, 'Die Architekturzeichnungsbestände der Albertina/ Ein kurzer Überblick' in: exh. cat. Vienna, Albertina, 1996, p. 30, where it says in the introduction: "With approx 15,000 objects listed and an estimated nearly 10,000 more leaves, the architecture collection represents about a third of the Albertina drawings collection. Even though it does not seem right to include them from the art historical standpoint, mentioning the ratio of architecture to other drawings does give some idea of how important this special collection is to the museum." The other drawings classified as special collections (some 300 sketchbooks and about 300 miniatures) are, since they bear the inventory numbers of the drawings collection, included in the general inventory of that collection. It should be noted, however, that the sketchbooks are as a rule catalogued by volume and not by page.

325 The figures represent the mean values for the leaves kept in the coffins, volumes and portfolios and have been checked against the historical acquisition records. I am indebted to Johann Oppenauer for his invaluable help with this task.

326 In 1920, after the collection had been amalgamated with the collection from the old Imperial Hofbibliothek, the print collection of the new Albertina comprised some 800,000 to 830,000 leaves (see p. 42). To date 19,000 to 20,000 works have been acquired; the duplicates which were sold off, estimated at several thousand, have been subtracted from this figure (see note 250). Including the approx 20,000 posters (special collection), the Albertina print collection currently comprises 840,000 to 870,000 leaves. The Austrian and other posters in the Albertina poster collection date from the turn of the 19th century and the years between the wars (the Ottokar Mascha and Julius Paul Collections, part from the former Hofbibliothek) as well as from ca 1940 to the present.

327 Letter written by Marie Christine to Albert, dated 4.1.1766 (UNA, Habsb. Fam. A., p 298–8A, p. 19). She does not say where she sent the volume and which leaves it contained.

328 That year, 1768, Albert was made an honourary member of the Vienna Copperplate Engravings Academy (cf. Archiv der Akademie der Bildenden Künste, Vienna, Academie-Matricul mdccli, p. 88f.).

329 Duplessis 1857, Vol. 1, esp. pp. 447, 455, 468, 476, 541, 583. He does not say which leaves they were (for Johann G. Wille see Schulze-Altcappenberg 1987).

330 See Wagner 1967, passim, esp. pp. 28–33, 45–49.

331 Albert of Saxe-Teschen, *Mémoires*, Vol. 7, pp. 221–223 (comment on the year 1775; see Koschatzky and Krasa 1982, p. 102).

332 See pp. 13–16.

333 Durazzo 1776, Fassung I, inv. no. 30858c, recto; see p. 13f. and note. 26.

334 Durazzo 1776, Fassung I, inv. no. 30858d, verso; see note 36.

335 Albert of Saxe-Teschen 1776; Albert of Saxe-Teschen, *Mémoires*, Vol. 7, pp. 226 – Vol. 10, p. 641.

336 Albert of Saxe-Teschen, *Mémoires*, Vol. 7,

p. 287f. (see Koschatzky and Krasa 1982, p. 112).

337 Albert of Saxe-Teschen, *Mémoires*, Vol. 8, p. 364 (see Koschatzky and Krasa 1982, p. 115).

338 Rotenstein 1793, p. 60.

339 Moroni 1840–1861, LIX, 1852, p. 143 (see Koschatzky and Krasa 1982, p. 122). The magnificent volumes mentioned above as not included in the entailment because they were part of the library, became the private property of Archduke Frederick when the Austro-Hungarian Monarchy came to an end. With the 32-volume (*Œuvres complètes* of Giovanni B. Piranesi, they were sold at auction in 1932 (June 14–15) by Gilhofer and Ranschburg, Lucerne, (see note 240).

340 Albert of Saxe-Teschen, *Mémoires*, Vol. 9, p. 473f. (see Koschatzky and Krasa 1982, p. 122f.).

341 See p. 16.

342 In addition to these sources, an inventory of prints acquired on a regular basis by Albert of Saxe-Teschen (and partly by Archduke Charles) from the Viennese firm of Artaria is extant: *Artaria Compagnie 1784–1828*. Mention of works offered for sale and acquisitions of individual prints are also recorded in the few extant letters from Albert's correspondence with art agents (see pp. 48–53).

343 See p. 47f.

344 See note 243.

345 Koschatzky/Strobl 1969, p. 46.

346 The remains of the archives, which were partly damaged by fire, primarily contain, as the author personally ascertained in Budapest, source material that is useful for reconstructing Albert of Saxe-Teschen's biography (e.g. his *Mémoires de ma Vie*), material on his travels and on the inventory made of Albert's collection after his death (e.g. by Rechberger and Straube; see p. 31f.). Correspondence dealing with acquisitions is sporadic, lists of acquisitions and receipts of invoices pertaining to acquisitions of art work are missing entirely. Koschatzky published most of this archive material (see note 313). In some points the author has been able to draw additional conclusions. Most of the archive material on the Albertina kept in UNA is under: Habsb. Fam. A., p 298, 1d to 15d and p. 1490, 1d to 9d .

347 See p. 48f.

348 Note the list of expenses accurate down to the last Kreuzer for the years 1783–1822 (Fig. 16) or the estate inventory of 1799 (Fig. 23). Extant letters also show how carefully Albert of Saxe-Teschen kept notes and records of his. collection. The extant material reveals a man who was very orderly, indeed a perfectionist. One would not expect inaccurate documentation or gaps in the records of acquisitions he made.

349 Benesch 1964, p. 15. This miniature (Vienna, Österreichische Galerie, inv. no. 2296) is recorded as having belonged to the Imperial paintings gallery since 1783 (see Mechel 1783, p. 144, no. 9). In 1922 it was taken over by the Österreichische Galerie (cf. records of the Österreichische Galerie, Vienna). As early as 1778 Meusel emphasized the importance of the picture within Füger's body of miniatures: "however, a superb painting of considerable size with full-length figures representing the return of the Duke of Teschen and his wife from Italy" (Meusel 1778, p. 38; see Schwarzenberg 1974, p. 35f.).

350 See Wolf 1863, Vol. 1, p. 157; the sources are not sufficiently explicit to allow reconstruction of which drawings they were.

351 From the intervening period mentioned only once, a reference to prints: in 1777 Albert received engravings (copies after A. R. Mengs)as a present

from the Duke of Kaunitz (see Koschatzky and Krasa 1982, p. 132).

352 The earlier Stadholder, Duke Charles of Lorraine, died on July 4, 1780. Albert and Marie Christine's inauguration in this office was delayed by Maria Theresia's death (November 29, 1780). Albert and Marie Christine were received with due ceremony in Brussels on July 10, 1781 (cf. *Entrée solennelle de SS. AA. RR. l'archiduchesse Marie-Christine, et Albert, duc de Saxe-Teschen, Juillet. 1781*, Brüssels city archives; photokopies in the Albertina archives).

353 See p. 57; Dossi and Kertész (work in progress).

354 'Journal du premier Voyage fait 1781 dans les Provinces des Pays, écrit à la hâte pendant celui-là' in: Albert of Saxe-Teschen, *Mémoires*, Vol. 12, p. 19f.

355 See Albert of Saxe-Teschen, *Mémoires*, Vol. 12, pp. 19A–27.

356 UNA, Habsb. Fam. A., p 298-22, p. 31f. (photokopies in the Albertina archives).

357 UNA, Habsb. Fam. A., p 298-22, pp. 33–48 (photokopies in the Albertina archives).

358 UNA, Habsb. Fam. A., p 298-22, p. 7f. (photokopien in the Albertina archives).

359 Albert of Saxe-Teschen, *Mémoires*, Vol. 12, p. 13 (see Koschatzky and Krasa 1982, P.142).

360 Old inventory lists (called Cahiers) of the drawings, Albertina, Sc. Fran., Vol. XVIII. There is only the one note referring to this drawing although Albert had several leavs from Le Prince.

361 ÖNB, Handschriftensammlung, Autographen 289 (see Koschatzky and Krasa 1982, p. 149f.). In general, it can be said of Albert's extant letters that they are not in his own handwriting, except for the signature, but were written by a professional secretary. I am indebted to Gottfried Mraz for this information.

362 For the biographies of François Lefèbvre and Joseph van Bouckhout see note 126.

363 See p. 16 and note 32.

364 UNA, Habsb. Fam. A., p 298-26/a, pp. 69–73 (photokopies in the Albertina archives).

365 See Lugt 1938, nos. 4178, 4698, 5643, 5648, 6388.

366 Albert of Saxe-Teschen, *Mémoires*, Vol. 12, p. 113 (see Koschatzky and Krasa 1982, p. 158).

367 Letter from Jean Charles Pierre Lenoir to Comte d' Angiviller dated 14.8.1786 (Paris, Archives Nationales, ref. *Bibliothèque du Roy*; Microfilm no. 01/609); see Koschatzky and Krasa 1982, p. 158. The Albertina has a series in numerous volumes *Cabinet du Roi Prémier édition Paris 1672 à 1683*, but it came from the Imperial Hofbibliothek.

368 The presents included tapestries, carpets and porcelain (see Koschatzky and Krasa 1982, pp. 159–161).

369 See Gottfried von Rotenstein quoted on p. 46, note 338.

370 For the drawings by "[Louis] Le Paon Peintre et Dessinateur du Pr. de Condé" cf. the old inventory lists (Cahiers) of the drawings, Albertina, Sc. Fran., Vol. XVIII: "Ce Dessein à été acheté avec le suivant à la Vente [20.4.1786] de ce Maitre." For the leaf by Meunier (no first name given) cf. the old inventory lists (Cahiers) of the drawings, Albertina, Sc. Fran., Vol. XXIV: "Il à été vendu à la Vente de Mr. Wailly [from November 24, 1788] au prix de 300 fl."

371 Albert of Saxe-Teschen, *Mémoires*, Vol. 13, p. 269 (see Koschatzky and Krasa 1982, p. 168).

372 On Johann F. Richter (Leipzig 1729–1784) see Dossi and Kertész (work in progress).

373 See the old inventory lists (Cahiers) of the drawings, Albertina, Sc. Fran., Vol. XVII: "Ce Dessein à

été acheté à la Vente de ce Maitre."

374 See p. 30 and the parts of the letter quoted on p. 52f.

375 Stadt- und Landesbibliothek Vienna, Handschriftensammlung, Nachlaß Artaria 756/36 (see Koschatzky and Krasa 1982, p. 207).

376 On the Artaria family of art agents and publishers see Dossi and Kertész (work in progress).

377 The following additional information has come to light on the art agent Joseph Zanna, who had his shop in the Rue de la Madeleine in Brussels hatte (see Koschatzky and Krasa 1982, p. 264): Joseph Zanna, born in "thesino/ Tirolensi" 1759, married November 23, 1788 in Brussels, died there on November 25, 1807 (Brussels city archives).

378 UNA, Habsb. Fam. A., p 298-61A, nos. 2–3 (photocopies in the Albertina archives).

379 ÖNB, Handschriftensammlung, Autograph 119/ 1–87 (Beilage); see Koschatzky and Krasa 1982, p. 202.

380 Quite a few drawings by the artist, collectior and later academy professor Johann Christian Klengel (1751–1825) have been identified in Albert's collection (Albertina, inv. nos. 5575–5596 and inv. nos. 14741–46).

381 Hans Albrecht von Derschau (1755–1824) of Nuremberg owned an important collection of paintings, drawings and especially prints. Parts of it were put up for sale at auction in 1810 and 1825 (see Lugt 1921, p. 471f.; Lugt 1956, p. 365).

382 UNA, Habsb. Fam. A., p 298-61A, no. 4f. (see Koschatzky and Krasa 1982, p. 207f.). The "three large … watercolours" cited have been identified as *Ariadne and Bacchus* (after Reni, inv. no. 17443), *Aurora* (after Guercino, inv. no. 17442), *Aurora* (after Reni, inv. no. 17445).

383 See p. 56 and note 437.

384 See Rieger 1992 (with further references).

385 The author discovered several inventory pages (Cahier pages), which were presumably prepared by François Lefèbvre (see note 126) and in case checked and corrected by Bartsch. The handwriting has been identified as Bartsch's by means of comparison with assured samples of his writing.

386 Founded in 1766 by Jakob Matthias Schmutzer, the Copperplate Engraving Academy was united with the Malerakademie zur Akademie der Bildenden Künste (Fine Arts Academy for Painters) in 1772 (see Wagner 1967, p. 42f.).

387 Bartsch executed more than 500 prints, most of them after other work, in various techniques. Nearly all his work is in the Albertina (see Rieger 1992, pp. 35–39).

388 For the correspondence between Bartsch and van Swieten see Stix 1927, pp. 312–352; Rieger 1992, p. 8f.

389 See Bartsch (F.) 1818, p. 12f.: "Frontispice de livre représentant une grande pierre surmontée d'un vase. Au bas on voit les attributs de la peinture, sculpture, et gravure. Ce frontispice a été gravé pour les volumes d'estampes de la Bibliothèque Imp. et Royal de la Cour.—Adam Bartsch fecit 1786." The copper plate for this frontispiece is in the Albertina archives.

390 For the Mariette family see p. 16 and note 55; Dossi and Kertész (work in progress).

391 See p. 16.

392 Bartsch has been shown to have advised Moriz von Fries and Johann von Harrach as well as Albert of Saxe-Teschen on art (see Rieger 1992, p. 13).

393 Among his best known works are the catalogue of the drawings collection owned by Charles A. de Ligne (1794), the catalogues of prints by G. Reni (1795), A. Waterloo (1795), Rembrandt (1797), L. van Leyden (1798), M. von Molitor (1813) and

the introduction to copperplate engraving (1821).

394 Bartsch and Krauss lived in the Bürgerspital-Zinshaus no. 1100 (see note 509 and Rieger 1992, p. 15).

395 See note 385; see also Rieger 1992 (with further references).

396 See p. 53f.

397 See Rieger (dissertation in progress); Rieger 1992, Appendix, pp. VIII–XXVI.

398 See Bartsch (F.) 1818, p. 26, no. 59 and no. 60: "1804. 59. Un tableau surmonté de la lyre d' Apollon, d'ou pendent des festons de fleurs, et qui est environnée de rayons et de nues. Frontispice pour les portefeuilles de desseins de la collection de Son Altesse Royale, Msgr. le Duc de Saxe-Teschen. D'après un dessein de Mr. le Fevre, garde des desseins de Son Altesse. 60. Une bordure au bas de laquelle on voit un piédestal surmonté d'un médaillon ménagé au milieu de deux aigles, et d'un vase orné de riche sculpture. Le médaillon présente un génie ailé qui écrit les mots: *Quo vota trahunt*. Sur le piédestal on lit: auspiciis. felicibus. perfecit. an. MDCCLXXVI. Pièce marquée à la droite d'en bas: A. Bartsch fecit. Titre pour la collection d'estampes de Son Altesse Royale, Msgr. le Duc de Saxe-Teschen." The cover for the prints collection derives from the unsigned drawing, which may be by by Durazzo himself in *Discorso Preliminare* (Fig. 59; Durazzo 1776, Version II, inv. no. 30858²).

399 On Joseph F. van der Null (only his name was previously known): He came from Cologne, was an accountant early in 1780 in the employ of Johann, Count Fries, and, from 1787, was an independent bookseller in Vienna. From 1783 to 1786 he was a member of Vienna Freemasons' lodges (see Huber (E.) 1991, Vol. 4). He owned a collection of copperplate engravings(among them the Œuvres of Bartolozzi and Woolet) and drawings, particularly by Bartolozzi and Cipriani (see Küttner 1801, Vol. 3, pp. 214–216). The collection was sold off at three (1808, 1819 and 1824) auction sales (see Lugt 1938, nos. 7493, 9694, 10745).

400 The letter is in the Albertina archives (see exh. cat. Vienna, Albertina, 1969, p. 124). Albert's inventories of the Bartolozzi prints contain no reference to having come from van der Null.

401 The letter is in the Albertina archives.

402 The letter is in the Albertina archives.

403 The letter is in the Albertina archives.

404 The letter, dated March 12, 1796, is in UNA, Habsb. Fam. A., p 298-61A, nos. 6 and 7 (photocopies are in the Albertina archives). The two other letters are kept in the Albertina archives.

405 Karl Christian H. Rost (1741–1798), merchant, art agent and art expert in Leipzig, published (in collaboration with his fellow Leipzig connoisseur, Michael Huber) the *Handbuch für Kunstliebhaber und Sammler über die vornehmsten Kupferstecher und ihre Werke*, 9 vols., Zurich 1796–1808 (cf. letter dated 26.11.1796, quoted on p. 53).

406 The letter is in the Albertina archives (see Koschatzky and Krasa 1982, p. 208).

407 Albert had been mulling over the swap for quite some time as a note on the year 1786 in the catalogue *Artaria Compagnie 1784–1828* (Albertina archives) shows: "For part of various old engravings of all Schools, which was destined for the exchange for [the drawings of] Alb: Dürer['s] … 105.28 [Guilders]" (Fig. 62).

408 HHSTA, O-Me-A, Carton 65, Zl 276/1796; see Koschatzky 1971, p. 51f. (quotes a later copy).

409 HHSTA, O-Me-A, Carton 65, Zl 276/1796; see Koschatzky 1971, p. 51 (quotes a later copy).

410 HHSTA, O-Me-A, Carton 65, Zl 276/1796; see Koschatzky 1971, p. 52 (quotes a later copy).

411 Benesch 1964, p. 20; cf. Koschatzky 1971, p. 50.

412 "Albert was friends with Alexander Friedrich Freiherr von Seckendorff (1743–1814) ... for decades. From May 1, 1779 the latter was in the Duke's employ in Pressburg ... The Manuscript Collection of the Nationalbibliothek owns a collection of 195 letters written by the Duke to him between 1779–1810" (exh. cat. Vienna, Albertina, 1969, p. 11).

413 ÖNB, Handschriftensammlung, 119/1–55 (Beilage); cf. Koschatzky and Krasa 1982, p. 196.

414 A list of the leaves exchanged in the swap could not be found in the Albertina archives nor in HHSTA (I am grateful to Franz Dirnberger, HHSTA, for his help with archive work). A copy of the Hofbibliothek records of the exchange (see Stummvoll 1968 and 1973, Vol. 1 (1968), p. 286), which had been believed lost (HB 1796/594 and HB 1796/595) were found by the author (Albertina archives). They are identical word for word with the records of the exchange cited above and dated July 4 to 8, 1796 (HHSTA: see p. 53f.). Whether the original Hofbibliothek records may (have) contain(ed) annexes with additional important information on the leaves exchanged remains unknown.

415 Whereas the official record of the exchange mentions "some drawings"; (HHSTA, O-Me-A, Carton 65, Zl 276/1796; see p. 54), a report made in the Hofbibliothek in 1871 states "that such a [collection of drawings] does not exist at the Imperial Hofbibliothek since everything that was here formerly [was already given] in 1796 ... to the Duke of Saxe-Teschen in exchange for copperplate engravings" (HHSTA, O-Me-A, R 74/1 ex 1871, fol. 44). Parts of Prince Eugene's drawings collection are still today in the ÖNB, Handschriftensammlung, under the *Codices Miniati*, which in turn just goes to show that not all leaves which went to the Hofbibliothek with Prince Eugene's collection in 1738 were then given to Albert of Saxe-Teschen in 1796 (see Unterkirchner 1959, pp. 127–135).

416 See Stummvoll 1968 and 1973, Vol. 1 (1968), p. 39f.

417 See Stummvoll 1968 and 1973, Vol. 1 (1968), pp. 39–58.

418 After Prince Eugene's death (in 1736) "his niece and heir, Prinzess of Saxe-Hildburghausen, née Victoria of Savoy, [sold] ... the collection for a life-long annuity ... to the Emperor Charles VI. ... Since Prince Eugene's library was taken over in toto by the Hofbibliothek, this collection remained entire" (Stummvoll 1968 and 1973, Vol. 1 (1968), p. 210f.).

419 See Krasa 1986, pp. 293–331.

420 For this family see Dossi and Kertész (work in progress).

421 A large part came from the Mariette family estate (see Krasa 1986, p. 294).

422 See p. 16 and note 41; Koschatzky 1963, pp. 8–12.

423 exh. cat. Vienna 1986, p. 25. On the same page: "Among the *Imagines* there are 45 works with reproductions of works by the Italian Masters divided into the Schools of Florence, Rome, Venice, Bologna and Genoa-Naples, further 50 volumes with artists from Germany and the Netherlands, 70 with artists from France. There follow 40 volumes of views of ancient and modern Rome, of Paris and Versailles, further an *Imaginum delineatarum Collectio*, a collection of drawings ordered according to Schools, however also watercolours of birds and flowers by Nicolas Robert."

424 See note 427.

425 See Krasa 1986, pp. 293–97. Not very much is

known about the provenance of the drawings in Prince Eugene's collection (see Benesch 1964, p. 21).

426 ÖNB, Handschriftensammlung, Cod. 14378. The volumes do not reveal when and by whom or for what purpose they were drawn up.

427 ÖNB, Handschriftensammlung, Cod. 14378, Vol. 3, fol. 1401–1402 (26 portfolios are listed).

428 See Krasa 1986, p. 296.

429 *Raphaël et son Ecole, ... L' Ecole Florentine, ... de Venise, ... de Lombardie, ... de Bologne, ... de Sienne.*

430 See Unterkirchner 1959, pp. 127–135.

431 Krasa 1986, p. 297.

432 See Stummvoll 1968 and 1973, Vol. 1 (1968), passim, esp. p. 238f. and p. 277.

433 Stummvoll 1968 and 1973, Vol. 1 (1968), p. 276 (cf. Koschatzky 1971, p. 22f.). The drawings collection which belonged to Rudolf II was probably kept in Prague until his death and then went into the Imperial Schatzkammer via the Vienna Kunstkammer and from there, in 1783, to the Hofbibliothek.

434 Stummvoll 1968 and 1973, Vol. 1 (1968), p. 276f., p. 278, p. 284f. and p. 319. The document gives no indication of what the ratio of drawings to copperplate engravings was. On the disbandment of the monasteries see Tropper 1963, pp. 95–139.

435 See Thausing 1870–1871, p. 79; Schönbrunner 1887 (Berichte), p. 198; Wickhoff 1891 and 1892 (1st Theil, 1891) p. 11; Meder 1922, p. 84.

436 Benesch 1964, p. 20.

437 The Cahiers are divided into regions or Schools, and further ordered chronologically. The individual pages of the inventory are in French. Their slipcasesIhre bear Italian inscriptions (Figs. 66, 67). François Lefèbvre may have written the inventories: "The inventory, written for the most part by Fr. Lefebre [and] in French, is very accurate" (Jaeck 1822, p. 191). It would seem logical that Lefèbvre, who took care of the drawings collection, would have been charged with drawing up an inventory of it. The following procedures were probably used: Lefèbvre prepared designs for these Cahiers and Bartsch corrected them (see p. 50 and note 385; Figs. 52, 53). Whether these versions of the design, of which only a very few exemplars are extant, really are from Lefèbvre's own hand is not clear and would have to be determined by comparison with enough samples of his writing. The fair copy in the Alte Cahiers is the writing of a professional secretary (I am indebted to Gottfried Mraz for this information). It is also not clear whether Bartsch edited all Cahiers or only parts of them. The sources do not make clear when writing up the inventories of the ducal collection began. A letter written by Albert and dated October 18, 1795 does show, however, that by 1795, staff were hard at work on them (see p. 48). The Alte Cahiers were presumably kept up until just before Albert's death—the terminus ante quem is 1820: This date (Sc. Ted. Vol. XXVIII, referring to a drawing by Jakob Gauermann) is the latest to occur in the Alte Cahiers. The reason why the Alte Cahiers were no longer kept up after that but were replaced by new ones is unknown. Not all the earlier data contained in the Old Cahiers was transferred to the more recent version, which was presumably begun before Albert's death.

438 Old inventory (Altes Cahier) marked Sc. Ted. Vol. 11: 136 drawings listed as Dürer originals, 8 as copies.

439 Old inventory (Altes Cahier) marked Sc. Fiam. Vol. XVI (see Benesch 1964, p. 20).

440 The old inventory (Alte Cahier) marked Sc. Ted.

Vol. 1 bears the following note: "This drawing, like most of the following Old German Masters, comes from the Imperial Hofbibliothek." Following the first, 21 Old German Master drawings are listed (Benesch 1964, p. 20). Krasa has enlarged the list to include six Guercino drawings and nine by Raimond la Fage (see Krasa 1986, pp. 293–331). Altogether there are 39 drawings by various masters which can be traced to the Hofbibliothek, among them 21 Italian sheets, by means of Bartsch's reproductions (cf. the prints in the Albertina as well as *Recueil d'Estampes d'apres les Desseins Originaux qui se trouvent à la Bibliothèque I. et R. de Vienne gravées par Adam Bartsch*, ÖNB, picture archives).

441 Old inventory (Altes Cahier) marked Sc. Rom. Vol. 1.

442 The notes occurred 178 times in the German School, 111 times in the Italian, 131 times in the Flemish, 9 times in the French and 39 times in the School called Miscellaneous (Divers).

443 See p. 60f.

444 On this collector see Dossi and Kertész (work in progress). See also p. 47.

445 Old inventory (Altes Cahier) marked Sc. Rom. Vol. 1. This drawing, originally attributed to Filippo Lippi, is under inv. no. 36 (now attributed to Giovanni A. Sogliani) in the Albertina (see Birke and Kertész 1992–1997, Vol. 1 (1992), p. 21). According to the note in the Cahier, the leaves marked with one asterisk entered Albert's collection through the auction mentioned. According to de Ligne's will and the foreword to the auction catalogue written by Bartsch, the roughly 2,500 drawings listed were to go "in globo" to the highest bidder (see auct. cat. de Ligne 1794, *Avertissement* p. 5; Koschatzky and Krasa 1982, p. 205f.). Whether in fact the drawings went as one lot to Albert of Saxe-Teschen cannot be determined because the catalogue descriptions are not always explicit. In any case the bulk can be shown to have gone into Albert's collection. In 1801 Albert gave more than 600 drawings from the de Ligne collection to the Swedish ambassador, Jacob G., Count de la Gardie (see Magnusson 1982, p. 118). It has been handed down in this connection: "an old report goes that Christine gave him [i.e. Albert] these auction lots as a birthday present" (Meder 1922, p. 84; see Koschatzky and Krasa 1982, p. 206; Benesch 1933, p. 32). This statement can (no longer) be confirmed due to lack of documentation. On the de Ligne collection see Dossi and Kertész (work in progress).

446 In the Italian drawings section, provenance from the de Ligne collection can be demonstrated by means of the old inventory (Alte Cahiers) in 411 cases. Analysis of the auction catalogue leads to a figure of over 500. As for the Dutch drawings, provenance from the de Ligne collection is shown in 373 cases through the asterisk but in about 800 with the auction catalogue.

447 On this collector see Dossi and Kertész (work in progress).

448 Old inventory (Altes Cahier) marked Sc. Fiam. Vol. 1.

449 In the new inventory (Cahiers) four asterisks occur three times.

450 On this collector see Dossi and Kertész (work in progress).

451 Old inventory (Altes Cahier) marked Sc. Fiam. Vol. 1.

452 Gleisberg and Mehnert 1990, p. 21.

453 It is not recorded when this sale took place, how many and which drawings were sold and how much was paid for them.

454 From October 16, 1815 original drawings in 2,469

lots and, in 109 additional lots, copperplate engravings and drawings from all regions (Schools) were sold at auction in Leipzig (cf. auct. cat. Winkler 1815 and Lugt 1938, no. 8772). The auction catalogue was difficult to find. I am greatly indebted to Marie Luise Sternath for finding it in the Weimar Landesbibliothek. Since the sketchy data in the catalogue do not permit reliable identification of works, it is not possible to ascertain even roughly how many leaves may have come from the above auction.

455 The letter is in the Albertina archives.

456 The letter, "Expediert den 6. 8obre 1806", is in the ÖNB, Handschriftensammlung, Autographen 448/15-5. Cf. exh. cat. Vienna, Albertina, 1969, p. 130, no. 194.

457 On the Artaria family of art agents and publishers see Dossi and Kertész (work in progress).

458 UNA, Habsb. Fam. A., p 298–83, p. 116 (photocopies in the Albertina archives). This work, which, according to Artaria, was attributed to Caspar Netscher, has not been found in Albert of Saxe-Teschen's drawings inventories.

459 A letter written by Albert to Generalleutnant von Thiollaz, Saxon Emissary to the Prussian Court (Staatsarchiv Dresden, Loc. 2978, Vol. I, p. 49).

460 UNA, Habsb. Fam. A., p 298–90, no. 21, p. 1. Albert seems to have turned down this offer since no drawings by Carl Wernett can be shown to have been in his collections.

461 See Koschatzky and Krasa 1982, pp. 230–236. Albert's collection of 19th-century German drawings is rich in contemporary work (see Gröning and Sternath 1997).

462 The drawing in this sketchbook and diary (Albertina, inv. no. 41939^{1-87}), p. 42 verso, recorded as the next to last entry, can be identifed from the description as: inv. no. 14681.

463 Stadt- und Landesbibliothek Wien, Handschriftensammlung, Johann Scheffer von Leonhartshoff, I.N. 117209/5. Albert owned five drawings by this artist(inv. no. 6371–6375), but none of them can be identified with certainty as those mentioned in the diary.

464 Many collectors of drawings marked their leaves with a typical personal collection stamp. The standard handbook on this subject is by Frits Lugt (see Lugt 1921 and Lugt 1956; Johnson 1986, pp. 191–199; Wildenstein 1982, pp. 2–5).

465 See p. 61.

466 See Sachs 1971, p. 82.

467 Meder 1919, p. 652.

468 Koschatzky and Krasa 1982, p. 14.

469 UNA, Habsb. Fam. A., p 1490, no. 19, 3d, S. 49f. (see p. 32).

470 Only in a few instances is the provenance of prints noted in the ducal inventory (Alte Cahiers) and entailment inventories. On what came from Durazzo all that is recorded is that more than 30,000 works thus came into Albert's collection. It is, however, (no longer) possible to determine which works these were. The inventory lists of the prints which Durazzo gave to the Duke went down at sea late in 1792 when the ship was lost (see note 98).

471 See Lugt 1938, from no. 1795: as far as can be ascertained from these lists, the largest group of agents during the time with which we are concerned here were active in Paris, followed at quite some distance by London, Amsterdam and German cities. Among the best known names were, as analysis of Lugt (Lugt 1938, from no. 1795) as well as Préaud and Casselle et al. 1987 has shown: Pierre-François Basan, Denis Charles Buldet, François Joullain, Jean-Baptiste-Pierre Lebrun, Lenoir and Alexandre Paillet (the latter can be ver-

ified as owners of drawings just before Albert of Saxe-Teschen) as well as Jean-Guillaume Alibert, Blaizot, Vincent Donjeux, Dufour, Laurent Guyot, Jauffret, C. F. Julliot, Le Rosey, Nicolas, Potrelle, Remoissenet, Reslut, Roger and Sallé. Among the London agents S. Vivares, W. Ayton, W. Palmer, N. Smith and in Amsterdam P. Fouquet, in Leipzig Karl Christian H. Rost and Heinrich A. Mauser, in Nürnberg Johann F. Frauenholtz crop up must frequently. Albert has been shown to have been in contact with Rost and Frauenholtz (see pp. 50–52).

472 Cf. Lugt 1938, from no. 1795. Among the most important auctioneers were Alexandre Paillet, François L. Regnault, François-Charles Joullain, Jean-Baptiste-Pierre Lebrun, Pierre-François Basan and Pierre Remy.

473 On the individual collectors see Dossi and Kertész (work in progress).

474 See exh. cat. Hannover 1992, pp. 23–31; exh. cat. Frankfurt 1989, pp. 30–33; Sutton 1981, passim; Haskell 1958, pp. 48–59.

475 See Schudt 1959, passim.

476 See Schudt 1959, p. 262.

477 On the individual collectors see Dossi and Kertész (work in progress).

478 Christie's held the largest number of auctions, followed by Hassil (?) Hutchins, Thomas (?) King, Abraham Langford and John (?) Greenwood (see Lugt 1938, from no. 1795).

479 With the cabinets of Louis F. Du Bourg, Jan Jansz.Gildemeester, Pieter Teyler, Jakobus Lauwers, Hendrik van Eyl-Sluyter or A. Vermande.

480 See p. 47.

481 Among them were those of Hendrik Busserus (1782; more than 3,000 drawings; see Lugt 1938, no. 3469), Theodorus van Duijsel (1784; 2,700 drawings; see Lugt 1938, no. 3779), Simon Fokke (1784; more than 1,500 drawings; see Lugt 1938, no. 3803), Jan Danser Nijman (1798; some 1,700 drawings; see Lugt 1938, no. 5730), Cornelis Ploos van Amstel (1800; some 4,000 drawings; see Lugt 1938, no. 6031), Jan Jansz. Gildemeester (1800; more than 2,000 drawings; see Lugt 1938, no. 6156), Daniel van Diepen (1805; more than 1,700 drawings; see Lugt 1938, no. 6929), Diderick Baron van Leyden (1811; some 2,000 drawings; see Lugt no. 7991). Among the most important chief auctioneers were Philippus van der Schley, Hendrik de Winter and Jan Yver (see exh. cat. Amsterdam 1974, pp. 121–126; exh. cat. Amsterdam 1992).

482 On Genevosio see Dossi and Kertész (work in progress). On Winckler see p. 57f.; Dossi and Kertész (work in progress).

483 Cf. the old inventory list (Altes Cahier) der Zeichnungen, Albertina, Sc. Ted. Vol. XIII: "Most of the Dietrich drawings in these portfolios here as well in the four following were bought by the artist's widow after his death." In the Alte Cahiers (Sc. Ted. Vol. XIII–XVI) more than 1,000 drawings are registered under the name of Christian W. E. Dietrich—in the more recent Cahiers only about 300 as originals.

484 On these collectors see Dossi and Kertész (work in progress).

485 See notes 380 and 405.

486 In an appraisal dated 25.3.1770 for Maria Theresia, Kaunitz advocated Kaunitz enlarging and promoting the Viennese Art Academy and enabling young artists to study abroad in Paris and London. See Walter Koschatzky, *Die Kunst des Aquarells*, Salzburg and Vienna 1982, p. 210. On Kaunitz see exh. cat. Brünn 1994.

487 Lützow 1877, p. 58.

488 Distinguished members of the Viennese cultural

scene who had links to Freemasonry were, in Albert's day, besides Albert himself (see p. 153): Prince Nikolaus Esterházy, Wenzel, Prince Kaunitz-Rietberg, Prince Charles-Joseph de Ligne and his Sohn, the art collector Charles A. de Ligne, Karl, Count Pálffy von Erdöd, Ferdinand, Count Harrach, Franz, Prince Lubomirski, Prince Wenzel Paar, Adam von Bartsch, Jakob Matthias Schmutzer, Friedrich H. Füger, Johann M. Birckenstock, Pasquale Artaria, Joseph F. van der Null and possibly also Gottfried Freiherr van Swieten (see exh. cat. Vienna 1992/93; Rieger 1992, pp. 10 and 14; Huber (E.) 1991; exh. cat. Vienna 1984; Abafi 1890–1899).

489 Meder 1922, p. 84.

490 Cf. Böckh 1821, p. 298. On the Esterházys see exh. cat. Eisenstadt 1995.

491 Gerszi 1988, p. 6. According to Jaeck the collection contained 2,000 drawings in 1822 (see Jaeck 1822, p.195).

492 Albert and Marie Christine often visited the Esterházys, who had vast domains in Hungary (see Koschatzky and Krasa 1982, pp. 37, 61, 81, 102).

493 On this family of collectors see Dossi and Kertész (work in progress).

494 Since, as Reinhold Baumstark, from 1976 to 1992 Director of the collections of the reigning Prince of Liechtenstein, has informed me, no inventory catalogues or inventory lists exist of the drawings collection (which was almost entirely dispersed after the second world war), the original size can only be roughly estimated at several hundred sheets. As Schönbrunner and Meder have shown in illustrations (see Schönbrunner and Meder 1896–1908) and also the auction catalogue of Klipstein & Kornfeld no. 98 (June 16, 1960) shows with 150 examples, there were some top quality drawings from the most important Schools among them. On the works acquired by Otto Benesch from the Liechtenstein Collection see exh. cat. Vienna, Albertina, 1958.

495 To date 4 drawings by Giovanni Benedetto Castiglione have been verified as having come into Albert's collection through the Prince de Ligne from Charles Eusebius, Prince of Liechtenstein (inv. nos14421–14423 and inv. no. 49263). On the House of Liechtenstein see Dossi and Kertész (work in progress).

496 How many of Albert's drawings came from the Fries collection cannot be determined at present since the computerized inventory has not yet been completed. On this collector see Dossi and Kertész (work in progress).

497 In 1811 drawings from all regions (Schools) from this collection were sold at auction in Vienna under 261 numbers. Some 20 sheets owned by Albert of Saxe-Teschen have been shown to have been of this provenance. On Birckenstock see Dossi and Kertész (work in progress).

498 Zu dieser Familie vgl. Dossi und Kertész (Publikation in Vorbereitung).

499 For the prints, too, there are only very few records giving evidence of specific earlier owners. Among the most valuable old notes of earlier ownership are those of Pierre (II) Mariette (1634–1716) on the back of some sheets.

500 More frequently verifiable evidence of earlier (i.e. before Albert's day) provenance exists as follows: for France, especially the Crozat, Mariette, d'Argenville (less frequent: Gouvernet, Nourri, Calvière) collections; from Britain the Lely, Lanier, Richardson the Elder and Younger collections; from Italy the Vasari and Viti collections; from Germany/Austria the Jabach and Praun collections.

501 The most frequent variants: Crozat—

d'Argenville—Gouvernet—Julien de Parme—Prince de Ligne; Crozat—(Mariette)—Gouvernet—Julien de Parme—Prince de Ligne.

502 The chains of provenance which can be reconstructed are presumably on in part without gaps. Intermediate provenance of minor importance may not have been recorded. On the collectors named Dossi and Kertész (work in progress).

503 See Koschatzky 1971, pp. 13–52.

504 On these collectors see Dossi and Kertész (work in progress).

505 See note 129.

506 See p. 31.

507 The old inventory (Alte Cahiers) for the drawings collection were kept in blue-grey slipcases (Figs. 66–67)—the more recent lists, which are still being added to at present, were kept in the coffins mentioned above (for illus. p. 24).

508 On October 18, 1795 Albert noted that drawings were kept in portfolios (see p. 48).

509 I am indebted to Anita Waibl and Peter Zehetmayer, formerly bookbinders to the Albertina, for drawing my attention to Krauß and Otto Mazal, former Director of the manuscripts collection, ÖNB, for information concerning the attribution to Krauß (see Halbey 1986, p. 395; Rössler 1939, pp. 39–45). Georg Friedrich Krauß (1732–1821; k.k. Hof- und bürgerlicher Bookbinder; Vienna, Bürgerspital no. 1100; Wiener Stadt- und Landesarchiv, Verlassenschaftsabhandlung Friedrich Krauss/Fasz. 2/386/1821) was among the most renowned exponents of the Neo-Classical style of binding in Austria. From the 1790s he made magnificent, sumptuously decorated and hand-gilt bindings in various techniques and styles which, as can be seen from the illus. p. 24, frequently featured motifs taken from Etruscan art (see Halbey 1986, p. 395; Rössler 1939, pp. 39–45). There are no records of deliveries to Albert of Saxe-Teschen; however, an inventory list has been preserved from Archduke Charles's time which refers to bindings, among them Etruscan portfolios, executed by Krauß's son of the same name, Friedrich (b. 1806; the list is in the Albertina archives). It is not known why Albert of Saxe-Teschen used different coffins for his drawings, which were not marked with his personal stamp of ownership.

510 The Diverse Schule (Miscellaneous School) included, for instance, Spanish and Portuguese, Swedish, Russian and Polish—and, in the drawings collection, English work—as well as leaves of unknown origin. Albert's old prints inventories are written in Italian. The old drawings inventories only bear Italian inscription on the slipcases; the inventory sheets were by then written in French: see note 437.

511 Apart from a few even earlier works.

512 Only the Maîtres Modernes (see note 521; Fig. 84) were ordered alphabetically.

513 The practice of using inventory numbers started in 1895 (drawings) and 1897 (prints). See p. 38.

514 See p. 32 and notes 132, 136.

515 See p. 32 and note 141.

516 Inventory lists made in 1821 are enclosed with the alphabetical catalogues of artists represented in the ducal prints inventories (Cahiers). They give the number of leaves in the Italian section (School) as 43,600 (rounded off), in the German School 38,700, in the French 32,200, the Dutch 31,000, the Miscellaneous 12,000 and the English School 5,100 leaves (see note 139). According to these lists, therefore, the portfolios contained some 163,000 prints in all. Each leaf that was not in a portfolio but was kept in bound works like the Gallery and Vedute volumes must also be added to this figure. This leaves us then with an estimated

total of about 200,000 leaves (see note 141).

517 Many of the greatest Masters, among them Leonardo, Dürer, Michelangelo, Raphael, Rubens, Rembrandt, Poussin and Boucher are listed in the old inventories (Alte Cahiers) with a particularly large number of works making up quite an Œuvre. However, since then, research has shown that many of these attributions cannot be retained. Other artists, who are listed in the ducal Cahiers as represented by a strikingly large number of works are Theodor van Thulden, Albert Flamen, Christian W. E. Dietrich (drawings) and Giovanni B. Franco, Marten de Vos, Hendrick Goltzius, Claude Mellan, Jacques Callot, Wenzel Hollar, Daniel Chodowiecki, Francesco Bartolozzi (prints).

518 In respect of the drawings: The Italian artists of this period are, in comparison with exponents of the other Schools, better represented. Nevertheless, there were no drawings by several of the renowned quattocento Masters (e.g. Benozzo Gozzoli, Antonio Pollaiuolo, Francesco Cossa, Sandro Botticelli, Luca Signorelli, Francesco Francia, Filippino Lippi, at least as far as attributions are concerned. In addition, German artists active in the first half of the 16th century (e.g. Lucas Cranach the Elder, Jörg Breu the Elder, Hans Süss von Kulmbach, Hans Baldung called Grien, Nikolaus Manuel Deutsch, Wolf Huber) and French Masters (Jean Fouquet, François Clouet, Antoine Caron) are not listed– under those names—in Albert's inventories. However, after Albert's era, some drawings from his collection listed under other names were subsequently discovered by scholars to be originals by artists listed above. Not even the early Netherlandish artists are so well represented. See Benesch 1928, Introduction, p. VI: "The early material, which is encountered sporadically and with gaps throughout, seems, as the 16th century advances, to become more complete, resulting for the later Romanists and Mannerism in a complete survey of all currents in art." Nor are 15th and early 16th-century prints, compared with the number of works from later periods, so well represented and there are gaps here too.

519 Only the Neapolitan drawings of the 18th century and the Austrian Baroque drawings are not so well represented in Albert's collections.

520 Albert of Saxe-Teschen owned no drawings by the German Neo-Classicists Asmus J. Carstens and Gottlieb Schick (prints by Carstens are listed, however). The Nazarenes,too, are scantily represented in Albert's collection and works by distinguished Romantic artists like Philipp O. Runge, Georg F. Kersting, Johan C. C. Dahl and Carl G. Carus are not present, or at least no work in the collection is attributed to them. In the French School the ducal drawings collection reveals larger deficiencies in drawings than in prints. In Albert's drawings inventories (Alte Cahiers) the names of Esprit A. Gibelin, Pierre-Paul Prud'hon (according to the current state of research there are, however, two Prud'hon drawings in the Albertina, which bear the stamp of Albert's collection), Anne-Louis Girodet-Trioson, Antoine-Jean Gros and Jean-A.-D. Ingres are missing. Prints by these artists, with the exception of Ingres, are listed. Albert owned neither drawings nor prints by Théodore Géricault.

521 The Maîtres Modernes, for the most part artists born after the mid-18th century, are particularly well represented in the German and French Schools. There are very long lists of drawings by Jacob W. Mechau, Friedrich H. Füger, Martin von Molitor, Josef Abel, Wilhelm Kobell, Vincenz

Kininger and, in the French School, by Jean B. Greuze, Nicolas Pérignon, Honoré Fragonard, Jean P. Norblin, Ignace Duvivier. In the prints section the German School is recorded as well represented by Domenico Quaglio, Franz K. Zoller, Johann G. T. Prestel, Friedrich Tischbein, Jakob Gauermann, Jakob Alt and in the French School Niclas Lavrince, Dominique V. Denon, Jacques Louis David, Charles Vernet, Louis L. Boilly, Jean-B. Isabey, François Gérard and Horace Vernet.

522 Apart from gaps in the list of 18th-century exponents of drawing—the names of William Hogarth, François Vivarès, Allan Ramsay, Thomas Gainsborough, George Romney and John Hoppner do not appear at all in the ducal inventories of the drawings (and the attribution of work to Joshua Reynolds cannot be maintained today)—contemporaries like William Blake, George Morland, Sir Thomas Lawrence, Sir David Wilkie and, in landscape drawing, Thomas Girtin, J.M.W. Turner, John Constable, John Sell Cotman, John Crome, Richard P. Bonington are missing entirely. Paul Sandby is represented by one sheet (inv. no. 15450). In the prints collection, by contrast, the above artists, except for Blake, and exponents of contemporary landscape drawing are all represented.

523 In addition to a marked emphasis on 17th century Dutch work, early 19th-century landscape representations are noticeably well represented in the collection. The presence of German and French—fewer exemplars but with a decided emphasis on the subject matter in the Dutch—drawings as well as entire series of German, French, Dutch and particularly English Vues, Paysages, Marines etc. among the prints implies that Albert of Saxe-Teschen concentrated more on this genre than purely art historical interest would have warranted.

524 I am indebted to Marie Luise Sternath for drawing my attention to this. Not until after 1810 did interest in English art become more widespread on the Continent and even then, it remained largely confined to prints. English painting and drawings were not really prized to any great extent until the latter half of the 19th century, that is, well after Albert's death (see exh. cat. Munich 1980).

525 See pp. 13–16.

526 Only a very few other distinguished collectors have bequeathed similarly large, good, well balanced and art historically similarly weighted cabinets of comparable scope. Important precursors of Albert's as collectors of drawings such as Giorgio Vasari, Everard Jabach, Sebastiano Resta, Pierre Crozat, Pierre-Jean Mariette, Antoine-Joseph Dezallier d'Argenville, J.-B. Nourry and distinguished contemporaries such as Hendrik Busserus, Bartolomeo Cavaceppi, Sir Joshua Reynolds, Cornelis Ploos van Amstel, Gerhard J. Schmidt, Saint-Morys, William Esdaile, Charles A. de Ligne, Thomas Lawrence, Theodorus Duijsel (Duysel), Jan D. Nijman and Jan J. Gildemeester seem, as far as this can be judged to date, to have collected art less with deliberate aims in mind, that is, not exclusively with the objective of comprehensively documenting the history of art. The range of artists and Schools is, therefore, rarely so broad in other collections as it is in Albert's. By contrast, individual preferences are often much easier to recognize. They often tended towards the Italian and the Dutch sectors.

527 For the Italian and Dutch drawings which have already been inventoried by computer, it is easy to demonstrate that comparatively few acuisitions were made in these sectors after Albert's death: from Albert's collection about 3,800 of what are

now some 4,100 Dutch drawings and roughly 3,600 of what are now approx 4,500 Italian sheets. Not much was added to the print collection, either, after Albert's death, or, more precisely, after 1920: in 1822 Albert of Saxe-Teschen left after about 50 years of collecting, 190,000 to 200,000 leaves. Archduke Charles added about 18,000 and Archduke Albrecht some 12,000 works. The works acquired by Archduke Frederick did not go to the Albertina (see p. 42). Further, acquisitions made during the tenures of Meder and Stix were almost entirely counterbalanced by the sale of duplicates. When the collection became the property of the Republic of Austria on April 3, 1919, it must in fact have contained 220,000 to 230,000 prints which were added to the 550,000 to 600,000 leaves from the former Imperial Hofbibliothek. The prints collection, which contained some 800,000 to 830,000 works in April 1919 has to date only been enlarged by about 20,000 works.

528 Archduke Charles bought over 400 drawings, among other things, by Martin von Molitor and between 15 and 25 drawings by each of the following: Franz E. Weirotter, Lorenz Janscha, Joseph Mössmer, Joseph Danhauser for the collection. Under Archduke Charles, acquisitions policy focused on Italian prints, notably a collection of over 600 chiaroscuro woodcuts (cf. Archduke Charles's acquisitions inventory, 1822–1829, p. 7: *Collection d'Estampes gravées en clair obscur; composée de plus de 600 pièces parmi lesquelles il s'en trouvent beaucoup de très rares, de rarissimes et même d'uniques, d'autres avec des différences dans les couleurs de l'impression et dans les adresses. Cette Suite dont la réunion est l'ouvrage de plus d'un siècle, et laquelle a beaucoup servie pour la formation du Catalogue resonné fait par Mr de Bartsch: Tome 12e: est contenue dans quatre Volumes in fol. reliés en cuir de Russie.* This acquisition from the Fries Collection was made in 1823 and is recorded as follows in the old section Cahiers: *Cette Collection, la plus ample et la plus complette qui puisse jamais se rassembler, a été formée par Mr Mariette, et provient du cabinet de Mr le Comte de Fries;* see Plate 10). Further focal points were the more than 300 leaves collected by Pierre und Pierre-Jean Mariette which comprised the *Œuvre complette de Lucas van Leyden* (this group came into the archducal cabinet from Count Fries's collection in 1824; most of the leaves also bear verifiable evidence of having come from Ploos van Amstel) and , also in 1824 and acquired from the Fries collection the *Œuvre complette de Henri Aldegrever; formée en Hollande par le Bourguemestre Six, et perfectionné en France par M. M. Mariette père et fils; il a passé en 1775 dans le cabinet de M. de Saint Yves, et en 1805 dans celui de M. le Comte de Fries.* More valuable Old Master prints (many bound works) of the German, Netherlandish and especially the Italian Schools were also acquired. Mainly Austrian and German works were added to the collection of contemporary prints. The drawings collected by Archduke Albrecht were for the most part 19th-century Austrian works, e.g. work by Jakob Alt, Thomas Ender, Joseph Kriehuber, Rudolf von Alt, August von Pettenkofen and Joseph Selleny. Particularly notable is the Stefano della Bella sketchbook (today in separate leaves). A fairly large group of views of Vienna and environs entered the archducal collection with what is known as the *Viennensia Collection* (some 200 drawings and 150 prints) owned by Theodor von Karajan. The most valuable and large groups of prints acquired include work by Israhel van Meckenem, Hans Burgkmair, Hans Holbein the Younger, Hans Sebald Beham,

Augustin Hirschvogel, Virgil Solis, Anton Van Dyck, Adrian van Ostade and, from the 19th century, Julius Schnorr von Carolsfeld, Joseph von Führich, Joseph Kriehuber and Ludwig Richter.

529 More gaps arose in the drawings collection than in the print collection. See Hans Tietze, 'Die neue *Albertina* in Wien' in *Kunstchronik und Kunstmarkt*, 56. Jg., N. F. XXXII, 1920/1921, p. 369: "As for the 19th-century drawings nothing … has been systematically collected. What is there appears to have been acquired arbitrarily. Not even 19th-century Austrian drawings are represented in any quality; Waldmüller, Pettenkofen, Makart, Klimt, all those whom one would expect to be completely represented, here especially with the most outstanding exemplars and in all their phases, are in fact only present to the extent that one feels the loss of their really excellent drawings all the more keenly, not to mention the great 19th-century German draughtsmen. This holds even more for the 19th-century French Impressionists … Things look a bit better for 19th-century prints."

530 Since the first world war, especially during Alfred Stix's tenure, these gaps have been largely closed (see p. 64).

531 See p. 38.

532 The drawings acquired (by Duke Albert and his heirs) were not catalogued in chronologically in groups according to owner but were mixed up. The acquisitions made by each heir cannot therefore be determined as groups from the inventory books.

533 In the acquisitions inventory of the drawings begun in 1895 (*Zuwachsverzeichniss Zeichnungen 1895*) there are both German and Austrian artists such as Jakob Gauermann, Ferdinand G. Waldmüller, Moritz von Schwind, Friedrich Gauermann, Adolf von Menzel, Max Liebermann, Max Klinger, Gustav Klimt and Franz von Stuck interspersed with French and English names, among them Eugène Delacroix, Camille Pissarro, Edward Burne-Jones, Paul Signac, Frank Brangwyn and Muirhead Bone. The prints added to the collection primarily represented the work of Goya, Joseph Kriehuber, Honoré Daumier and Max Klinger.

534 Several German, Netherlandish and Italian 15th and 16th-century drawings are recorded. The prints were primarily the work of Hans Schäufelein, Hans Sebald Beham, Jost Amman and Tobias Stimmer.

535 Benesch 1964, p. 23 (see also p. 42).

536 Particularly noteworthy is the collection of some 650 drawings acquired in 1922 (but not catalogued until Stix) from the estate of the Viennese art historian and collector Oswald Kutschera von Woborsky. The focal point of this collection, which includes all Schools, is 17th and 18th-century Austrian and German drawings as well as Italian Baroque ones, including numerous Neapolitan drawings, a sector which up to then had been only scantily represented. Of over 700, primarily 19th-century Austrian and German drawings and watercolours, about 300 were transferred to the Albertina from the formerly entailed Imperial library (Fideikomiß-Bibliothek). A group of about 1,000 leaves by which the collection was enlarged includes mainly German, Austrian and French prints from the late 19th and early 20th centuries, among them important Expressionist works.

537 See p. 42.

538 See p. 42 and note 252.

539 Between 1920 and 1930 the Albertina acquired important works from the collections of Luigi Grassi (including many early Venetian works),

Heinrich Berstl, Stefan von Licht and Max Hevesi. On the individual collectors see Dossi and Kertész (work in progress).

540 In 1924 the Albertina acquired some 100 French drawings from the Simon Meller Collection, including work by the most important artists of the period such as Jean-A.-D. Ingres, Camille Corot, Eugène Delacroix, Honoré Daumier, Jean-François Millet, Edouard Manet, Edgar Degas, Paul Cézanne, Auguste Renoir and Henri de Toulouse-Lautrec. For Meller see Dossi and Kertész (work in progress).

541 Large transfers of drawings from the Wiener Staatsgalerie (later Österreichische Galerie) included several works each by Friedrich H. Füger, Johann Scheffer von Leonhardshoff, Josef von Führich, August von Pettenkofen, Hans von Marées, Wilhelm Leibl, Karl Schuch, Gustav Klimt, Oskar Kokoschka and Egon Schiele as well as several books of sketches by Ferdinand G. Waldmüller. Such transactions have contributed substantially to completing this area of the collection (see Akten-Archiv der Albertina, Zl 39/1923). Under Stix about 5,900 prints were added. His acquisitions policy focused on the work of Francisco de Goya, Camille Corot, Honoré Daumier, Adolf Menzel, Edgar Degas, Lovis Corinth, James Ensor, Edvard Munch, Henri de Toulouse-Lautrec, Ludwig H. Jungnickel and Oskar Kokoschka.

542 Notable acquisitions include drawings by Albrecht Dürer, Lucas Cranch the Elder and Wolf Huber as well as Daniel Gran, Paul Troger, Martin J. Schmidt and Franz A. Maulbertsch.

543 On the Artaria family see Dossi and Kertész (work in progress).

544 Including drawings by Carlo Carrà, Gino Severini, Giorgio de Chirico, Marino Marini, Giacomo Manzú and Renato Guttuso.

545 Large transfers of works occurred again from the Österreichischen Galerie in Vienna.

546 His most important acquisitions of Old Masters include 16th-century Austrian and German drawings, for instance from the Danube School, and additions to the Rembrandt collection. Egon Schiele drawings were bought for the Albertina mainly from the Arthur Rössler collection, from Heinrich Benesch's estate and from a bequest to the Albertina from Erich Lederer. In 1960 Alfred Kubin's estate, which included some 1,400 drawings and more than 500 prints by various artists was taken over. Most of the works added to the print collection are by 20th-century artists, including important Cubist work by Pablo Picasso, Fernand Léger and Georges Braque.

547 Among the most outstanding 19th-century artists whose work was added to on a large scale in the drawings collection are Thomas Ender, Peter Fendi, Josef Kriehuber, Rudolf von Alt, Gustav Klimt and Oskar Kokoschka. Koschatzky concentrated on the 20th century in adding to the print collection. His acquisitions policy focused mainly on Austrian work although work by an international array of artists was also bought. In addition to the regular acquisitions budget, the Albertina has also had access to important funds from the Austrian Ludwigstiftung since 1983 to cover the purchase of work from countries other than Austria. Through this endowment Walter Koschatzky was able to acquire work by artists like Martin Disler and Ernesto Tatafiore for the collection (see exh. cat. Vienna, Albertina, 1997).

548 Oberhuber has not only continued to enlarge the collection of Austrian art—for instance by purchasing work by Oskar Kokoschka (the artist's widow, Olda Kokoschka, also gave the Albertina important works), Fritz Wotruba, Max Weiler,

Maria Lassnig, Alfred Hrdlicka, Arnulf Rainer, Walter Pichler, Franz West and Siegfried Anzinger—but has also concentrated on adding work by US artists (for instance, Louise Bourgeois, Robert Rauschenberg, Donald Judd, Sol Lewitt, Jasper Johns, Jim Dine, Brice Marden and Bruce Nauman) as well as Eastern Europe (e.g. János Mattis-Teutsch, Nadeshda Udaltsova, Frantisek Kupka, Ivan Kliun, Karel Malich and Ilya Kabakow). The most important acquisitions made possible by the Austrian Ludwigstiftung include works by Barnett Newman, Jackson Pollock, Jasper Johns and—from the Emanuel and Sophie Fohn Collection—by Paul Klee, August Macke and Oskar Schlemmer.

549 For detailed biographical information on Albert of Saxe-Teschen see Koschatzky and Krasa 1982 (with further references) and exh. cat. Vienna, Albertina, 1969. For the historical background see Roegiers 1980; Zöllner 1979; Mikoletzky 1963 (each with further references).

550 See p. 12.

551 On Januar 9, 1760 Albert and his brother Clement arrived in Vienna. On January 10, they were introduced to the Emperor and Empress and on January 11, Albert first saw the Archduchess Marie Christine (cf. *Wienerisches Diarium*, Num. 4, Saturday, January 12, 1760, p. 6).

552 See p. 12.

553 HHSTA, za Prot. 27, fol. 256.

554 See *Wienerisches Diarium*, Num. 40, Saturday, May 17, 1760, p. 6; Englebert 1964, pp. 68–75.

555 *Wienerisches Diarium*, Num. 18, 2. Martii 1763, p. 4 (see Koschatzky and Krasa 1982, p. 55).

556 My thanks to Ferdinand Zörrer, Archivist of the Großloge Österreichs (Austrian Grand Lodge; see p. 60, note 488).

557 See exh. cat. Vienna 1992/93, p. 431.

558 *Wienerisches Diarium*, Num. 104, December 28, 1765, p. 4 (see Koschatzky and Krasa 1982, p. 69).

559 See p. 12, note 19.

560 See Pfarr-Protokoll, 2, 182 of 8.4.1766 (HHSTA, Familienarchiv, Stammbaum, Carton 1A, Tafel 1A29); *Journal de Schloß-Hof de l'an 1766 à l'occasion du mariage de l'Archiduchesse Marie Christine* (HHSTA, Familienakten, k. 48, Konvolut 1766, April 7 – October 17, [II/1], fol. 1–6); Koschatzky and Krasa 1982, pp. 74–76.

561 See p. 12.

562 For descriptions of Pressburg Castle see Rotenstein 1783, pp. 198–208; Rotenstein 1793, pp.54–61.

563 See pp. 13–16.

564 See exh. cat. Vienna, Albertina, 1969, pp. 59–69.

565 See p. 46.

566 Durazzo 1776, Version I, inv. no. 30858ᵇ, recto (see p. 16).

567 See Ypersele de Strihou 1991, p. 19 and pp. 174–176; Ypersele de Strihou 1991 (Bulletin).

568 See p. 47.

569 See p. 47.

570 François Lefèbvre and Joseph van Bouckhout (see p. 47).

571 See p. 48.

572 Cf. Marie Christine's will, August 17, 1766 (HHSTA, Ministerium des k. und k. Hauses, Verlassenschaften, Carton 1, Fasc. 1, no. 6); Hertenberger and Wiltschek 1983, p. 21, note 4.

573 Cf. Albert of Saxe-Teschen, *Mémoires*, Vol. 14, p. 369: "During those days he [Leopold] came to speak of our request, first with my wife and then with me to entrust us with his third son, Charles, as our adoptive son and to appoint him as [our] successor to the government of the Netherlands" (see Koschatzky and Krasa 1982, p. 177; Hertenberger and Wiltschek 1983, p. 21, Wandruszka

1965, p. 313, Criste 1912, p. 19; Thausing 1870–1871, p. 75). There are probably no formal records of acquiescence in the request—certainly no evidence of such has been found. I should like to thank Leopold Kammerhofer, HHSTA, for his help in looking through the archive material.

574 Will of January 11, 1791 (HHSTA, Ministerium des k. und k. Hauses, Verlassenschaften, Carton 1, Fasc. 1, no. 6).

575 See Wandruszka 1965, Vol. 2, p. 45.

576 Marie Christine's will of January 11, 1791, including the Emperor's acquiescence in the adoption: HHSTA, Familienurkunden, no. 2135 (photocopies: Albertina archives).

577 See *Wiener Zeitung*, Sunday October 15, 1791, p. 2650.

578 See pp. 27–29.

579 Handwritten letter from the Emperor Franz II to Marie Christine dated March 16, 1793 (HHSTA, Hausarchiv, fk 28A, fol. 205–207); see Koschatzky and Krasa 1982, p. 194.

580 See p. 57.

581 See p. 57.

582 See Krasa 1967–1968.

583 See Koschatzky and Krasa 1982, p. 15.

584 See p. 57.

585 See Herzmansky 1965, pp. 61–77.

586 For the confiscation of art in Vienna during the Napoleonic Wars see Koschatzky 1971, pp. 66–73; Pellar 1988, pp. 46–48.

587 See exh. cat. Vienna, Albertina, 1969, p. 199.

588 See note 124; for the danger that the collection would be lost see pp. 38–45.

# Selected Bibliography

Exhibition catalogues are listed in alphabetical order according to place names;
auction catalogues are similarly listed according to proper names and,
wherever several are mentioned under the same name, these are listed chronologically.

ABAFI 1890–1899
Abafi, Ludwig (= Ludwig von AIGNER), *Geschichte der Freimaurerei in Österreich-Ungarn*, 5 volumes, Budapest 1890–99

ALBERT of Saxe-Teschen 1776
Albert of Saxe-Teschen, *Journal, worinnen nur angezeigt ist, wo ich von Tag zu Tag gewesen*, 1776 (Budapest, Ungarisches Nationalarchiv, Habsburgisches Familienarchiv, P 298-16/2; photocopies in archive at the Albertina)

ALBERT of Saxe-Teschen, *Mémoires*
Albert of Saxe-Teschen, *Mémoires de ma Vie* (compiled after 1805, covering the years 1738–1798; in the supplement volumes: subsequent years up to 1812), 6 cassettes, Budapest, Ungarisches Nationalarchiv, Habsburgisches Familienarchiv, P 298-1d, no. 2 (17 volumed photocopied version in the Albertina)

ANONYMOUS 1810
Anonymous, *Catalogue des tableaux et desseins des maitres célèbres des différentes écoles … qui composent le cabinet de feu Mr. J. M. de Birckenstock*, Vienna 1810

ANONYMOUS 1970
Anonymous, *Geschichte der Firmen Artaria & Compagnie und Freytag-Berndt und Artaria. Ein Rückblick auf 200 Jahre Wiener Privatkartographie 1770–1970* (company's commemorative volume), Vienna/Innsbruck 1970

D'ARGENVILLE 1745–1752
d'Argenville, Antoine-Joseph Dezallier, *Abrégé de la vie des plus fameux peintres avec leurs portraits gravés en taille-douce, les indications de leurs principaux ouvrages. Quelques Réflexions sur leurs caractères, et la manière de connaître les desseins des grands maîtres*, 3 volumes, Paris 1745–1752

D'ARGENVILLE 1767–1768
d'Argenville, Antoine-Joseph Dezallier, *Leben der beruehmtesten Maler, nebst einigen Anmerkungen über ihren Charakter, der Anzeige ihrer vornehmsten Werke und einer Anleitung, die Zeichnungen und Gemaelde großer Meister zu kennen*, 3 volumes, Leipzig 1767–1768

ARQUIÉ-BRULEY/LABBÉ/BICART-SÉE 1987
Arquié-Bruley, Françoise/Labbé, Jacqueline/Bicart-Sée, Lise, *La collection Saint-Morys au Cabinet des Dessins du Musée du Louvre* (Notes et Documents des Musées de France 19), 2 volumes, Paris 1987

AUCTION CAT. DURAZZO 1872
Auction cat. Durazzo, *Catalog der … Kupferstich-Sammlung des Marchese Jacopo Durazzo in Genua, welche … den 19. November 1872 und folgende Tage … zu Stuttgart … versteigert wird*, Stuttgart 1872

AUCTION CAT. Fries 1828
Auction cat. Fries, *Catalog von Original-Handzeichnungen, der Concurs-Massa Fries et Compagnie gehörend, welche gegen gleich baare Bezahlung werden versteigert werden*, Vienna 1828

AUCTION CAT. Ligne 1794
Auction cat. Ligne, *Catalogue Raisonné des Desseins Originaux … du Cabinet de feu le Prince Charles de Ligne … par Adam Bartsch*, Vienna 1794

AUCTION CAT. Ploos van Amstel 1800
Auction cat. Ploos van Amstel, *Catalogus der Teekeningen, Prenten, Schilderyen, … van wylen den Heer Cornelis Ploos van Amstel* (ed. by Philippus van der Schley, Jan de Bosch Jeronz., Bernardus de Bosch Jeronz., Jan Yver und Cornelis Sebille Roos), Amsterdam 1800

AUCTION CAT. Winkler 1815
Auction cat. Winkler, *Verzeichniss der Handzeichnungen aller Art, aller Nationen und Schulen aus dem Nachlass des Herrn Gottfried Winkler, Banquiers, Senators und Rathsbaumeisters in Leipzig, welche daselbst … öffentlich versteigert werden sollen. Die Auction fängt an den 16ten October 1815*, Leipzig 1815

AUCTION CAT. Amsterdam 1974
*Franse Tekenkunst van de 18de eeuw uit nederlandse verzamelingen*, Amsterdam 1974

AUCTION CAT. Amsterdam 1992
*De wereld binnen handbereik Nederlandse Kunst – en rariteitenverzamelingen, 1585–1735*, Amsterdam 1992

AUCTION CAT. Brno 1994
*Wenzel Anton Fürst Kaunitz-Rietberg und die bildende Kunst*, Brno 1994

AUCTION CAT. Eisenstadt 1995
*Die Fürsten Esterházy. Magnaten, Diplomaten & Mäzene*, Eisenstadt 1995

AUCTION CAT. Essen 1986
*Barock in Dresden. Kunst und Kunstsammlungen unter der Regierung des Kurfürsten Friedrich August I. von Sachsen und Königs August II. von Polen genannt August der Starke 1694–1733 und des Kurfürsten Friedrich August II. von Sachsen und Königs August III. von Polen 1733–1763*, Essen 1986

AUCTION CAT. Frankfurt 1989
*Die Sammlung des Consul Smith. Meisterwerke italienischer Zeichnung aus der Royal Library, Windsor Castle. Von Raffael bis Canaletto*, Frankfurt 1989

AUCTION CAT. Hanover 1992
*Venedigs Ruhm im Norden*, Hanover 1992

AUCTION CAT. London 1996
*Grand Tour. The Lure of Italy in the Eighteenth Century*, London 1996

AUCTION CAT. Munich 1980
*Zwei Jahrhunderte englische Malerei. Britische Kunst und Europa 1680 bis 1880*, Munich 1980

AUCTION CAT. Munich 1992
*Friedrich der Große. Sammler und Mäzen*, Munich 1992

AUCTION CAT. Nuremberg 1994
*Das Praunsche Kabinett. Meisterwerke von Dürer bis Carracci*, Nuremberg 1994

AUCTION CAT. Vienna, Albertina, 1958
*Neuerwerbungen alter Meister 1950–1958*, Vienna, Albertina, 1958

AUCTION CAT. Vienna, Albertina, 1959
*Neuerwerbungen moderner Meister 1950–1959, I. Teil*, Vienna, Albertina, 1959

AUCTION CAT. Vienna, Albertina, 1960/61
*Neuerwerbungen moderner Meister 1959–1960, II. Teil*, Vienna, Albertina, 1960/61

AUCTION CAT. Vienna, Albertina, 1969
*200 Jahre Albertina. Herzog Albert von Sachsen-Teschen und seine Kunstsammlung*, Vienna, Albertina, 1969

AUCTION CAT. Vienna, Albertina, 1976
*Giacomo Conte Durazzo 1717–1794. Zum Jubiläum des Wiener Burgtheaters 1776–1976*, Vienna, Albertina, 1976

AUCTION CAT. Vienna, Albertina, 1988
*Albert, Herzog von Sachsen-Teschen, 1738–1822, Zum 250. Geburtstag*, Vienna, Albertina, 1988

AUCTION CAT. Vienna, Albertina, 1996
*Exempla & exemplaria. Architekturzeichnungen der Graphischen Sammlung Albertina und Architekturmodelle der Graphischen Sammlung Albertina aus der TU Wien*, Vienna, Albertina, 1996

AUCTION CAT. Vienna, Albertina, 1997
*Balthus bis Warhol. Österreichische Ludwigstiftung, Erwerbungen für die Albertina*, Vienna, Albertina, 1997

AUCTION CAT. Vienna 1984
*Zirkel und Winkelmaß. 200 Jahre große Landesloge der Freimaurer*, Vienna 1984

AUCTION CAT. Vienna 1986
*Bibliotheca Eugeniana. Die Sammlungen des Prinzen Eugen von Savoyen*, Vienna 1986

AUCTION CAT. Vienna 1992/93
*Freimaurer. Solange die Welt besteht*, Vienna 1992/93

BARTSCH (1782–90)
Bartsch, Adam von, *Recueil d'estampes d'après les desseins originaux qui se trouvent à la Bibliothèque I. & R. de Vienne gravées par Adam Bartsch*, n.p. (1782–90)

BARTSCH 1820
Bartsch, Adam von, *Ueber die Verwaltung der Kupferstichsammlung der K.K. Hofbibliothek*, 1820, English trans. by W. L. Strauss entitled *Concerning the Administration of the Collection of Prints of the Imperial Court Library in Vienna*, New York 1982

BARTSCH (F.) 1818
Bartsch, Friedrich von, *Catalogue des Estampes de J. Adam de Bartsch*, Vienna 1818

BARTSCH (F.) 1854
Bartsch, Friedrich von, *Die Kupferstichsammlung der k.k. Hofbibliothek in Wien. In einer Auswahl ihrer merkwürdigsten Blätter dargestellt*, Vienna 1854

BENEDIK (work in progress)
Benedik, Christian, *Der hofbauamtliche Zeichnungsbestand der Graphischen Sammlung Albertina* (working title)

BENESCH 1928
Benesch, Otto (Ed.), *Die Zeichnungen der Niederländischen Schulen des XV. und XVI. Jahrhunderts* (= descriptive cat. on the drawings in the Graphische Sammlung Albertina, volume II, ed. by Alfred Stix), Vienna 1928

BENESCH 1933
Benesch, Otto, 'Die Handzeichnungen des Fürsten von Ligne' in *Die Graphischen Künste*, LVI, 1933, entry no. 2/3, pp. 31–35

BENESCH 1964
Benesch, Otto, *Meisterzeichnungen der Albertina.*

*Europäische Schulen von der Gotik bis zum Klassizismus*, Salzburg 1964

BENESCH (E.) 1961
Benesch, Eva, *Otto Benesch. Verzeichnis seiner Schriften*, Bern 1961

BENESCH (E.) 1970–1973
Benesch, Eva (Ed.), *Otto Benesch. Collected Writings*, 4 volumes, London 1970–73

BENESCH (E.) 1979
Benesch, Eva (Ed.), *Otto Benesch. From an Art Historian's Workshop. Rembrandt, Dutch and Flemish Masters, Velázquez, Frederik van Valckenborch*, Lucerne 1979

BENINCASA 1784
Benincasa, Bartolommeo, *Descrizione della Raccolta di Stampe di S. E. Il Sig. Conte Jacopo Durazzo Patrizio Genovese ec. ec. esposta in una Dissertazione sull'Arte dell'Intaglio a Stampa*, Parma 1784

BERENGER 1997
Berenger, Jean, *The Habsburg Empire 1700–1918*, USA 1997

BIRKE 1991
Birke, Veronika, *Die italienischen Zeichnungen der Albertina. Zur Geschichte der Zeichnung in Italien*, Munich 1991

BIRKE/KERTÉSZ 1992–1997
Birke, Veronika/Kertész, Janine, *Die italienischen Zeichnungen der Albertina. Generalverzeichnis*, 4 volumes, Vienna/Cologne/Weimar 1992–97

BÖCKH 1821
Böckh, Franz-Heinrich, *Wiens lebende Schriftsteller, Künstler und Dilettanten im Kunstfache*, Vienna 1821

BÖSEL 1996
Bösel, Richard, 'Die Architekturzeichnungsbestände der Albertina. Ein kurzer Überblick' in *exempla & exemplaria. Architekturzeichnungen der Graphischen Sammlung Albertina und Architekturmodelle der Graphischen Sammlung Albertina aus der TU Wien* (exhib. cat.), Vienna, Albertina, 1996, p. 30f.

BONNAFFÉ 1873
Bonnaffé, Edmond, *Les Collectioneurs de l'ancienne France*, Paris 1873

BONNAFFÉ 1884
Bonnaffé, Edmond, *Dictionnaire des Amateurs français au XVIIe siècle*, Paris 1884

BRAUN 1880
Braun, Adolph, *Catalogue Général des Photographies Inaltérables au charbon faites d'après les originaux Peintures, Fresques, Dessins et Sculptures … par Ad. Braun & Cie*, Paris 1880

BRISANZ-PRAKKEN 1995
Brisanz-Prakken, Marian, *Drawings from the Albertina: Landscape in the Age of Rembrandt*, USA 1995

BUCHOWIECKI 1957
Buchowiecki, Walther, *Der Barockbau der ehemaligen Hofbibliothek in Wien, ein Werk J. B. Fischers von Erlach* (Museion. Published by the National Library of Austria, Vienna, new ed., 2nd series, volume 1), Vienna 1957

CAYLUS 1732
Caylus, Comte de, 'Discours sur les dessins lu dans une Conférence de l'Academie Royale de Peinture et Sculpture en 1732' in *Le Cabinet de l'Amateur et de l'Antiquaire*, volume 4, 1845–46 (revised ed. by H. Jouin), pp. 400–479

CAYLUS 1748
Caylus, Comte de, *De l'Amateur* (Conférence du Comte de Caylus à l'Académie le 7 septembre 1748), Paris 1748

CHRIST 1757
Christ, Johann Friedrich, *Catalogue d'une grande Collection d'Estampes des meilleurs maitres d'Italie, de Flandres, de France, et d'Allemagne*, Leipzig 1757

CRISTE 1912
Criste, Oskar, *Erzherzog Carl von Österreich. Ein Lebensbild*, 2 volumes, Vienna/Leipzig 1912

DACIER 1954
Dacier, Emile, 'Catalogues de ventes et livrets de salons illustrés et annotés par Gabriel de Saint-Aubin, 13, Catalogue de la vente du Marquis de Calvière (1779)' in *Gazette des Beaux Arts*, XLIV, 1954, pp. 5–46

D'ARGENVILLE, see ARGENVILLE 1745–1752 and ARGENVILLE 1767–1768

DAVIS 1974
Davis, Walter Wilson, *Joseph II: An imperial reformer for the Austrian Netherlands*, Den Haag 1974

DE FREDDY, see FREDDY 1800

DICKSON 1987
Dickson, P.G.M., *Finance and Government under Maria Theresia, 1740–1780: Finance and Credit*, UK 1987

DICKSON 1987
Dickson, P.G.M., *Finance and Government under Maria Theresia, 1740–1780: Society and Government*, UK 1987

DITTRICH 1965/66
Dittrich, Christian, 'Carl Heinrich von Heineckens kunsthistorische Schriften' in *Jahrbuch der Staatlichen Kunstsammlungen Dresden*, 1965/66, pp. 79–85

DIZION. BIOGR. 1960–1996
*Dizionario Biografico degli Italiani*, published to date: volumes 1–46, Rome 1960–96

DOSSI/KERTÉSZ (work in progress)
Dossi, Barbara/Kertész, Janine, *Die italienischen Zeichnungen der Albertina und ihre Provenienzen* (working title. The Italian drawings in the Albertina. Works cat., volume 5, ed. by Veronika Birke)

DUCHESNE 1834
Duchesne, Jean, *Voyage d'un Iconophile. Revue des principaux Cabinets d'Estampes, Bibliothèques et Musées d'Allemagne, de Hollande et d'Angletterre*, Paris 1834

DUMESNIL 1858–1860
Dumesnil, Jules-Antoine, *Histoire des plus célèbres amateurs français … et de leurs relations avec les artistes*, 5 volumes, Paris 1858–60 (reprinted Geneva 1973)

DUPLESSIS 1855
Duplessis, Georges (Ed.), *Le livre des Peintres et Graveurs par Michel de Marolles, abbé de Villeloin* [Paris 1673], new edition by M. Georges Duplessis, Paris 1855

DUPLESSIS 1857
Duplessis, Georges, *Mémoires et Journal de J.-G. Wille, Graveur du Roi. Publiés d'après les manuscrits autographes de la Bibliothèque Impériale*, 2 volumes, Paris 1857

DUPLESSIS 1874
Duplessis, Georges, *Les ventes de tableaux, dessins, estampes et objets d'art aux XVIIe et XVIIIe siècles (1611–1800). Essai de bibliographie*, Paris 1874

DURAZZO 1776
Durazzo, Giacomo, *Discorso Preliminare*, Venice 1776 (Vienna, Graphische Sammlung Albertina, version I, inv. no. 30858a–f, version II, inv. no. 30858¹⁻⁵)

DUVERGER 1984–1992
Duverger, Erik, 'Antwerpse Kunstinventarissen uit de zeventiende eeuw' in *Fontes Historiae artis neerlandicae*, 6 volumes, Brussels 1984–92

EFFENBERGER 1912
Effenberger, Hans (Ed.), *Graf August de La Garde. Gemälde des Wiener Kongresses 1814–15*, Vienna/Leipzig 1912

ENGLEBERT 1964
Englebert, Georges, 'Le Duc Albert de Saxe-Teschen et son Régiment de Cuirassiers' in *Albertina-Studien*, 1964, no. 3, pp. 68–75

ENGLEBERT 1965
Englebert, Georges, 'L'aquarelliste François Lefèbvre et le Château de Laeken' in *Albertina-Studien*, 1965, no. 2, pp. 83–90

FAGAN 1883
Fagan, Louis, *Collectors' Marks*, London 1883

FÉLIBIEN 1676
Félibien, André, *Des Principes de l'Architecture, de la Sculpture, de la Peinture, et des autres Arts qui en dependent. Avec un dictionnaire des Termes propres à chacun de ces Arts*, Paris 1676

FÉLIBIEN 1706
Félibien, André, *Entretiens sur les vies et sur les ouvrages des plus excellens peintres anciens et modernes* [2. Ausgabe, Paris 1690], revised edition, 4 volumes, Amsterdam 1706

FIORILLO 1798–1808
Fiorillo, Johann Dominik, *Geschichte der zeichnenden Künste von ihrer Wiederauflebung bis auf die neuesten Zeiten*, 5 volumes, Göttingen 1798–1808

FLOERKE 1905
Floerke, Hanns, *Studien zur niederländischen Kunst- und Kulturgeschichte. Die Formen des Kunsthandels, das Atelier und die Sammler in den Niederlanden vom 15.–18. Jahrhundert*, Munich/Leipzig 1905

FREDDY 1800
Freddy, Giovanni-Luigi de, *Descrizione della città, sobborghi e vicinanze di Vienna*, Vienna 1800

FREY 1919
Frey, Dagobert, 'Die Verstaatlichung und Inventarisierung des Habsburg-Lothringischen Kunstbesitzes' in *Mitteilungen des Staatsdenkmalamtes* (previously: notes to the commission for the preservation of historically important buildings), volume 1, Vienna 1919, pp. 1–22

FRIMMEL 1918/19
Frimmel, Theodor von, 'Die Gemäldesammlung in der Wiener Akademie der Bildenden Künste ist wieder eröffnet. – Die Albertina wieder zugänglich' in *Studien und Skizzen zur Gemäldekunde* (ed. by Th. Frimmel), volume IV, Vienna 1918/19, p. 126

FRODL-KRAFT 1980
Frodl-Kraft, Eva, 'Hans Tietze 1880–1954. Ein Kapitel aus der Geschichte der Kunstwissenschaft, der Denkmalpflege und des Musealwesens in Österreich' in *Zeitschrift für Kunst und Denkmalpflege*, XXXIV yr., 1980, pp. 53–63

FUESSLI 1801–1802
Fuessli, Hans-Rudolph, *Annalen der bildenden Künste für die österreichischen Staaten, Erster und zweyter Theil*, Vienna 1801–02

GATES-COON 1994
Gates-Coon, Rebecca, *The Landed Estates of the Esterhazy Princes: Hungary during the Reforms of Maria Theresia and Joseph II*, USA 1994

GERSZI 1988
Gerszi, Teréz (Ed.), *Von Leonardo bis Chagall. Die schönsten Zeichnungen aus dem Museum der Bildenden Künste in Budapest*, Budapest 1988

GIBSON-WOOD 1989
Gibson-Wood, Carol, 'Jonathan Richardson, Lord Somers' collection of drawings, and early art-historical writing in England' in *Journal of the Warburg and Courtauld Institutes*, volume 52, 1989, pp. 167–187

GLEISBERG/MEHNERT 1990
Gleisberg, Dieter/Mehnert, Karl-Heinz, *Meisterzeichnungen. Museum der bildenden Künste Leipzig*, Leipzig 1990

GOMBRICH/HELD/KURZ 1958
Gombrich, Ernst/Held, S. Julius/Kurz, Otto, *Essays in honor of Hans Tietze 1880–1954*, Paris 1958

GRÖNING/STERNATH 1997
Gröning, Maren/Sternath, Marie Luise (Ed.), *Die deutschen und Schweizer Zeichnungen des späten 18. Jahrhunderts* (= descriptive cat. on the

drawings in the Graphische Sammlung Albertina, volume IX, ed. by Konrad Oberhuber), Vienna 1997

HAGEDORN 1755
Hagedorn, Christian Ludwig von, *Lettre à un Amateur de la Peinture avec des Eclaircissemens historiques sur un cabinet et les autres des tableaux qui le composent*, Dresden 1755

HAGEDORN 1762
Hagedorn, Christian Ludwig von, *Betrachtungen über die Mahlerey*, Leipzig 1762

HALBEY 1986
Halbey, Hans A. (Ed.), *Museum der Bücher*, Dortmund 1986

HAMANN 1988
Hamann, Brigitte, *Die Habsburger. Ein biographisches Lexikon*, Vienna 1988

HAMMER 1986
Hammer, Katharina, *Glanz im Dunkel. Die Bergung von Kunstschätzen im Salzkammergut am Ende des 2. Weltkrieges*, Vienna 1986

HASKELL 1958
Haskell, Francis, 'The market for Italian Art in the 17th Century' in *Past and Present* 1958, no. 15, pp. 48–59

HASKELL/PENNY 1988
Haskell, Francis/Penny, Nicholas, *Taste and the Antique*, New Haven/London 1988

HATTORI 1993
Hattori, Cordélia, *La collection de dessins de Pierre Crozat étude sur le fonds d'Art Graphique du musée du Louvre*, Université de Paris IV-Sorbonne, Paris 1993

HAUPT 1991
Haupt, Herbert, *Das Kunsthistorische Museum. Die Geschichte des Hauses am Ring*, Vienna 1991

HAUPT 1995
Haupt, Herbert, *Jahre der Gefährdung. Das Kunsthistorische Museum 1938–1945*, Vienna 1995

HEINECKEN 1753/1757
Heinecken, Carl Heinrich von, *Recueil d'estampes d'après les plus célèbres tableaux de la Galerie Royale de Dresde*, 2 volumes, Dresden 1753/1757

HEINECKEN 1768–1769
Heinecken, Carl Heinrich von, *Nachrichten von Künstlern und Kunst-Sachen*, Leipzig 1768–69

HEINECKEN 1771
Heinecken, Carl Heinrich von, *Idée Générale d'une Collection complette d'Estampes*, Leipzig/Vienna 1771

HEINECKEN 1782
Heinecken, Carl Heinrich von, *Abrégé de la vie des peintres, dont les tableaux composent la Galerie Electorale de Dresde*, Dresden 1782

HEINECKEN 1786
Heinecken, Carl Heinrich von, *Neue Nachrichten von Künstlern und Kunstsachen*, Dresden/Leipzig 1786

HEINZ 1967
Heinz, Günther, *Die Gemäldegalerie des Kunsthistorischen Museums Wien*, Munich 1967

HELBIG 1980
Helbig, Herbert, *Die Vertrauten 1680–1980. Eine Vereinigung Leipziger Kaufleute*, Stuttgart 1980

HERES 1991
Heres, Gerald, *Dresdener Kunstsammlungen im 18. Jahrhundert*, Leipzig 1991

HERRMANN 1972
Herrmann, Frank (Ed.), *The English as Collectors. A documentary chrestomathy*, London 1972

HERRMANN 1992
Herrmann, Luke (rev.), *Die Englische Schule. Zeichnungen und Aquarelle britischer Künstler* (descriptive cat. on the drawings in the Graphische Sammlung Albertina, volume VII, ed. by Konrad Oberhuber), Vienna 1992

HERTENBERGER/WILTSCHEK 1983
Hertenberger, Helmut/Wiltschek, Franz, *Erzherzog Karl. Der Sieger von Aspern*, Graz/Vienna/Cologne 1983

HERVEY 1921
Hervey, Mary, *The Life, Correspondence & Collections of Thomas Howard Earl of Arundel*, Cambridge 1921 (reprinted 1969)

HERZMANSKY 1965
Herzmansky, Hedwig, 'Die Baugeschichte der Albertina' in *Albertina-Studien*, 1965, pp. 3–21, 55–81, 111–138

HERZMANSKY 1966
Herzmansky, Hedwig, 'Die Baugeschichte der Albertina (cont.)' in *Albertina-Studien*, 1966, pp. 3–17, 59–69

HILCHENBACH 1781
Hilchenbach, Carl-Wilhelm, *Kurze Nachricht von der Kaiserl. Königl. Bildergalerie zu Wien und ihrem Zustande im Jenner 1781*, Frankfurt 1781

HÖFLECHNER/POCHAT 1992
Höflechner, Walter/Pochat, Götz (Ed.), *100 Jahre Kunstgeschichte an der Universität Graz* (publication from the archives of the University of Graz, volume 26), Graz 1992

HUBER (M.) 1801–1810
Huber, Michael, *Catalogue Raisonné du Cabinet d'Estampes de feu Monsieur Winckler*, 7 volumes, Leipzig 1801–10

HUBER/ROST 1796
Huber, Michael/Rost, Carl C.H., *Handbuch für Kunstliebhaber und Sammler über die vornehmsten Kupferstecher und ihre Werke*, Zurich 1796

IMPEY/MAC GREGOR 1985
Impey, Oliver/Mac Gregor, Arthur (Ed.), *The Origins of Museums. The cabinet of curiosities in sixteenth and seventeenth-century Europe*, Oxford 1985

IRMEN 1994
Irmen, Hans-Josef (Ed.), *Die Protokolle der Wiener Freimaurerloge 'Zur Wahren Eintracht' (1781–85)*, Frankfurt 1994

JAECK 1822
Jaeck, Joachim Heinrich, *Wien und dessen Umgebungen, beschrieben vom Koenigl. Bibliothekar Jaeck zu Bamberg*, Weimar 1822

JÄGERMAYR 1863–1866
Jägermayr, Gustav, *Albrecht-Gallerie. Auswahl der vorzüglichsten Handzeichnungen aller Meister aus der Privatsammlung Sr. k.k. Hoheit des Durchlauchtigsten Herrn Erzherzog Albrecht. Photographiert von Gustav Jägermayr*, 6 volumes, Vienna 1863–66

JOHNSON 1986
Johnson, W. MacAllister, 'Paintings, Provenance and Price: Speculations on 18th-century connoisseurship apparatus in France' in *Gazette des Beaux-Arts*, CVII, May-June 1986, pp. 191–199

JULIEN DE PARME 1862
Julien de Parme, 'Histoire de Julien de Parme racontée par lui-même' in *L'Artiste* 1862, I, pp. 80–88

KEIL 1977
Keil, Nora, *Die Miniaturen der Albertina Wien*, Vienna 1977

KOSCHATZKY 1963
Koschatzky, Walter, 'Die Gründung der Kunstsammlung des Herzogs Albert von Sachsen-Teschen. Ein Beitrag zur Geschichte der Albertina' in *Albertina-Studien*, 1963, pp. 5–14

KOSCHATZKY 1963 (Durazzo I)
Koschatzky, Walter, 'Jacob Graf Durazzo – Ein Beitrag zur Geschichte der Albertina (Part 1)' in *Albertina-Studien*, 1963, pp. 47–61

KOSCHATZKY 1963 (Durazzo II)
Koschatzky, Walter, 'Das Fundament des Grafen Durazzo – Ein Beitrag zur Geschichte der Albertina (Part 2)' in *Albertina-Studien*, 1963, pp. 95–100

KOSCHATZKY 1964 (Durazzo III)
Koschatzky, Walter, 'Der Discorso Preliminare des Grafen Durazzo – Ein Beitrag zur Geschichte der Albertina (Part 3 – Conclusion)' in *Albertina-Studien*, 1964, pp. 3–16

KOSCHATZKY 1971
Koschatzky, Walter, *Dürerzeichnungen. Die Geschichte der Dürersammlung der Albertina*, Salzburg/Vienna 1971

KOSCHATZKY 1979
Koschatzky, Walter, 'Es ging um die Wiener Albertina' in *Die Presse*, March 17/18, 1979, pp. 15, 19

KOSCHATZKY 1991/92
Koschatzky, Walter, *Auf Spurensuche (unedierte Lebenserinnerungen)*, Vienna 1991/92

KOSCHATZKY/KRASA 1982
Koschatzky, Walter/Krasa, Selma, *Herzog Albert von Sachsen-Teschen 1738–1822. Reichsfeldmarschall und Kunstmäzen*, Vienna 1982

KOSCHATZKY/MITSCH/KNAB 1964
Koschatzky, Walter/Mitsch, Erwin/Knab, Eckhart, 'In Memoriam Otto Benesch – Karl Garzarolli-Thurnlackh – Erwin Hänisch' in *Albertina-Studien*, 1964, no. 3, pp. 63–67

KOSCHATZKY/STROBL 1969
Koschatzky, Walter/Strobl, Alice, *Die Albertina in Wien*, Salzburg 1969

KRAPF-WEILER 1986
Krapf-Weiler, Almut, *Zur Geschichte des Tietze-Kreises* (= intellectual life in Austria during the First Republic. Selection of lectures held in Vienna from November 11–13, 1980 and October 27/28, 1982; special publication), Vienna 1986

KRASA 1967–1968
Krasa, Selma, 'Antonio Canovas Denkmal der Erzherzogin Marie Christine' in *Albertina-Studien*, 1967–68, pp. 67–134

KRASA 1986
Krasa, Selma, 'Imagines: Die Stich- und Zeichnungensammlung des Prinzen Eugen' in *Bibliotheca Eugeniana. Die Sammlungen des Prinzen Eugen von Savoyen* (exhib. cat.), Vienna 1986, pp. 293–331

KÜTTNER 1801
Küttner, Carl Gottlob, *Reise durch Deutschland, Dänemark, Schweden, Norwegen und einen Theil von Italien, in den Jahren 1797, 1798, 1799*, 4 volumes, Leipzig 1801

LABBÉ/BICART-SÉE 1987
Labbé, Jacqueline/Bicart-Sée, Lise, 'Les dessins de la collection Saint-Morys au Cabinet des Dessins du Louvre' in *La collection Saint-Morys au Cabinet des Dessins du Musée du Louvre* (I, ed. by Arquié-Bruley, Françoise/Labbé, Jacqueline/Bicart-Sée, Lise), Paris 1987, pp. 127–141

LABBÉ/BICART-SÉE 1987 (d'Argenville)
Labbé, Jacqueline/Bicart-Sée, Lise, 'Antoine-Joseph Dezallier d'Argenville as a Collector of Drawings' in *Master Drawings* XXV/3, 1987, pp. 276–281

LA GARDE-CHAMBONAS 1820 (reprinted 1901)
La Garde-Chambonas, A(ugust Louis Charles comte de), *Souvenir du Congrès de Vienne 1814–1815* (Paris 1820), revised ed. (introduction and commentary by Le comte Fleury), Paris 1901

LAIRESSE 1728
Lairesse, Gérard de, *Grosses Mahler-Buch*, Nuremberg 1728

LAURENTIUS/NIEMEIJER/PLOOS VAN AMSTEL 1980
Laurentius, Theo/Niemeijer, Jan W./Ploos van Amstel G., *Cornelis Ploos van Amstel, 1726–1798, Kunstverzamelaar en prentuitgever*, Assen 1980

LENNHOFF/POSNER 1965
Lennhoff, Eugen/Posner, Oskar, *Internationales Freimaurerlexikon* (reprint of 1932 edition in unaltered form), Munich/Zurich/Vienna 1965

LHOTSKY 1955
Lhotsky, Alphons, 'Die Verteidigung der Wiener
Sammlungen kultur- und naturhistorischer Denk-
mäler durch die Erste Republik' in *Mitteilungen des
Instituts für österreichische Geschichtsforschung*
LXIII, 1955, pp. 614–649

LOEHR 1954
Loehr, August, 'In memoriam Hans Tietze (Aus der
Zeit der österreichischen Kulturkrise)' in *Österreichi-
sche Zeitschrift für Kunst und Denkmalpflege*, VIII,
1954, pp. 121 f.

LÜTZOW 1877
Lützow, Carl von, *Geschichte der k. k. Akademie
der bildenden Künste. Festschrift zur Eröffnung des
neuen Akademie-Gebäudes*, Vienna 1877

LUGT 1921
Lugt, Frits, *Les marques de collections de dessins
et d'estampes*, Amsterdam 1921

LUGT 1938
Lugt, Frits, *Répertoire des Catalogues de Ventes
Publiques*, volume 1 (First Period: c. 1600–1825),
The Hague 1938

LUGT 1956
Lugt, Frits, *Les marques de collections de dessins et
d'estampes*, Supplement, The Hague 1956

MAGNUSSON 1982
Magnusson, Börje, 'The De la Gardie (Borrestad)
Collection of Drawings' in *Nationalmuseum Bulletin*
1982, volume 6, no. 3, pp. 113–140

MALÍKOVA 1990
Malíkova, Mária, 'Neue Erkenntnisse über die
Einrichtung der Bratislavaer Burg in den Jahren
1766–1784' in *Zborník Slovenského Národného
Múzea*, História 30, LXXXIV, 1990, pp. 149–173
(with summaries in German)

MANDROUX-FRANÇA 1986
Mandroux-França, Marie-Thérèse, 'La collection
d'estampes du Roi Jean V de Portugal: une relecture
des Notes Manuscrites de Pierre-Jean Mariette' in
*Revue de l'art*, 73, 1986, pp. 49–54

MARIETTE 1741
Mariette, Pierre-Jean, *Description sommaire des
Desseins des Grands Maîtres d'Italie, des Pays-Bas
et de France, du Cabinet de Feu M. Crozat. Avec des
Réflexions sur la maniere de dessiner des principaux
Peintres*, Paris 1741

MAROLLES 1666
Marolles, Michel de / Abbé de Villeloin, *Catalogue
de livres d'estampes et de Figures en taille douce*,
Paris 1666

MAROLLES 1672
Marolles, Michel de / Abbé de Villeloin, *Catalogue
de livres d'estampes et de figures en taille-douce. Avec
un denombrement des Pieces qui y sont contenuës*,
Paris 1672

MARX 1979
Marx, Harald, 'Pierre Jean Mariette und Dresden'
in *Dresdener Kunstblätter*, 23, 1979, pp. 77–87

MECHEL 1778
Mechel, Christian von, *La Galerie Electorale du
Dusseldorff ou Catalogue Raisonné et Figuré de ses
Tableaux*, Basel 1778

MECHEL 1783
Mechel, Christian von, *Verzeichniss der Gemaelde
der Kaiserlich Königlichen Bilder Gallerie in Wien,
verfaßt von Christian von Mechel der Kaiserl.
Königl. und anderer Akademien Mitglied nach der
von ihm auf Allerhoechsten Befehl im Jahre 1781
gemachten neuen Einrichtung*, Vienna 1783

MEDER 1919
Meder, Joseph, *Die Handzeichnung. Ihre Technik
und Entwicklung*, Vienna 1919

MEDER 1922
Meder, Joseph, 'Herzog Albert von Sachsen-Teschen.
Zu seinem 100jährigen Todestag' in *Die Graphi-
schen Künste*, 45, 1922, pp. 73–85

MEDER n.d.
Meder, Joseph, *Matery of Drawing*, n.p., n.d.

MEUSEL 1778
Meusel, Johann Georg, *Teutsches Künstlerlexikon
oder Verzeichnis der jetztlebenden teutschen
Künstler*, Lemgo 1778

MEUSEL 1795
Meusel, Johann Georg, *Neues Museum für Künstler
und Kunstliebhaber*, part 4, Leipzig 1795

MIKOLETZKY 1963
Mikoletzky, Hanns Leo, 'Die privaten geheimen
Kassen Kaiser Franz I. und Maria Theresias' in *Mit-
teilungen des Instituts für österreichische Geschichts-
forschung* LXXI, 1963, pp. 380–394

MIKOLETZKY 1969
Mikoletzky, Hanns Leo, 'Die Bedingungen von Saint-
Germain und ihre Auswirkungen' in *Österreichische
Zeitgeschichte vom Ende der Monarchie bis zur
Gegenwart*, Vienna/Munich 1969, pp. 76–81

MONIER 1698
Monier, Pierre, *Histoire des Arts qui ont Rapport au
Dessein, divisée en trois livres*, Paris 1698

MORONI 1840–1861
Moroni, Gaetano, *Dizionario di erudizione storico-
ecclesiastica da pp. Pietro sino ai nostri giorni (etc.)*,
103 volumes, Venice 1840–61

NECK 1974
Neck, Rudolf, 'Die österreichische Friedensdelega-
tion in St. Germain (Ihr Archiv und ihre Arbeits-
weise)' in *Scrinium* 11, 1974, pp. 36–46

NICHOLAS 1994
Nicholas, Lynn H., *The Rape of Europa. The Fate of
Europe's Treasures in the Third Reich and the Second
World War*, New York 1994

ÖST. BIOGR. LEX. 1957–1994
*Österreichisches biographisches Lexikon 1815–1950*
(ed. by the Österreichische Akademie der Wissen-
schaften), 10 volumes [to date], Vienna 1957–1994

PELLAR 1988
Pellar, Brigitte, *Albertinaplatz*, Vienna/Zurich 1988

PILES 1681
Piles, Roger de, *Dissertation sur les Ouvrages des
plus fameux peintres*, Paris 1681

PILES 1708
Piles, Roger de, *Cours de peinture par principes*,
Paris 1708

POMIAN 1979
Pomian, Krzysztof, 'Marchands, connaisseurs,
curieux à Paris au XVIIIᵉ siècle' in *Revue de l'Art*, 43,
1979, pp. 23–36

POMIAN 1986
Pomian, Krzysztof, *Der Ursprung des Museums.
Vom Sammeln*, Berlin 1986

POMIAN 1987
Pomian, Krzysztof, *Collectionneurs, amateurs et
curieux Paris, Venise: XVIᵉ–XVIIIᵉ siècle*, Turin 1987

POPHAM 1936
Popham, Arthur E., 'Sebastiano Resta and his
Collections' in *Old Master Drawings*, XI, 1936,
pp. 1–15

PRÉAUD/CASSELLE et al. 1987
Préaud, Maxime/Casselle, Pierre et al., *Dictionnaire
des éditeurs d'estampes à Paris sous l'Ancien Régime*,
Paris 1987

REICHEL 1922
Reichel, Anton, 'Die Handzeichnungensammlung
der Graphischen Sammlung Albertina. Ein Rückblick
und Ausblick' in *Wiener Jahrbuch für bildende
Kunst*, 1922, pp. 115–126

REICHEL 1924
Reichel, Anton, 'Die Handzeichnungen-Reproduk-
tionen im Wandel der Zeiten' in *Neue Freie Presse*,
July 4, 1924, no. 21483, pp. 27

REICHEL 1941
Reichel, Anton (Ed.), see STIX/SPITZMÜLLER
1941

REINALTER 1983
Reinalter, Helmut (Ed.), *Freimaurer und Geheim-
bünde im 18. Jahrhundert in Mitteleuropa*, Frankfurt
1983

RICHARDSON 1715, see RICHARDSON 1792

RICHARDSON 1728
Richardson, Jonathan sen./jun., *Traité de la Peinture
et de la Sculpture*, 4 volumes, Amsterdam 1728

RICHARDSON 1792
Richardson, Jonathan, *Works, containing 1. the
theory of painting 2. essay on the art of criticism (so
far as it relates to painting) 3. the science of a con-
noisseur. A new edition, corrected, with the additions
of an essay on the knowledge of prints, and cautions
to collectors* (1st edition 1715), reprinted London
1792

RIEGER 1993
Rieger, Rudolf, 'Bartsch, Johann Adam' in *Saur All-
gemeines Künstlerlexikon. Die Bildenden Künstler
aller Zeiten und Völker*, volume 7, Munich/Leipzig
1993, pp. 313–314

ROBERT 1898
Robert, Ulysse, *Voyage à Vienne*, Paris n.d. (1898)

ROBERT 1899
Robert, Ulysse, *De Pont-de-Roide a Vienne,
De Vienne a Pont-de-Roide, Souvenirs de voyage*,
Besançon 1899

ROEGIERS 1980
Roegiers, Jan, 'Der Umsturz in Brabant
(1789–1790)' in *Österreich zur Zeit Kaiser
Josephs II.* (exhib. cat.), Melk 1980, pp. 266–273

ROSSITER 1972
Rossiter, Henry P., 'The Albertina for Boston?' in
*Apollo, The Magazine of the Arts*, XCVI, no. 126,
August 1972, pp. 135–137

ROTENSTEIN 1783
Rotenstein, Gottfried von, 'Reisen durch einen Theil
des Königreichs Ungarn im Jahr 1763 und folgenden
Jahren. Zweyter Abschnitt. Beschreibung von Preß-
burg und einiger nahe gelegener Lustörter' in *Johann
Bernoulli, Sammlung kurzer Reisebeschreibungen
und anderer zur Erweiterung der Länder- und Men-
schenkenntniß dienender Nachrichten*, volume 10,
Berlin 1783, pp. 185–208

ROTENSTEIN 1793
Rotenstein, Gottfried von, *Lust-Reisen durch Bay-
ern, Wuertemberg, Pfalz, Sachsen, Brandenburg,
Oesterreich, Maehren, Boehmen und Ungarn, in den
Jahren 1784–1791*, part 3, Leipzig 1793

SACHS 1971
Sachs, Hannelore, *Sammler und Mäzene. Zur Ent-
wicklung des Kunstsammelns von der Antike bis zur
Gegenwart*, Leipzig 1971

SAISSELIN 1964
Saisselin, Rémy G., 'Amateurs, Connoisseurs,
and Painters' in *The Art Quaterly*, 27, 1964,
pp. 429–437

SAXE-TESCHEN, see ALBERT of Saxe-Teschen

SCHAGER-ECKARTSAU 1922
Schager-Eckartsau, Albin, *Die Konfiskation des
Privatvermögens der Familie Habsburg-Lothringen
und des Kaisers und Königs Karl*, Innsbruck 1922

SCHMIDT 1837
Schmidt, A., *Vienne en 1837*, Vienna 1837

SCHNAPPER 1994
Schnapper, Antoine, *Curieux du Grand Siècle.
Collections et collectionneurs dans la France du
XVIIe siècle*, Paris 1994

SCHÖNBRUNNER 1887
Schönbrunner, Joseph, *Die Albertina*, Vienna 1887

SCHÖNBRUNNER 1887 (reports)
Schönbrunner, Joseph, 'Die Albertina' in *Berichte
und Mittheilungen des Alterthums-Vereines zu Wien*,
volume XXIV, 1887, pp. 190–204

SCHÖNBRUNNER/MEDER 1896–1908
Schönbrunner, Joseph/Meder, Joseph (Ed.), *Hand-*

zeichnungen alter Meister aus der Albertina und anderen Sammlungen, 12 volumes, Vienna 1896–1908

SCHUDT 1959
Schudt, Ludwig, *Italienreisen im 17. und 18. Jahrhundert*, Vienna/Munich 1959

SCHULZ 1937
Schulz, Georg Wilhelm, 'Gottfried Winckler und seine Sammlungen' in W. Teupfer (Ed.), *Kunst und ihre Sammlung in Leipzig*, Leipzig 1937, pp. 63–102

SCHULZE-ALTCAPPENBERG 1987
Schulze-Altcappenberg, Hein.-Th., *'Le Voltaire de l'Art' Johann Georg Wille (1715–1808) und seine Schule in Paris*, Münster 1987

SCOTT 1973
Scott, B., 'Pierre-Jean Mariette. Scholar and Connoisseur' in *Apollo, The Magazine of the Arts*, XCVII, no. 131, January 1973, pp. 54–59

SMITAL 1920
Smital, Ottokar, 'Die Hofbibliothek' in *Die beiden Hofmuseen und die Hofbibliothek*, Vienna/Leipzig 1920

SPITZMÜLLER 1995
Spitzmüller, Anna, *Albertina-Gespräche* (NBM-Video), Perchtoldsdorf 1995

STIX 1921
Stix, Alfred, 'Adam Bartsch. 1757–1821' in *Die Graphischen Künste*, XLIV, 1921, pp. 87–102

STIX 1922
Stix, Alfred, *Französische Kupferstiche des 18. Jahrhunderts aus den Dubletten der Kupferstichsammlung Albertina in Wien und einer anderen deutschen Sammlung*, in auction cat., C. G. Boerner, Leipzig 1922

STIX 1926–33
Stix, Alfred (Ed.), *Beschreibender Katalog der Handzeichnungen in der Graphischen Sammlung Albertina*, volume I–V, Vienna 1926–33

STIX 1927
Stix, Alfred, 'Herzog Albrecht von Sachsen-Teschen' in *Die Zeichnung*, vol. II. German drawings in the XV–XVIII centuries, cat., Vienna 1927

STIX/FRÖHLICH-BUM 1926
Stix, Alfred/Fröhlich-Bum, Lili (Ed.), *Die Zeichnungen der venezianischen Schule* (descriptive cat. on drawings in the Graphische Sammlung Albertina, volume I, ed. by Alfred Stix), Vienna 1926

STIX/FRÖHLICH-BUM 1932
Stix, Alfred/Fröhlich-Bum, Lili (Ed.), *Die Zeichnungen der toskanischen, umbrischen und römischen Schulen* (descriptive cat. on drawings in the Graphische Sammlung Albertina, volume III, ed. by Alfred Stix), Vienna 1932

STIX/SPITZMÜLLER 1941
Stix, Alfred/Spitzmüller, Anna (Ed.), *Die Schulen von Ferrara, Bologna, Parma und Modena, der Lombardei, Genuas, Neapels und Siziliens mit einem Nachtrag zu allen italienischen Schulen* (descriptive cat. on drawings in the Graphische Sammlung Albertina, volume VI, ed. by Anton Reichel), Vienna 1941

STRUBELL 1979
Strubell, Wolfgang, 'Das Handelshaus Richter in Leipzig' in *Genealogie. Deutsche Zeitschrift für Familienkunde* (ed. by G. Gessner and H. Reise), 28th yr., volume 14, no. 11, November 1979, pp. 737–751

STUMMVOLL 1968/1973
Stummvoll, Josef (Ed.), *Geschichte der Österreichischen Nationalbibliothek*, 2 volumes, Vienna 1968/1973

SULZER 1771–1774
Sulzer, Johann Georg, *Allgemeine Theorie der Schoenen Künste, Erster und Zweyter Theil*, 2 volumes, Leipzig 1771–74

SUTTON 1981
Sutton, Denys, 'Aspects of British Collecting, Part I'

in *Apollo, Magazine of the Arts*, CXIV, no. 237, November 1981, pp. 282–339

SZABO 1994
Szabo, Franz A.J., *Kaunitz and Enlightened Absolutism 1753–1780*, n.p. 1994

TAYLOR 1983
Taylor, Alan J.P., *The Habsburg Monarchy, 1809–1918: A History of the Austrain Empire and Austria-Hungary*, Chicago 1983

THAUSING 1870 (Mittheilungen)
Thausing, Moriz von, 'Geschichte der Albertina' in *Mittheilungen des k.k. Österreichischen Museums für Kunst und Industrie*, volume III, no. 52 dated January 15, 1870, p. 85 f.

THAUSING 1870–1871
Thausing, Moriz von, 'La Collection Albertina a Vienne, son histoire, sa composition' in *Gazette des Beaux Arts*, 29, volume 4, 1870–71, pp. 72–82

TIETZE 1919
Tietze, Hans, *Die Entführung von Wiener Kunstwerken nach Italien … Mit einem offenen Brief an die italienischen Fachgenossen von Max Dvořák*, Vienna 1919

TIETZE 1922
Tietze, Hans, 'Das Vermächtnis Oswald von Kutscheras' in *Wiener Jahrbuch für bildende Kunst* V, 1922, pp. 49–56

TIETZE 1923
Tietze, Hans, *Die Zukunft der Wiener Museen*, Vienna 1923

TIETZE/TIETZE-CONRAT et al 1933
Tietze, Hans/Tietze-Conrat, Erika et al (Ed.), *Die Zeichnungen der deutschen Schulen bis zum Beginn des Klassizismus* (descriptive cat. on drawings in the Graphische Sammlung Albertina, volume IV/V, ed. by Alfred Stix), Vienna 1933

TRAUTSCHOLDT 1957
Trautscholdt, Eduard, 'Zur Geschichte des Leipziger Sammelwesens' in *Festschrift Hans Vollmer*, Leipzig 1957, pp. 217–252

TRENKLER 1949
Trenkler, Ernst, *Die Kartensammlung*, Vienna 1949

TROPPER 1963
Tropper, Christine, 'Schicksale der Büchersammlungen niederösterreichischer Klöster nach der Aufhebung durch Joseph II. und Franz (II.) I.' in *Mitteilungen des Instituts für österreichische Geschichtsforschung*, XCI, 1963, pp. 95–139

TURBA 1925
Turba, Gustav, *Neues über Lothringisches und Habsburgisches Privateigentum*, Vienna/Leipzig 1925

VIVIAN n.d.
Vivian, Frances, *The Consul Smith Collection. Masterpieces of Italian Drawing from the Royal Library, Windsor Castle: Raphael to Canaletto*, n.p., n.d.

UNTERKIRCHNER 1959
Unterkirchner, Franz, *Inventar der illuminierten Handschriften, Inkunabeln und Frühdrucke der Österreichischen Nationalbibliothek*, part 2 (Museion. ÖNB publication, volume 2), Vienna 1959, pp. 127–135

WAAGEN 1867
Waagen, Gustav Friedrich, *Die vornehmsten Kunstdenkmäler in Wien*, 2 volumes, Vienna 1867

WAGNER 1967
Wagner, Walter, *Die Geschichte der Akademie der Bildenden Künste in Wien*, Vienna 1967

WANDRUSZKA 1964
Wandruszka, Adam, *The House of Habsburg*, n.p. 1964

WANDRUSZKA 1965
Wandruszka, Adam, *Leopold II. Erzherzog von*

Österreich, Großherzog von Toskana, König von Ungarn und Böhmen, Römischer Kaiser, 2 volumes, Vienna/Munich 1965

WATELET/LÉVESQUE 1792
Watelet, Claude Henri/Lévesque, Pierre Charles, *Dictionnaire des Arts de Peinture, Sculpture et Gravure*, 5 volumes, Paris 1792

WAWRIK 1991/1992
Wawrik, Franz, 'Zur Vorgeschichte und Entstehung der Kartensammlung der Österreichischen Nationalbibliothek' in *Jahrbuch des Vereins für Geschichte der Stadt Wien*, volume 47/48, 1991/92, pp. 141–161

WEBER 1992
Weber, Nicholas Fox, *Patron Saints. Five rebels who opened America to a new art 1928–1943*, New York 1992

WECKBECKER 1891
Weckbecker, Wilhelm (Ed.), *Handbuch der Kunstpflege in Österreich*, Vienna 1891

WHITEHILL 1970
Whitehill, Walter Muir, *Museum of Fine Arts Boston. A Centennial History*, volume 2, Cambridge/Massachusetts 1970

WICKHOFF 1891/1892
Wickhoff, Franz, *Die italienischen Handzeichnungen der Albertina*, 2 volumes, Vienna 1891/92

WILDENSTEIN 1982
Wildenstein, Daniel, 'Les tableaux italiens dans les catalogues de ventes parisiennes du XVIIIe siècle' in *Gazette des Beaux Arts*, C, July/August 1982, pp. 1–48

WOLF 1863
Wolf, Adam, *Marie Christine, Erzherzogin von Oesterreich*, 2 volumes, Vienna 1863

WURZBACH 1856–1891
Wurzbach, Constant von, *Biographisches Lexikon des Kaiserthums Österreich*, 60 volumes, Vienna 1856–91

YPERSELE DE STRIHOU 1991
Ypersele de Strihou, Anne und Paul, *Laeken. Un château de l'Europe des Lumières*, Paris 1991

YPERSELE DE STRIHOU 1991 (Bulletin)
Ypersele de Strihou, Anne van, 'Charles De Wailly. Architecte du château royal de Laeken (Belgique)' in *Bulletin de la Société de l'Histoire de l'Art français*, Paris 1991

ZÖLLNER 1979
Zöllner, Erich, *Geschichte Österreichs*, Vienna 1979

# List of Color Plates, Color Illustrations, and Figures

## Color Plates
(in alphabetical order by artist)

OLD MASTERS ACQUIRED
BY DUKE ALBERT AND
SUBSEQUENT ACQUISITIONS
UP TO THE PRESENT

Rudolf von Alt, 1812–1905
*The Spa Promenade at Teplitz*, 1876
Watercolor, gouache, 432 x 340 mm
Signed bottom right: R Alt, inscribed and dated bottom
left: Teplitz Aug 876
Inv. 32880
Acquired under Otto Benesch  (Plate 55)

Albrecht Altdorfer, 1480–1538
*Adoration of the Magi*
Pen drawing in ink, opaque white, on a blue ground on
paper, 187 x 136 mm
Inv. 30959
Acquired under Otto Benesch  (Plate 11)

Federico Barocci, 1535–1612
*Study for a head of the Christ Child*
Chalk, ruddle, ochre, opaque white, 255 x 204 mm
Inv. 2238
Provenance: Prince de Ligne –
Albert, Duke of Saxe-Teschen
Acquired by Duke Albert  (Plate 19)

Federico Barocci
*Woman's head in profile*
Chalk, ruddle, ochre, heightened in white,
340 x 248 mm
Inv. 24359
Acquired under Joseph Meder  (Plate 18)

Stefano della Bella, 1610–1664
*Death Seizes the Countess and Beats the Drum
for the Noblewoman*
Pen, 112 x 177 mm
Inv. 11249
Acquired under Archduke Albrecht  (Plate 29A)

Stefano della Bella
*A Nobleman and a Warrior in Combat with Death*
Pen, 111 x 176 mm
Inv. 11243
Acquired under Archduke Albrecht  (Plate 29B)

Stefano della Bella
*Death Riding across a Battlefield*
Chalk, ruddle, pen, grey wash, 194 x 220 mm
Inv. 961
Provenance: Moriz von Fries – Albert, Duke of Saxe-
Teschen
Acquired by Duke Albert  (Plate 36)

Herbert Boeckl, 1894–1966
*The Erzberg*
Charcoal, watercolor, 539 x 734 mm
Monogrammed bottom right: H[?] B,
inscribed bottom left: 2
Inv. 35178
Acquired under Walter Koschatzky  (Plate 75)

Jacques Callot, 1592/93–1635
*The Santa Maria della Impruneta Fair near Florence*
Chalk, pen and brush in brown, wash, 205 x 394 mm
Inv. 11218
Provenance: Prince de Ligne – Albert, Duke of Saxe-
Teschen (1794)
Acquired by Duke Albert  (Plate 28)

Annibale Carracci, 1555–1619
*The Triumph of Bacchus and Ariadne*
Chalk, pen, wash, heightened in white, 238 x 429 mm
Inv. 23370
Acquired under Alfred Stix

Ludovico Carracci
*Crucifixion*
Chalk, pen, wash, 228 x 133 mm
Inv. 2072
Provenance: Pierre-Jean Mariette – Radel –
Moriz von Fries – Albert, Duke of Saxe-Teschen
Acquired by Duke Albert  (Plate 22)

Paul Cézanne, 1839–1906
*Château Noir and Monte Sainte-Victoire*
Pencil, watercolor, 309 x 483 mm
Inv. 24081
Acquired under Alfred Stix  (Plate 63)

Marc Chagall, 1887–1985
*Lute Player*, 1911
Pen, tusche, brush, watercolor, 238 x 308 mm
Signed and dated bottom right: Chagall 911
Inv. 23810
Acquired under Alfred Stix  (Plate 68)

Christo, *b.* 1935
*Project for Packed Kunsthalle Bern*, 1961
Silkscreen print, 707 x 550 mm (sh.)
Inscribed and dated bottom left: 18/135 and
Packed Kunsthalle Project for Kunsthalle Bern –
Switzerland – July 1961
Inv. 1975/256
Acquired under Walter Koschatzky  (Plate 82)

Lovis Corinth, 1858–1925
*Still-Life with Flowers*, 1922
Watercolor, 365 x 570 mm
Signed and dated to the left of the vase:
"Lovis Corinth 19 September 1922"
Inv. 23284
Acquired under Alfred Stix  (Plate 74)

Camille Corot, 1796–1875
*Southern Landscape with a Large Tree*, 1871
Charcoal on dark browned paper, 298 x 435 mm
Signed and dated bottom left. C. Corot. 1871
Inv. 24167
Acquired under Alfred Stix  (Plate 58)

Joseph Danhauser, 1805–1845
*Boy Playing the Violin*
Pencil, heightened in white on blue-grey paper,
288 x 215 mm
Inv. 5107
Acquired under Archduke Charles  (Plate 48)

Albrecht Dürer, 1471–1528
*Innsbruck*
Watercolor, 127 x 187 mm
Inscribed and monogrammed top center: Isprug AD
Inv. 3056
Provenance: Kaiserliche Schatzkammer – Kaiserliche
Hofbibliothek (1783) – Albert, Duke of Saxe-Teschen
(1796)
Acquired by Duke Albert  (Plate 2)

Albrecht Dürer
*Hare*, 1502
Watercolor, body color, opaque white, 251 x 225 mm
Monogrammed and dated bottom center: AD and 1502
Inv. 3073
Provenance: Imhoff Collection – the Emperor Rudolf II
– Kaiserliche Schatzkammer – Kaiserliche Hofbiblio-
thek (1783) – Albert, Duke of Saxe-Teschen (1796)
Acquired by Duke Albert  (Plate 4)

Albrecht Dürer
*Mary with a Multitude of Animals*
Pen, watercolor, 319 x 241 mm
Inv. 3066
Provenance: The Emperor Rudolf II – Kaiserliche
Schatzkammer – Kaiserliche Hofbibliothek (1783) –
Albert, Duke of Saxe-Teschen (1796)
Acquired by Duke Albert  (Plate 3)

Albrecht Dürer
*Large Piece of Turf*, 1503
Water and body color, 403 x 311 mm
(inside passe-partout)
Dated bottom right: 1503
Inv. 3075
Provenance: Kaiserliche Schatzkammer – Kaiserliche
Hofbibliothek (1783) – Albert, Duke of Saxe-Teschen
(1796)
Acquired by Duke Albert  (Plate 5)

Albrecht Dürer
*The Virgin and Four Saints*, 1511
Pen in brown, 292 x 216 mm
Signed top right: AD; dated top left: 1511
Inv. 3127
Provenance: Kaiserliche Schatzkammer – Kaiserliche
Hofbibliothek (1783) – Albert, Duke of Saxe-Teschen
(1796)
Acquired by Duke Albert  (Plate 7)

Albrecht Dürer
*Wing of a Blue Roller*, 1512
Watercolor and body color, 197 x 201 mm
Monogrammed bottom center: AD; dated top center:
1512
Inv. 4840
Provenance: Imhoff Collection – the Emperor Rudolf II
– Kaiserliche Schatzkammer – Kaiserliche Hofbiblio-
thek (1783) – Albert, Duke of Saxe-Teschen (1796)
Acquired by Duke Albert  (Plate 6)

Albrecht Dürer
*Antwerp Harbor*, 1520
Pen in brown, 214 x 287 mm
Dated and inscribed top center: 1520 Antorff
Inv. 3165
Provenance: Kaiserliche Schatzkammer – Kaiserliche
Hofbibliothek (1783) – Albert, Duke of Saxe-Teschen
(1796)
Acquired by Duke Albert  (Plate 8)

Albrecht Dürer
*Study of an old man's head*, 1521
Brush in ink, opaque white, 415 x 282 mm
Monogrammed and dated top left: AD 1521
Inv. 3167
Provenance: Imhoff Collection – Kaiserliche Schatz-
kammer – Kaiserliche Hofbibliothek (1783) – Albert,
Duke of Saxe-Teschen (1796)
Acquired by Duke Albert  (Plate 9)

Antony van Dyck, 1599–1641
*The Betrayal of Christ*
Pen and brush in brown, 217 x 230 mm
Inv. 17537
Provenance: Kaiserliche Hofbibliothek – Albert,
Duke of Saxe-Teschen (1796)
Acquired by Duke Albert  (Plate 26)

Thomas Ender, 1793–1875
*The Matterhorn Viewed from the Gornergrat*
Watercolor, 333 x 503 mm
Inv. 36935
Acquired under Walter Koschatzky (Plate 53)

Thomas Ender
*Arva Castle*
Watercolor, 334 x 477 mm
Signed bottom center: Tho Ender
Inv. 28371
Acquired between 1934 and 1947 (Plate 52)

James Ensor, 1860–1949
*Two Girls*
Chalk, watercolor, 251 x 145 mm
Signed bottom right: Ensor
Inv. 30069
Acquired between 1934 and 1947 (Plate 57)

Allart van Everdingen, 1621–1675
*Storm at Sea*
Black chalk, brush in grey and brown, wash, opaque
white, 225 x 416 mm
Monogrammed bottom right: AVE
Inv. 9590
Provenance: Gottfried Winckler – Albert, Duke of
Saxe-Teschen
Acquired by Duke Albert  (Plate 40)

Caspar David Friedrich, 1774–1840
*Landscape with Graves*
Pencil, brush in brown, wash, 238 x 286 mm
Inv. 24610
Acquired under Alfred Stix (Plate 46)

Giovanni Gallo after Marco Pino da Siena
*Cain Slaying Abel*
Chiaroscuro woodcut, 400 x 266 mm (leaf)
It I 3, p. 5a
Acquired under Archduke Charles  (Plate 10)

Paul Gauguin, 1848–1903
*AUTI TE PAPE (Women at the River)*, 1894
Colored woodcut, 205 x 355 mm
Inv. 1921/66
Acquired under Joseph Meder (Plate 60)

Vincent van Gogh, 1853–1890
*Graveyard in the Rain*
Pencil, pen, tusche, 239 x 375 mm
Inv. 2791
Acquired between 1934 and 1947 (Plate 56)

Hendrick Goltzius, 1558–1617
*Self–Portrait*
Black and colored chalks, watercolor wash, opaque
white, 430 x 322 mm
Monogrammed left center: HG
Inv. 17638
Provenance: Dionis Muilman – Cornelis Ploos
van Amstel – Albert, Duke of Saxe-Teschen (1800)
Acquired by Duke Albert  (Plate 20)

Francisco de Goya, 1746–1828
*Bobalicón (Folly)*
Etching, aquatint, drypoint, 243 x 357 mm (pl.)
Inv. 1924/597
Acquired under Alfred Stix  (Plate 47)

Francesco Guardi, 1712–1793
*The Grand Canal near the Fish Market*
Pen, wash, 269 x 245 mm
Inv. 24333
Acquired under Alfred Stix  (Plate 42)

Guercino (Giovanni Francesco Barbieri), 1591–1666
*The Virgin with the Infants Christ and St John*
Ruddle, pen, wash, 145 x 143 mm
Inscribed bottom left: Guercyn del Cento
Inv. 2317
Provenance: Gottfried Winckler – Albert, Duke of
Saxe-Teschen
Acquired by Duke Albert  (Plate 24)

Hans Hartung, 1904–1989
*Composition*
Color etching, 394 x 525 mm (pl.)
Signed bottom right: Hartung; marked bottom left:
73/75
Inv. 1957/21
Acquired under Otto Benesch  (Plate 77)

Jan van Huysum, 1682–1749
*Still–Life with Flowers*
Chalk, pen, watercolor, 401 x 316 mm
Inv. 10553
Provenance: Gottfried Winckler – Albert, Duke of
Saxe-Teschen
Acquired by Duke Albert  (Plate 30)

Wassily Kandinsky, 1866–1944
*Composition*, 1915
Brush, tusche, watercolor, 227 x 339 mm
Signed and dated bottom left: K/15
Inv. 23492
Acquired under Alfred Stix  (Plate 69)

Paul Klee, 1879–1940
*Villas on a Lake*, 1920
Pencil, brush in tusche, watercolor, 142 x 224 mm
Signed right center: Klee; dated and inscribed bottom
left: 1920.84 Villen am See
DL 78
Acquired under Konrad Oberhuber (Plate 72)

Gustav Klimt, 1862–1918
*Floating*, study for an allegorical mural for Vienna
University: Medicine.
Black chalk, 415 x 273 mm
Inv. 23664
Acquired under Alfred Stix  (Plate 65)

Käthe Kollwitz, 1867–1945
*Sketch for the etching 'Outbreak', from the 'Peasants'
War' cycle*, 1901
Pencil, black chalk, opaque white, 600 x 635 mm
Signed and dated bottom right: K. Kollwitz 1901
Inv. 30033
Acquired between 1934 and 1947 (Plate 61)

Alfred Kubin, 1877–1959
*Mammoth*
Pen and brush in tusche, watercolor wash,
239 x 280 mm
Signed bottom right: Kubin
Inv. 33212
Acquired under Otto Benesch  (Plate 70)

Maria Lassnig, b. 1919
*Head*, 1963
Watercolor, 298 x 415 mm
Signed and dated bottom left: M. Lassnig 1963
Inv. 35162
Acquired under Walter Koschatzky (Plate 81)

Fernand Léger, 1881–1955
*Still–Life with a Blue Vase*
Color lithograph, 355 x 435 mm (repr.)
Signed bottom right: Fleger
Inv. 1959/215
Acquired under Otto Benesch  (Plate 76)

Leonardo da Vinci, 1452–1519
*Half-length of an Apostle (Peter?)*
Silver point, pen in brown, 146 x 113 mm
Inv. 17614
Provenance: Prince de Ligne – Albert, Duke of Saxe-
Teschen (1794)
Acquired by Duke Albert  (Plate 12)

Max Liebermann, 1847–1935
*On the Beach at Nordwijk*
Pastel, black chalk, 119 x 192 mm
Signed bottom left: Mliebermann
Inv. 22856
Acquired under Joseph Meder (Plate 66)

Cluade Lorrain, 1600–1682
*Copse and a Shepherd, Resting*
Traces of lead stylus, pen and brush in brown, washes,
283 x 207 mm
Inv. 11529
Provenance: Prince de Ligne – Albert, Duke of Saxe-
Teschen (1794)
Acquired by Duke Albert  (Plate 37)

Edouard Manet, 1832–1883
*Laburnum, Iris, and Geranium*
Watercolor, 367 x 254 mm
Inv. 24129
Acquired under Alfred Stix  (Plate 54)

Carlo Maratta, 1625–1713
*Adoration of the Shepherds*
Chalk, rubbed, grey wash, 252 x 170 mm
Inv. 1052
Provenance: Prince de Ligne – Albert, Duke of Saxe-Teschen (1794)
Acquired by Duke Albert  (Plate 39)

Franz Marc, 1880–1916
*Horses Resting*, 1911/12
Color woodcut, 169 x 228 mm (repr.)
Inv. 1913/252
Acquired under Joseph Meder  (Plate 67)

Franz Anton Maulbertsch, 1724–1796
*Angels with the Book and the Crown of St Stephen*
Watercolor, gouache, 470 x 320 mm
Inv. 27396
Acquired between 1934 and 1947  (Plate 44)

Franz Anton Maulbertsch
*The Assumption*
Brush in oils, 272 x 203 mm
Inv. 26610
Acquired under Alfred Stix  (Plate 45)

Adolph Menzel, 1815–1905
*Sawmill*, 1892
Pencil, rubbed, 308 x 225 mm
Signed and dated bottom left: A.M. 92.
Inv. 24226
Acquired under Alfred Stix  (Plate 59)

Michelangelo Buonarroti, 1475–1564
*Male nude, seen from the back*
Chalk, opaque white, 188 x 262 mm
Inscribed bottom left: impossible de trouver plus beau;
top right: Collezione di P.P. Rubens
Inv. 123 verso
Provenance: Peter Paul Rubens – Pierre–Jean Mariette –
Prince de Ligne – Albert, Duke of Saxe-Teschen
Acquired by Duke Albert  (Plate 16)

Michelangelo Buonarroti
*Seated male nude (ignudo) and two arm studies*
Ruddle, opaque white, 268 x 188 mm
Inv. 120
Provenance: Peter Paul Rubens – Pierre Crozat –
Pierre–Jean Mariette – Julien de Parme – Prince de
Ligne – Albert, Duke of Saxe-Teschen (1794)
Acquired by Duke Albert  (Plate 17)

Barnett Newman, 1905–1970
*Untitled*, 1960
Tusche, 356 x 245 mm
Signed and dated top left: Barnett Newman 60
DL 43
Acquired under Konrad Oberhuber  (Plate 79)

Nadeshda Oudaltsova, 1885–1961
*Composition*
Pencil, watercolor, 255 x 245 mm
Inv. 41927
Acquired under Konrad Oberhuber  (Plate 73)

Pablo Picasso, 1881–1973
*Jacqueline lisant*, 1958
Lithograph, 559 x 445 mm
Signed bottom right: Picasso; dated top right (in the
stone): 11.1.58 and 27.12.58; inscribed bottom left:
42/50
Inv. 1962/196
Acquired under Walter Koschatzky  (Plate 78)

Pisanello (Antonio Pisano), 1395–1455
*Allegory of Luxury*
Pen, reddish ground on paper, 129 x 152 mm
Inscribed bottom right: Pisanello
Inv. 24018
Acquired under Alfred Stix  (Plate 1)

Jackson Pollock, 1912–1956
*Untitled*
Black ink, 520 x 660 mm
DL 50
Acquired under Konrad Oberhuber  (Plate 80)

Nicolas Poussin, 1594–1665
*View of Rome from Monte Mario*
Lead stylus, pen in ink, washes, 182 x 257 mm
Inv. 11447
Provenance: Crozat – Pierre–Jean Mariette – Prince de
Ligne – Albert, Duke of Saxe-Teschen (1794)
Acquired by Duke Albert  (Plate 25)

Raphael, 1483–1520
*Virgin, Reading, and Child*
Traces of lead stylus, pen in brown, 187 x 146 mm
Inv. 205
Provenance: Timoteo Viti – Marchese Antaldi –
Prince de Ligne – Albert, Duke of Saxe-Teschen (1794)
Acquired by Duke Albert  (Plate 15)

Raphael
*Studies for a Madonna and Child*
Pen in brown, ruddle, 263 x 192 mm
Monogrammed bottom right (partly covered): R.V.
Inv. 209 verso
Provenance: Timoteo Viti – Marchese Antaldi – Pierre
Crozat – Marquis de Gouvernet – Julien de Parme –
Prince de Ligne – Albert, Duke of Saxe-Teschen (1794)
Acquired by Duke Albert  (Plate 14)

Arnulf Rainer, b. 1929
*Above Gromaire*
Tusche, wax crayons, 495 x 690 mm
Signed bottom right: A. Rainer
Inv. 34972
Acquired under Walter Koschatzky  (Plate 85)

Rembrandt Harmensz van Rijn, 1606–1669
*Three studies of an elephant with an attendant*
Black chalk, 239 x 355 mm
Inv. 8900
Provenance: Kaiserliche Hofbibliothek – Albert, Duke
of Saxe-Teschen (1796)
Acquired by Duke Albert  (Plate 32)

Rembrandt Harmensz van Rijn
*Cottages before a Stormy Sky (in sunlight)*
Pen in brown, brown and grey washes, opaque white,
181 x 244 mm
Inv. 8880
Provenance: Kaiserliche Hofbibliothek – Albert, Duke
of Saxe-Teschen (1796)
Acquired by Duke Albert  (Plate 34)

Rembrandt Harmensz van Rijn
*Jonah at the Walls of Nineveh*
Pen in brown, washes, traces of opaque white,
217 x 173 mm
Inv. 8808
Provenance: Gottfried Winckler – Albert, Duke of
Saxe-Teschen
Acquired by Duke Albert  (Plate 35)

Guido Reni, 1575–1642
*Apollo in the Chariot of the Sun*
Ruddle, pen, 125 x 257 mm
Inv. 24550
Acquired under Alfred Stix  (Plate 23)

Auguste Rodin, 1840–1917
*Figure studies*
Pencil, brush, brown washes, 118 x 185 mm
Inscribed bottom left: Maladie; bottom right: riccio
Inv. 25657 recto
Acquired under Alfred Stix  (Plate 62)

Anton Romako, 1832–1889
*Carnival in Venice*
Pencil, watercolor, 254 x 353 mm
Signed and inscribed bottom right:
A. Romako. Venedig
Inv. 36479
Acquired under Walter Koschatzky  (Plate 50)

Peter Paul Rubens, 1577–1640
*Two Young Women, one holding a Lapdog*
Black chalk, pen in brown, grey wash, opaque white,
290 x 235 mm
Inv. 8274
Provenance: Gottfried Winckler – Albert, Duke of
Saxe-Teschen
Acquired by Duke Albert  (Plate 27)

Peter Paul Rubens
*Study of a dress*
Black chalk, ruddle, opaque white, 410 x 320 mm
Inv. 8255 verso
Provenance: Kaiserliche Hofbibliothek – Albert, Duke
of Saxe-Teschen (1796)
Acquired by Duke Albert  (Plate 31)

Pieter Jansz. Saenredam, 1597–1665
*Interior of St Laurence's Church (Grote Kerk)
in Alkmaar*, 1661
Graphite stylus, pen in brown, watercolor washes,
453 x 605 mm
Signed and dated bottom center (on the back of the
choir pews): Anno 1661, in de Maent Maij, heb ick
Pr Saenredam dese reeckening tot Alcmaer in de Kerck
gemaeckt
Inv. 15129
Provenance: Cornelis Ploos van Amstel – Albert, Duke
of Saxe-Teschen (1800)
Acquired by Duke Albert  (Plate 41)

Egon Schiele, 1890–1918
*Seated Couple (Egon and Edith Schiele)*, 1915
Pencil, gouache, 519 x 410 mm
Signed and dated bottom center. Egon Schiele 1915
Inv. 29766
Acquired between 1934 and 1947  (Plate 71)

Carl Schindler, 1821–1842
*Wedding Trip*
Pencil, watercolor, 142 x 225 mm
Inv. 31189
Acquired under Otto Benesch  (Plate 49)

Alfred Sisley, 1839–1899
*Forest Track*
Pastel, 169 x 210 mm
Signed bottom left: Sisley
Inv. 24153
Acquired under Alfred Stix  (Plate 64)

Francesco Solimena, 1657–1747
*The Apotheosis of Louis XIV*
Chalk, pen, washes, 352 x 252 mm
Inv. 24375
Acquired under Joseph Meder (Plate 38)

Giovanni Battista Tiepolo, 1696–1770
*Saints Fidelis of Sigmaringen and Joseph of Leonessa Banish Heresy*
Chalk, pen, washes, brush in opaque white,
504 x 350 mm
Inv. 1813
Provenance: Gottfried Winckler – Albert, Duke of Saxe-Teschen
Acquired by Duke Albert (Plate 43)

Giorgio Vasari, 1511–1574
*Sheet framed with eight drawings*
Pen in brown and grey, washes, 493 x 373 mm
Inscribed bottom left: Pet. Crozat; bottom center: Già di Giog. Vasari ora di P. Gio: Mariette (above: N.o 2); bottom right: Julien de Parme 1775
Inv. 14179
Provenance. Giorgio Vasari – Pierre Crozat – Pierre–Jean Mariette – Julien de Parme – Prince de Ligne – Albert, Duke of Saxe-Teschen
Acquired by Duke Albert (Plate 13)

Cornelis Hendricksz Vroom, 1591–1661
*A Tree–Lined Country Lane*
Pen in brown, washes, watercolor, 364 x 311 mm
Inv. 8166
Provenance: Cornelis Ploos van Amstel – Albert, Duke of Saxe-Teschen (1800)
Acquired by Duke Albert (Plate 33)

Sebastian Wegmayr, 1776–1857
*Roses*
Watercolor and gouache, 217 x 287 mm
Inv. 6737
Acquired under Archduke Albrecht (Plate 51)

Max Weiler, b. 1910
*Natural Phenomenon (Avalanche)*, 1988
Pencil, egg tempera, 1090 x 610 mm
Signed and dated bottom right: Weiler 88
Inv. 40184
Acquired under Konrad Oberhuber (Plate 86)

Franz West, b. 1947
*Made by (Untitled)*, 1976/77
Mixed technique, 605 x 430 mm
Signed and dated center (on the woman's thigh):
West 76–77
Signed, dated and inscribed bottom left:
Made by F. West 76–77
Inv. 42353
Acquired under Konrad Oberhuber (Plate 84)

Fritz Wotruba, 1907–1975
*Tectonic Figure Composition*, 1964
Tusche, watercolor washes, 420 x 297 mm
Signed bottom right: F Wotruba; dated bottom left: 1964
Inv. 41742
Acquired under Konrad Oberhuber (Plate 83)

## Color Illustrations

p. 17
Friedrich Heinrich Füger
*Albert, Duke of Saxe-Teschen*
Watercolor miniature on ivory, 71 x 46 mm
Graphische Sammlung Albertina, inv. 41398

p. 17
J. Lutz after Eduard Gurk
*Duke Albert's Palace*, after 1804
Copperplate engraving, colored, 94 x 139 mm (bord.)
Graphische Samlung Albertina, Cim. Kasten, F. VI, no. 68, Fig. 8

p. 18
Pietro Rotari
*Albert, Prince of Saxony, in a White Coat holding a Fortification Plan*, before 1763
Oil/canvas, 108 x 86 cm
Moritzburg Castle near Dresden, Gallery no. MO 2118

p. 18
In the manner of Jean Etienne Liotard
*The Archduchess Marie Christine*
Pastel, 445 x 370 mm
Vienna, Kunsthistorisches Museum,
Inv. GG 8755

p. 19
Albert of Saxe-Teschen
*Design for a grotto in the park of Schoonenberg Castle*, 1782
Graphite pencil, chalk, watercolor, 206 x 335 mm
Signed and dated bottom right: P. A. del. 1782; inscribed bottom center: Vue de la Grotte 3 Reservoir. A.
Graphische Sammlung Albertina, Cim. K. F. I, No. 17, p. 63

p. 20
Anonymous
*The Archduchess Marie Christine*
Oil on canvas, 112 x 85 cm
Budapest, National Museum,
Historical Picture Gallery,
Inv. 415

p. 21
Friedrich Heinrich Füger / Jean Galucha (?)
*Albert, Duke of Saxe-Teschen and the Archduchess Marie Christine*
Watercolor miniature on ivory
(Lid of a snuff-box),
71 mm (diameter)
Signed bottom right: H. F. Füger
Vienna, Kunsthistorisches Museum
Inv. KK 1598

p. 21
Jean–Baptiste Isabey
*Archduke Charles of Habsburg–Lorraine (1771–1847)*, 1812
Watercolor miniature on paper, 137 x 100 mm
Signed and dated right center: Isabey à Vienne 1812
Graphische Sammlung Albertina, inv. 34659

p. 22
Entail inventory of Duke Albert's drawings collection
1 vol., drawn up by Franz Rechberger, 1822
Calf leather, gold–tooled, 380 x 250 x 70 mm
Graphische SammlungAlbertina, archives

p. 22
Detail of binding (monogram CL) for inventories of prints drawn up under Archduke Charles according to Franz Rechberger's section system
Calf leather, gold–tooled monogram of Archduke Charles,
28 x 24 mm (oval of the monogram)
Graphische Sammlung Albertina, historical inventories

p. 23
Friedrich Heinrich Füger
*Duke Albert and the Archduchess Marie Christine Showing Works of Art (Drawings ?) Brought from Italy to the Royal Family*, 1776
Tempera on vellum, 342 x 390 mm
Signed and dated (on the vase pedestal): H. F. Füger pinx: 1776
Vienna, Österreichische Galerie, inv. 2296

p. 24
Monogram of Duke Albert AS on the index volumes of the hand–written catalogue of his library
Red morocco, gold tooling, 465 x 295 x 50 mm
Graphische Sammlung Albertina, Cim, K. F. VI, no. 111

p. 24
Original bindings for the inventory of Duke Albert's drawings and prints
Red morocco leather, gold tooling, 470 x 335 x 70 mm (detail with monogram: 70 x 60 mm)
Graphische Sammlung Albertina, historical inventories

p. 24
Original bindings used for Duke Albert's drawings collection
Calf leather, gold-tooled, 667 x 480 x 100 mm
Graphische Sammlung Albertina

# Figures

1 View of the Albertina; the front facing onto the Burggarten
Photograph taken in 1996
Graphische Sammlung Albertina, Photothek

2 The Archduchess Marie Christine
*Christmas presents given to members of the Imperial family*
Gouache, 300 x 450 mm
Vienna, Kunsthistorisches Museum, inv. GG 7521

3 Jakob Schmutzer after Martin van Meytens
*Giacomo Conte Durazzo*, 1765
Copperplate engraving, 461 x 318 mm (pl.)
Graphische Sammlung Albertina, ÖK Schmutzer, vol. 1, fo. no. 102

4 Giacomo Conte Durazzo
*Discorso Preliminare*, page with dedication to Duke Albert, September 1776
Pen and brush in grey–black, grey and brown washes, 728 x 528 mm
Graphische Sammlung Albertina, inv. 30858 (1st version)

5–14 Giacomo Conte Durazzo
*Discorso Preliminare*, foreword (Figs. 5–6) and text, 1776
Pen in grey–black, 728 x 528 mm
Graphische Sammlung Albertina, inv. 30858² (1st version)

15 James Thomson after George Lewis
*Portrait of Adam von Bartsch*
Copperplate engraving, 157 x 123 mm (bord.)
Graphische Sammlung Albertina, HB 52 (12) I, p. 1, leaf no. 2

16 Duke Albert's ledger with monies spent on drawings and prints from 1783–1822 in a copy of the registry files made in 1886 by Joseph Schönbrunner, 360 x 244 mm (leaf)
Graphische Sammlung Albertina, archives

17 Albert of Saxe-Teschen
*View of old Schoonenberg Castle near Brussels*
Graphite, 330 x 382 mm
Graphische Sammlung Albertina, inv. 13693

18, 19, 19A Three–page inventory of cargo transported for Duke Albert which went down in a storm between Rotterdam and Hamburg late in 1792
Budapest, Hungarian National Archives, Habsburg Family Archives, P 298–84, no. 67, pp. 1–3

20–21 Index vols of the catalogue of the library owned by Albert, Duke of Saxe-Teschen
Vol. 1, 'Note preliminaire' (2 pages), 455 x 285 mm (leaf)
Graphische Sammlung Albertina, Cim. K. F. VI, no. 111

22 Index vols of the catalogue of the library owned by Albert, Duke of Saxe-Teschen
Vol. 1, table of contents of Vol. VI, 455 x 285 mm (leaf)
Graphische Sammlung Albertina, Cim. K. F. VI, no. 111

23 The estate of Duke Albert on 1 April 1799
Budapest, Hungarian National Archives, Habsburg Family Archives, P 298–57, p. 18

24 Funerary monument of the Archduchess Marie Christine in the Augustine Church, Vienna
Photograph
Vienna, Bildarchiv der Österreichischen Nationalbibliothek, L. 2012 B

25–26 The will of Albert, Duke of Saxe-Teschen, written in his own hand (with codicils dated 1819), title page and 1st page, 1816
Paper, 14 pages, 430 x 265 mm
Vienna, Haus- Hof- und Staatsarchiv, Family documents 2264, 1816 VI. 16

27 Clause 7 of the will of Albert, Duke of Saxe-Teschen, 1816, with provisions for the entailing of his art collection
Vienna, Haus- Hof- und Staatsarchiv, Family documents 2264, 1816 VI. 16, p. 9

28–30 Three–page appraisal of Duke Albert's drawings collection, written by Franz Rechberger for Archduke Charles, 1822
Budapest, Hungarian National Archives, Habsburg Family Archives, P 1490, no. 19, 3 d, p. 46f.

31 Entailment inventory of Duke Albert's drawings collection drawn up by Franz Rechberger, 1822
Title page, 370 x 240 mm
Graphische Sammlung Albertina, archives

32 Entailment inventory of Duke Albert's print collection
7 vols, drawn up by Franz Rechberger and Gottlieb Straube, complete from 1825
Morocco leather bindings, gold tooling, 390 x 260 x 65 mm
Graphische Sammlung Albertina, archives

33 Entailment inventory of Duke Albert's print collection
Title page of Vol. 1, 375 x 230 mm
Graphische Sammlung Albertina, archives

34 Gottlieb Straube's inventory of the ducal print collection, 7 September 1822
Budapest, Hungarian National Archives, Habsburg Family Archives, P 1490, no. 19, 3 d, p. 38

35 Carl Müller
*Joseph Meder in the so–called 'Alte Albertina'*, 1915, watercolor, 318 x 458 mm (inside passe-partout)
Signed and dated bottom left: C. Müller 1915.
Graphische Sammlung Albertina, inv. 26440

36 Inventory entry recording that Duke Albert decorated the walls of his private apartments with drawings
The entry refers to a sheet by Hans V.F. Schnoor von Carolsfeld, which is in the Graphische Sammlung Albertina under inv. 17347 (cf. Fig. 37)

37 Hans V.F. Schnorr von Carolsfeld
*Mythological Scene* (copy after Adam F. Oeser)
Pencil, brush in brown and grey, watercolor, 626 x 684 mm
Graphische Sammlung Albertina, inv. 17347

38 Inscriptions on spines of bindings for historical print inventories divided according to Franz Rechberger's system into three sections: 1ère Section Graveurs; 2de Section Peintres; 3e Section Eaux fortes
Graphische Sammlung Albertina, historical inventories

39 Frontispiece in the inventory volumes of prints, arranged in sections, in the Albertina
Etching, 348 x 253 mm
Monogrammed bottom center with Archduke Charles's initials CL (Carl Ludwig)
Graphische Samlung Albertina, It. 116, frontispiece

40 Title page of an inventory book, begun in 1895, of the Albertina archducal art collection, 384 x 240 mm (leaf)
Graphische Sammlung Albertina, inventories

41–42 Statute of the state of German Austria, no. 209; law enacted April 3, 1919 on the banishment of the house of Habsburg-Lorraine and the confiscation of its fortunes and property

43–45 Statute of the Republic of Austria, no. 303; the Treaty of Saint-Germain-en-Laye of September 10, 1919

46 Statute of the State of German Austria, no. 90; law enacted on December 5, 1918 on forbidding the export and selling at auction of items of historical, aesthetic or cultural significance.

47 Statute of the state of German Austria, no. 479; law enacted on October 16, 1919 authorizing the national government to pawn, sell at auction and export individual items owned by the state.

48 Index volumes of the hand–written catalogue of the library belonging to Albert, Duke of Saxe-Teschen, undated (drawn up after 1819)
Red morocco leather, gold tooling, 465 x 295 x 50 mm
Graphische Sammlung Albertina, Cim. K. F. VI, no. 111

49 Index volumes of the catalogue of the library belonging to Albert, Duke of Saxe-Teschen
Vol. 1, title page, 455 x 285 mm (leaf)
Graphische Sammlung Albertina, Cim. K. F. VI, no. 111

50 The Albertina after the bombing raid of March 12, 1945
Photograph
Graphische Sammlung Albertina, archives

51 Jean–Baptiste Le Prince
*Russian Family*
Graphite, watercolor, 222 x 259 mm
Graphische Sammlung Albertina, inv. 12346

52–53 Two versions of a design (330 x 204 mm) corrected by von Bartsch for the ducal historical inventories; next to them the corrected version recopied (309 x 202 mm)
Graphische Sammlung Albertina, archives

54 Adam von Bartsch
*Design for the frontispiece in the portfolios of the imperial copperplate engravings collection*
Graphite, 460 x 330 mm
Signed bottom right: Ad. Bartsch fe
Graphische Sammlung Albertina, inv. 23008

55 Adam von Bartsch
*Frontispiece for the portfolios of the imperial copperplate engravings collection*, 1786
Copperplate engraving, 453 x 323 mm (pl.)
Signed and dated bottom right: Adam Bartsch fecit 1786
Graphische Sammlung Albertina, HB 52 (12) I, 2nd frontispiece (without pagination)

56 Adam von Bartsch
*Conclave of the Court Library Officials*
Pen in brown, wash, 232 x 300 mm
Inscribed on the old support cardboard: 1. Le Baron von Svieten Prefec 2. M^r de Kollar: Conseiller Antique 3. M^r. de Schwandner: Garde (Curator) 4. Reisenhuber 5. Sanach 6. Bianchi [the last three are in parentheses and called Ecrivains] 7. M^r Martinez: Garde (Curator) 8. Bartsch: Ecrivain.
Graphische Sammlung Albertina, inv. 5014

57 Adam von Bartsch
*Cover for Duke Albert's drawings portfolios*, 1804
Copperplate engraving, 382 x 273 mm (pl.)
Graphische Sammlung Albertina, HB 52 (12) I, p. 36, leaf no. 115

58 Adam von Bartsch
*Cover for Duke Albert's print portfolios*, 1804
Copperplate engraving, 629 x 420 mm (pl.)
Signed bottom right: A. Bartsch fecit.
Graphische Sammlung Albertina, HB 52 (12) I, p. 38

59 Giacomo Conte Durazzo (?)
*First cover for the 2nd version of the 'Discorso Preliminare'*
Brush in grey, washes, 322 x 213 mm (leaf)
Graphische Sammlung Albertina, inv. 30858²

60–61 Letter from Duke Albert
to Joseph van Bouckhout,
November 26, 1796
2 pages, 370 x 238 mm
Graphische Sammlung Albertina, archives

62 Page from an (unnumbered) purchase inventory 'Artaria Compagnie 1784–1828', ref. March 1786, 358 x 230 mm
Graphische Sammlung Albertina, archives

63 Volume of engravings from the former collection of Prince Eugene of Savoy
650 x 490 mm
Graphische Sammlung Albertina, print catalogue from the Kaiserliche Hofbibliothek,
HB X 5

64–65 List of portfolios which belonged to Prince Eugene's drawings collection as *Imaginum Delineatar. Collectio*
Vienna, Manuscript Collection of the Österreichische Nationalbibliothek, Cod. 14378, fol. 1401, 1402

66–67 Slip cases in which Duke Albert's historical drawings inventories (called cahiers) were kept (and are still to be found today)
Cardboard, 235 x 365 x 40 mm
Graphische Sammlung Albertina, historical inventories

68 Title page of first volume (Sc. Rom. Vol. 1) of Duke Albert's historical drawings inventories (called cahiers)
309 x 212 mm
Graphische Sammlung Albertina, historical inventories

69 Title page of the historical inventories (called cahiers) of the Dürer drawings (Sc. Tedes. Vol. II), 310 x 200 mm
Graphische Sammlung Albertina, historical inventories

70 Page from the historical inventories (called cahiers) of Duke Albert's drawings collection, referring to the meaning of three asterisks in identifying provenance (i.e.: Vienna, Kaiserliche Hofbibliothek, 1796), 310 x 200 mm
Graphische Sammlung Albertina, historical inventories, old drawings cahiers, 'Sc. Rom. Vol. 1'

71 Page from the historical inventories (called cahiers) of Duke Albert's drawings collection, referring to the meaning of one asterisk in identifying provenance (i.e. : Prince de Ligne, 1794), 310 x 200 mm
Graphische Sammlung Albertina, Historical inventories, old drawings cahiers, 'Sc. Rom. Vol. 1'

72 Page from the historical inventories (called cahiers) of Duke Albert's drawings collection, referring to the meaning of two asterisks in identifying provenance (i.e. : Ploos van Amstel), 310 x 200 mm
Graphische Sammlung Albertina, Historical inventories, old drawings cahiers, 'Sc. Fiam. Vol. 1'

73 Page from the historical inventories (called cahiers) of Duke Albert's drawings collection referring to the meaning of five asterisks in identifying provenance (i.e. : Gottfried Winckler), 310 x 200 mm
Graphische Sammlung Albertina, Historical inventories, old drawings cahiers, 'Sc. Fiam. Vol. 1'

74 Jakob Gauermann
*Diary, 1789, with various entries (among them expenditure and earnings from 1799, 1800, and later years*
Page 42 verso, 219 x 180 mm (leaf)
Penultimate entry: d[en] 28 August 99 für eine Landschaft (Amor und Psiche bey Pan) v[on] Herzog Albert in Wien empfang[en] 30. f. – (Cf. Fig. 75)
Graphische Sammlung Albertina, Inv. 41939

75 Jakob Gauermann
*Landscape with Psyche, Cupid, and Pan*
Gouache, 465 x 640 mm
Graphische Sammlung Albertina, inv. 14651

76 Impress of Duke Albert's seal (6 x 5 mm) on drawings which entered his collections up to the time of his death (on 10 Feb. 1822)

77 Seal of Graphische Sammlung Albertina collection, used from the 1940s, 16 mm (diameter)

78 Albert of Saxe-Teschen
*The Old Castle at Lednitz (Lednické) in the Comity of Trentschin*, 1819
(now: Trencin an der Váh (Waag), Slovakia)
Pencil, 228 x 338 mm
Signed and dated bottom left: Das alte Schloß von Lednitz im Trentschiner Comitate nach der Natur gezeichnet 1819 AS.
Graphische Sammlung Albertina, inv. 25791

79 Detail of Duke Albert's monogram AS (4 x 5 mm) shown in Fig. 78

80 Duke Albert's monogram, detail of Fig. 81
80 x 70 mm (monogram section of binding spine)

81 Original bindings of Duke Albert's print collection
Red morocco leather, gold tooling
785 x 570 x 80 mm
Graphische Sammlung Albertina

82 Duke Albert's monogram marking books:
Adam von Bartsch, Le peintre graveur, Vol. IV, Vienna 1805, 200 x 120 mm
Graphische Sammlung Albertina B–680 (library)

83 Bookbinder inscription 'Krauss' (2 x 11 mm) as it appears on the spines of bindings for drawings in the archducal collections
Graphische Sammlung Albertina

84 Title page of Duke Albert's inventory sheets for drawings by contemporary artists (*Maitres Modernes*), 310 x 200 mm
Graphische Sammlung Albertina, historical inventories

# Index of Proper Names

## A

Albert of Saxe-Teschen, Duke 11–13, 16–19, 21–27, 29–34, 37f., 42f., 45–48, 50–54, 56f., 59–63, 153–157
Albrecht Habsburg-Lorraine, Archduke 31–33, 38, 43, 45, 64, 158
Albrecht III, Duke 54
Allen, W. G. Russel 43
v. Alt, Rudolf 64
Altdorfer, Albrecht Pl. 11
van Amstel, Cornelis Ploos 32, 57, 60, 157
d'Argenville, Antoine J. Dezallier 26
Artaria, Dominik II 48, 51, 59
Artaria, Dominik III 48

## B

Barocci, Federico Pls 18, 19
Bartolozzi, Francesco 51
v. Bartsch, Adam 16, 25, 48–52, 63
Becker, Wilhelm G. 60
della Bella, Stefano Pls 29 A, B, 36
Benesch, Otto 28, 54, 57, 64, 158
Benincasa, Bartolomeo 16, 26
Bianconi, Carlo 32
Bick, Josef 43–45
v. Birkenstock, Johann Melchior Edler 60f.
Böckh, Franz Heinrich 31
Boeckl, Herbert Pl. 75
van Bouckhout, Joseph 31, 47f., 51–53, 59

## C

Callot, Jacques Pl. 28
Canova, Antonio 30, 157
Carracci, Annibale Pl. 21
Carracci, Ludovico Pl. 22
Charles Habsburg-Lorraine, Archduke 21f., 31, 38, 64, 154, 156, 158
Casanova, Giovanni Battista 53
Caylus, Anne-Claude-Philippe Comte de 26
Cézanne, Paul Pl. 63
Chagall, Marc Pl. 68
Christ, Johann, F. 16
Christo Pl. 82
Claude Lorrain 57, Pl. 37
Corinth, Lovis Pl. 74
Corot, Camille Pl. 58
Crozat, Pierre 16, 26, 32, 61

## D

Danhauser, Joseph Pl. 48
Daun, Leopold Joseph, Count 12, 153
Demont, Louis 41
v. Derschau, Hans Albrecht 50f.
Dietrich, Christian Wilhelm E. 60
Duchesne, Jean 32, 37

Durazzo, Giacomo 12–16, 25f., 34, 37, 45–47, 52, 154
Dürer, Albrecht 33, 45, 54, 56f., 61, 157, Pls 2–9
van Dyck, Antony Pl. 26

## E

Edgell, Harold 43
Ender, Thomas Pls 52, 53
Enderes, Bruno 39
Ensor, James Pl. 57
Esterházy, Duke 61
Eugene of Savoy, Prince 16, 54f.
van Everdingen, Allart 59, Pl. 40

## F

Félibien, André 26
Ferri, Ciro 53
Franz I, Stephan of Lorraine, Holy Roman Emperor 154
Franz I, Emperor of Austria (as Franz II, Holy Roman Emperor) 30f., 54, 156f.
Frauenholtz, Friedrich 48, 50f., 59f.
Frederick Augustus I of Saxony (The Strong), Prince 16
Frederick Augustus II of Saxony, Prince 12, 153
Frederick Habsburg-Lorraine, Archduke 38, 41, 43, 45f., 64, 158
Frederick III, Emperor 54
Friedrich, Caspar David Pl. 46
v. Fries, Count Moriz 61
Füger, Friedrich Heinrich 17, 21, 23, 47f.
Füssli, Hans Rudolph 37

## G

Gallo, Giovanni Pl. 10
Galucha, Jean 21
de la Garde Chambonas, Auguste 31
Garzarolli-Thurnlackh, Karl 45, 158
Gauermann, Jakob 59
Gauguin, Paul Pl. 60
van Gogh, Vincent Pl. 56
Goltzius, Hendrick 57, Pl. 20
Goya, Francisco de Pl. 47
Guardi, Francesco Pl. 42
Guercino, called Giovanni Battista Barbieri 48, Pl. 24
Guiffrey, Jean 41
v. Gundel, Paul Anton 60
Gurk, Eduard 17

## H

v. Hagedorn, Christian L. 26
Hartung, Hans Pl. 77
v. Heinecken, Carl Heinrich 16
Heinz, Günther 25
v. Heucher, Johann Heinrich 16
Hone, Nathaniel 60

Huber, Michael 25
Hudson, Thomas 60f.
van Huysum, Jan 59, Pl. 30

## I

Isabey, Jean Baptiste 21

## J

Jabach, Everard 61
Jaeck, Joachim Heinrich 31
John V, King of Portugal 16
Joseph II, Emperor of Austria 27, 154–156

## K

Kandinsky, Wassily Pl. 69
Kaunitz, Wenzel 60
Klee, Paul Pl. 72
Klengel, Johann, Christian 48, 60, 64
Klimt, Gustav 64, Pl. 65
Koechlin, M. Raymond 41
Kokoschka, Oskar 64
Kollwitz, Käthe Pl. 61
Koschatzky, Walter 45f., 54, 64, 158
Krauß, Georg Friedrich 62f.
Kubin, Alfred Pl. 70

## L

de Lagoy, Marquis 60
de Lairesse, Gerard 25
Lassnig, Maria Pl. 81
Léger, Fernand Pl. 76
Le Paon, Jean-Baptiste 48
Le Prince, Jean Baptiste 47
Lefèbvre, François 31, 47
Lempereur, Jean-Denis 60
Lenoir, Jean Charles Pierre 47f.
Leonardo da Vinci 57, Pl. 12
v. Leonhartshoff, Johann Evangelist Scheffer 60
Leopold II, Emperor (as Leopold I, Regent of the Grand-Duchy of Tuscany) 46, 156
Leporini, Heinrich 45, 158
Lévesque, Pierre Charles 25
Lewis, George 25
Lhotsky, Alphons 38
Liebermann, Max Pl. 66
Liechtenstein, Duke of 61
de Ligne, Charles Antoine 47, 57, 60f., 154
Liotard, Jean Etienne 18
Ludwig, Carl 45
Lutz, J. 17

## M

Manet, Edouard Pl. 54
Maratta, Carlo Pl. 39
Marc, Franz Pl. 67
Maria Josepha, Archduchess 12, 153

Maria Theresia, Empress 12, 47, 153f.
Marie Christine, Archduchess 12, 16, 20f., 23, 27, 30, 46–48, 153–157
Mariette, Jean 16, 50, 55, 61
Mariette, Pierre Jean 16, 26, 32, 50, 55, 61
Maulbertsch, Franz Anton Pl. 45
Maximilian I, Holy Roman Emperor 54
Mayer, Gustav 43–45
v. Mechel, Christian 25
Meder, Joseph 35, 38, 41f., 60, 64, 158
Menzel, Adolph Pl. 59
Meunier, Louis 48
van Meytens, Martin 12
Michelangelo Buonarroti 57, Pl. 16, 17
van Mieris, Frans 47
Mitsch, Erwin 45, 158
Mongan, Agnes 43
Monier, Pierre 26
de Montoyer, Louis 154
Moroni, Gaetano 46
Müller, Carl 33, 35, 158

## N

Napoleon I 31
Newman, Barnett Pl. 79
van der Null, Joseph Friedrich 51

## O

Oberhuber, Konrad 45, 64, 158
Oeser, Adam Friedrich 36
Oudaltsova, Nadeshda Pl. 73

## P

de Parme, Julien 60f.
Payen, Antoine-Marie 154
Picasso, Pablo Pl. 78
de Piles, Roger 26
Piranesi, Giovanni Battista 46
Pisano, Antonio, called Pisanello Pl. 1
Pius VI, Pope 46
Pollock, Jackson Pl. 80
Poussin, Nicolas 57, Pl. 25
Praun, Paulus II 61

## R

Raphael 57, 61, Pls 14, 15
v. Rechberg, Carl 59
Rechberger, Franz 31–33, 37, 60, 158
Reichel, Anton 43, 45, 158
v. Reiffenstein, Johann F. 46
Rembrandt Harmensz. van Rijn 57, 59, Pls 32, 34, 35
Reni, Guido 48, Pl. 23
Resta, Sebastiano 61
Reynolds, Joshua 32, 60f.
Richardson the Elder, Jonathan 26
Richter, Johann Friedrich 48

Robert, Ulysse 38
Rochlitz, Johann Friedrich 59
Rodin, Auguste Pl. 62
Rogers, Charles 60
Romako, Anton Pl. 50
Rosa, Joseph 25, 48
Rossiter, Henry P. 43
Rost, Carl Christian Heinrich 25,
    52f., 60
Rotari, Pietro 18
v. Rotenstein, Gottfried 46
Rubens, Peter Paul 57, 59, Pls 27, 31
Rudolf II, Emperor 56, 61

S

Saenredam, Pieter Jansz. Pl. 41
Saiko, George 45, 158
Schiele, Egon 64, Pl. 71
Schindler, Carl Pl. 49
Schmutzer, Jakob 12, 46
Schnorr von Carolsfeld, Hans V.F. 36
Schönbrunner, Joseph 34, 37f., 158
v. Seckendorff, Alexander 48, 54
Seipel, Ignaz 42
Sengel, Carl 32f., 158
Sisley, Alfred Pl. 64
Solimena, Francesco Pl. 38
v. Sperges, Joseph Freiherr 60
Starhemberg, Duke of 53f.
Stix, Alfred 42f., 64, 158
Straube, Gottlieb 32
Sulzer, Johann Georg 25
van Swieten, Gottfried Freiherr 53f.

T

Teniers, David 47
Thausing, Moritz 33f., 37f.
Thomson, James 25
Tiepolo, Giovanni Battista Pl. 43
Tietze, Hans 42, 44f.

V

Vasari, Giorgio 61, Pl. 13
Vernet, Joseph 48
Viti, Timoteo 61
Vroom, Cornelis Hendricksz. 57,
    Pl. 33

W

de Wailly, Charles 154
Watelet, Claude Henri 25
Weber, Nicholas Fox 43
Weckbecker, Wilhelm 38
Wegmayr, Sebastian Pl. 51
Weller, Max Pl. 86
Wernett, Carl 59
West, Franz Pl. 84
Wille, Johann Georg 46
Winckler, Gottfried 57, 59f.
Wolf, Adam 47
Wotruba, Fritz Pl. 83

Z

Zanna, Joseph 48

This book has been published in conjunction
with an exhibiton held at the Art Gallery of
Ontario/Musée des beaux-arts de l'Ontario
(January 22 – March 26, 2000), and at The Frick
Collection, New York (April 11 – June 4, 2000)

Front cover:
Michelangelo Buonarroti, *Seated male nude (ignudo)
and two arm studies*, detail (see plate 17)
Rear cover:
August Macke, *Garden at Lake Thun*
Frontispiece:
Jackson Pollock, *Untitled*, (see also plate 80)

Translated from the German
by Joan Clough-Laub, Munich
Essays edited by Kate Garratt, Alston, GB

Editorial direction: Christopher Wynne

Library of Congress Card Number: 99-069129

The photographs are the property of the Graphische
Sammlung Albertina, with the exception of the
following (numbers refer to page nos.):
Bildarchiv der Österreichischen Nationalbibliothek,
    Vienna 30 (bottom), 55
Haus-, Hof- und Staatsarchiv, Vienna: 31, 32
Kunsthistorisches Museum, Vienna:
    12 (top), 21 (top), 18 (bottom)
National Museum, Budapest: 20
Österreichische Galerie · Belvedere, Vienna: 23
Photo-Atelier Frankenstein, Vienna: 44
Staatliche Kunstsammlungen, Dresden: 18 (top)
Hungarian National Archive, Budapest:
    28, 30 (top), 33, 35 (top)

Prestel Verlag
Mandlstrasse 26 · 80802 Munich
Tel. (089) 381709-0, Fax (089) 381709-35;
16 West 22nd Street · New York, NY 10010
Tel. (212) 627-8199, Fax (212) 627-9866;
4 Bloomsbury Place · London WC1A 2QA
Tel. (0171) 323 5004, Fax (0171) 636 8004

Prestel books are available worldwide.
Please contact your nearest bookseller
or one of the above Presel offices for
details concerning your local distributor.

Lithography: Karl Dörfel, Munich
Typeset and layout: Stefan Engelhardt, Mühldorf
Printing: Peradruck, Gräfelfing
Binding: Conzella, Pfarrkirchen

Printed in Germany on acid-free paper
ISBN 3-7913-2340-7